ABOUT THE EDITORS

Marian Fitzgibbon has held a number of positions in arts management in Ireland, primarily with the Arts Council/An Chomhairle Ealaíon. She is currently a Newman Scholar in the Business Research Programme, Graduate School of Business, University College Dublin where she is working towards a PhD in the area of arts management.

Anne Kelly is Director of Arts Administration Studies at University College Dublin. She writes and lectures on cultural policy issues, and is an editor and member of the editorial board of the European Journal of Cultural Policy. She is an external assessor for a number of universities and a member of the Board of the National Museum of Ireland.

Irish Studies in Management

Editors:

W.K. Roche
Graduate School of Business
University College Dublin

David Givens
Oak Tree Press

Irish Studies in Management is a new series of texts and research-based monographs covering management and business studies. Published by Oak Tree Press in association with the Graduate School of Business at University College Dublin, the series aims to publish significant contributions to the study of management and business in Ireland, especially where they address issues of major relevance to Irish management in the context of international developments, particularly within the European Union. Mindful that most texts and studies in current use in Irish business education take little direct account of Irish or European conditions, the series seeks to make available to the specialist and general reader works of high quality which comprehend issues and concerns arising from the practice of management and business in Ireland. The series aims to cover subjects ranging from accountancy to marketing, industrial relations/human resource management, international business, business ethics and economics. Studies of public policy and public affairs of relevance to business and economic life will also be published in the series.

FROM MAESTRO TO MANAGER

CRITICAL ISSUES IN ARTS AND CULTURE MANAGEMENT

Edited by
Marian Fitzgibbon
Anne Kelly

Oak Tree Press
Dublin
in association with
Graduate School of Business
University College Dublin

Oak Tree Press
Merrion Building
Lower Merrion Street
Dublin 2, Ireland

© 1997 Individual contributors and the Michael Smurfit Graduate
School of Business, University College Dublin

A catalogue record of this book is
available from the British Library.

ISBN 1-86076-041-4

Printed in Ireland by Colour Books Ltd.

CONTENTS

ACKNOWLEDGEMENTS

We would like to thank a number of people for their assistance with this publication:

Professor Bill Roche for originating the project and for helpful advice throughout; David Givens, our publisher, for his patience and understanding; Michael Martin, LAN (Local Area Network) Administrator of the Graduate Business School for his ever-cordial help with technology; Monique Le Treut for some assistance with translation; Paula Clancy for some good ideas and helpful suggestions; Niamh McCarthy for secretarial assistance.

We wish to thank all the contributors to this publication. However a special word is directed at the practitioners in the arts who were willing to give of their time without recompense and to allow students and colleagues the benefit of their experience.

CONTRIBUTORS

Lluís Bonet is Professor and Director of the Cultural Management Programme at the University of Barcelona

Catherine Breathnach is a Management Consultant within the non-profit sector in Ireland

Xavier Castañer is a Lecturer in Business Policy at ESADE in Barcelona and a member of the Institute of Public Management

Paula Clancy is a Senior Research Associate in the Business Research Programme, Graduate School of Business, University College Dublin

Mary Cloake is Director of Development, The Arts Council/An Chomhairle Ealaíon, Dublin

Pat Cooke is Manager of the Pearse Museum and Kilmainham Jail Museum on behalf of the Office of Public Works

Xavier Cubeles is an Associate Professor and Research Director of Cultural Economics at the Centre d'Estudis de Planificacio

Joe Dennehy is a Lecturer in Marketing Economics, Faculty of Business, Dublin Institute of Technology

Niall Doyle is Chief Executive of Music Network, an organisation charged with the development of regional music provision in Ireland

Marja Eriksson is Lecturer in management and organisation, School of Business Administration, University of Tampere, Finland

Andrew Feist is Senior Policy Analyst, The Arts Council of England, and Associate Fellow, University of Warwick

Jeremy Isaacs is General Manager of the Royal Opera House, Covent Garden, London

Laurent Lapierre is Professor of Leadership in the Management and Policy Department of École des Hautes Études Commerciales de Montréal

Patrick Mason is Artistic Director of the Abbey Theatre, Dublin

Declan McGonagle is Director of the Irish Museum of Modern Art

Emer Ní Bhrádaigh is a lecturer in arts marketing for the Higher Diploma in Arts Administration, University College Dublin, and for the Diploma in Cultural Management at the University of Ulster, Belfast

Ann O'Connell is Senior Manager in the Management Consultancy Division of Coopers and Lybrand, Dublin. She is responsible for the firm's Business Strategy services

Pierre François Ouellette is a PhD candidate in management at École des Hautes Études Commerciales de Montréal

Paul O'Sullivan is Director, Faculty of Business, Dublin Institute of Technology

Arja Ropo is Associate Professor of Management, School of Business Administration, University of Tampere, Finland

Jordi Roselló is Economist and Executive Manager of a construction firm

Louise Scott is European Officer, Scottish Film Council

Anne Marit Waade is PhD student in the Centre for Interdisciplinary Aesthetic Studies, University of Aarhus, Denmark

Aidan Walsh is Director of the Northern Ireland Museums Council, Belfast

INTRODUCTION

> The administration of the arts begins with the moment in which we give them their names . . . it is because the word sculpture is available that we can talk about it. . . . Anyone who proposes to manage the arts can claim at least this justification, that the arts are themselves ways of managing more primitive impulses. . . . Form is management (Donoghue, 1982: 72, 82).

Arts managers, culture managers, impresarios, arts administrators, cultural workers, arts workers, arts professionals, *animateurs*: all "just labels" but as usual, despite the commonly professed contempt for semantics, such labels excite surprising passions, especially among those whom they purport to name. This book addresses some aspects of what goes into making a good executive in the culture sector, thus attempting to build a definition of the contemporary culture manager by virtue of a series of shared interests, preoccupations and problems.

The philosophical polarities on the issue of the arts and their management range from the notion that the arts are separate from society and perform their function best in a state of conflict with society (Donoghue, 1982) to the concept of the arts as symbol systems which are essential elements of social communication (Williams, 1961). The first premise would have the arts retain their "mystery" in a state where academic explanation and the "cherishing bureaucracy of management" (Donoghue, 1982:71) have no role to play, while the second reflects the idea that the arts, by expressing universal values, mirror society, and are literally part of our social organisation.

The complexity of the area can also be seen at the practical level in the division between the artist (or some artists) and the manager in contemporary society. Competition for resources can provoke the artist to challenge the system of administration which stresses the importance of developing cultural infrastruc-

ture. The idea that such development is in the interests of art and artists can sometimes seem remote when viewed from the perspective of the economic deprivation of many artists.

The absence of certainty and complexity is at least as evident in the area of managing heritage, an area defined as "a contemporary mode of popular or non-specialist history" and one where "the writing or presentation of such histories is always and necessarily contentious" (Brett, 1996:2). Nothing is neutral. Presentation, for example, is a management issue in museums because of the move away from the concept of the museum as a temple presenting one version of "truth" to that of the museum as a forum for contesting interpretations. Apart from internal contentions, this sector is also to some extent divided between the traditional collections-based institutions and more modern heritage interpretations and presentations which have been developed with cultural tourism in mind and which rely heavily on the use of multimedia techniques.

Even within the culture management sector itself there can be resistance to the very idea of management, because some arts managers believe not just that they thrive on chaos, but that there is a certain organisational benefit in this. There is sometimes a belief that the mission of an arts organisation can best be expressed in an informal environment which reflects individuality and freedom from constraint. However, with the growth in levels of public support comes the demand for greater accountability and it is now recognised by most managers that the efficient and effective management of resources is required by government, funding bodies and the public. Hence, the need for management skills in the arts and in the promotion of cultural development.

Traditional definitions of arts administration have been in terms of specific categories of professions such as museum directors, theatre managers, civil servants and area-based cultural administrators, mainly in the public sector. However, the need to extend audiences and facilitate access and participation, along with the explosion in popular culture, has broadened the area to include cultural *animateurs*, artists, managers and workers in the cultural industries. Some attempts have been made to define an arts manager or cultural administrator given "the structural complexity of management in the arts — an area where the manager can be at the mercy of tides and currents over which he has

little control" (Pick, 1980:16). Five skills categories were identified (Mitchell and Fisher, 1992:25):

- Administration/organisational/financial skills

- Entrepreneurial/development/marketing/promotional skills

- Creative/generative/performing skills

- Teaching/education/training skills

- Technical and support skills.

The compilation of this publication which comprises chapters on specific aspects of the management of the arts was prompted by a number of factors. First, the increasing importance of the culture sector and its popularisation is borne out by its almost continuous media presence. This stimulates a hunger for increased understanding of the arts and heritage with consequences for their facilitation, mediation and management. Second, as indicated above, the increased financial resources, public and private, being invested in the culture sector demand greater efficiency, effectiveness, transparency and accountability: these are all management concerns. Third, there is a dearth of material in the English language on the subject — at least on this side of the Atlantic. The last major publication on this topic was by John Pick in 1980. In the meantime, much in the arts environment has changed and the emphasis on arts management has grown, predictably enough in tandem with the "professionalisation" of the sector and the need — most noticeable up to recently within the Thatcherite sphere of influence but now more and more within the wider and wealthier European context — to adapt to the increasing influence of market forces. By professionalisation we mean a number of things: the growing number of people who earn their living in the cultural sector; the recognition that as a sector with certain distinctive characteristics, it requires greater delineation; the proliferation of specialised training courses in arts and heritage management.[1]

Professionalisation trends in the cultural sector imply an effort to introduce order into areas of vocational life which are subject to the disorganising tendencies of societies undergoing continuous change. The concept is associated with ideas of standards of excellence and the development of a sense of responsibility in knowledge-based organisations where it is important for managers to

know their own field and its organisational context, as well as having management and leadership skills. The move towards professionalisation tends to emphasise managerial skills and this is a matter which concerns one of our writers, Pat Cooke. He cites the example of Diaghilev as a great impresario who was guided by "an early-begotten and consistent obsession with the art form" and whose organising abilities reflect "the spectacle of the amateur in pursuit of his destiny rather than the professional in pursuit of a career". However, while there is evidence that the pursuit of professionalisation is an international trend in the cultural sector (Mitchell and Fisher, 1992:28), this is by no means an unambiguous concept but is a phenomenon which differs between private and public sectors and between Anglo-American and European traditions. Although evidence of "a new managerial professionalism" was found, different emphases in the conceptions of professionalism were observed between the Nordic welfare states, France, Italy, Spain, Portugal and Greece (Mitchell and Fisher, 1992:58, 59).

This book spans both the contemporary arts and the heritage sectors since these areas have more in common than the sometimes artificial distinctions necessitated by funding or other administrative arrangements would suggest. Given the diversity within the arts sector itself we have included chapters which, as well as dealing with issues which are common to organisations in all art forms, cover problems which arise specifically in theatre, music and the visual arts.

The book has a very specific target audience: students of culture administration and practitioners in the fields of arts and heritage. Above all, it aims to be of practical assistance in a number of ways: providing a discussion of certain issues in culture management; offering some case studies as examples of practice and actual experience; providing frameworks or models in some areas which may present difficulties for culture managers; pointing up problem areas in the sector; and for the student, encouraging the development of concepts as well as indicating where one may access more information on given topics.

For these reasons and as a unique feature of the publication, there was a deliberate decision to include papers by practitioners as well as academics. Given the diversity and dynamism of the cultural area, the practitioner has a vital role in grounding and extending the discourse on culture management. Hence the

inclusion of interviews and colloquia with arts managers, intended to stimulate discussion — even disagreement — and to reflect what practitioners actually think and do, regardless of whether or not it accords with theory or management practice in other fields. The anomalies or inconsistencies — as well as the good ideas — thrown up by these discussions will hopefully supply food for thought and provide the basis for debate among students and practitioners.

While most of the chapters in this book refer in particular to the Irish and British arts contexts, there are also contributions from the other fringes of Europe: Catalonia, Denmark, and Finland. These contributions indicate that, despite different metapolitical and economic contexts, by and large the concerns of culture managers in the different European countries — the thrust towards innovation, the need for a more evaluative approach, the human resource issues which arise in such a labour-intensive sector — are widely shared. As a result, one can anticipate the likely interest and application of the Irish perspective within the wider European sphere. The inclusion of only one chapter from North America — a Canadian piece dealing with boards of management of arts bodies — is explained by the substantial environmental differences which apply there, as well as the literature in arts management which already exists in the US (Langley, 1990; Byrnes, 1993).

The book is divided into sections which address major aspects of culture management. These deal with the general debate on management in the sector; the application of strategic planning techniques to the sector; marketing the arts; consumption patterns in the arts and cultural industries; innovation and changing practice; and the "people" issues so important in a highly labour-intensive occupation. Because everything is interconnected, there is inevitable overlap between the different sections: the chapter on marketing offers a very comprehensive discussion of planning; the Finnish piece addresses issues around the difficulty of meeting objectives as well as HR matters; many case studies touch on a range of issues. The scope of the book excluded any prolonged direct discussion of financial management and resourcing, in itself an ample topic for a dedicated publication. It was also felt important to try to emerge from under the cloud of debate on funding/underfunding which so often darkens discussion of the arts in the Irish and British contexts and instead to emphasise

other dimensions. It is quite common for arts managers to think that funding is the only issue. This is not so.

Section One of the book directly addresses the culture management debate from the perspective of practitioners: the managers themselves. While it may seem self-evident that the arts, like any other sector, require skilled and effective management, as indicated above, there is a sense of unease with the concept among those directly involved. This has a number of sources: the rather vague belief that the arts, in their essence anarchic and in their nature inspirational, are not amenable to management; the ill-defined distaste which "arts people" feel for "the greasy till" of an economics or commerce-based discipline (indeed Yeats' popularity with contributors is notable!); the feeling among artists that limited resources are being sunk in administration and management to little effect while they continue to live on "the clippings of tin"!; the guilt of arts administrators who, knowing the subsistence level of most artists, have difficulty in justifying their own salary. These beliefs and feelings spring from particular concepts both of art and of management, many of which find expression in this chapter. The exposition here of different perspectives shows them to be related to values, both political and aesthetic, and often bounded by time and context. Their juxtaposition is in itself revealing.

Declan McGonagle's piece (Chapter 1) posits a high role for cultural managers, the need for them to appreciate the wider social context and the importance of a strategic approach to sectoral development, and rejects both the modernist basis for ideas which sees art as "disconnected" and artists as alienated, and the Thatcherite pre-eminence of the exchange value of art as opposed to its use value. For McGonagle the task is "to create structures and a language in the present which do not deny their inheritance but accept that culture is not immune to the forces which are constantly making and remaking reality around us".

Pat Cooke (Chapter 2) also calls for a wide approach which disdains the "fissure" between arts and heritage and advocates a "strategic scepticism" of what he sees as the ascendant management culture, if the inclusiveness which he favours is to flourish.

The interviews in Chapter 3 with Jeremy Isaacs (Royal Opera House) and Patrick Mason (Abbey Theatre) explore the attitudes of these two leading arts figures to aspects of managing the arts: the similarities and differences in their responses to some broadly

similar questions serve to illustrate both the broad general para-
digm within which they both operate and the nuances which de-
rive from variations in context, environment and their perception
of their roles.

Section Two of the book delves into the application of strategic
planning to the arts, aiming to show its value while recognising
that many people in the sector find it sits uneasily with their no-
tion of the arts as spontaneous and unplanned, springing from
the creativity of individuals and communities. (In any case,
"buccaneering" is altogether more attractive![2]) Implicitly ac-
knowledging this difficulty, the section is designed to help those
charged with a developmental role. The design of the section also
reflects Zammuto's view of the relationship between evaluation,
decision-making and strategic planning:

> Viewed within the continuity of time, all three are the same activ-
> ity. Each is concerned with judgements about organizational ac-
> tion. The only difference is that they have different temporal di-
> mensions. Evaluation is making judgements about past perform-
> ance; decision-making about present performance; and strategic
> planning about future performance (1983:159).

Ann O'Connell (Chapter 4) provides a practical model for strate-
gic planning taken from general management literature and
shows its potential for cultural managers. She makes a distinction
between the planning process and the development of a strategic
plan, goes through the different elements of the process while
pointing up its integrated and interactive nature, and emphasises
the need for developing measurable objectives, offering some tips
on dealing with the fact that many of the objectives of arts organi-
sations are qualitative rather than quantitative.

Hand-in-hand with planning goes evaluation, which not only
is vital to assess the progress of the cultural organisation towards
achieving its objectives, but will soon, in a climate of increasing
public scrutiny, become a requirement. In Chapter 5 Lluís Bonet
and his colleagues, while they recognise that the topic is a much
larger one than can be effectively covered in a short chapter, dis-
cuss some of the difficulties of measuring goals in the arts area,
distinguish between different levels of indicators and different
kinds of evaluation and point up the problems linked with the
evaluation process for cultural organisations.

As many culture managers experience it, the main thrust of planning is to give shape to the amorphous and the unwieldy, whether in a geographical area or an organisation.

In an area-based context, Aidan Walsh (Chapter 6) relates the progress of museums policy in Northern Ireland and the effort to bring it into line with the rest of the UK. In its essence a planning task, he shows nevertheless how many reports and recommendations gathered dust since the late 1970s for want of an appropriate agency to drive development. Showing how the context of Northern Ireland has proved contentious for the development of museums, necessitating as it does the exploration of cultural history and identity, he demonstrates the centrality of partnership to territorial cultural planning and the importance of a strategic approach.

Taking the individual organisation as a unit — in this case Music Network, a body charged with regional music provision in Ireland — Catherine Breathnach and Niall Doyle (Chapter 7) give an exhaustive account of how a major organisational turnaround was effected by careful strategic planning based on the two-fold process of, on the one hand, "envisioning", and on the other, "evaluation and evolution". Their chapter covers in some detail the process involved in developing a mission, identifying objectives, devising a framework to address these, putting in place structures for planning and evaluation, and the application of the management principles underlying good communication and human resource policies. Interestingly too, the chapter tracks what is probably a feature common to many arts organisations: the transition from the embryonic stage in its life-cycle to a second growth phase. It is worthy of note too that Music Network almost failed to make that transition (also quite common) but its triumph in adversity makes very instructive reading.

Enough has been written about the crisis in audiences in the arts and heritage areas to explain the emphasis given to marketing (**Section Three**). The weakness of its focus on the client has long been recognised as a particular feature of public service management. Culture managers can be accused with some justice of showing little concern for the needs of audiences and the general public. Whether this is born of the *hauteur* associated with the "high" arts; the belief in the inalienable right of the arts to exist without explanation, mediation or justification; a perception of the crudeness of marketing techniques when applied to the arts;

or simply a lack of training in marketing skills, the increasing democratisation of culture as well as shrinking public budgets render it imperative that the arts exploit all the means at their disposal to expand their audience base and increase income.

Paul O'Sullivan in Chapter 8 offers a detailed and practical framework for culture managers who wish to introduce a planned approach to marketing within their organisations. His chapter takes full account both of the crudeness of certain marketing formulations and the consequent resistance within the sector and offers relationship marketing as a more sophisticated and differentiated paradigm. Most usefully, he takes the reader through the various steps involved in a planned approach in a manner which is meaningful from an arts perspective, rejecting the more mechanistic dimensions of SWOTs and STEPs, and he even offers a quick pill for the faint-hearted.

Joe Dennehy (Chapter 9) has explored the main issues in arts marketing with a group of practitioners in the theatre, visual arts, film and music fields and offers a lively account of their perception of attitudes, their understanding of what constitutes barriers and problems and their ideas about what needs to be done.

Emer Ní Bhrádaigh (Chapter 10) provides an outline of some arts marketing issues along with a review of research, and her bibliography will guide students and practitioners to further reading in the field.

Marketing is closely related to issues of consumption and participation in the culture sector. **Section Four** focuses on these. In an international comparison of participation trends in a number of countries (Chapter 11), Paula Clancy examines such issues as attendance, the popularity of individual art forms, the home-based audience, participation in amateur activities and attitudes to the arts. The significance of home-based cultural activities based on entertainment technology is a common factor in all of the countries studied.

Andy Feist (Chapter 12) looks at consumption patterns in the arts and the cultural industries in the UK. Feist points to the fundamental changes in the use of leisure time in modern society and outlines the problems in measuring the market for cultural activities and the factors which will determine future changes in the consumption of cultural goods. He also considers some of the arguments developed over the relative importance of price, innovation and taste formation in this complex area.

The ultimate objective of culture management has to be the encouragement of innovation and creativity. Culture managers must always be on the lookout for what is new and the means of stimulating it. In **Section Five**, Mary Cloake applies the principles of innovation which apply in high technology manufacturing industry to the arts sector and investigates how this actually works through a case study of Artform, an EU-funded arts training project which took place in 1992/3 (Chapter 13). She reveals that innovation as a process may be managed and describes three types of groupings which foster the synthesis which seems to be its fundamental aspect. This leads to an in-depth and discriminating discussion of the nature and functioning of partnerships, a much-vaunted if little understood dimension of institutional life in the arts and elsewhere.

Networking, both intra- and inter-sectoral, has shown immense possibilities as a technique for the development of innovative projects, especially in a context which emphasises the continuity of culture with other aspects of life. Louise Scott (Chapter 14) explains the key elements of a cultural network, shows how this way of working subverts many aspects of traditional management practice and gives some practical advice to people who wish to operate as part of a networking structure.

Again in the context of increased cultural democracy, Anne Marit Waade (Chapter 15), noting the contemporary tendency towards the instrumentalization of culture, makes a plea for the innovative approach implicit in *cultural projects*. Aware of the tendency toward the bureaucratisation of culture, she draws on the writings of Nielsen and Ziehe to formulate a conceptual framework for innovation, in her view exemplified by projects like Copenhagen '96, and draws out some of the implications for arts management and management training. In an interesting way her ideas link up with Declan McGonagle's chapter in the importance she attributes to the role of art in society and the consequent high vocation of the cultural manager or, as she prefers to say, the cultural worker.

The neglect of good human resource policies is perhaps understandable in a sector which is in the course of professionalisation, experiences understaffing and generally has compensated for lack of procedures and proper structures by youthful enthusiasm and commitment. However, there is no doubt that this situation has caused much pain. One hears of the hidden subsidy by

both artists and administrators who earn few of the rewards experienced by other sectors. However, as cultural managers age and as their organisations move from the embryonic entrepreneurial stage, human resource issues become much more important, and it is to these issues our contributors turn in **Section Six**.

From a study of arts and heritage managers conducted in Ireland in 1994, Paula Clancy in Chapter 16 describes key features of this changing sector, changes which derive mainly from the small scale of organisations, their financial instability, the heavy reliance on peripheral forms of work and the relatively high growth (and turnover) of organisations. She charts the main characteristics of jobs in culture management and goes on to present the key management competencies required by the cultural manager.

A further cluster of human relations problems inhere in the relationship between culture managers and their boards — an area which is often a breaking point and is resolved only at high human or financial cost. For an arts organisation to receive public subsidy, it must be formally constituted. For this reason, almost all culture managers report to boards of trustees and many experience difficulties in exploiting these effectively so that appropriate structures and relationships between boards and managers can be developed. Jean-Pierre Ouellette and Laurent Lapierre (Chapter 17) survey the literature relating to boards of management in the arts and discuss the role of the Director at the different stages in the organisational life-cycle. While no infallible formula for success is offered, a general understanding of the issues helps the culture manager to set realistic aspirations and alerts policy makers to have regard for the implications of their decisions about the type and composition of boards they put in place.

In Chapter 18, which deals with the relationship between creative and managerial staff, Xavier Castañer addresses another major source of contention in the management of arts organisations. He applies different subsets of management theory to come up with practical recommendations for this particular arts organisation.

Finally, Arja Ropo and Marja Eriksson (Chapter 19) deal with one very interesting and almost unique feature of arts organisations — how they tend to combine a steady-state and a dynamic dimension — by direct application to the management of a theatre production in the Tampere Theatre in Finland. This leads into a discussion of how conflicting objectives can hinder the work of

a theatre, and the potential and the limits of communication in conflict resolution.

In this collection a dialogue of sorts between culture managers and academic researchers, hitherto the preserve of a very few specialist journals, has been widened, providing a forum for these groups to talk to each other in what is hoped are intelligible and relevant terms. This helps to encourage a reflective approach to practice and to demystify the sometimes jargon-ridden area of management. Both sides share experience, suggest solutions and demonstrate the value of research not only in the grand sense of exploding myths but also in the more modest but more frequently useful way of making explicit what is often vague or "floating" and thus a source of anxiety. The consoling knowledge that one is not the only arts manager to have a problem with one's board, the possibility of inquiring into the reasons for that problem and the exposure to those responses which have proved most useful for others both deepens one's understanding as a culture manager and helps one to devise a blueprint for action or change. Such knowledge also engenders collegiality and confidence, the former in a sector where isolation is always an issue and the latter in the belief that together, within the cultural sector, one can develop appropriate and tailored solutions.

From Maestro to Manager in no way purports to be the last word: rather it hopes to reopen a substantial exchange on the substantive issue of what it is to work in culture management.

Notes

[1] Xavier Castañer, in Chapter 18 of this book, explores in depth the meaning of the word "professional" both in and outside of the arts sector.

[2] See Paul O'Sullivan's chapter (8) in this book.

References

Byrnes, W. (1993), *Management and the Arts*, Boston, MA: Focal Press.

Brett, D. (1996), *The Construction of Heritage*, Cork: Cork University Press.

Donoghue, D. (1982), *The Arts without Mystery*, London: BBC.

Langley, S. (1990), *Theatre Management and Production in America: Commercial, Stock, Resident, College, Community and Presenting Organizations*, New York: Drama Book Publishers.

Mitchell, R. & Fisher, R. (1992), *Professional Managers for the Arts and Culture*, Helsinki: Arts Council of Finland, Council for Cultural Co-operation.

Pick, J. (1980), *Arts Administration*, New York: Methuen Inc.

Zammuto, R.F. (1983), *Assessing Organizational Effectiveness: Systems Change, Adaptation and Strategy*, Albany, NY: SUNY Albany Press.

PART ONE

THE CULTURE MANAGEMENT DEBATE

1

THINGS CHANGE: THE NEED FOR NEW TRANSACTIONS IN CULTURAL MANAGEMENT

Declan McGonagle

In this chapter I set out to examine some of the principles which underpin cultural management with particular reference to the speculative nature of a new Museum of Modern Art in Ireland at the end of the twentieth century. The creation of this institution at this time, in this place, raises questions about the role of public resources, the representation of historical and contemporary experience, as well as national identity.

This is important because new uncertainties in culture co-exist with the dismantling of previous certainties in the social, political and economic world. They always did but it is only recently that the grammar and syntax of this interaction have become the subject of widespread open debate which goes beyond art constituencies.

It is important to begin with the origins of institutional structures — the value-making structures in our society — which have mostly been understood and accepted as natural (given) rather than cultural (made). While a debate on these terms may be going on within the art world and the world of museums about the nature and function of institutional practice, we have to acknowledge that most people in society believe most of the time that they already know what the nature and the function of a museum is, what it does and what it should do. In fact it could be said that the more uncertainty infects other areas of lived experience the more people turn to culture for certainty on questions of their identity. Nationalism, which is returning to Europe, for example, begins in any context with statements which are fundamentally cultural.

In the specific context of the Irish Museum of Modern Art it is interesting that a key point in recent audience research shows just

how deeply implanted are expectations of what a museum is, especially in such a major historical building as the Royal Hospital Kilmainham[1]. These expectations are challenged not just by the nature of contemporary art itself but by the Museum's developing strategy which emphasises change and debate over permanence and authority. It is not surprising therefore that first-time visitors find that their expectations are not necessarily met and can be confused by the experience, although this decreases with return visits and is totally absent from the experience of engaged visitors, i.e. people who return many times, or who engage in workshop and contact activities with artists. I am using "engaged" here to mean those people who have the opportunity to get at the meaning of the exhibited artworks and have a quality of experience which goes beyond the merely retinal. The real subject of this transaction anyway is the viewer's mind rather than the properties of the art object. It was Oscar Wilde who said, in *De Profundis*: "It is in the head that the poppy is red, the apple odorous and the skylarks sing."

It has also been said that the crowds who regularly storm the Louvre in search of the Mona Lisa, for example, are there not to see it but to *have* seen it — to possess it in a way which can then be traded with friends and colleagues.

Of course, there is nothing wrong with blockbuster-type exhibitions as long as everyone involved is aware of the specific transaction which is taking place at any given time. If there is a lack of clarity or, more importantly, honesty, about this, it will not work even for an intended mass audience, and secondly, would lead to a serious confusion of institutional purpose. The "deal" between the institution and the visitor in any particular project or process has to be clear and visible.

So despite seismic changes in the way people think and live over the last century or so an older model of the museum is still in place in people's minds. This sense of already knowing what to expect and of carrying expectations which may be felt rather than stated, reveals that a template exists against which new art or institutional practices are unconsciously tested. Yet in reality no-one

[1] The Royal Hospital, Kilmainham, built between 1680 and 1686 as a hostel for retired soldiers, is one of the most significant seventeenth-century buildings in Ireland. It has been home to the Irish Museum of Modern Art since 1991.

is innocent nor is there a neutral position from which observations can be made about an absolute line to which one does or does not conform. Renegotiating this deeply implanted model and proposing new transactions is one of the most important tasks which in my opinion faces museums in particular and cultural provision and management in general — cultural provision, that is, which aspires to a public rather than a private transaction.

We have to understand that most people do not realise, firstly, that the template is man-made or secondly how the template originated, how it was formed and how the cultural presumptions operate on which subsequent structures in the modern era were founded. We should also note the diverging nature of funding for public institutions in the Irish, British, American and European contexts. Unlike the European situation, public funding has historically played little or no part in the development of museum structures in the United States. In Britain the argument for state funding for the arts in general, and visual arts institutions in particular, has largely been lost in recent years. In the near future the majority of arts funding in Britain will come directly from Lottery sources rather than the State. This has not happened in Ireland, despite initial evidence that it might, because our own political circumstances have led in recent years to the creation of a full Ministry of Arts and Culture and the expansion rather than contraction of public support. The real test in Ireland will come after 1999 when the balance of provider and receiver in European funding terms will shift. This is why new thinking needs to be put in place in Ireland now.

But the fundamental point is that retrenchment in public funding of public institutions changes the nature of the transaction. Any trend from a public to a private transaction will be value-led as well as part of an economic programme and has to be addressed as such. It can be argued now that Thatcherism, though increasingly discredited as a narrow, short-term view, created and celebrated models of measurement which were primarily economic for a whole range of social functions. This view of things insisted on a particular type of transaction, defining the artist as the provider of cultural products and reducing the viewer/visitor to consumer. It is this same mindset which describes doctors as providers of products and patients as customers. This economic transaction draws on a logic which is as deep-seated, as man-made and as artificial as any cultural model. It is informed by

self-serving nineteenth-century cultural precepts about self-reliance and the individual which also nourished industrial capitalism, imperialism and colonialism. We should remember that colonialism was only successfully dismantled when it was first dismantled culturally. The real debate in which cultural managers will take part is actually about the distribution of power and cultural value in society.

We must recognise therefore that attempts by artists or gallery and museum professionals to develop practices which tackle these issues within an art zone, but do not transcend that zone, run the risk of generating confusion and dissonance. It is this dissonance which leads to alienation and subsequent unease with contemporary art on the part of most people and which allows reactionary commentators to describe contemporary practice or new readings of historical practice as eccentric, unnatural and a deviation from a "true path"!

It allows the easy journalism of the mass media, including broadsheet media, to avoid taking responsibility for the one-dimensional views they promote when dealing with contemporary art practice. There is no easy route to the creation of these new transactions. There is no short cut via a third agency. It is essential to take a long view and to work and think strategically rather than swim in an ocean of short-term single issues or topicalities which may generate seductive media interest which can then replace strategic thinking.

I am arguing here for a renegotiation of the set of relationships between artist, mediator and non-artist which has to be understood as political — in the sense that it is about the distribution of resources, value, empowerment and, as a consequence, disempowerment, in society. I would argue that anyone entering this field of cultural management must therefore acknowledge that these issues are not just subjects of academic debate but have real implications for funders and fundees alike, not to say artists and non-artists alike who are both the potential victims of public-funding decisions.

The paradox for organisers who become dependent on the media is that they can actually achieve the reverse of what is intended because the media can never be innocent or simply thought of as a transparent force. The media's appetite for "the story" will always dramatise events and issues in ways that make them comprehensible to them in the first instance. Artists and

administrators involved in contemporary practice have to be prepared to manage these processes, not simply to seek publicity. This requirement is unlikely to change as long as we continue to operate within the matrix which defines and holds the artist as producer and the non-artist as consumer of cultural products rather than participants together in a cultural process. It is this process, this new transaction, which needs to be consistently placed in the foreground by cultural managers and distributed as widely as possible.

The goal is to articulate and inhabit differently the space between the artist and the non-artist. In the West it is usual to think of the space between things as a separation rather than a connection. In the Far East, for example, there is not only a word for a triangle and a circle but also for the shape made between the triangle and the circle. It can be named as something which connects two positions. We should be concerned about inhabiting and articulating the space between positions and making connections which will not diminish the artist's intention, or the non-artist's responses, but create a conversation, a participation in the cultural process. This is clearly articulated in the practice and writings of the artist and polemicist Joseph Kosuth (1991) and the critical writings of Tom McEvilley in *Artforum* and various other publications. In literature, Terry Eagleton (1995) has also argued that a far more porous process was involved in nineteenth century British novels in relation to subject/object and "otherness" than is usually acknowledged. This seems to me to be a role for cultural institutions which is even more important than connoisseurship and it brings us to the models of institutional practice and their origins which currently inhabit this space. We have to look at the nature of transactions within which a set of powerful, definitive models became established until the present debates began about their role and function.

Museums as we know them really became visible at the end of the eighteenth and beginning of the nineteenth centuries. It is no coincidence that this happened at a time when industrial capitalism was established, when European nation-states coalesced and when the idea of the artist as a poetic, tragic and disconnected figure was established. It could be argued broadly that the last 150 years have institutionalised that disconnection, that the heart of this era's manifestation of Modernism is a split between figure and ground, between the artist and society, between the

individual and community. The result is a state of affairs where our transactions — social, economic and cultural — have been increasingly polar. In this context I am referring to Modernism as a mindset, a set of values which places man at the centre as surely as did pictorial perspective in the Renaissance, but which also believes that events happen as a result of the actions of man (literally) rather than nature.

The space left by this disconnection had the effect of disenfranchising art and the artist and was then inhabited by processes which represented the antithesis of art's function which claim an innocence for art in a guilty world.

I was struck recently by an anecdote about Josef Albers and his work, about his flight from Germany, his work at Black Mountain College in the United States and how his father, who was a house painter, taught him how to paint a door from the inside panels out in order to keep his cuffs clean. It is possible that, as a result of his experiences in Germany, Albers worked to create an art, a language, as seen in its ultimate form in the Homage to the Square series of paintings, which could physically but also emotionally keep his cuffs clean. The development, not just of an abstract but an abstracted art in the twentieth century, was no accident, supported and exported as it was by corporate post-war America. The disconnection of artist and society was an important facet of this corporate process. Similarly, the Irish artist Mainie Jellett, in turning away from one reality, attempted to construct an art language by abstracting subject matter, hence her self-conscious pursuit of an abstracted self-referential language. She may have failed in that Modernist project but succeeded on a more important level because towards the end of her life she produced a series of paintings which combined figures, landscapes and a Cubist language which represented a combination of her earlier powerful figurative work and the non-figurative imagery of her middle period.

The point of these two illustrations is that the Modernist principle of separation was and is at work in artists' individual practice as well as in the institutions. The process of removing social references not only informed individual art practice and works of art but also architecture and the nature and function of arts institutions for a long time. The paradox is that the work which then went on to bring audiences to these institutions was actually a disempowering transaction. The nineteenth-century model was of

a museum as a temple whose resources were only accessible to those who were initiated. To pursue the classical reference it is no coincidence that the original museums and banks coming out of the nineteenth century mimicked the architecture of classical temples because both were fulfilling the same function: fixing and policing value — one cultural and one fiscal. From that period on the museum was concerned with discovery, research and the establishment of an authoritative reading — the fixing of value. This obsession with classification was an attempt to own the world materially, on one level, and on another to own nature. This creeping ownership was at the heart of the Modernist project. The great exhibitions in London and Paris in the nineteenth century were displays of this ownership which continued thereafter in museum structures.

However, I believe a permanent consensual representation of anything is no longer possible. In these terms Modernism did not begin in the early twentieth century with a movement in art like Cubism but was a much longer process which began in the Renaissance with its reclamation of classical humanism which emphasised the pre-eminence of man. Of course, we know that not all men had the necessary credentials and those without were defined out of history.

In the later rush to possess the world by white Western Europe whole cultures and societies were rendered invisible and destroyed. The visual culture of others was read and presented as no more than a sort of preparation for the real thing — the real thing being Western European Modernism which was the product of the forces which ran through the Reformation, the Enlightenment and nineteenth-century capitalism. Until recently this momentum was driven by a belief in the inevitability of such progress led by the European mind. This was religious belief disguised as secular thought. This basic mindset, confirmed and nourished by successful adventures in the world, provided the form and content for many of the models for functioning cultural transactions.

Yet the public is uneasy. It is clear that a major shift is taking place in our world, which is why there are increasing dollops of nostalgia for a past, which is invented, in the face of a changing present. This new uncertainty has led to previous definitions and expectations having to be loosened, revised or dismantled altogether. The dual process of deconstruction and construction can only be achieved peacefully in this era if it is pursued culturally.

What is dramatically true at the edges of Europe is true also at the centre. The faultlines may only be visible at the edge of the land-mass, like strata on a coastal cliff face, but they are present under the whole continent.

Culture is an important mechanism for changing states of mind which does not insist on the disappearance of other states of mind. It is crucial therefore that new managers of culture take this on board and understand the importance of placing specific policy and programming objectives of whatever scale in a much wider strategic social context. If this therefore questions the status and resources of the traditional treasure house, as a place rather than a function, then so be it. This approach is not iconoclastic, does not insist on closure of previous models, just the addition of new inclusive values. It insists on adding new values to old structures where the structures themselves become part of the meaning.

Things have changed when even the Director of the Victoria and Albert Museum who, on taking up his recent post, argued in a long newspaper interview that the treasure house model any-way was no longer tenable. His argument may have rested pri-marily on the economic impossibility of that model in the British context, but it is also clear that the idea of an authoritative per-manence which the treasure house reflects is also conceptually impossible.

Change is at the heart of artistic practice. Attempts in human affairs to stop change or to end history have always led to stagna-tion and collapse. The pretence of permanence is a false starting point for current museology. A new starting point is not only possible and desirable but it is also necessary. In the long term the contradiction of fixing expressions of humanity in our culture needs to be recognised as supplying a creative tension. Displaying this contradiction at the core of a new institution need not be seen as arbitrary or whimsical, in search of novelty, but as an acknow-ledgement of the flow of the social narrative. It is a question of accepting that we are in it rather than attempting to create citadels which are fixed and inevitably resist reality. It is about becoming rather than being.

In recent years two great temples of twentieth century Modern-ism in the visual arts — the Museum of Modern Art and the Gug-genheim in New York — have acknowledged these circumstances by attempting to create, apart from their core centres, dynamic

programming "branch offices", initially elsewhere in New York but in the Guggenheim's case elsewhere in the world. A sort of cultural franchise.

This is almost tragic. It can be argued that it was corporatism which led them into the cul-de-sac in the first place, a phenomenon to which these recent initiatives are a response. What is needed, even in their case, is a renegotiation of their role in society. The development of a social rather than corporate model would have to challenge the hierarchies which inform and often control major institutions which attempt to describe an historical narrative. It has always been and always will be in the interest of that hierarchy to separate art and society, art and politics, aesthetics and ethics. The associated institutional model will also always relegate the values of "otherness", however they are defined at any given moment, to a marginal or primitive position whether it is twentieth-century United States or seventeenth-century Nigeria. While that transaction of power was successful and in operation it was impossible to sustain an alternative argument about new ways of working, in favour of adding other values to these models. But in our present circumstances of flux it would be absurd not to make and follow through that argument in whatever context we work as cultural managers.

Artists have regularly tried to transcend this Modernist hierarchy, whether it was the Pre-Raphaelites trying to achieve, as they thought, pre-Renaissance innocence and clarity, or Dadaism's post-First World War attempts to confront the middle classes, or conceptualism and pop art's use of real material to step outside the previous credentials of the art object. These were necessary challenges to the nineteenth-century Modernist hierarchy discussed above which insists that meaning and value was mysteriously and quasi-religiously locked into the object by the artist. Celebration and conservation of the object therefore became an absolute prerequisite for museums. In some people's minds it is the first and last test for a museum. But if the emphasis is shifted to the making and receiving of the art object, to the process as well as the product, there are immediate dynamic possibilities wherever one works and on whatever scale. It allows for a projection of use value over an exchange value for art — a premodern state I would argue but one which has to be articulated without nostalgia or sentimentality.

Nostalgia is a dangerous thing, especially in a colonial or post-colonial context. We have example after example of pre-modern states of mind in the past and the present producing cultural and economic systems which are based on a need rather than greed, on use value rather than exchange value and which have a qualitatively different relationship with nature. The most important Shinto shrine in Japan, a wooden temple, is demolished every 20 years and rebuilt. There is no sentimental nostalgia for the materiality of the object but a respect and care for its function, its use. The meaning does not lie in the object and its materials but in its use and its regular renewal.

Art is in your head. This could be the starting point for programming in many institutions. The product and process meet in the mind of the audience, the viewer and the participant, and it should be the institution's job to reveal that. This represents a re-negotiation of the transaction that, in the particular context of the Irish Museum of Modern Art, means that we are engaged in constructing a museum of modern art which approximates to its own myth and in simultaneously deconstructing the idea of a museum of modern art. This is being done in order to create a new, third reading, a third set of possibilities which go beyond the first two.

There are two references I can make, one public and one more private, which dramatise this idea of a third reading coming out of the original schism between the pre-modern and the modern. In Derry the city walls, which were built in the early seventeenth century and withstood a long siege in 1690, are a fundamentally important symbol for the Protestant community of the survival of their identity in Ireland. This siege mentality still runs through their contemporary politics. A slogan written on a part of the city walls overlooking the Bogside area states "God Made the Catholics and the Armalite Made Us Equal". It is a direct attempt to take back the ownership of the historical moment of victory and defeat represented by the dominant reading of the city walls. At the time they were built, the city walls were paid for by the Guilds of the City of London (hence the second name Londonderry) which enclosed the first bit of town planning in Ireland. The streets inside are laid out in a rational grid pattern representing imperial order over native disorder. This concept of power within and powerlessness outside which was created politically and culturally in the seventeenth century staked out the territory which is still inhabited today. The slogan writer was trying to

dismantle that history, or at the very least force his way into the conversation. The divide between the communities in Northern Ireland is finally not religious. It is articulated politically but is fundamentally cultural.

The other reference is to a book on medieval marginalia by Michael Camille (1992) where he argues that the received idea, the down to earth and vulgar imagery in the margins of medieval manuscripts, which often contains political and sexual references, is not in fact the product of boredom on the part of the scribes. It was a conscious process of problematising the piety of the main text and gave the reader of the main text and the marginalia a third reading. This pre-modern ability to hold dualities needs to be recovered and redeveloped in a contemporary context.

The artwork with its reading can become the subject of a new reading — a reading that need not be in the exclusive domain of the professional but one which, when it functions, can be a mechanism of emancipation and empowerment. I would argue that this would be no more than an acceptance of what is already in place — that we are all participants in the same cultural process, artists, mediators and non-artists alike.

Where better then to work to that score than in the context of the Royal Hospital Kilmainham where a new Museum of Modern Art is being developed. A context which, when looked at from the point of view of the Modernist hierarchy, is an unlikely and inappropriate choice in which to establish such a museum, but if looked at from a position beyond Modernism it is the ideal environment in which to irrigate this field and respond to these questions. When the museum was established and opened at the Royal Hospital Kilmainham there were a number of objections. Three main disadvantages were cited. The problematic architectural and historical identity of the building, location in a neighbourhood to the west of the city centre and the inadequacy of its funding. All of those ideas presumed that a certain model of a museum of modern art already existed and was viable and should be implemented in this context. In fact, those so-called disadvantages are the key advantages which IMMA possesses in developing its future identity. That it is in a neighbourhood rather than in the city centre means that it is impossible for this institution to avoid entering into a conversation with people who are traditionally defined as non-participants in contemporary art practice. That we did not have tens of millions of pounds to establish the

Museum and its collection, genesis-like, meant that we could not go "shopping", but had to renegotiate a relationship with artists in making exhibitions and acquiring works. That the building was problematic because of its architectural and historical identity just means that it is tuned into the questions which have to be addressed in this era, the ownership of history, the inheritance of previous definitions and the need for their transformation. This is why the first series of exhibitions in the Museum was called "Inheritance and Transformation". It signalled that elements articulated within the name of the institution were the key subjects for its work: what it is to be Irish at the end of the twentieth century, what it is to be a museum and what modern art is and what it could be.

In fact, it is the specific nature of this context which gives the Museum the potential to develop a unique situation, based on this new transaction, which is empirical rather than theoretical. The scale and nature of the Royal Hospital building and its site, its open spaces, other buildings and its historical identity which is widely legible, make it the ideal space from which to develop this new transaction. It will be possible to have a treasure house function alongside a dynamic exhibition programme and to have working artists present. This involves a rereading of the previous ways of working, a rereading of art to move away from the idea that it exists in a zone of its own, created by people in a zone of their own, accessed only by the few and always distant from the many. There is ample evidence that even the mechanisms which were set up in the 1960s under the heading of Community Arts became part of the structure of disempowerment by locking in place existing relationships of power within the Modernist hierarchy instead of trying to renegotiate those relationships. Art is not an antidote to reality but a means of exploring and understanding and, if necessary, remaking it. It is a public not a private transaction.

What is it then to be a cultural manager in the light of the new transactions which I am recommending? We can either roam around within the existing matrix, occasionally occupying new parts, or we can set out to configure the matrix differently in the knowledge that any new configuration will also be provisional. The task therefore is to find or create structures and a language in the present which do not deny their inheritance but accept that culture is not immune from the forces which are constantly mak-

ing and remaking reality around us. I would argue that culture is in fact how that is done. Since there is no neutral part of the field it might be better therefore to think of ourselves as cultural participants rather than cultural managers. The rest would follow.

References

Camille, Michael (1992), *Image on the Edge — The Margins of Medieval Art*, London: Reaktion Books.

Eagleton, Terry (1995), *Heathcliff and the Great Hunger*, New York, NY: Verso.

Kosuth, Joseph (1991), *Art After Philosophy and After*, Cambridge, MA: MIT Press.

2

THE CULTURE OF MANAGEMENT AND THE
MANAGEMENT OF CULTURE

Pat Cooke

At the heart of Ireland's greatest epoch of cultural expression —
the Revival that occurred between the years 1890 and 1916 — lay
two great institutional experiments: the Abbey Theatre, founded
in 1904 and St. Enda's School, founded in 1908. Judged by pres-
ent-day standards of arts management, neither could be regarded
as a particularly good model. The Abbey came into being when
the wealthy and theatre-loving Miss Horniman provided the
money and an electrician and accountant's assistant (the Fay
brothers) provided the organising skills. St. Enda's, a pioneering
bilingual school for boys, was set up by Patrick Pearse, a 28-year-
old non-practising lawyer with a lot of enthusiasm for the Irish
language and little more to recommend him as a teacher than sev-
eral years as the editor of a bilingual paper. For the eight years it
remained under the guidance of its founder, the school teetered
on the brink of bankruptcy. And yet, despite its practical failings,
St. Enda's was the single most inspired educational experiment in
Irish history. The Abbey's existence was from the start only a little
less financially precarious, but it has nevertheless remained at the
heart of Irish theatrical life ever since.

Throughout the period the towering figure of Yeats operated as
a kind of self-appointed poetry and theatre officer, dispensing
criticism, advice and encouragement to younger writers who
wished to be part of the movement on which he had singularly
stamped his character. It was all very unprofessional but amateur-
ish in the strict and highest sense of that word.

The landscape of Irish cultural endeavour has changed pro-
foundly since. The Abbey is still with us but electricians and ac-
countant's assistants are to be found in their appropriate back-
stage and administrative roles rather than at the heart of the

theatrical process (although the shift from amateurism to professionalism in management appears to have done little to disrupt the institution's enduring condition of financial crisis). That a 28-year-old enthusiast could nowadays set up his own school seems almost unthinkable. There are policies, structures, procedures, regulations in place to screen out such a possibility. Back then, the role of the (British) state in that great outpouring of nationalistically-hued cultural activity ranged from passive indifference to outright hostility. Cultural expression occurred despite, not because of, the state's involvement. Now, perhaps to an unprecedented degree, the state has a hands-on interest in and enthusiasm for, the management of culture. As for the patronage side of the equation, that too has become less a case of wealthy patron meeting penniless enthusiast and more a matter of corporate funding filtered through the appropriate sponsorship procedures and public-relations mechanisms.

Of course it should be noted that the Revival, despite the qualitative excellence of so many of its achievements in artistic terms, had failings in socio- and arts-political terms which, for good reasons, we would no longer find acceptable in our more democratic and communal conception of the arts. Narrowness and elitism can be ascribed to it. Its focus was overly centralised on Dublin. Its main impact was in the area of literature and drama, with other art forms invigorated to a far lesser extent. And it was achieved by a small, loosely linked coterie which showed very little concern for popular appeal. Yeats, having set out to inspire a nation, soon became disenchanted with the "seeming needs" of his "fool-driven land". It is worth noting however that as his tone became increasingly patrician he did not have to look over his shoulder at a benevolent sponsor, private or public; the aloofness from popularity was purchased at the price of penurious artistic independence. His first significant bursary in recognition of his literary talents was probably the £200 that went with the Nobel Prize.

Nevertheless, the spectacle of an epochal achievement based on such slim but brilliantly talented human resources surely presents a challenge to our confidence in the process of arts management (a term that was almost wholly unknown even at that relatively recent time): does the better management of the arts lead to more and better art, or simply to more, but not necessarily better, artistic "activity"?

The very term "arts management" is of relatively recent origin. Two factors were necessary for its inception. The first was the direct involvement of the state in arts funding. The second was the growth of the "science" of management into a major cultural force in its own right, what will henceforth be described as the culture of management.

The greater involvement of the state in the field of culture, with considerable expenditure of tax payers' money across the whole spectrum of cultural activities, brings with it the requirement that the same standards of transparency and procedural efficiency apply as in other areas of state expenditure. However, once the Arts Council was founded it was never likely that its role would remain a passively fiscal one. The Council's adjudicative role, as it works comparatively to make allocations of funding across a whole variety of artistic activities, has surely been a key factor in forging a sense of the "arts" as an inter-related amalgam — a community defined as much by a persistent anxiety about funding as by shared cultural instincts. (It would be an interesting etymological exercise to determine when the term "arts", used in the sense of an administrative compound, first entered common usage.) This adjudicative role, involving a complex balancing of practical financial and cultural judgements, demanded a new kind of organisational skill, the skill we have come to call arts management and the development of a new kind of specialist, the arts manager.

In one sense the arts manager was not an invention but an adaptation. Many of the skills associated with the role are recognisable as those that inhere in the increasingly unfashionable word "impresario". The word is not entirely free of dubious associations of shady deal-making but it also carries about it a hint of flair, even genius, that is singularly absent from the uninspiring "arts manager". When one looks at the life of a great impresario, such as Diaghilev, for example, one finds a pattern of self-electing enthusiasm, an early-begotten and consistent obsession with the art form to which he has dedicated his native shrewdness and organising abilities. It is the spectacle of the amateur in pursuit of his destiny rather than the professional in pursuit of a career. Indeed, the way the word "amateur" has taken on connotations of unskilled or disorganised behaviour is significant in itself. Its decline into dubiety is almost directly proportionate to the rise of the word "professional" as indicating good sense and recognised

standards in a whole variety of activities. From this perspective, arts management can be seen to represent the necessary professionalisation of the arts, the wresting of the arts out of the hands of the amateurs.

This brings us to the second factor which was necessary to the primacy of arts management in the modern sense: the growth of the culture of management.

It is surely no exaggeration to talk of an explosion in management culture over the past 20 or 30 years. Any well-stocked bookshop now carries a whole section on the subject of management. What is most noticeable about this phenomenon is the cultural nature of its ambitions. With its recognised gurus and use of such quasi-religious terms as "personal development" and "liberation management", one of the effects of management culture has been to blur the distinction, to hybridise the attributes, of two spheres of human activity which, since the onset of the Industrial Revolution, have been seen as antagonistic. The development of this idea of Culture in reaction to the Industrial Revolution, from Edmund Burke through the Romantic period and on to modern thinkers such as Arnold, Orwell and T.S. Eliot, has been traced by Raymond Williams (1958). It is clear that to thinkers within this tradition a term like "management" would have fallen on the utilitarian and mechanistic side of the human equation, in direct opposition to the cultivation of the spiritual and imaginative faculties which they neologised in the word "culture" itself. The pivotal question this raises is whether the culture of management operates to strengthen and deepen the values inherent in the idea of culture or to change, intentionally or inadvertently, our perception of culture as a coherent and inclusive form of human activity?

This question brings us back again to the fact that the latter-day arts manager is more likely to be the product of a specific process of training than the kind of self-electing enthusiasm which I have earlier described. Arts management is a qualification, involving not only the demonstration of instincts and sympathies in tune with the fostering of artistic endeavour but with an explicit range of practical skills such as accountancy, marketing and personnel management. The arts manager, in other words, is a specialist.

Some cultural commentators have felt sufficiently alarmed by the process of specialisation at work in modern society as to describe it in culturally negative terms. The American poet and

essayist Wendell Berry (1977) links specialisation to a growing preoccupation with credentialism — the desire to render all areas of human activity quantifiable and qualifiable in academic terms. A specialist he defines as "somebody elaborately and expensively trained to do one thing" (Berry, 1977:19). Berry goes so far as to describe specialisation as "the disease of the modern character".

There is some substance in this criticism. However, this only becomes clear when the field of arts management is seen from a broader cultural context. For only within this wider view is it evident that we are looking not at a landscape of organically and dynamically related elements but at one that is fissured and segmented into specialised fields. The most significant of these fissures is that between "Arts" and "Heritage".

Underlying the apparent utility of these two terms is a conceptual difficulty in arriving at convincingly exclusive definitions of them. This is because both words describe forms of cultural activity. An exact meaning for the word "heritage" is difficult to pin down. Nevertheless, it has come to embrace more comprehensively than any other word our sense of personal, tribal and human identity as encoded in all that has come down to us from the past. "Arts" is a collective plural implying the grouping together of a number of individual art forms. At a superficial level it carries the connotation of administrative convenience already referred to, but at a deeper level it embodies our sense of the different forms of human expression as organically related. However, for the purpose of distinguishing it from "heritage" it is easier to talk about art, or the work of art. A work of art, regardless of its date of composition, manages to escape the past in a way that heritage does not. It impels us into a palpably existential engagement with value and meaning; though the artist's effort at communication is "historically" prefigured in the work before us, our effort of interpretation as viewers is always an act of the present moment. Indeed, one of the strengths which art can bring to the interpretation of heritage is the insistence that all acts of interpretation are existential, that history is ever-present.

At a practical level, however, "arts" and "heritage" appear to be more radically divorced than these relative definitions would permit. There is an Arts Council and a Heritage Council, Arts Management courses and Heritage Management courses and, of course, arts managers and heritage managers.

Arts Councils and Heritage Councils preside over functionally autonomous empires and arts managers and heritage managers run their respective provinces autonomously. The trouble with these distinctions is that while, on the face of it, they look like sensible arrangements, they can escalate into arbitrary and artificial specialisations, disrupting the potential for flexible and synthetic approaches to issues and themes across the spectrum of cultural life (Cooke, 1992)[1]. To come back to Berry's diagnosis, they would appear to be symptoms of a prevailing tendency to compartmentalise aspects of culture, of a disconnectedness based on a perception that the management of culture requires its practical segmentation into specialisms.

Of course, it is difficult to determine whether the latter-day culture of management derives its humanistic emphasis from a genuine concern to meet the anxieties of the humanists on their terms, or is simply mimicking the language of culture for the purposes of fulfilling its own quasi-mystical ambitions. It is likewise difficult to determine whether the adoption of this mode of thinking to the cultural field amounts to a positive symbiosis between the practical and impractical realms of human experience, or is based on a confusion of categories.

Ironically, it seems that the tradition which gave us the modern idea of culture, in the inclusive humanistic sense, was in fact partly responsible for such specialisation. Since the onset of industrialisation, the main thrust of thinking on the subject has been to define culture as a coherent and organic realm of activity on which we depend for spiritual wholeness and imaginative integrity, in direct antithesis to the very threat of segmentation presented by the machine age. As Williams points out (1958:xvi), one of the effects of this perception of culture as a grouping of humanistic disciplines opposed to the forces of mechanistic capitalism was to reduce artistic activity to a realm of specialisation. For the first time, the arts became grouped together as having something essentially in common which distinguished them in a special way from other human skills.

There is a danger, however, in dismissing modern management culture in terms of some facile prejudice of "high" culture.

[1] In this article I examined in more practical detail the cleavage between arts and heritage as reflected in the way art galleries and museums are run as separate kinds of institution.

Looked at positively, and despite its accretions of mumbo-jumbo and questionable psychologising, there is evidence of a growing appreciation within management theory of the intrinsic value of wider cultural values to its own success. We see this, for example, in the way literary, folkloric and sporting paradigms are seen as capable of teaching valuable lessons about the nature of human endeavour. The potential is that a management culture (in the specialised sense) properly informed by cultural values (in the broadest sense) may yet contribute vitally to that integration of all aspects of human endeavour which the pioneers of cultural thinking saw as the ultimate goal.

But there is little room for complacency. Management theory remains, for the most part, essentially utilitarian in its motives and goals. The high priests of modern cultural thinking saw resisting this utilitarianism as one of the vital roles of culture. The danger lies in the uncritical assimilation of management values to the cultural field without sufficient regard to how they can lead to a utilitarian way of thinking about culture itself. There are those who nowadays speak all too readily, perhaps, about the cultural product, about successful marketing strategies for dealing with it and about its contribution to the economy ahead of its value in spiritual or imaginative terms.

The essential point here is that we should reserve our greatest scepticism for the very notion of the manageability of culture itself. From an educational point of view, it means perhaps re-examining the relationship between the traditional idea of a general education and the more recent ascendancy of specialist qualifications. In practical terms, this means assessing the relationship between arts degrees and post-graduate qualifications in arts and heritage management. The virtue of the traditional arts degree lies in its demonstrable non-utilitarianism. Yet the idea of an education being a preparation for life has come, perhaps, to have a quaint ring about it. The objective of a qualification in arts or heritage management, on the other hand, is clearly to provide a focused training for a specific role.

There are two points worth making about this relationship. First, that such post-graduate qualifications, especially when they allow for the transition of students from basic degrees, uninterrupted by work or life experience, inevitably detract from the status of a general education. They do this by implying that such an education is not a sufficient basic qualification unless finished

by a specific kind of training. This is not the fault of education-
alists in isolation but of a change of emphasis in educational val-
ues brought about by a general social demand that a third-level
education should be a preparation for work rather than for life.
The root of the problem lies in the historically endemic levels of
unemployment which have affected developed societies over the
past quarter of a century. The idea of a general education has now
been radically qualified and circumscribed by vocational de-
mands. In a more consciously cynical form, such credentialism is
a form of suspended employment, a demand-side method of
controlling and regulating the attenuated labour market. To an
extent, endemic unemployment has been followed by endemic
education, with many people now remaining in full-time educa-
tion until well into their twenties.

The second point, which follows from the first, is that a greater
separation of the roles of basic education and specialist training
would be to the advantage of both. The value and integrity of a
general education needs re-affirmation and support. It is surely
reasonable to insist that a basic degree ought to be a suitable
qualification for a job, so that young people can build up an inter-
vening stock of experience before embarking upon forms of spe-
cialist training. It would then be much easier for those running
cultural management courses to insist upon practical experience
in some cultural field as an entry requirement.

But there is also a need to examine the distinctions of expertise
which courses in arts and heritage management represent. If we
are to have management within the field of culture, let it be a dis-
position which takes the widest view of the subject in philosophi-
cal as much as in practical terms. If we are to have managers, let
them be trained to see the connection between things rather than
to pride themselves on the specialist authority which the qualifi-
cation bestows on them.

None of this is to argue, it should be stressed, that the adapta-
tion of specific management skills to the management of culture is
invalid, or to suggest that the complex of cultural amenities and
activities sustained and demanded by modern society can be
supported by a group of inspired amateurs. In the end, a broad
social consensus about the value of artistic activity and heritage
amenities is what distinguishes contemporary society from the
era of the Revival. Then, the political alienation of the majority of
the people from the dominant political culture more or less

guaranteed that any significant artistic movement would be anti-establishment and amateur to the extent that it was self-realising. Now, in conditions in which national self-determination is an established reality for most western states, the area of ground on which art or the artist can carve out an anti-establishment position has become much more difficult to define. The assent of artists and other practitioners within the cultural field to being part of a more democratic or communal process has as its corollary a more conscious level of socio-cultural responsibility — and a conscious process of management is a necessary concomitant of this responsibility. In a positive sense, therefore, a culture of management is one manifestation of cultural democracy, of an idea of artistic responsibility which is not necessarily inherent in the idea of amateurism, no matter how positively defined.

Nevertheless, there is a tension which needs to be maintained between the evangelical certitude of the ascendant management culture and the more comprehensive idea of culture as an organic and assimilative process. For those who are concerned to sustain this inclusive and organic vision of culture, a kind of strategic scepticism is required to keep the sub-cultural elements of which it is constituted in a state of balance. Williams makes the point forcefully (1958:238). He agrees with T.S. Eliot's vision that the future for an inclusive culture will consist in "a very complex system of specialised developments". Under such conditions, the tendency will be for "selected elements" of the cultural composite, and especially the arts, to achieve a wider social diffusion. However, he warns that "there are dangers, both to the arts and to the whole culture, if the diffusion of this abstracted part of the culture is planned and considered as a separate operation".

In the end, to be concerned about the management of culture and about the impact of the (sub)culture of management upon it, is about the idea of culture as representing a practically inclusive process — the only transcendent meaning which the word has. It is the concern which has remained at the centre of the modern tradition that has sought to define it in this way: a concern that culture should always be more, and if at all possible never less, than the sum of its subcultural parts.

References

Berry, Wendell (1977), *The Unsettling of America — Culture and Agriculture*, San Francisco, CA: Sierra Club Books.

Cooke, Pat (1992), "A Modern Disease: Art and Heritage Management", *Circa*, no. 61, Jan./Feb. 1992, 30–33.

Williams, Raymond (1958), *Culture and Society*, London: Hogarth Press.

SPEAKING FOR THEMSELVES

Part 1 — Interview with Jeremy Isaacs,
General Manager, Royal Opera House, Covent Garden

Conducted by Marian Fitzgibbon

MF: Many arts managers have worked only in the arts sector and there have been some high-profile failures in the case of people who have moved from other sectors to work in the arts. You have a special perspective in that you have been a manager outside the subsidised art sector, albeit broadly in the entertainment industries. How would you compare these experiences?

JI: The essence of all management in a way is to release the talents of those one works with towards an agreed purpose. So the leader of any institution at all, particularly of an arts institution, has to be able to define what the purpose of the institution is and then to create or allow the space in which other people more talented than the administrator can make the work that justifies the institution's existence. Actually, in this matter, the work that I did in broadcasting was absolutely identical to what I do here: the function of an executive in a creative institution is to create the space in which people make television programmes, create theatre, make music, paint or whatever. And the essence of management is the prudent or skilful or cunning or conjuror-like management of resources to provide the wherewithal. You can't provide inspiration, you can't provide genius, you can't provide even talent. All that has to come from the people whom you choose to work with, but you can provide space. You can try to provide funds and you have to work with people who are creative to see that they deliver to the public's satisfaction. The function of arts administration is not at all to keep creative people happy: it is to please the public. Engendering creativity is only a means to that end.

Artists who don't care to consider that they are supposed to be addressing a public should work on their own and should not expect to be provided for.

MF: Your answer is comprehensive: you take in a number of dimensions of arts administration. It is modest too in that you seem to be describing yourself as a facilitator.

JI: I seriously do that because I myself was a programme maker — I still am potentially. I know from experience that there are certain jobs in broadcasting administration that you can combine with making your own programmes, but at a certain point, if you are put in an administrative or management position, you really have to make your mind up. You're either running the channel or you're making programmes. You cannot do both. A priori that applies even more to me here since I cannot sing a note or dance a step. I thought I would have a lovely time here just listening to and watching people rehearse. But it isn't like that at all. I'm not directing opera; I'm not even casting opera. I broadly approve the repertory in ballet and opera that is put in front of me and I watch other people get on with it — and I cheer them up!

MF: That's important?

JI: Yes, very. Because if you don't hold their hand, you're denying them something that they need to rely on. They need somebody they can fall back on and they need to be encouraged in their work because aspects of it are terribly lonely. When a singer goes out on the stage, it doesn't matter how good he or she is, they are entirely on their own and they risk their lives in a way, each time any of them gives a fully committed performance. Now they may be a pain in the neck but they deserve support. Because without encouragement, commendation, praise, they wouldn't be able to do that.

MF: So an understanding of the arts and of artists matters.

JI: Yes. I think it is essential. I don't think you can do this type of job if you have no real interest in the arts. I don't say you need abilities in the arts, but the first thing is you have to believe pas-

sionately enough in the product — ghastly word — in what is being created, to go through fire and water for it. If you don't do that, if you don't understand what people go through when they make things, you can't appreciate what they need to keep them going. You don't understand which blow-ups are just blow-ups and which are serious concerns which have to be addressed.

MF: There is a debate which sees an essential intrinsic conflict between arts and management, which sees the arts, being "spontaneous and unplanned", as not amenable to management.

JI: That is partly true. But it is not true that artists have no interest in the efficient management of their lives. I think it is one of the great miracles of life that people of the dazzling talent of Cézanne or Charlie Chaplin or Harrison Birtwistle or Séamus Heaney or Placido Domingo are able to manage their lives in such a way that they have given us such great work. If they were the victims of passion, rage or folly they wouldn't have delivered. They have delivered — that's the main thing.

MF: And that presupposes an ability to manage?

JI: I absolutely refuse to accept the notion that people who are skilled in the arts cannot manage quite large institutions to the benefit of the arts. So I reject the notion that artists are a lot of irresponsible long-haired egotists. Of course, the central matter is to be able to draw the line: in terms of what can be afforded, what can be practically achieved, what can be tolerated. Though the latter is more a question of artistic freedom than anything else — it arises often in broadcasting. Now the question is: who is the better person to manage from that point of view — somebody whose first priorities are not artistic or somebody whose priorities are artistic? I take the view that it is the person whose priorities are artistic. Of course boundaries have to be set — will it be ready on time; can we afford it; will the realisation of this piece prevent other people from realising their pieces?

MF: What about risk?

JI: The chap who cares above all about the artistic quality of the work will certainly sail nearer the wind or come closer to the bor-

der of what is financially affordable and what makes the institution viable than somebody whose first priority is to ensure that the books are balanced each year. I would argue that there are very few occasions where a financial diktat will produce artistic success. On the other hand, one has to resist self-indulgence. I don't mean when people want to make the best possible film or production. I love that — it's admirable. But I hate it when people are so selfish in their cannibalising of resources that they couldn't care less what is going to happen to others. Decisions must be made; lines must be drawn; one must exercise one's informed judgement. When I became the Director of Programmes at Thames Television, the Chief Engineer asked me to promise that no drama would ever take more than two days in Studio 1. Now he was doing his job — at least up to a point: Thames was producing a number of quality popular programmes within a tight framework and a fixed allocation of resources. But I couldn't give that man the promise that he asked for because I knew it meant we would only produce formula drama which was not exciting or good enough. So I said I couldn't do that. We're going to do the best things we possibly can here and resource allocation will just have to come along with us. We were not making widgets, we were making drama. That just cannot be done in two days.

MF: So good arts administration is about sailing close to the wind, to use your metaphor.

JI: It's all about deciding what are the proper amounts of resources and finance and tolerance to allow the makers of a project. The arts administrator has to have proper regard for the total resources available and dare not risk the viability and the funds of the institution or the institution itself. Nevertheless he or she is the proper person to decide how close to that limit it is right to push. Otherwise, you just get safe play.

MF: Could you run an airport? There's a lot of scheduling and complicated logistics involved in running the Royal Opera House.

JI: That's quite a good comparison. . . . I imagine that all aeroplanes — except very tiny ones — need roughly the same allocation of time to take off or space to park on. But you can't run the

arts like that — some plays require twice as much rehearsal as others.

MF: You have a lot of balancing to do generally — between financial concerns and artistic integrity. Could you say which concern is uppermost for you at any one time or are both constant?

JI: All the time — not at any one time — all the time what matters is the quality of work that we put here on stage. Now you can't push that to the point of bankrupting the house or killing by overwork the people who work here. But I don't think they have any doubt that that is what comes first, that that is what we are here for. To make the point more savagely, it can easily become the case — in an institution whose administrators are too soft with their colleagues and employees and too keen themselves on a quiet life, or corrupt customs which sacrifice the real purpose of the institution to the well-being and self-interest of people who work there — it can easily become the case that the claims of artistic creativity take second place. In this house there was a period where artistic ambition was blunted and almost totally sacrificed by a failure of imagination that couldn't see that a way had to be found to get out of the financial prison that the house was in. They spared their customers: they would not put up prices. Because they wouldn't put up prices, they had insufficient income and because they had insufficient income they did extremely dreary work. They could not do new work. Then again, you can have a situation where people aren't prepared to take on their colleagues and say, between us — you making the greater sacrifice — we could find far more cheap, far more efficient ways of running this house. We can't go on paying the overtime that we are paying for the inadequate work we're getting. When I got here, night work, which was essential, was done extremely inefficiently and extremely expensively and by people who had already done a 15-hour day. Part of their privileged existence was that they were allowed to do the night work. But they couldn't do it properly. And we had to stop it. We had to tell them that we were going to bring in other people to do it. In other institutions — not in this country, but for instance on the continent where in some places there is excessively high subsidy for the arts — everybody connected with an institution has a job there for life. And then they have a very substantial pension afterwards. Now

this is a nonsense for people who can no longer sing or dance. It's a nonsense too for dozens of stage crew who are not pulling their weight.

MF: So you have to be tough.

JI: You have got to say — what we are here for is to do this and to do it well and we owe it to the people who fund us to do it as efficiently as we possibly can. Franco Zeffirrelli said of La Scala Milan that it was a cow with a thousand teats. That meant there were a thousand people there — which there still are — each of whom thinks that the Scala's obligation is to them and their life, during the whole of their working life — not to the art form and not to the public. Though of course they pretend that they are there as servants of the music and they glory in the *réclame* of La Scala. But principally, they see La Scala as the source of their livelihood and income. Then you must say to people, you are partly here because you believe in what you're doing here, not for the financial rewards it will bring you. Otherwise, the arts are out of the window or they are being sustained by weak management into a dependent stance in relation to the public from whom ultimately, one way or another, their income comes.

MF: Could you estimate the division of your time as a manager between internal and external matters?

JI: It's quite a hard question to answer — more internal than external. Of course, internal consists of external relations in the sense that a lot of the boards I sit on exist to keep the house right in relation to the external world. I would say that at least 30 per cent of our time is spent talking to the Arts Council, to other funders, partners, to government, catering to public opinion — 20–30 per cent.

MF: Where do artists rate on your scale of priorities?

JI: All the priorities here are not necessarily addressed directly by me. I am the general director after a major reform which involved delegating managerial responsibility for the running of the companies to the heads of those particular companies. We also have a

Head of Corporate Affairs and Public Relations, a Director of Finance, Director of Industrial Relations, a Technical Director and somebody who deals with fund-raising. Each of these has a different order of priorities. For the chap who runs the opera company, artists are number two, maybe often number one among his priorities. For the chap who runs the ballet company, and certainly for his colleague, the Artistic Director of the Royal Ballet, artists are number one priority. I'm pulling the whole thing together.

MF: You refer to the public frequently in your answers.

JI: Well, I'm very conscious of the public because nothing makes me more unhappy than empty seats in the house. I want to see it full. Also, the point of live performance is to thrill a public and the happiest news I have is smiling faces on the street after a performance or pleasant congratulatory remarks. "Loved it!" "Great show!" That's what we're here for. The other thing is the public, which gives us far less funding than it could or in my view should do, nevertheless does provide funding in different ways.

MF: Sixteen per cent of your funding comes from sponsors.

JI: That's in a good year.

MF: What about the conflict between exclusivity and accessibility: your sponsors are paying for exclusivity but your public funding is justified to a large extent by the intent to increase accessibility?

JI: That's a very real dilemma. But I don't think it has much to do with sponsors except that some wealthy corporations pay well over the odds for their tickets to be absolutely certain of getting tickets. But they pay so much over that they are actually contributing to the subsidy on other people's tickets. Our difficulty is simply that, unlike my predecessors who charged low prices which generated low revenue for a low level of artistic activity, I am aiming in the first instance at a high demanding taxing level of artistic activity. And the only way I can get income up is by charging high prices. The prices have gone as high as they can go and we're now operating at 80 per cent of capacity. We'd like to be operating at 90 per cent and sometimes we are finding that we

can increase capacity though not necessarily income by reducing prices. We simply cannot afford to turn a penny away. Of course, there are fixed limits too. The house only has 2,000 seats and we cannot give more than 250 or 260 performances a year and that means that 500,000 is the limit. And, of course, besotted opera or ballet lovers will come 20 times a year. In that 500,000, one must count a substantial number of repeat visits.

MF: Big bodies like this put a particular strain on funding bodies, especially as public funding is contracting.

JI: Yes. I think it is particularly difficult for them because they must think of others. I don't think life should necessarily be made that much easier for them, but in a way it would be if the biggest recipients were taken out of their gift and administered directly by Government.

MF: The risk then is that this would create a two-track arts economy.

JI: Yes. Well we haven't got that and it's not likely that we shall. But it would make it easier for them! They'd hate it!

MF: Turning to the question of planning, do you think that you can plan for most things in here? Or is running the Royal Opera House by its nature very unpredictable?

JI: No. You can plan for most things. Of course, if a singer cancels or if you haven't got quite as much money as you thought, then you have to adjust. But you can plan. Artistic institutions have a responsibility to plan their future use of resources as effectively as they can and to get the match right between what they can afford and what they seek to do. That is in one way the essence of the job. If you allow ambition — which is admirable — wholly to outride practicability, you have a train crash on your hands. If you never raise your sights a bit above what you can really afford and push it a little bit, you'll never do as well as you really should do.

MF: Many arts managers have difficulty in relating to their boards, in appreciating that they may have a different perspective.

JI: It is almost a prerequisite for coming on the board of a place like this that you care enough about the arts — even pretty passionately about them — to be able to empathise with what your manager and his or her colleagues are saying to you. And they are really there as a kind of backstop to make sure that the thing doesn't go off the rails. They must however be the kind of person who understands a crucial difference. The big difference between arts administration and all kinds of other jobs in the private sector and industry and finance and the city is that there the goals are absolutely clear. You may have certain obligations to your workforce but the income measure is the bottom line. The first priority in the arts can never be the bottom line. Anybody who thinks it is is wasting their time.

MF: Another aspect of many arts jobs, especially senior ones, is their high visibility. Does this affect your work?

JI: Yes, that is true and it does affect work. It's tiring, demanding, it eats at you. In the easy early days it may be a cheap source of some kind of vain satisfaction. Actually, in the end it is a corrosive and almost depressing factor. It means that everything you do publicly and privately is subject to public scrutiny. And that is a whole added thing to carry with you through life. I wouldn't say that it's the end of the world but it's certainly an additional factor.

MF: Another difference in managing the arts is that you manage at the same time both the steady-state and the dynamic: by that I mean that you have people working here all the time and then you have key people — singers, dancers, directors — who come in and are here for a while. That's not a situation you would come across in a factory or in most businesses.

JI: Very, very different indeed. It's not as difficult as this particular thing is in television. It doesn't arise with singers because that's just a question of massaging egos — by which I mean the sensible business of providing encouragement and support and comfort and looking after their practical needs, making sure the costume fittings go well — I don't do any of that but it has to happen. The problem comes back to this business of two days of drama in Studio One. The best examples I know are film directors. Film di-

rectors — and somehow they succeed in communicating this to their whole crew — will tell you that the only thing which matters, *the only thing*, nothing else matters, is the quality and success of their film. The budget doesn't matter; the resources don't matter; the time doesn't matter. The disaster that lies at the end of that you find out in a book like *Final Cut*, the account of Michael Cimino's *Heaven's Gate*. That's the kind of book that gives people the wrong idea about the arts. But, of course, *Heaven's Gate* happened and cost $30 or $40 million more than the budget. Now Hollywood can cope with that sort of thing up to a point because it consists of a series of individual groupings that are brought together on a particular budget to make a particular film. But if you try to graft that operation, or even people who are perfectly content to make a film on a six week shoot, on to people who are making *Crossroads* or *Neighbours* or *EastEnders*, who know in advance that they have got to turn out 90 minutes of soap opera a week — no arguments about it — and these are the studios it will be done in and no, we can't go back and do that bit again because we're out of time, then you do get a kind of mismatch, a difficulty.

MF: Yet such issues must arise frequently because of the nature of your operation?

JI: And the people who are likely to cause us problems are not singers but producers because producers behave in the same way as film directors. They don't belong to the House, what they care about is the quality of the product they make and it doesn't matter what havoc they may cause, they go away and go on with their freelance life. But actually, in spite of the tensions that attended many things I did when I first came here, when I was a bit more involved in the nitty-gritty of individual opera company decisions than I am now, in spite of those tensions and very real difficulties that partly were caused by my desire, on the producer's behalf, to get more out of the system, not to confine them with inadequate rehearsal but to allow them to realise full potential, in spite of that we've had very little trouble in this area. And my advice to any arts administrator wondering how to cope with the major ego of a director who wants to be the best and wipe everyone's eye with the most marvellous piece of work they've ever seen, it's very simple. Agree absolutely categorically in advance what you can give by way of resource and what you

cannot. And the people we deal with, they're not potty, they're not madmen, they're not crooks, they just want to do the best they can. If they know, if the conductor (who is another ego) knows that he can have only so many rehearsals, then he won't complain. If he believes he's going to get X and when he arrives he's told he's going to get X minus 3, then he's a very upset and miserable man. But then the management has short-changed him.

MF: Again, it comes back to planning and good communication.

JI: In a couple of weeks time this theatre will be dark for a week. It's never happened. This is because we have a particular director coming here and he needs a week to get this production of *Don Carlos* up and running and it will be worth it. We've taken the decision and built it into the planning book and I've had to fight the board off on it over and over again because they cannot reconcile themselves to the fact that we're not performing in that week. And we've had to demonstrate that once that week of rehearsal is over, the productivity, the strike rate of opera performance over the next few weeks will be as high as it could conceivably be expected to be. So the thing will be justified both by the amount of work we can do and also by the quality of what this chap does. If it's as good as we hope and believe, we'll be forgiven. But in any case, it's all been planned and budgeted for. Setting parameters that are artistically adventurous and imaginative and working within them: that is my point.

SPEAKING FOR THEMSELVES

Part 2 — Interview with Patrick Mason,
Artistic Director of the Abbey Theatre, Dublin.

Conducted by Marian Fitzgibbon

MF: You have not always been attached to an arts organisation, having had experience as a freelance director before coming to the position of Artistic Director of the Abbey.

PM: Yes, I trained as a teacher in speech and drama. I came first to the Abbey as a voice coach. A subsequent position in Manchester University gave me the opportunity to direct. My first full-time directing job was with the Abbey in the late 1970s for three years. Then I was freelance right through the 1980s here, in the UK — wherever I could get the work. I always kept a link with the Abbey, particularly in the area of new writing. That was a strand I developed while continuing as a freelance director. I was approached a couple of times about this particular job in the course of the 1980s and on those occasions it just didn't seem the right time for me, for various reasons. But when it came up again in 1993/94, I thought that having advanced to a certain point in my freelance career, I couldn't really go around saying no all the time so I took a deep breath and jumped. Because it is a very difficult thing to become an Artistic Director, an extraordinarily difficult thing.

MF: To what extent do you see your job as requiring the skill of "management"?

PM: There's a huge element of management in being a theatre director. It's not all about vision and imagination: you really are dealing with the logistics of production. As normally happens in

the theatre, one is asked by a producer or production company to direct the play. You will put together the team: designer, lighting designer, stage management. You will then cast it: if it's a new play you will cast it in consultation with the writer. You put the whole thing together and you work through the physical production and all this happens before you get into the rehearsal room. So you're talking maybe of two or three months dealing with a lot of people at different levels. So I always say that one of the basics of a director is actually logistical managerial skill.

MF: And you don't find that description too workaday?

PM: Not at all. It's absolutely vital. Because you have to lead the team and be able to speak to them, bring them all on board and all into the same play. When you enter the role of an Artistic Director — my colleague as chief executive is a General Manager who is on the day-to-day administration — what you have to do is to mediate, to translate the artistic vision that you are supposed to have in terms of the development of theatre, the people, the areas, the kind of imagination that you wish to foster — to translate from this language of art and inspiration and imagination into the hard language of logistics: how many people do I need to do that, who do I need, how much money do I need? That's where being a freelance director is similar except that the scale of it for an Artistic Director is much larger: we do 14 productions a year here and, in a sense, I produce them all. So I am actually involved in the setting up of 14 production teams, 14 casts and not only that, there is also a very clear remit for the National Theatre: there are clear areas of responsibility where you are working to foster particular developments and particular talents and a particular vision.

MF: So unlike many people in the arts sector, you do not experience any kind of allergy to the term "management"?

PM: I have an allergy to the vocabulary of business studies and of management.

MF: Well, much of the language relating to "strategy" comes from warfare, the movement of masses of people during the world wars, as well as from economics.

PM: Yes. And I choose to talk about audiences — not clients or consumers. I prefer to talk about productions or plays, not about product. I think the danger which I feel very alert to in the vocabulary of the business world is that there is a kind of reductive tendency in that vocabulary that refuses to deal with the complexities of creativity. Creativity is a very troublesome thing — it's irritating to the average manager because it won't lie down or be tidied up.

MF: Yet current management studies refer widely to the need for "creative management".

PM: Yes, they do. But there is a very strong and a fundamentally reductive tendency in the business world to organise, that is to put order on something at all costs; and creativity — this is the great paradox of all creativity, particularly theatre — needs freedom as well as the incredibly precise analysis of resources to make it happen. You cannot do without one or the other. You have to try and balance both. But I think probably most people who regard themselves as creative or in creative work would feel instinctively defensive about what they see as this hard-headed business of management.

MF: How do you react to this quotation from a book about arts training: "traditionally the arts are thought to be spontaneous and unplanned, unsuitable for management by technocrats and bureaucrats" (Mitchell and Fisher, 1992:10).

PM: Well, I sympathise with the impulse but it is disingenuous to deny that every working moment of an artist's day, be it as an individual or in a collective, involves organisation. It's like structuring a rehearsal. If you're a good director, you try to structure a rehearsal so that there is a framework for freedom, that there are parameters and yet that they are parameters which encourage exploration, within which things can happen and people are comfortable to explore. But you don't want too strict parameters which actually stifle that. And that's the art of direction, in many

ways. To say that art is anarchic and all that — well you can end up at the end of the day and there's nothing! Theatre works to deadlines: the demands are very immediate and very practical. Audiences aren't interested in intellectual justifications or abstruse ideological background. If it doesn't work, it doesn't work. Theatre is this constantly frustrating and paradoxical beast. Film you can play around with. Theatre is in the here and now and then it's gone. That's the great challenge of theatre. You try that without organisation!

MF: You are in reality walking a tightrope, balancing artistic and commercial or management concerns?

PM: Yes, absolutely. In a more theatrical metaphor, it's like roles: there are moments of the day when your role is to be an artist and moments when you must be a manager. Just as there are some times in rehearsals when you must throw the thing over and encourage the most astounding risks from the performers. There are also moments when directing is about saying "do this", "don't do that" and the great art of direction is knowing when to do which.

MF: To take a practical instance of when management concerns might impact, what factors govern selection of productions?

PM: This is very interesting because this theatre, by definition as a national theatre and from its tradition, is art-led: in other words, it holds to be foremost the integrity of the artist's creation and it is not reactive in the consumerist sense. It doesn't reply to the market. It seeks to lead the market. It never wanted to be a commercial theatre and it was established for clear artistic ends. So we have a very strong commitment still to those ends. That brings us into conflict most of the time with what I'd call market trends. Now, the truth of the matter is we live in a mixed economy. We don't have enough subsidy to be entirely free of the box office. I am not saying we want to be — that can lead to its own indulgences. Yet we don't have enough to be as clear as we would like to be of box office pressures. So we try to balance the programme by doing our new work and pushing the boat out while we also do plays which are proven, which we know can attract audiences. Unfortunately that repertoire is very small and it's one that is being competed for by many other places. Once a play is done it's

going to take at least five to six years before it can be done again. So the thing is to find the new bankable repertoire and establish it: that is very high risk, extremely high risk.

MF: So balance is a major concern?

PM: Yes. The balance of a programme is all-important. No one is in an ivory tower: our heads are not in the clouds. And yet clearly there are new writers, new talent which must be brought to the fore. There are also plays which are not going to be commercial but which are of enormous artistic importance — Chekhov, Ibsen, Shakespeare. These have to be part of the repertoire: it is part of our remit as the National Theatre. Those are our main guiding lights in programme selection. Now we also have a responsibility to stay in business — one is picking one's way between all sorts of things. As artistic director, I believe that we must be anti-reductive, anti-consumerist. We are here to raise a voice to say there are alternatives; there is another way of looking at things which is not reductive, which is not the hard materialist way. I am talking about the life of the imagination, the aesthetic, emotional and psychic life of artists and audiences. The National Theatre is here to engage with and nourish that need. In the end I have to start talking about soul. This makes people from the business world incredibly uneasy, but I insist on that vocabulary of the soul because the other vocabulary is far too dominant. We must fulfil a historic role. In the early part of the century, the theatre was involved in hammering out the whole question of national identity. I think it is now here to examine the relationship between art and commerce, to talk the language of the unseen needs, not the hard material needs.

MF: Yet you live in a hard material world.

PM: But of course. And that's the point!

MF: Management is often taken to be about greater efficiency: cost-effectiveness, speed, etc. This sits somewhat uneasily with the arts. William Baumol pointed out in 1966 that it still takes approximately the same amount of time to play a piece of music like Beethoven's Ninth and roughly the same number of musicians. So in aspects of arts management, it is not possible to cut corners.

PM: It just won't go. We all know you can do a production of *Macbeth* with six actors and it can be a wonderful production. But if you say no, I'm going to do *Macbeth* with all the characters as written because that is the production I want, then a National Theatre should be able to do that. It shouldn't be told that it *has* to do it with six people. How can we then realise on an appropriate scale — not a lavish scale but on one which is decent, a whole range of repertoire? And my chief concern at the moment is the shrinking repertoire.

MF: What's available or . . .

PM: What's possible, given the resources.

MF: And do you ever find yourself having discussions of this type, for instance: a play has been cast, you have your list of actors and your marketing director makes the point that there are no "names", that is, that it will be difficult to "sell", to attract audiences.

PM: There are two answers to that. First this is a company theatre, an ensemble theatre, so no one part of the work dominates.

MF: Do you mean that there are no stars?

PM: There are no stars in this theatre. Though we have certainly had great actors. Unlike cinema, we value stars because they are wonderful actors, not because they are stars. Therefore, the answer is that if it is appropriate to have a wonderful actor who happens to be a star in that role, we'll try to do it. But we are not led by that. Sometimes it has been possible and it has worked out wonderfully well.

MF: As with Brian Dennehy in *The Iceman Cometh*.

PM: Yes, that's a classic example of it working extremely well. But it's when you are led by that that you start getting into trouble.

MF: The Abbey has to be conscious of many factors. Your main resource provider is government through the Arts Council. You deliver a public service . . .

PM: This is where the situation is totally anomalous. Though we are perceived as a semi-state body, we are in fact a private limited company with a 10 per cent government shareholding. We are not like a real semi-state. For instance, we are bound to national wage agreements and the like but our grant funding is not index-linked. This is a public service in terms of impulse — an educational impulse. This is evident in many ways: our pricing policy (we offer many concessions); our outreach programme; our liaison with amateur as well as professional theatre; our archive; our script-reading service which is open to anyone in the country.

MF: Typically in the public service the position of the customer or the audience is weak. The clients do not exert the same influence as they do on private companies, for instance. *Managing the Cultural Sector* (Clancy, 1995) rated audiences a low priority — number 14 out of 18 after the Arts Council and artists. There was quite a marked disregard for the concerns of audiences. Would you comment on that?

PM: Well, it can be explained very easily. We are all obsessed with finding enough money to keep going and the Arts Council holds the purse-strings. I'm surprised that they are not first on the list. Obviously, however, the other source of money is the audience and we do have a great concern for the audience. No one puts on a play to empty a theatre. That's folly, stupid. But when you believe in the artistic vision of a playwright, when you believe in the intrinsic artistic value of what you are doing, then you make an act of faith and you say "this can work, we're going to do this so well, make it so compelling that that it will bring in the audience". Not that we are trying to tell the audience what is good for it; really, it is rather an act of revelation. Now sometimes you just get it hopelessly wrong and sometimes the audiences get it hopelessly wrong. Of course, the basic rule of consumerism is that the consumer is never wrong.

MF: You start with the customer.

PM: Yes. Now in the art world you start with the rule that the artist is never wrong. The truth is that both are constantly wrong: both sides need a certain humility. The trouble is, of course, that the stridency of consumerism makes the artist immediately defensive and this reinforces the arrogance. But counter that with the arrogance of the consumer. So it's an uneasy relationship, a necessary tension perhaps.

MF: Where would you place the audience on the scale of priorities?

PM: Well, I wouldn't put it down at number 14. I would have give the three groupings — Arts Council, artists and audiences — more or less equal billing.

MF: The findings of this study which took on board the views of 300 or so managers/arts administrators is interesting in terms of policies of access and education.

PM: The truth is that they are all priorities and from moment to moment, one nudges the other out of position. I go back again to my views on this culture of consumerism. Obviously, if you're not selling lots of tickets there is something wrong, and yet everything we know about the history of art, theatre, opera tells us that there have always been plays lost, ignored or whose time has not yet come. Art does not work in a straight hit or miss way: that is reductive. It's the Broadway smash-or-flop thing. But look where Broadway is now — dead! It's dead because art doesn't work like that.

MF: Do you do audience research — who comes to the Abbey?

PM: Oh yes. There's a new one going on at the moment. We do them regularly, roughly every four years.

MF: So do you find that your audiences change or is it the same people who come all the time?

PM: There's a good mix. And it depends on what plays you do. There are different constituencies, in part as a result of the fragmentation of Irish society that has taken place in the last ten

years. Unfortunately, there are very few forms of theatre that go right across those constituencies, very few plays like *Dancing at Lughnasa*.

MF: In choosing plays do you say: "We have dealt with X constituency; now it's time to turn to another"?

PM: That becomes a consideration: it is one of the elements that goes into the discussion of programme — one of the many. There is certainly an awareness of it. We should resist the tendency to think monolithically "the audience". Audiences are myriad.

MF: Marketing people segment the audience.

PM: Art and theatre throw up exceptional circumstances. You put on a play like *Six Characters in Search of an Author* and you suddenly find there are people in their teens, in their 20s and in their 40s who want to see it; people from Dublin 6 and from the Liberties[1]. The basis for me is you are dealing with individuals and individuals cross barriers all the time. It's when you get into groups and collectives that they don't. If I do for instance a Behan or a Heno Magee, I get proportionately much more of a Dublin inner-city working-class audience. They won't come back when I do Chekhov or Ibsen — they'll wait for the next Behan. But *Dancing at Lughnasa* — and plays like this come around once a decade if you are lucky — just seems to pull everyone.

MF: Do you think management skills are transferable between sectors — is managing in the arts sector substantially different to managing in industry or business?

PM: Hugely so. We've talked about differences in vocabulary which is of course symptomatic of mind-set and values. If you talk about "product" you have already handled the thing wrongly because you are already talking about cost effectiveness and placing it in the market and responding to the market. Instead you must start with the imagination: not a product but a play which will not sit easily in any one category, which requires a more flexible mind-set, a more subtle and supple imaginative ap-

[1] Rich and poor areas of Dublin.

proach. This is not to say that one is not aware of the need to effect economies; indeed, you can turn certain economies to aesthetic benefit. There is a constant dialectic between hard economic necessities and artistic requirements. An old but a good rule in theatre says less is more. This is evident in a whole aesthetic of opera production that has become almost standard in Europe: it is both imaginative and deconstructive and it doesn't wish to be caught in the shackles of realism. It has a philosophical basis as well as an economic one and the two very neatly combine.

MF: So you need a sensitivity to, and a knowledge of, the sector.

PM: Absolutely. Also, because in the arts you are dealing with people's aspirations, their feelings, sometimes their deepest feelings and their most noble aspirations. If you're unsympathetic to that it can be absolutely disastrous.

MF: Are the arts more unpredictable than other sectors? Do you regard planning as feasible?

PM: I have to. I have to try anyway. The arts are unpredictable in the sense that you do not know what the response is going to be. Yet I have to lock the theatre into a schedule. Now places like the Royal Opera House or the National Theatre in London have the money and the staff to operate a continental repertory system where they can hold three or four productions together in a season and can schedule productions on an alternating basis. I have to go basically from production to production. I have to take reasonable steps to feel that this play will last for five weeks because I can't put up another one if it goes down. I have to book directors, designers and indeed actors six months to a year in advance. So planning is vital. Even just for our workshops. Today a bit of the set of *The Sons of Ulster*[2] which has been on tour in the UK was found to be damaged when it was unpacked in Galway. It's had to come up to our workshops; we've had to put something down to Galway.

[2] *Observe the Sons of Ulster Marching towards the Somme* by Frank McGuinness.

MF: Are there other ways in which managing the arts differ? For instance, you have a lot of people to answer to, a range of stakeholders — more than a private company would have to deal with. Your bottom line is not profit. You operate in a vaguer world when it comes to setting objectives.

PM: Yes. We're not in business to make profit: we're in business to make theatre and to stay in business if we can. With all the high ideals and great ambition that they had, Yeats and Lady Gregory ran very quickly into the hard facts of the market. So they gave the theatre to the State. And to everyone's surprise, it took it! And it is interesting that it was first given a grant on educational grounds. If you look around today, there is a great crisis in theatre world-wide. The play is disappearing. It's disappearing on Broadway, the musical is taking over. This is the form of theatre that generates profit. This is an enormous cultural shift and a perplexing one. We are part of this broad picture.

MF: And you have to take account of it.

PM: That's what I say to people all the time. Of course I can fill this theatre with *Cats* or the Chippendales but then what's happened to the National Theatre?

MF: So you are the guardian of the flame?

PM: Yes.

MF: Can I ask you about the people who work in the arts field. Generally they are seen to be very committed and dedicated to their work. Is that a feature of what you find here?

PM: The closer you get to the creative sector, the higher the dedication: no one in their right mind would be an actor unless there is nothing else they want to do in their life. It's the most appalling life. Very few experience the glamour of a handful of stars. The theatre is kept going by thousands of very hard-working and abused actors. When you get to what I might call — in the best sense — the more mechanical parts of the theatre, then it is hard to inspire the same enthusiasm. We try a lot to engage everyone in the process but you are dealing with the front-of-house and the

bar — it's not quite the same as dealing with the stage. There are differences in temperature in the involvement, the engagement and dedication.

MF: Many texts on arts management would seem to suggest, somewhat idealistically, that self-interest never enters into the arts: all is commitment?

PM: Of course self-interest enters in. So we use our subsidy, at least in part, to pay people. When people come here they get at least Equity minimum. We are of our essence a professional theatre and it is the one theatre where an artist can come and at least be paid a decent wage. One of the first things Yeats did with his subsidy was pay the actors and from that day to this, this has been a core value.

MF: Arts managers at your level — and even those not at your level — are very visible and subject to public scrutiny, more so than their equivalents in other sectors. Is this difficult?

PM: Yes. I know it is a feature so I was under no illusions about the job but I'm not in this business to be a personality. My work speaks for me. I accept that this theatre is in a privileged position and therefore there is an amount of scrutiny that is absolutely justified and fair. We provide more detail about our operation than any other theatre I know. Colleagues in Britain and France are amazed that we actually publish so much. But it's an odd thing and maybe a heartening thing that anything to do with the Abbey will end up on the front page. It's a frustrating thing, too, because despite all the stuff we put out, there is still so much ignorance about the Abbey.

MF: An unusual feature of arts management, certainly in theatres, is the necessity to manage both a steady-state core and a dynamic element: at the same time as a core staff, you have people coming in — directors, actors, designers, playwrights. And these "outsiders", if you like, may play at least for a time very key roles. I think that this is something that very few managers in the private sector would have to cope with. Do you notice that?

PM: Yes, very much. I go back to this thing of mediation: I try to mediate between these two very different dynamics. What is interesting about this is that it creates tension. Now that tension can be turned to very good effect — creative — or it can go sour, become negative and break out in rows and resentments. The way to solve this is to keep the focus always on the work. That is the most important thing — what is happening on that stage tonight. Whatever our grievances or problems, that is what we are all working towards. I always say to directors and designers coming in, "if you haven't made your major design decisions before you go into rehearsal, then our workshops will not be able to build the sets — it takes four to five weeks to build a set. And if you change your mind in the fourth week of rehearsal and you want a 30-foot wall, you won't get it because it will cost too much." Now this is not just this theatre, it is any theatre. Some directors and designers are used to working like that, that's fine; some feel it impinges on their artistic spontaneity. In that case one has to say "I'm sorry but . . .". There is a parting of the ways.

MF: And would you negotiate all that in advance?

PM: In advance. Because if you don't the rest is misery. And equally a designer or a director may say, "I know we said that but the way things are going . . ." Then I have to go to the technical people and say, "look, I know this is a hassle but how much overtime can we manage?" If everyone knows the ground rules and the parameters, then within that we can negotiate flexibilities. There's no such thing as a totally free or a totally fixed situation. There has to be mutual understanding. It's not like in the German theatre — we are not at that level of subsidy. So it's about balancing reality and aspiration.

MF: Could an incoming director have very different priorities to yours, and again, how would you balance that?

PM: We have to talk it through in the beginning. I can start with the play or the director but it has all to be talked out. There are bound to be problems.

MF: Are there issues of loyalty and confidentiality when you are dealing with people who are not "of the building" — actors,

directors, writers, designers — suddenly becoming important people in it?

PM: That can cause enormous strain. When sometimes things go wrong, you must just put it down to experience and I'm afraid you decide that that person is not going to work here again while I'm here because I can't cope with that. I expect confidentiality.

MF: And the issue of "managing" creative people? You have 80 actors working here at the moment. Now actors can be described as a fairly volatile and quite vulnerable grouping of people. In industry the management equivalent might be a research unit in an industrial setting with research scientists who enjoy more freedom than other workers. That is a headache for some managers. How do you feel about it?

PM: I spend my life in rehearsal rooms! That's where I think there is great benefit in an artistic director being him or herself a director. Though you don't need to be, I think that someone who is creatively involved in the theatre has an advantage as an Artistic Director. There is a shift at the moment in a lot of European theatres towards the "intendant" model, the chief executive who is not creatively involved. That I find very worrying. And in my experience as a freelance director working in such theatres, I find this very difficult.

MF: So you feel your own creative involvement gives you a very good understanding of the perspective of the artist, a sympathy with her or his position?

PM: Yes. Basically I know the process from the inside.

MF: How do you react to the antipathy which artists may feel in relation to arts administrators or managers — the fact that such intermediary people are getting all the money while the real creative people are impoverished?

PM: It's a reality. Particularly in the Irish scene where arts administration looks like a growth industry. It's amazing how many such jobs have been created and it's a problem that bureaucrats prefer to speak to bureaucrats; administrators prefer to speak to

administrators. So arts administrators proliferate. I'm afraid that the process is that the administrator does push out the artist. And I think that has to be a bad thing and it does eat up valuable resources. Now at the same time I don't hold out that the artist must have total freedom either because there is money involved. People's livelihoods are involved — there must be a sense of responsibility. The ultimate responsibility is to the soul, towards the imagination, not the pound note. And that is where the real tension lies. It's not all just about survival. Survival is not life. Survival is just survival. In the end, art theatre is supposed to be about life — in Yeats' sense: "that the people should have a more abundant and intense life".

References

Baumol, William J. & Bowen, William G. (1966), *Performing Arts: The Economic Dilemma*, Cambridge, MA.: MIT Press.

Clancy, Paula (1994), *Managing the Cultural Sector*, Dublin: Oak Tree Press.

Mitchell, Ritva and Fisher, Rod (1992), *Professional Managers for the Arts and Culture*, Helsinki: Arts Council of Finland, Council for Cultural Co-operation.

PART TWO

STRATEGIC PLANNING ISSUES IN ARTS AND
HERITAGE MANAGEMENT

STRATEGIC PLANNING AND THE ARTS ORGANISATION

Ann O'Connell

"Cheshire Puss," she (Alice) began, "would you please tell me which way I ought to go from here?"

"That depends on where you want to get to," said the cat.

Lewis Carroll, *Alice in Wonderland*

Strategic planning is a necessary and integral part of effective organisational management, regardless of whether it is for a commercial enterprise, a government department or a non-profit organisation. Arts organisations operate in an increasingly competitive market for audiences and consumers, and in the context of limited financial resources are coming under increasing pressure to be more innovative in their art or artform and more professional in terms of the way in which they are organised and managed.

This chapter seeks to contextualise the strategic planning process as it applies to an arts organisation. The overall objective is to assist arts managers/administrators in understanding the planning process so that they can readily apply it to their own situation. To do this, the chapter will:

- Outline the reasons why an organisation should plan and the benefits that ensue from taking a systematic approach

- Consider some of the characteristics of a well-managed organisation and good management

- Introduce the reader to the strategic planning process itself through the use of a simple planning model which sets out each of the phases involved in the process

- Outline the key elements of a strategic development plan — its structure, scope and contents.

WHY PLAN?

> To be in hell is to drift, to be in heaven is to steer.
>
> *George Bernard Shaw*

The answer to the question "why plan?" is quite simply "in order to get things done". Without a constructive and continuous planning process and a development plan, an organisation may just drift along, stagnate and die. Those organisations that engage in a planning process, whether formal or informal, are endeavouring to determine the future destiny of the organisation and believe that the best way for the organisation to be lucky is to make its own luck.

In addressing the area of strategi planning it is necessary to differentiate between the planning process itself and the strategic or development plan.

The planning process should be viewed as an on-going analytical and consultative process and not something that happens on a once-off or ad hoc basis. The most effective organisations seek the involvement and contribution of management and certain levels of staff in the planning process so that the resultant plan incorporates their collective wisdom. Having being engaged in the process, staff tend to have a greater sense of ownership of the plan and feel responsible for achieving the objectives set. When the planning process is viewed in this way it becomes an integral part of the culture and mind-set of the organisation.

The strategic plan itself is the embodiment of the analysis undertaken and the decisions made in relation to the development of the organisation. As such it is a comprehensive blueprint of management's answers to three basic strategic questions facing the organisation:

- **What will we do and for whom will we do it?** The response to this question should encapsulate the "mission" or the long-term "vision" of what the organisation seeks to do and what kind of organisation it intends to become. In looking to the long term it should also seek to answer the related questions of

— what is our business or *raison d'être* now, what will it be and what should it be?

- **What objectives do we want to achieve?** The setting of objectives, both quantitative and qualitative, reveals the priorities of the organisation. It forces management to set down the type of results or deliverables which the organisation wishes to achieve through its chosen activities. For most managers the setting of quantifiable or measurable objectives is relatively straightforward. However, the establishment of qualitative objectives can be somewhat more difficult as these tend to embrace the softer aspects of the organisation — its creativity, originality and quality aspects of its art or artform. Such objectives are more reflective of the organisation's culture, value-norms and core beliefs.

- **How are we going to manage the organisation's activities so as to achieve the chosen objectives?** The comprehensive response to this question is in effect the "strategy" of the organisation and how it will be managed. Strategy can be broadly defined as the match an organisation makes between its own resources and the threats or risks and opportunities created by the external environment in which it operates: that is, its "game plan" for approaching target markets and audiences; the development of the art or artform so as to strengthen or reinforce its position; and the manner in which the internal resources — individuals, skills, finance and systems — will be deployed.

Collectively, the answers to these three strategic questions constitute a directional map for managing the organisation and they serve as guidelines for establishing the management's action programmes.

The type of benefits to be realised by an organisation that engages in the proactive and systematic approach to planning for its future are:

- A greater sense of focus and a clearer understanding of where the organisation is headed

- Better teamworking as a result of having been involved in the planning process

- A more effective and efficient use of scarce resources: people, skills, facilities, funds and systems

- A more cohesive organisation with the cross linkages and synergies being more fully exploited

- Improved internal and external communications, the actual plan or document itself being a useful communications tool.

While arts organisations may raise some commercial income from the sale of their art or service, many are dependent on raising funds from other sources such as the state, the local authority, a grant-giving organisation or from the corporate sector. In trying to raise such funds, arts organisations must be mindful that the capability of the applicant to manage the resources allocated will be carefully examined. To this end, evidence of a clear vision, a well defined set of objectives and a convincing strategy or game-plan for the organisation will be an important factor. Increasingly, strategic development plans are explicitly sought by such bodies as a key element of the submission package and in some instances may be the only means of communication between the arts organisation and the funding body. A strategic development plan is therefore an important tool.

WHAT IS GOOD MANAGEMENT?

> Weak leadership can wreck the soundest strategy; forceful execution of even a poor plan can often bring victory.
>
> *Sun Zi*

> Just being able to conceive bold new strategies is not enough. The general manager must also be able to translate his or her strategic vision into concrete steps that "get things done".
>
> *Richard G. Hamermesh*

Why is it that some organisations are consistently more successful than others? Is it just pure good luck — being in the right place at the right time — or is there something more? What are the characteristics and practices that differentiate the high-performing organisations from the others? Two factors weigh heaviest in explaining success: that elusive quality called good management and the ability to earn a favourable competitive position. Arts

organisations may not feel that they operate in a competitive environment in the same way that business organisations do. However, it must be remembered that arts bodies often have to compete with other interests to get audiences, and that they also have to compete for funds.

The managers or administrators of well-run organisations typically are:

- Proactive and take an entrepreneurial stance in shaping the organisation's long-term direction. They have a vision of where the organisation is headed and why. They are not afraid to break new ground and to be innovative.

- Intent on giving priority to formulating and reformulating a strategic game plan, one that builds on the organisation's key strengths and is focused on achieving a competitive advantage and a defendable long-term market position.

- Tuned in to changing environmental trends, the changing needs and tastes of the target market or audiences and the emergence of new opportunities.

- Performance-conscious and results-oriented. They measure success in terms of how well their organisation is performing and its relative strength. They concentrate on achieving target objectives.

- Supportive of practical risk taking and innovative change.

- Able to strike a good balance in focusing their energies externally on audiences/customers as well as internally on operations.

- And, of critical importance, able to motivate and secure the support and loyalty of their staff.

Thus, successful managers are good strategists and entrepreneurs as well as good administrators.

THE STRATEGIC PLANNING PROCESS

> Without a strategy the organisation is like a ship without a rudder, going around in circles.
>
> *Joel Ross and Michael Kami*

As noted earlier, the organisation's strategic plan is effectively a directional map which charts where the organisation is headed and how it intends to achieve its objectives. However, in order to be able to formulate a strategic plan it is necessary to understand what goes into it, what needs to be considered and how the task of developing a plan is actually managed.

Who Should Be Involved?

In any organisation it is necessary that the senior management team and indeed the Board of Directors are actively involved, and seen to be actively involved, in the strategic planning process. There are three main reasons for this: first, to benefit from the collective knowledge and opinions of those involved at such a senior level; second, having been involved in the process they are more likely to have ownership of the plan and in this way to have implicitly bought into its implementation; and third, their involvement shows other members of staff that the process is being taken seriously. Of necessity one person will have to take overall responsibility for the co-ordination and production of the strategic plan. The most appropriate person will depend on the size of the organisation. Some large organisations may have a Development Manager but for most small arts organisations the task will fall to the Manager or Director.

In arts organisations the Directors or Members of the Board frequently take a proactive role in strategy and policy formulation. The Directors or Members tend to be appointed to a Board because of their experience and skill in a particular area. The diversity of interests and ambiguity of purpose stemming from the composition of the Board, especially in a non-profit organisation, may affect the internal decision-making processes. Lack of goal clarity and strategic direction positively invites internal political behaviour. For the Chairpersons of such organisations, managing the Board and deriving the maximum possible benefit from its skills and experience needs adept management and considerable diplomatic skills. In this regard, it helps to make a distinction

between the roles and responsibilities of the executive and non-executive people in the beginning so as to avoid subsequent conflict.

FIGURE 4.1: THE STRATEGY FORMULATION PROCESS

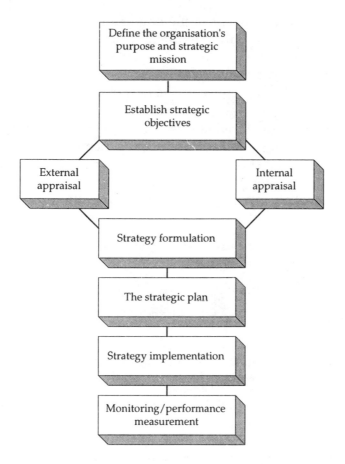

The Process

The strategic planning process is an integrated and interactive decision-making process which is primarily concerned with the development of the organisation's mission and objectives; the commitment of its resources; and overcoming the environmental constraints. This process has several elements which are depicted in Figure 4.1. The model is an attempt to organise and structure

the strategy formulation process. It cannot hope to give a full sense of the complexity of the strategy-making process. The reader should be aware that there are other such models, many of which are more complex than the one illustrated here. Some organisations develop their own model or approach to the process over time.

Although each component of the strategy formulation model will be reviewed here in turn, the different elements are interconnected. Because of this interrelationship the strategy-formulation process, as mentioned previously, is interactive by nature, involving negotiation and compromise on the part of those involved.

Purpose and Strategic Mission. The starting point in organisational direction-setting is to develop a clear concept and vision — "why does the organisation exist?" "what is our purpose or business, what will it be and what should it be?". The types of questions that may help an arts organisation to think their way through this stage include:

- Should we be a single-activity or single-service organisation or a diversified organisation?

- Whom do we primarily want to reach with our activities?

- Who are our audiences to be and which of their needs should we try to satisfy?

- What values will audiences or users of our service obtain from *our* products and/or services?

- What, if anything, can we do that is distinctive from or better than our nearest competitor?

The organisation's answers to these questions will be greatly influenced by its own specific situation and the background and judgements of those involved in the process. Moreover, the answers to the questions "what is our purpose, what will it be and what should it be?" are never final: they evolve out of past experiences, changing circumstances (both internal and external) and the renewed vision of management in relation to the best long-term course for the organisation.

Management's views on what the organisation is trying to do and the audience/user groups and audience/user needs it

intends to satisfy define the business or core purpose of the organisation and establish its "mission". This gives a view of what activities or services the organisation as a whole intends to provide now and in the future. It says something about what kind of organisation it is and what it is to become. It depicts the organisation's core values, the identity and the scope of its activities/services in a way that should distinguish the organisation from other types of organisations.

The managerial value of a carefully stated mission statement is that it crystallises the organisation's long-term direction and steers entrepreneurial decisions down a consistent path. A succinct and clear answer to "what is our purpose, what will it be and what should it be?" can help managers avoid the trap of trying to march in too many directions at once and the other extreme of being so confused that one does not know when or where to march at all.

Strategic Objectives. The second component of the process relates to setting specific strategic objectives. Unless and until the direction of the organisation is converted into *specific* performance targets, into achieving a specific standing and position and into *specific* commitments to action, there is the risk that the strategic mission will remain a statement of good intentions and unrealised achievement. Organisations that set objectives for themselves and for their managers are more likely to achieve them than organisations that operate without performance targets. To specify objectives is to be more transparent: it helps to prevent organisational drift; it promotes and reinforces a results-driven culture; and it focuses attention throughout the organisation on making the right things happen. In addition, when results are clearly specified and, where possible, measurable it is more likely that resources can and will be allocated to their attainment; that priorities can be agreed upon and deadlines set and that responsibilities can be assigned and somebody held accountable for getting the job done.

In setting strategic objectives it is wise to differentiate between them according to their time perspective (short-term and long-term) and according to whether they are quantitative or qualitative. Long-term objectives keep management alert and focused on what has to be done now to attain the desired results later. Short-term objectives serve to illustrate the speed and momentum that the organisation seeks to maintain; they highlight to management

and staff the level of performance and the achievements required in the short term.

In setting objectives that are quantifiable it is best to clearly set out the targets to be attained. A drama production company might aim, for instance, to increase the number of new performances from six to nine per annum — an increase of 50 per cent; to increase the box office takings by 65 per cent; and to perform in three different venues in different geographical locations within the next twelve months. An arts centre, which provides a service or range of services in a particular catchment area, may wish, for example, to increase the number of users and visitors to the centre by 20 per cent by developing and marketing two new service areas — youth drama classes and contemporary art exhibitions showing the works of young emerging artists in the region — within the next six months.

Strategic objectives that are qualitative in nature tend to be more difficult to measure; in some instances too, it may be difficult to determine whether they have been achieved or not. Where possible, key performance indicators should be established in order to benchmark the progress made. For example, an art gallery could have as an objective "to improve the quality and diversity of the contemporary art exhibited and sold in the gallery and to improve the user-friendliness of the gallery facilities". One might establish the extent to which such an objective has been achieved by surveying and seeking the views of a cross section of the visitors to the gallery before and after the proposed change programme and by comparing the second set of responses to those of the first.

In summary, therefore, for objectives to be truly meaningful they should, as far as possible, conform to the following criteria:

- An objective should relate to a single, specific topic. It should not be stated in language that is abstract or vague

- An objective should relate to a result, not to an activity to be performed. The objective is the result of the activity, not the performing of the activity

- An objective should be measurable, stated in quantitative terms where possible, or accompanied by the most appropriate performance indicator

- A time deadline should be set for the achievement of the objective

- An objective should be challenging but achievable.

Some arts organisations, when attempting to raise corporate sponsorship or in seeking to obtain grants, may set objectives that are intrinsically linked to and dependent upon receiving such funding. In the event that such funds are not secured and no alternative source of funds identified it may be necessary for certain objectives to be reconsidered so that they are more in keeping with the resources available to the organisation.

Internal Appraisal. The task of strategy formulation is to achieve a match between the organisation's internal skills, capabilities and resources on the one hand and all the relevant external considerations on the other.

The objective in undertaking an internal appraisal is to produce a picture of the organisation itself. It not only indicates what resources the organisation has but also evaluates how well they have been used in the past. This may also lead to a judgement on how well resources may be used in the future with the same management and personnel.

In undertaking an internal appraisal a number of questions are relevant:

- What are the organisation's strengths and weaknesses in terms of resources, skills, competencies and capabilities? What does it do best? Does it have a distinctive competence and is it sufficient to give it a competitive advantage or a strong and sustainable position?

- What are the personal values, aspirations and vision of the Board members, management and staff? Are they consistent and compatible with the objectives set?

- What are the organisation's philosophy, core beliefs and culture and are they consistent with the objectives and strategic intent of the organisation?

The output from the internal analysis should be a clear understanding of the current situation and the gaps that need to be

bridged, in terms of further development of the organisation, if the objectives are to be achieved.

External Appraisal. No organisation operates in a vacuum; all are influenced both favourably and adversely by factors outside the organisation itself. In order to develop a realistic strategy, it is necessary to appreciate the likely impact that changing environmental conditions may have on the organisation and its strategy.

The type of questions that may help to work out and identify the external factors most likely to impact on an organisation's future are:

- Are there any emerging threats that could impact adversely upon the organisation's well-being and performance?

- What opportunities exist to develop further and market the activities/services or products of the organisation?

- How attractive is the environment in which the organisation operates?

- How competitive is the environment — how much competition is there, for example, for audiences and consumers on the one hand and for state and other sources of funding on the other?

In answering these questions it is necessary to consider the social, political, regulatory, ethical, economic and demographic features of the external environment as well as the technological developments that are likely to have an impact on the organisation in the future.

Opportunity, the attractiveness of the environment or sector in which the organisation operates and the competitive forces which operate in that environment are always factors in formulating strategic plans. Most of the time these are pivotal strategy-shaping considerations, for unless an organisation believes it is positioned to pursue an attractive opportunity there is usually the option of heading in other directions. But once an opportunity is deemed to exist, the focus turns to the detail of assessing the competitive forces and in positioning the organisation to avail of such opportunities. Opportunities for arts organisations include increases in the level of funding provided to the Arts Council or other funding bodies; a growing appreciation by the public of a

particular artform, resulting in an increase in demand; the development of new technology, as for example in the multimedia area which has opened up a whole new artform and industry.

For the most part, organisations appear to react to environmental threats rather than to plan for or to anticipate them. This is not always a criticism of management; many strategically important environmental changes seem to occur at random or are not readily subject to prediction. Some occur without warning and with few, if any, advance clues; others are bound to happen but one cannot know when. And still others are simply unknowable. Moreover, even when threatening signals are detected early, it is not always easy to assess the extent of their strategic significance. Trying to forecast the strategic significance of future events is scarcely ever an exact science. Nonetheless, staying alert to threatening developments and shaping a strategy capable of coping with adverse environmental changes is something that the Board members and managers of arts organisations have to try to do.

Strategy Formulation. Strategy formulation is the task of selecting an action-oriented game plan that indicates *how* chosen objectives will be pursued and *what* entrepreneurial, competitive and operational approaches management will adopt to get the organisation in the position it wants to be.

An organisation's strategy, when formulated, may or may not be spelt out in a document such as a strategic plan. Very often written versions may only summarise the primary elements of the strategy and may not contain a detailed account of it. Many aspects of strategy may remain couched in verbal discussions, the unspoken thoughts of the manager and the implicit consequences of managerial actions and decisions. Outsiders may be able to deduce certain elements of the strategy from such visible actions as the provision of new services or a change in the behaviour of the organisation in the market, e.g. applying new ways of marketing and promoting one's art or artform. Other elements of strategy may appear in the annual report, speeches made by Board members or management, interviews and articles in the press.

How well the task of strategy formulation has been done depends on how well it suits the particular circumstances of the organisation. The type of questions that may assist in this task include:

- Does the strategy offer a potentially effective match with the organisation's internal and external environments?

- Does the strategy allow the organisation to avail of, or exploit, attractive opportunities and/or escape the impact of externally imposed threats?

- Is the strategy compatible with the organisation's internal strengths and weaknesses?

- Does it capitalise on or maximise what the organisation does best?

- Is it timely?

All things considered, is there a good fit between the chosen strategy and the relevant external/internal considerations — does the strategy fit the situation?

Ultimately, of course, the test of good strategy formulation is whether the chosen strategy produces the desired levels of performance and culminates in the achievement of the target objectives.

The Strategic Plan. The strategic plan is the comprehensive statement of an organisation's strategic mission, objectives and strategy. It is a detailed road map of the direction and course the organisation intends to follow in conducting its activities.

For each objective stated it is necessary to clearly set out the action programmes, initiatives, tasks or projects that need to be undertaken; the persons responsible for undertaking such action; the timescale and deadlines involved; and the resources required in terms of people, skills, funds, facilities and systems.

Strategy Implementation. Strategy implementation is crucial to effective strategic management and in this regard the importance of people in the implementation process should not be underrated. Putting the strategy into place and getting the organisation moving in the right direction calls for a fundamentally different set of managerial tasks and skills. Whereas strategy formulation has an entrepreneurial focus, strategy implementation has primarily an administrative focus. Whereas strategy formulation emphasises the abilities to conceptualise, analyse and judge what constitutes an entrepreneurially effective strategy and what does

not, successful strategy implementation depends upon the skills of working through others, instituting internal change, guiding the action programmes necessary for the execution of the strategic plan and achieving results. In comparison, strategy implementation poses the tougher management challenge. Many believe that it is a whole lot easier to develop a sound strategic plan than it is to "make it happen".

Linking the daily activities and work programmes directly and clearly to the accomplishment of the organisation's strategic plan is critical to successful strategy implementation. The two main strategy-implementation tasks of the manager that aim at creating this linkage are (a) building a capable organisation and (b) allocating resources and focusing work effort on strategic objectives. The first task is concerned with matching the structure of the organisation to fit the requirements of strategy and staffing each unit of the organisation with the skills, expertise and competencies it needs to carry out its assigned role in the strategic plan. The second task involves providing organisational units with the budgetary resources and a clear set of priorities for accomplishing their piece of the overall plan and then keeping organisation-wide attention focused on "what to achieve" rather than letting work efforts aim simply at "what to do".

Monitoring/Performance Measurement. A crucial part of the implementation process involves putting in place a system of performance monitoring in order to establish whether the organisation is on schedule or whether some slippage has occurred. In this regard, it is essential to review the action programmes described above on a regular basis with the person(s) responsible for their achievement.

The criteria used to evaluate performance and the frequency with which it is undertaken should be clearly understood by those involved in the implementation process. Reviewing performance in a constructive manner can have a significant motivational impact in terms of "keeping up the pace".

SUMMARY

Strategic planning is an action-oriented activity. It requires actual hands-on practice to achieve proficiency and a mind-set that is questioning and open to change. To be successful, the process should be consultative and strive to engage those who will

eventually be empowered to realise the vision. Thus, while the responsibility of the plan rests with many, one person of necessity must champion its co-ordination and development. For most arts organisations, this will be the domain of the manager.

> I keep six honest serving men
> (They taught me all I knew);
> Their names are What and Why and When
> And How and Where and Who.
>
> *Rudyard Kipling*

References

Thompson, A. and Strickland, A.J. (1989), *Strategy Formulation and Implementation — Tasks of the General Manager*, Homewood, IL: Irwin.

MANAGEMENT CONTROL AND EVALUATION OF PUBLIC CULTURAL CENTRES

Lluís Bonet, Xavier Cubelles and Jordi Roselló

In Catalonia, and in Spain in general, many public cultural facilities have been created by local and regional governments over the last twenty years. This strong public investment in the cultural sector can be explained by the shortage of theatres, exhibition halls, neighbourhood centres and other cultural facilities during forty years of dictatorship. Now, there is an increased need to focus on how these institutions are being run. We propose to examine evaluation and management control in the context of strategic planning and to present a model of specific indicators to measure the performance, efficiency and effectiveness of public cultural centres. This micro-analytical approach to evaluation is intended to provide the managers of public cultural facilities with a tool to improve their decision-making processes and organisational performance.

Strategic planning is a managerial process for formulating strategic objectives and assigning responsibilities so as to achieve the mission and goals of the cultural centre. It implies a continual process of organisational readjustment to the external threats and opportunities of the environment, in accordance with its internal organisational strengths and weaknesses. This model allows us to rationalise evaluation as part of the management process of cultural centres.

DISTINCTIVE FACETS OF PUBLIC CULTURAL CENTRES

Public cultural centres are constrained by some limitations which affect the evaluation of their management and performance.

First, public facilities which are often non-profit organisations have more problems in measuring their performance than their

private counterparts. Profit-led organisations use basic financial indicators to measure profit, which is their main goal. These indicators allow them not only to measure profits but also to test whether supply and demand in the market is satisfactory and whether the organisation has the capacity to run efficiently. Public cultural centres, like other governmental facilities and non-profit organisations, define themselves by their "high" mission and the services they offer. People might have a degree of tolerance for the fact that a governmental facility loses money, provided its mission is regarded as worthy: public goals and mission are always of the utmost importance. Management control must adhere closely to the mission and the objectives of the centre.

Second, there is the difficulty of goal specification. Most public cultural services must deal with a diversity of heterogeneous, diffuse, ambiguous and sometimes contradictory goals. This explains why in most cases it is difficult to prioritise among them, even when the mission is clear. Very often, goals are more ambitious than resources will allow.

Some examples may help to illustrate this. Take, for instance, the case of a cultural centre situated in a neighbourhood with a strong representation of immigrants. The following goals have been identified, flowing from the centre's mission to realise the social and cultural integration of the local population: (a) to explain and share the cultural wealth of the different neighbourhood communities; (b) to promote self-confidence and creativity among young immigrants; (c) to present attractive activities to secure earned income for the centre; (d) to offer quality programming; and (e) to encourage use of the centre by all generations and social classes. In this case the problem stems from the ambitious nature of the goals and the resulting difficulty in establishing priorities. Consequently, management control and evaluation of the centre will prove complex.

A similar type of problem arises in the case of some museums, archaeological sites and nature parks. Two primary goals are likely: the dissemination of knowledge of heritage for the community (which involves trying to attract as many people as possible to heritage facilities) and the conservation and protection of their non-replaceable heritage (which is threatened by too many visitors). Often the strategies to realise both goals have conflicting consequences and it is difficult to achieve a balance between both, especially as public organisations — and this is a third problem —

often find themselves in a situation which encourages the pursuit of short-term objectives at the expense of the long-term ones: with elections every few years, politicians may feel that people will only support them for their more visible programmes. Short-term analysis tends to place greater emphasis on quantity rather than quality, a factor which may run counter to the social values which underpin cultural policies.

The difficulty in reaching a consensus on goals and priorities among different public patrons and constituency groups with varying and often conflicting political and cultural positions constitutes a further problem for many public cultural facilities. On the one hand, there is the arts lobby (artists, amateurs and other supporters of culture) which may advocate the allocation of public money for the support of elitist (and sometimes very expensive) artistic activities. On the other hand, some community groups may be calling for more money for neighbourhood projects and for more "grass roots" cultural activity. Some businessmen, although critical of public spending in culture, may wish to take advantage of certain government provisions: publishers or private broadcasters, for instance, may see governmental activities in these fields as unfair competition, but just the same may try to externalise some of their own costs by using the public interest argument.

Any new arts policy which prioritises a specific sector and allocates the additional funding which goes with it usually provokes a strong reaction from the less-favoured constituencies, given a generally static cultural budget. Some of the strongest artistic disciplines, such as theatre or cinema production, are effective lobbyists and adept at mobilising the media in support of their interests. Given this tension between the different arts lobbies, many administrations in Spain have preferred during the last decade to maintain the status quo, or succumb to budget inflation, without cutting any previous programmes. However the current crisis in public spending demands a more analytical approach and a drive to measure the performance of public cultural centres.

The situation is even more difficult because, leaving aside the cultural sector, other social areas such as health, education or defence, many of which have a higher priority in the eyes of the public, also depend on public patronage. This is especially apparent now when most European governments are replanning their

welfare system and cutting social expenditure because of their need to reach EU requirements.

As a result of all these factors, it is clear that we need to work more assiduously to develop a new methodological approach for measuring the performance of public cultural facilities. First of all, in order to evaluate results, we need to identify a more specific set of goals. Though difficult, this is not enough in itself. As we have seen, cultural institutions work with a wide range of goals which are difficult to assess and evaluate separately. The individual experience which is often the aim of arts policies cannot be easily aggregated; it is also difficult to isolate the results achieved over different periods of time and to distinguish between the activities of the cultural centre in terms of their specific contribution to each of the goals. Furthermore, it is important to bear in mind that since culture has a high symbolic value, consumer decisions are not always based on utilitarian and materialistic criteria but on social or emotional factors. This explains why price and cost do not always correspond.

MANAGEMENT CONTROL AS A FACET OF THE STRATEGIC PLANNING PROCESS

Management control and the evaluation of cultural policies are crucial for the successful and healthy functioning of an organisation. For this reason it is important that both should be integrated into the strategic planning process. Evaluation, management and planning are all phases of the one process. Management control is an important tool since it weighs the actual results of policies or actions against the initial goals and objectives of the organisation. An effective monitoring system assesses the programmes which have been implemented and determines both what has been done and how it has been done. Public management presumes a high level of accountability for programming content and for expenditure. In this context evaluation is a particularly relevant phase of management.

Evaluation indicators should be developed at the same time as objectives are being designed and plans put in place. This allows for the discrepancies that arise between the objectives and results (measured by a range of chosen indicators) to be understood and rationalised. That a certain inevitable discrepancy exists between the objectives and the final (evaluated) results is not necessarily a

bad thing. It demonstrates that it is not only necessary for the outcomes to fulfil the expectations of the organisation but it also points up the necessity for sensitivity to changes in the demands and requirements expressed by the public in the long term. In short, a certain degree of flexibility is necessary to adjust ourselves to the mission implied by our service to the public.

In the course of the planning and evaluation process it is necessary to reflect, in a continuous and dialectical way, on the organisation and its relationship to its external environment — which, after all, the centre exists to serve. That is to say, it is necessary to guarantee a good flow of information at all levels of the organisation so as to ensure accurate programming and control of the management process. The director should always know what is happening (bottom-up) and at the same time make sure that his or her observations and decisions reach the base of the organisation (top-down).

This type of democratic management of information has a high cost for the organisation in economic terms but it allows the centre to monitor its objectives for improved quality of service. This is important in any type of organisation, but in a cultural centre where human resources are paramount and where services of the highest qualitative value are offered it is fundamental. Everyone from the porter to the stage manager should know and understand the mission and role of the centre. This endows the personnel with a certain autonomy to make responsible decisions in crisis situations. If internal communication functions successfully, the discrepancies alluded to above have a better chance of working themselves out in time through effective budget management. This minimises the all-too-common mishandling of economic resources. Budget control is a basic management tool that allows for decisions to be rationalised and controlled.

THE SEARCH FOR EVALUATION INDICATORS

Imagine an organisation which has developed a strategic planning process based on a few well chosen long-range goals. From these goals are derived concrete objectives, each one of which is sub-divided into multiple operational objectives which result in activities. The system of evaluation which we are proposing is based on the design of a group of indicators related to each of the different levels of goals of the cultural centre. This is a primary

reason why such indicators should be devised and agreed in parallel with the centre's goals and objectives. Each of the long-range, strategic and operational goals, are measured with the corresponding set of indicators: impact indicators, interim indicators and process indicators.

- **Impact indicators**. These measure the degree of organisational goal achievement of a specific program to be implemented. Evaluation in this case can only be after a long period of time, perhaps some years.

- **Result indicators**. These measure the level of accomplishment of the operating objectives in relation to the strategic objectives.

- **Process indicators**. These measure the efficiency with which the different task elements of a programme are implemented. Although they show whether the operating objectives have been accomplished in an efficient manner, they don't measure the level of accomplishment of the strategic objectives or of the long-range goals. They are measures of efficiency but not of effectiveness and can be carried out within a shorter period of time.

FIGURE 5.1: HIERARCHY OF GOALS AND INDICATORS

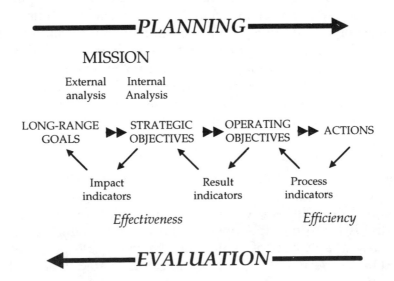

To offer an example, a *long-range goal* of a cultural centre might be to increase awareness of folk music among children. The *strategic objective* might be to restore ancient folk music instruments and to teach school children how to play them and the *operating objective* might offer a beginner's folk music course for music teachers in schools. The tasks involved in this last objective might include sending out publicity and advertising material.

Impact indicators, which measure the level of goal achievement, might include the number of school children who can play a folk music instrument after one, two or three years of school lessons, or the percentage audience increase of children at folk music concerts. *Interim indicators*, which measure the level of achievement of strategic objectives, might indicate the number of folk instruments restored, or the number of music teachers who teach their students how to play folk music instruments. Finally, *process indicators*, which measure the level of accomplishment of operational objectives, could include the availability of a sufficient number of musical instruments per course, or the effectiveness of course promotion (e.g. increases in demand for information over the previous year), resulting in a higher level of participants.

These indicators, which should always be considered together, can be used in conjunction with different evaluation methods. The following are suggested:

Experimental Evaluation

Based on the observation of actions and/or groups under controlled conditions, this method can only be applied when the programme to be evaluated has a very concrete objective: for instance, the percentage of audience increase at concerts when the regular ticket price has been reduced.

Comparative Evaluation

This determines the aspects of similarity or dissimilarity of projects over time and/or in similar horizontal scenarios. This type of evaluation can be implemented at different levels:

* **Evaluation over time.** The objective is evaluated at different moments in time. This historical analysis allows evaluation of current results in relation to those obtained in the past or predicted initially. Most activities can be evaluated in this way.

- **Horizontal evaluation**. This involves comparing different agents who have developed the same activity in similar conditions over a certain period of time. This method is used mainly in the management and evaluation of public policies at macro level.

Judgemental Evaluation

Based on judgements made by specialists, administrators and/or the public, this method should be used in conjunction with the others. When used as the only evaluation method, its results need to be carefully considered.

The evaluation methods and indicators described above assist managers in their decision-making process and should ultimately deliver a more efficient and effective level of organisational performance.

We are conscious of the limitations of this study, which has opted for clarity and easy application over a thorough study of the problem. This analysis leaves aside such important questions as the examination of external effects over time and throughout the territory and the relationship between the goods and services provided and consumer needs and choices.

PROBLEMS LINKED WITH THE EVALUATION PROCESS

A number of problems arise in relation to the use of performance indicators: first, there is the identification of indicators, and second, the evaluation process itself.

In the first case, a quick survey of the most common evaluation indicators shows that in many cases they implicitly incorporate a certain set of subjective value judgements which unconsciously project the cultural prejudices of the evaluator in favour of what they believe to be socially, politically and artistically correct. This explains why certain types of products tend to recur in cultural programmes (often coming from "high culture", of national origin or from economically powerful countries, or as a result of the latest fashion or hype generated by the media). Such values make it difficult to evaluate the relationship between the proposed objectives and the desired results.

This phenomenon has an enormous influence on the spirit in which we plan and evaluate our actions. Take the case of a modern art exhibition presented in two different cultural centres in the

same city. One centre attracts a considerably higher number of visitors than the other. Does it follow that the management of the centre with the greater number of visitors should receive more acclaim than the other? Or in another context, is it more important to bring in a greater number of amateur participants or to simply increase the number of concert tickets sold from whatever source? These examples may well demonstrate an inadequate specification of objectives as well as the need to analyse such results in relative terms (in relation to the available resources, local infrastructure or the geographic and social situation of the centre).

Following on from this, it is important to consider the relationship between qualitative and quantitative indicators. The latter are easier to measure and may seem more objective but they are often incapable of measuring the full result of a policy. For example, the increase in the number of theatre productions performed at the Municipal Theatre may well be taken to be a positive indication of good management. However, this does not necessarily follow. Sometimes it may be more important to observe an increase in attendance by a new sector of the public, or to present a small scale production that generates enthusiasm or the involvement of students and amateur theatre groups in the city.

Another very common problem relates to the timing of the results. Certain strategic objectives can only be evaluated at the end of what is sometimes quite a long period of time, as for instance in the case of training or arts education. How many years should we wait to evaluate the long-term results of a music campaign in schools? This becomes even more complicated when we use diverse evaluation indicators which mature at different times to analyse the same objective. For instance, taking the music in schools example, we may choose as an indicator the number of students who are involved in playing an instrument during school time, or who are part of a rock group after their school career, or those who, as adults, attend classical music concerts.

Finally, and following on from the time dimension, when we work with short-term goals as part of a long-term strategy, our main concern is with the future: whether we reached last month's objective is much less important than the business of reaching the one for next week. This is normal human behaviour and has implications for how we invest our time in control management.

The second major problem referred to above relates to the evaluation process itself. There are three main obstacles to a valid

performance evaluation of a public cultural centre: (a) the diffi-
culty of accurately measuring the net effects of a programme, due
to the competitive environment in which it takes place; (b) inter-
nal limitations in the design of the evaluation system; and (c) the
lack of a unique indicator to measure performance in non-profit
and public organisations.

The accurate determination of the net result of the program is
of particular relevance. This involves isolating the outcomes gen-
erated by our institution from those that arise from similar pro-
grammes of other competing organisations, i.e. a public cultural
centre can develop a project to increase the awareness of music for
children in the community. However, at the same time, the chil-
dren might receive additional or similar training from other
sources, such as in school or through the mass media. The diffi-
culty then comes in knowing how to segregate the success of one
programme from the other.

Evaluating cultural policies is a difficult and complex task
given the high number of factors that intervene in this process
and the internal limitations inherent in quantitative measurement
systems. Micro-level evaluation, that is, at the level of the indi-
vidual cultural centre, can enrich this process contributing as it
does to the analysis of the cultural reality as a whole.

References

Anthony, Robert N. & Young, David W. (1988), *Management and Con-
 trol in Non-Profit Organizations*, New York, NY: Irwin.

Bamberger, Michael and Hewitt, Eleanor (1976), "Monitoring and
 Evaluating Urban Development Programs", World Bank Techni-
 cal Paper no. 53.

Hutchison, Robert (1977), "Three Art Centers: A study of South Hill
 Park, the Garden Center and Chapter", London: Arts Council of
 Great Britain.

Kanter, Rosabeth Moss and Summers, David V. (1987), "Doing Well
 while Doing Good: Dilemmas of Performance Measurement in
 Nonprofit Organizations and the Need for a Multiple-
 Constituency Approach" in *The Nonprofit Sector: A Research Hand-
 book* (Walter W. Powell, Ed.), New Haven, CT: Yale University
 Press.

Kotler, Philip and Andreasen, Alan R. (1987), *Strategic Marketing for Non-Profit Organizations*, London: Prentice-Hall Inc.

Rossi, Peter H. and Freeman, Howard (1985), *Evaluation: A Systematic Approach*, Beverly Hills, CA: Sage Publications.

6

PLANNING AND DEVELOPING A MUSEUMS' FRAMEWORK FOR NORTHERN IRELAND

Aidan Walsh

POLICY DEVELOPMENT

Research and consultation are essential elements in the development of effective cultural policy in all countries. In Ireland, the relatively small population, even smaller cultural community and the familiar nature of society should facilitate the process. Yet until fairly recently little serious research or consultation was undertaken, especially in the museums sector. As a result, the basis for informed debate and decision-making was not developed and this absence has led to a policy vacuum and funding deficit at both central and local government level in Ireland, north and south.

In Northern Ireland the absence of a policy for museums was itself used as an argument for the status quo. The informal view was that since the government had no policy for museums it did not require the funding to implement such a policy. The other side of this argument was that a policy was not required since the funding to implement it had not been secured. The traditional "Catch 22" situation applied.

It would be useful here to give some background information about Northern Ireland itself. Twenty-six of the 32 counties of Ireland were established as the Irish Free State, later the Republic of Ireland, in 1921. The six remaining counties formed Northern Ireland, a region of the United Kingdom which was governed by its own parliament, situated in Belfast. This parliament was abolished by the British Government in 1972 and the province has been subject to direct rule from London ever since.

In the period 1921–72, the Northern Ireland State established two important museums, the Ulster Museum and the Ulster Folk and Transport Museum but only one of the local government authorities — County Armagh — established a county museum service. The year 1972, which saw the abolition of the old Stormont parliament, also brought reform of local government to the Province and this divided the six old counties into 26 district council areas. These new district councils had few powers in comparison to their predecessors but they did retain authority to establish leisure and recreation services. This in turn led to the establishment of new museum services, although there is still considerable under-provision in the sector.

Northern Ireland thus differs from the rest of the United Kingdom in entering the latter part of the twentieth century with too *few* museums, in contrast to England, Scotland and Wales, which some believe have too many. The United Kingdom as a whole has 1,600 registered museums while in Northern Ireland there are 20.

As indicated, up to the imposition of direct rule little policy development occurred. Other non-cultural agencies moved into this vacuum in the late 1980s, in particular the Northern Ireland Tourist Board and the International Fund for Ireland. In the absence of a network of museums in Northern Ireland and recognising the role of museums in tourism and their importance for inward investment, these agencies encouraged local authorities to develop heritage centres instead of museums. Some £20 million was spent in a five-year period on non-museum, non-collections-based institutions. This situation was not mirrored in the rest of the United Kingdom where local authorities such as Glasgow continued to invest substantially in the development of their museum services. It is also clear that the tourism industry in Britain valued the contribution of museums while in Ireland, north and south, the industry felt impelled to develop new heritage attractions which did not revolve around the collection and display of significant artefacts.

In Northern Ireland some museums were able to access some of this tourism funding, notably in Derry and Lisburn, but the bulk of the funding went elsewhere. The need for a museums policy could not have been clearer. This remains the case, especially with the continued capital funding from the EU, continued funding from the International Fund for Ireland and, most importantly, the new funding from the UK National Lottery. The latter

can spend approximately £6.5 million each year in Northern Ireland on museums and heritage.

The advent of the Northern Ireland Museums Council (NIMC), along with the cutback in capital funding, has brought about dialogue with the tourism authorities and other funding bodies and a change of approach. The Northern Ireland Tourist Board is now content to form partnerships with the National Lottery for the development of museums and has also worked closely with NIMC on the marketing of Northern Ireland's cultural heritage.

Interestingly, a number of attempts to develop a museums policy had occurred in Northern Ireland in the 1970s and the 1980s. These reports were not acted upon. In 1978, the Department of Education Northern Ireland (DENI) issued the report of a working party, chaired by W.G. Malcolm (DENI, 1978), which made recommendations on the development of regional and local museums in the province. The report recommended three tiers of museums: national, regional and display centres. A maximum of five regional museums was proposed, each with a specific brief for the heritage of its own region.

The Malcolm report identified the need to set and maintain standards in museums, to avoid wasteful overlap, to share ideas and to provide authoritative advice and expertise. It also concluded that a central agency was required and recommended the creation of "a regional museums service" to carry out these duties. Government subsequently indicated that insufficient resources were then available to implement any of the Malcolm recommendations.

In 1985, the Northern Ireland Assembly published a report on museums (Northern Ireland Assembly, 1985) recommending the provision of funding by government for the development of regional museums and the establishment of a Museums Council for Northern Ireland. The Assembly report also concluded that specialist thematic museums were needed in the province and recommended the development of a select number of these.

In 1993, the Museums and Galleries Commission (MGC) published a review, chaired by Professor Brian Morris (MGC, 1993). The MGC is the UK-wide umbrella body with responsibility for museums. The Morris study, although differing in scale from the previous report, broadly concurred with its recommendations. It also proposed that financial support from government should be made available for local authorities to enable them to develop

regional museums. However, just as in the previous report, Government did not act on the Morris recommendations.

THE NORTHERN IRELAND MUSEUMS ADVISORY COMMITTEE

The absence of a government policy for the further development of the museums sector was most keenly felt by professional museum curators of regional and local museums in Northern Ireland. Following discussions in 1988 and 1989 between these professionals, the Museums and Galleries Commission and the Department of Education for Northern Ireland, a three-year pilot project was announced, to be known as the Northern Ireland Museums Advisory Committee (NIMAC). The directors of the province's larger museums, together with Lord O'Neill, the Northern Ireland representative on the MGC, joined the group which Lord O'Neill chaired.

NIMAC had two main objectives: to produce a report on the type of Museums Council that was needed for Northern Ireland and to undertake an appraisal of local authority museum provision in the province (NIMAC, 1992).[1] In many ways these objectives were logical developments of the recommendations in the previous Malcolm and Morris reports. NIMAC adopted a definition of museums which is accepted by the International Council of Museums, the Museums Association (London) and the Irish Museums Association. It defined a museum as "a non-profit making permanent institution, in the service of society and of its development and open to the public which acquires, conserves, researches, communicates and exhibits, for the purposes of study, education and enjoyment, material evidence of man and his environment" (Museums Yearbook, 1996/7:352). This definition would, for example, exclude heritage centres which are non-collections-based institutions.

Under the 1981 Museums (Northern Ireland) Order, the 26 district councils in the province are empowered to establish museum services. They are not, however, required to so do. This mirrors the situation in the United Kingdom. The 1991 MGC report on "local authorities and museums" (MGC, 1991) pointed out that only 19 per cent of the Northern Ireland local authorities provided "recognisable" museums at that time, in comparison to England and Wales where approximately 75 per cent incur expenditure on museums. The position in Northern Ireland has improved slightly

in the interim with 27 per cent of district councils now incurring expenditure on museums.

It should be noted that NIMAC was not asked to look at the position of the major national museums in the province and that in 1995 a further review, by Alistair Wilson, was commissioned by DENI. This review (Wilson, 1995) proposed the merger of the three major museums (Ulster Museum, Ulster Folk and Transport Museum and Ulster American Folk Park) in the province, and secondly, the undertaking of a detailed study by the Museums Council into the development of regional museums. Government now responded by establishing a Steering Committee to implement the merger proposals. It was also decided to carry out a further review of regional and local museum provision in the province, in association with NIMC.

The NIMAC pilot project concluded its work and submitted a report to Government in May 1992 (NIMAC, 1992). All of Northern Ireland's professionally staffed museums were represented on the committee, in addition to the MGC and DENI. NIMAC also consulted bodies such as the National Trust, the Arts Council of Northern Ireland, the Department of the Environment, the Public Record Office of Northern Ireland, the Northern Ireland Tourist Board, the International Fund for Ireland and other bodies to gain support for the development of a Museums Council.

During its short life, NIMAC had provided a degree of service to museums in the form of advice, information and training. Work commenced on co-ordinating museum and related heritage developments. In conjunction with the major museums, substantial market research was developed and promotional literature produced. Applications from twelve museums for "Museum Registration"[2] were forwarded by the committee to the Museums and Galleries Commission, following appropriate advice and assistance (DENI, 1978). NIMAC could therefore rightly conclude that in recommending the establishment of a Museums Council for the province it had operated strategically, consulted widely and achieved widespread support throughout the cultural and related sectors.

REGIONAL AND LOCAL MUSEUMS

The Committee had been asked by DENI for a particular appraisal of museums provision by local authorities and it concluded inescapably that there was under-provision in the

province. Previous reports had spoken of "a state of imbalance, both geographical and quantitative", indicating also that many regions within Northern Ireland had no central regional museum and that their "origins and history were in danger of loss and oblivion through neglect" (DENI, 1978:26/27).

Unfortunately, almost 20 years after these statements were made, NIMAC had to point out that, although museums are now widely recognised for the social, cultural and economic contribution they can make, this situation still obtained. The Committee underlined its view by pointing out the imbalances which existed within UK provision. Figures in the mid-1980s indicated that £0.5 million was spent by local authorities on museums and galleries in Northern Ireland, whereas the equivalent in Scotland at that time was £11.6 million. Revenue funding of 39p per head was spent in 1987/1988 by Northern Ireland local authorities in comparison with 384p per head by local authority museums in the East Midlands area or 141p in Merseyside (DENI, 1993).

The Committee also pointed to the increasing attendance levels at regional and local museums in Northern Ireland. These figures have continued to increase, as indeed has the expenditure on museums. In 1995, the registered non-centrally funded museums of Northern Ireland attracted over 226,000 visitors, approximately a third of the total number for all museums in the Province (NITB, 1996; MGC, unpublished). District councils spend over £2 million annually in support of such museums. However, only 27 per cent of district councils are providing regional museums.

The fact that no new museums were developed in Northern Ireland between 1921 and 1972 gives rise to some important questions. In part the answer must lie in the poor state of the economy. However, another factor to be considered is that a very divided and traditional society viewed the examination of history as potentially divisive. It is no coincidence therefore that the development of museums and the exploration of cultural identity coincided with the explosion of civil unrest from 1969 onwards. Interest in local history grew substantially during this period and local history societies sprang up across the province. Frequently it was these bodies which first began to press for the establishment of museums. Museums have a major role to play in a divided and troubled society in helping to interpret the society to itself, thereby increasing understanding. Museums too have provided a

neutral ground for the exploration by one community of the history and traditions of the other.

Responsibility for regional museums generally rests with the district councils. The NIMAC Committee recommended that they should be characterised by the following:

- An active and articulated collecting policy

- Promotion of the educational aspects of collections and resources

- Achievement and maintenance of "Museum Registration"

- Co-operation with national museums and other agencies

- Extension of support to voluntary and independent museums

- Employment of professional staff as appropriate to size and need

- Provision of staff training.

Having examined provision in the province and consulted widely with local authorities and the museums sector in particular, the Committee recommended that at least seven and probably not more than nine strategically located regional museums would serve Northern Ireland's identifiable needs. Six regional museums already exist at Coleraine (covering four districts), Derry, Enniskillen, Downpatrick (providing a service to a number of districts), Lisburn and Armagh (providing a service to three districts). Two local museums exist at Bangor and Craigavon.

Northern Ireland has a population of 1.5 million people and is geographically very compact. The division of the six old historic counties in 1972 into 26 district councils has resulted in what many believe is an over-fragmented administrative framework. In addition, the populations of 25 out of the 26 districts range from as little as 14,635 in Moyle to 98,826 in Lisburn. The 26th district — Belfast City Council — has 280,972 people within its boundaries. It is clear that a majority of the district councils do not have sufficient funding to establish museum services of quality and, in particular, to establish regional museum services as defined above (see Figure 6.1).

FIGURE 6.1: NORTHERN IRELAND DISTRICT COUNCIL MUSEUMS

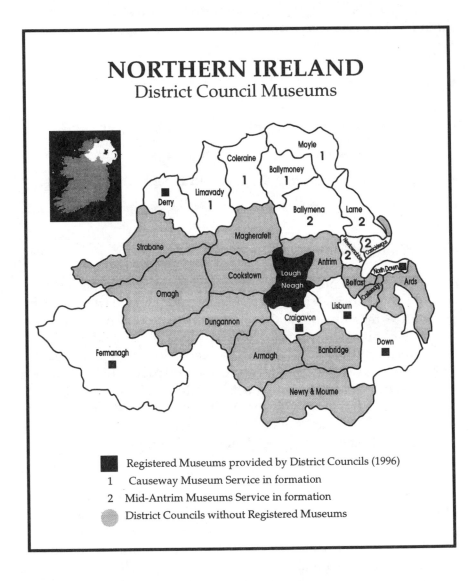

PARTNERSHIP MUSEUM SERVICES

The Committee believed that the establishment of modest local museums by district councils acting alone would not be a solution to the strategic museum needs of Northern Ireland. This course of action would not provide cost-effective services of quality and was not recommended for priority support by central government. It was therefore recommended that district councils come together and form consortia to provide regional museum services. These consortia or partnerships must be decided by the district councils themselves although the Committee recommended that an attempt should be made to respect local and county identities. It was also recognised that some councils were sufficiently well-resourced to establish their own services and Belfast in particular was cited as an example. The overall priority of the strategy must be the extension of a viable regional museum network, developed by partnerships of councils.

Partnerships allow authorities to benefit from economies of scale in the provision of the kind of specialist services which are required for collections care, research and display in museums. Such standards are necessary to achieve "Museum Registration" which in turn brings access to grant-aid. Partnership services aid the development of coherent collecting policies, cutting wasteful overlap and making the most of limited resources of collectable cultural material to build museum collections. Most importantly, partnership services make optimum use of the funding available to Northern Ireland's museums.

THE NORTHERN IRELAND MUSEUMS COUNCIL

The government responded to the recommendations of NIMAC in April 1993 and accepted its principal recommendations by establishing the Northern Ireland Museums Council (NIMC) and endorsing its strategy for the partnership development of regional museums (DENI, 1993). NIMAC had been a widespread and representative consultative exercise in itself throughout the three years of its existence. Its strength lay in recommendations which were "owned" by the district councils and the cultural sector. The consensus behind the development of partnership regional museum services has stood the test of time and has enabled the new Museums Council to adopt the partnership policy and to secure

its endorsement by government and other significant bodies such as the Heritage Lottery Fund.

The Northern Ireland Museums Council has been functioning since December 1993. It is one of ten Museums Councils in the United Kingdom which act as the main channels of central government support to local, non-centrally funded museums. NIMC is a non-departmental public body, sponsored by DENI which provides its core grant. The Council is a charity, managed by a Board of Directors, but is also a membership organisation which currently has 45 members.

The Council's mission is to support museums in Northern Ireland in maintaining and improving their standards of collection care and their service to the public and to promote a coherent framework of museum provision.[3]

NIMC has five broad objectives:

- The improvement of standards of collections care

- The improvement of quality and range of public services

- The improvement of the standing of museums

- The promotion of a coherent framework of museums provision

- The operation of NIMC efficiently, effectively and economically.

In order to discharge these objectives the Council delivers:

- Advice and information

- Training

- Grant-Aid

- Support for collections care and public services

- Advocacy for museums and co-ordination of development.

At the moment the Council is developing its annual training programme through the recent appointment of a Development Officer. In the future the Council would hope to add marketing expertise to its staff so that it can assist in the planning and delivery of marketing in its member museums.

DEVELOPING THE NEW REGIONAL MUSEUM FRAMEWORK

Since its foundation the Council has been working towards the development of partnership-based museum services with groups of district councils in Northern Ireland. NIMC has often provided the funding required to carry out feasibility studies into such services. The first fruits of this work have recently been seen in the appointment in Coleraine of a professionally qualified Director to head up the Causeway Museum Service which embraces the districts of Coleraine, Limavady, Moyle and Ballymoney. Over the next few years the Director will work on the development of the partnership museum service, providing a museum display in each of the four districts and establishing a central headquarters service at Coleraine into which all the partners buy. A similar process led by Ballymena Borough Council is currently underway to establish the Mid-Antrim Museum Service. Negotiations are currently taking place between the district councils, assisted and advised by NIMC, and a museum service is emerging which provides a regional museum covering the districts of Ballymena, Carrickfergus, Larne and Newtownabbey.

Additionally, the Council is currently supporting a study into the establishment of a partnership-based museum service for the County Tyrone area which may embrace a number of districts, led by Omagh District Council. Thus it can be said that although only in operation since 1993, the Council has played a significant strategic role in the development of cost-effective and professionally staffed museum services in the province.

At the operational level, partnership museum services work jointly through a district council partners committee. Staff costs are funded through this committee to which the officers answer. This system will operate for the positions of Director of the service and for other jointly funded positions such as education and marketing officers. Along with this, each district council is separately establishing a museum in its own area which it will staff and fund directly. The management of these local facilities will be through the joint committee to ensure co-ordination of policy, strategy and development. NIMC is a broker in this whole process and is not itself part of any of the partnership management committees.

IMPROVING EXISTING MUSEUMS

Much of the Council's funding is devoted to caring for collections in existing museums and promoting their use. For example, the Council has undertaken audits on the conservation and marketing needs of its member museums. Financial support for these audits was provided by the Museums and Galleries Commission and the Northern Ireland Tourist Board respectively. In response to the recommendations of the conservation audit the Council has just launched a Collections Management Initiative which will provide up to 75 per cent grant-aid support for the preparation of Collection Management Plans in our member museums. The recommendations of the Marketing Audit are currently being considered.

NIMC requires accurately researched information into the needs of its member museums and since its foundation it has been laying the information and research base which is required for strategic decision-making. In all of this work the Council has continued to consult widely with its members and all other stakeholders.

A further development of the Council's brief relates to the Wilson report, mentioned earlier. This recommended that the Council undertake a broad review of regional and local museum provision in Northern Ireland. Government has accepted this recommendation and intends to establish a major review which will examine museums, heritage centres and related facilities with the intention of developing a co-ordinated strategy for the protection and presentation of the heritage. This wider review will also look at the relationship of the formal education sector to these museum services and will engage NIMC in a further round of dialogue and consultation with public and private sector bodies in the province. In one way this review will bring our work at the Council back to where NIMAC started in 1990 but with a much broader agenda and with the Museums Council firmly placed within the spectrum of public sector agencies. There is no doubt that the absence of an appropriate agency to drive and act on policy considerably retarded the development of a museums framework for the province throughout the 1980s and early 1990s. The status of NIMC will allow it to contribute constructively and with authority to the further strategic development of the museums framework in Northern Ireland.

Notes

[1] The objectives of the three-year project were: (a) to study and report on the nature and need for an Area Museums Council (AMC); (b) to gain the support of government and of agencies involved with the heritage; (c) to co-ordinate heritage and museum-related development in Northern Ireland, in promoting the need for an adequately articulated, cost-effective heritage provision in the cultural, social and economic framework of the area; (d) to better integrate the work of Northern Ireland's museums within the United Kingdom and throughout Ireland; (e) to provide services to museums in Northern Ireland, comparing in nature though not in scale to those available from AMCs to museums elsewhere in the United Kingdom.

NIMAC was also asked by MGC to organise introduction of the Museums Registration scheme to Northern Ireland within the timetable for the scheme's implementation throughout the United Kingdom.

The Committee was requested by the Department of Education to carry out an appraisal of local authority museum provision in Northern Ireland. A statement of the existing provision together with the committee's advice on a development policy was requested.

The Committee was also asked to generate some income to assist in defraying its operational expenses.

[2] Museum Registration is a voluntary UK-wide scheme originated by the Museums and Galleries Commission, London. In Northern Ireland the scheme is administered by NIMC. To become registered, a museum must demonstrate that it has reached certain minimum standards of collection care and service to the public. Being registered provides the key to much grant-aid, from Area Museum Councils, charitable foundations and government sources. Over 1,600 museums have now joined the scheme.

[3] NIMC is managed by a board of 15 members: three nominees from the Department of Education; three from the Northern Ireland Regional Curators Group; three from District councils which operate registered museums; one from the universities in the Province; one from the independent/service museums; and a further position is available for co-option. The three major museums in the Province nominate their Directors, ex-officio. The Chairmanship is open to election from the broader membership of the Council.

References

Department of Education, Northern Ireland (1978), "Regional Museums in Northern Ireland", Report by a Working Party, Belfast: Department of Education.

Department of Education, Northern Ireland (1993), "Response to the Report of the Northern Ireland Museums Advisory Committee", Statement by Jeremy Hanley, MP, Belfast: Department of Education.

Museums Association (1996), *Museums Yearbook 1996*, London: Rheingold.

Museums and Galleries Commission (1978), "Review of Museums in Northern Ireland", Report by a Working Party, Belfast: Museums and Galleries Commission.

Museums and Galleries Commission (1991), "Local Authorities & Museums", London: Museums and Galleries Commission.

Museums and Galleries Commission (1993), "Review of Museums in Northern Ireland", Report by a Working Party, Belfast.

Museums and Galleries Commission (1995) "Digest of Museum Statistics" (Unpublished).

Northern Ireland Assembly, Education Committee (1985), "The Museums Service in Northern Ireland", and "Area Museums Service and Local Museum Development", Minutes of Evidence, Belfast.

Northern Ireland Museums Advisory Committee (1992), "A Northern Ireland Museums Council", Belfast: NIMAC.

Northern Ireland Tourist Board (1996), "Survey of Visitor Attractions 1995", Belfast: NI Tourist Board.

Policy Studies Institute (1989), *Cultural Trends*, London, January and December.

Wilson, A. (1995), *A Time for Change: A review of Major Museums in Northern Ireland*, Belfast: Department of Education.

7

MUSIC NETWORK: A CASE STUDY IN THE MANAGEMENT OF ORGANISATIONAL CHANGE

Catherine Breathnach and Niall Doyle

Music Network — an organisation working at national level to develop music in Ireland — was established in 1986 and almost wound up in 1991. A successful turnaround has been achieved and the organisation is currently on a very strong growth path.

This chapter provides an overview of this substantial organisational change process. In particular, we seek to highlight the impact of alternative managerial approaches on the development of an Irish arts organisation and the achievement of its brief. There is a focus on strategic management issues and a strategic management framework. We also indicate the effect of national arts management policies and structures on Music Network's development.

A case study approach has been adopted as we feel it will give the clearest practical illustration of the issues involved. This entails giving a background description of the situation until 1992, identification of the issues which emerged and a description under a number of headings of the strategy and actions implemented by Music Network in the subsequent period.

HISTORICAL BACKGROUND

Music Network was established in 1986, following an Arts Council initiative, as an independent organisation with the brief "to develop music in the regions". This reflected a hands-off Arts Council policy and was introduced against a background of generally poor arts provision in the areas outside of Dublin and the voluntary base of most arts activity in Ireland.

1986–1991

In its first period of development, Music Network concentrated exclusively on providing a concert touring service of high quality (mainly classical and traditional music) concerts to an emerging network of local authority Arts Officers and professionally managed arts venues around Ireland. These tours were managed and marketed nationally by Music Network and a comprehensive publicity package was made available to local promoters for local publicity and marketing.

The entire package was subsidised from Music Network funds to bring the cost within reach of promoters with a small audience and income base. The intention was that, over time, higher levels of organisational and financial independence would be reached as audiences grew. Levels of direct subsidy largely remained around 80 per cent.

During this period Music Network enabled 18 regional promoters in 12 counties to bring live, high quality, professional classical and traditional music to areas and audiences who would not otherwise have had the opportunity.

From its inception to 1992 the organisation employed one full-time staff member. By 1991 it had an annual budget of £90,160. Its annual grant from the Arts Council was £71,450 (79 per cent), the remainder of its income coming largely from programme sources. It was located in a single rented office. Music Network had been established as an association but was incorporated as a company limited by guarantee in 1991, with a voluntary board of five directors.

An external review of Music Network was carried out by the new Arts Council in 1991. This seriously questioned the cost effectiveness of the organisation; the level of financial and organisational dependence on Music Network that had been created among the existing client promoters; and the lack of comprehensive regional spread in service provision.

Having actively considered winding up Music Network, the Arts Council decided to continue providing financial support to the organisation for a further year in order to enable it to address the issues raised and to undertake major organisational change.

1992–1994/95

At the beginning of this period a new Chief Executive was appointed. In addition to the ongoing administration of the organi-

sation, his primary task was to undertake an internal organisational review with particular reference to Music Network's founding brief.

The review needed to elaborate a vision of musically developed regions (what should they be?) and a clear view of Music Network's role/mission in achieving this vision. From this would flow a long-term strategy for Music Network.

In order to achieve an explicit articulation of Music Network policy for the development of music in the regions, the organisation decided to consult as widely as possible. Almost 500 organisations and individuals working at national, regional and local level in music, the arts and more general regional and community development were asked for their views.

The resultant policy was agreed in 1993 by the Board of Music Network and was published in early 1994. The policy objectives were grouped under six programme headings:

• Access and independent regional promotion

• Access and education

• Partner development

• Irish composers, music and musicians

• Advocacy and publicity

• Resourcing.

These objectives provided an agenda and framework for the future of Music Network.

At Present (1996)

Today Music Network undertakes a wide range of activities:

Local Development. An area-based, ground-up, long-term, rolling development strategy, "Music County 2000", is in operation in two counties, with a further three in preparation. This is the primary and contextualising strategy for all music development at local level. It is designed to provide planned, integrated, locally-owned partnership development of all aspects of music access and participation.

An expanded concert promoter network now involves a large number of local voluntary groups and also includes organisations

in the greater Dublin area. There are currently 44 regional partner concert promoters in 22 counties (in the Republic of Ireland). At the same time direct levels of subsidy to concert promoter partners are highly variable and now range between zero and a maximum of 60 per cent.

Live Music Services. An expanded concert touring service and a new "Musicwide" performance scheme for young Irish professional musicians has been introduced. Between them, these provided around 175 concerts in 1996 both in the south and north of Ireland, the latter in conjunction with the Arts Council of Northern Ireland. The service now includes jazz, improvised and occasionally world music as well as classical, contemporary and traditional genres.

In addition, Music Network has developed an exchange scheme with European countries by which Irish musicians are given performing opportunities abroad in return for foreign musicians touring Ireland. The contemporary Irish music policy provides for the inclusion of a contemporary Irish work in most performances. In co-operation with the Contemporary Music Centre, Irish composers introduce their new work to audiences at concerts to maximise the accessibility of the music.

Information and networking services. A national music information service has been instituted for promoters, musicians and the general public. All of the information initiatives are computer databased and are available as a telephone and postal service and/or in the form of published directories. They include the Irish Music Handbook, the first comprehensive Irish Music Guide containing information on music organisations and infrastructure, promoters and musicians, promotion venues, festivals, music schools, competitions, bursaries, retail and manufacturing etc. in the north and south of Ireland.

At a local level as part of the regional development programme, music databases and directories are being produced. These give very detailed information on all amateur and professional music activity and services in different localities.

At the same time Music Network facilitates structured north and south networking of all music promoters to encourage inter-promoter co-operation, particularly cross-border. An annual Promoter Forum for all Irish music promoters is organised; informa-

tion on all promoter plans is gathered and distributed up to two years in advance and Music Network acts generally as a clearing broker for inter-promoter touring projects.

Public Relations and Publicity. Music Network provides a range of publicity and public relations initiatives including a free quarterly newsletter, *Musiclinks* with a circulation of 18,000.

Other Activities. The organisation sees its remit as including practical support for other music organisations with an interest in the development of music provision, and in addition, a number of education initiatives for adults and children are being developed and implemented. These have the specific objectives of providing positive and friendly early experience of different music types and breaking down the traditional perception barriers to access and participation. Advocacy and lobbying in the areas of general music, arts and education policies is becoming an increasingly important area of work.

Staffing. Music Network now employs eight staff members: Chief Executive, Performance Programme Manager and Assistant, Information and PR Manager and Assistant, Regional Development Manager and Assistant and an Administrative Assistant. It is likely that additional staff will be employed in the areas of strategic management and regional development in the near future. Music Network's voluntary board of directors has expanded to nine members.

Finance. Music Network's 1996 budget was £471,258. Its 1996 Arts Council grant was £200,000 (44 per cent of its total income). Its remaining income comes from a significant three-year corporate sponsorship from the ESB (Ireland's Electricity Supply Board); expanded programme income, primarily from the performance programmes; and a variety of other funding sources including the Irish Music Rights Organisation, the Office of Public Works at Dublin Castle and foreign cultural missions in Ireland. The President of Ireland has become the patron of the organisation which now has charitable status and is approved as a body under section 32 of the 1984 Finance Act. (Charitable donations are tax deductible.)

STRATEGIC CONCERNS

Criticisms of Music Network

In 1992 Music Network faced a number of important strategic issues which would impact on its future survival and development potential. At the time there were three main sources of criticism: the Arts Council (the organisation's founding body and primary funding source), the broader music community and the organisation's own internal review (1992).

The Arts Council. The Arts Council questioned the cost-effectiveness of the organisation, feeling that after almost six years Music Network was not producing an adequate level of concert tours and performances from the budget and grant-aid available and that the Arts Council grant represented too high a percentage of the total budget. The original concept of "rolling" development support for partner concert promoters was not evident. Levels of financial subsidy were largely unchanged and remained very high. Music Network had not enabled the development of local promoters to an extent where they were more financially independent, particularly in respect of audience size. This meant that Music Network's ability to take on new partner promoters was severely limited. Finally, although Music Network had a national brief, at the end of five years it had functioning relationships with only 12 organisations in nine out of a possible 26 counties. Some of these organisations were in relatively well-serviced large urban centres. Some organisations it had supported ceased activity during this period.

The Broader Music Community. There was dissatisfaction with the role and performance of Music Network among the broader music community, particularly in a large and growing number of voluntary music and arts organisations. These had remained unserved and in some cases felt alienated by Music Network. In a particularly strict interpretation of "professionalisation", the organisation had adopted the approach of working only with paid arts professionals at local level. (None of these had an exclusively musical brief and in some cases music would have been a low priority.) Musicians and composers were also critical of the impact of the subsidised touring scheme on performance opportunities for Irish musicians and composers. At best, Music Network

programmes were not seen to be sufficiently beneficial; at worst, they may even have been detrimental to a perilously underdeveloped sector.

Internal Review. Produced in May 1992, this used the Arts Council's criticisms of the organisation as a starting point but went much further in developing a critical perspective on all aspects of the operation, structure and role of Music Network. The fundamental problem was a lack of explicit policy defining the aims and objectives of the organisation. This had caused difficulties in external relationships as well as operational and decision-making problems. There was no development strategy with clear, measurable action plans.

The policy which one could discern from the operation of Music Network was flawed: its narrow approach was indicative of an incomplete underlying analysis of the problems of regional music development. The implicit rather than explicit nature of policy made the internal measurement of performance weak and inhibited debate on the underlying assumptions of the organisation, thus rendering the analysis of the problems associated with music development in Ireland superficial and unchallenged.

Music Network's broad brief to develop music in the regions had become a narrow programme of activity of live concert tour provision. The approach and services provided by Music Network were determined by the requests of a small number of professional regional arts officers and general arts venues. Their response to consultation was a desire to have inexpensive concerts of high quality and to reduce risk against losses given their limited audience base and programme budgets. This resulted in a small number of clients (with poor and largely static audience numbers) with a highly subsidised small-scale concert touring programme.

Music Network had not reflected on the local development process in any explicit or defined way. Its manner of operation, however, implied an unconsidered belief in trickle-down development. The core problem was perceived as the availability, image and marketing of music performance product at local level. This approach did not consider issues of access related to social attitudes and perceptions, education, or local means of delivery and ownership. It was completely performance/product-focused.

Feedback was gathered from client promoters and their audiences on the product provided. As this consultation process only spoke to those already involved, any expansion of the organisation's thinking or agenda was inhibited, thus perpetuating the principal weaknesses of the organisation.

There was no communication with client promoters about the broader music development agenda or the finite duration of concert subsidies. This resulted in highly dependent relationships between the client promoters and Music Network. While there were some notable exceptions who through their own initiative managed to build audience numbers, there was no inbuilt incentive, timetable or mechanism to address issues of growing independence or broader music development.

Music Network had little communication with the voluntary music and arts sector. Their exclusion from the concert touring network resulted in their alienation and their active lobbying of the Arts Council and others for substantial change of the organisation. Music Network's relationship with the Arts Council, though initially very good, had deteriorated to crisis point in 1991. The Arts Council and the voluntary sector were the natural support base of Music Network, but this support had been eroded to a very dangerous extent.

There was a general lack of public awareness of the organisation. Music Network had little communication with non-music/ non-arts organisations. The narrow and underdeveloped public profile of the organisation made it extremely difficult to attract significant additional funding, for example from the corporate sector. It also made potential synergies with non-arts sectors highly unlikely.

Based on this analysis, the review posed a series of strategic questions which Music Network would have to answer if it was to survive and grow in the future. It needed to address the main development needs of and obstacles to the development of a local musical life throughout Ireland. In this endeavour, it had to determine who it should support as well as where and how. The intervention of Music Network in the musical life of Ireland has the potential to impact either negatively or positively. How should the organisation maximise the positive effects of its intervention? Finally, what resources would Music Network need to do this job and how could they be sourced?

A STRATEGIC FRAMEWORK

Music Network then undertook the preparation of an explicit policy. This would provide an organisational philosophy based on a comprehensive analysis of the issues in music development, principles of operation and a framework for strategy — the cornerstone for the future development of Music Network.

Vision/Mission Statement

The mission statement contained in the policy document outlined the new underlying analysis on which the organisation was to build. It interpreted the founding brief around three axioms:

- **Music**: the organisation seeks to develop maximum public access to the widest possible range of high-quality musical experience at local level

- **The Regions**: the organisation seeks to work in all those parts of Ireland where access to a broad range of musical experiences can be said to be inadequate (effectively all parts of Ireland)

- **Development**: the organisation seeks to carry out its development brief by supporting the establishment and ongoing work of broadly based local organisations and structures dedicated to a planned, long-term, integrated and inclusive approach to local music development.

The policy adopted a systems perspective which took account of the complex interrelationships in the regional music development process. Having defined clearly the understanding of the organisation's brief in practical terms, it laid down operating principles and set out distinct programme areas expressed as action plans with measurable targets, to enable the achievement of aims. In this way the policy provided a guide to internal organisational decision-making, planning and evaluation in the long term; communicated to and clarified for "outsiders" the purpose of the organisation; and built on the consultation and analysis which had taken place.

Planning and Evaluation

Organisational development required a change in the type and range of information sources feeding into Music Network's planning and evaluation mechanisms. Extensive consultation resulted

in a redefinition of the organisation (mission statement), a much expanded programme of activity, a much larger client base and a new approach to local music development.

In the ongoing situation this has delivered a broader range of feedback sources contributing to planning and evaluation processes, enhancing effectiveness as well as keeping the organisation in tune with external developments and emerging needs. Music Network also seeks to gain quantitative feedback on its activities where possible. This ensures the practicality and accuracy of the planning and evaluation processes.

Such information is gathered by a variety of methods including informal contacts/meetings with local partner organisations; statistical performance programme returns; surveys of use of organisation services; regional promoter seminars; and an annual national promoter forum.

The evaluation and planning processes are completely integrated. A twice yearly review of activity in each area is carried out. The evaluation of all programme areas is then drawn together. The composite picture is considered in terms of the long-term vision of the organisation. The specific targets of each area for three years, two years, 18 months, one year and quarterly for the current year are also reviewed and amended as required. The closer the target dates the more measurable and specific the targets are made. In this process particular consideration is given to issues of resourcing, practicality, the overlap/impact on other programme areas and effective overall timetabling.

This approach aims to allow the constant and controlled evolution of the organisation's activity in response to change in the organisation's environment. Weekly staff meetings involving all staff provide an opportunity for ongoing monitoring of activity and difficulties as well as effective internal communication.

The primary difficulty in this process is its prioritisation in the context of day-to-day management, given the small staff. In addition, since many of the programme areas are breaking new ground, planning is somewhat inhibited by the lack of precedents to guide the formulation of targets. The mismatch of the planning

time scale of a development organisation and the annual State/Arts Council grant aid cycle adds greatly to the complexity of the situation.

Communications

Information Gathering/Feedback. As identified earlier, a key task in the change process was the extension of the range of feedback sources available to Music Network. This was begun immediately, as part of the 1992 policy development process and involved the creation and maintenance of an extensive database of organisations and individuals who had a national/regional interest in music and/or the general development of communities. A systematic approach facilitated written and/or oral submissions on the role of Music Network and related music development issues. Those contacted were encouraged to extend the process to others who might also have an interest. The response was systematically reviewed and a report produced which identified the main issues and concerns which had arisen. Broader consultation mechanisms are a central component of the area development planning processes and were enabled by the computerisation of the organisation in 1992.

External Communications. To guarantee Music Network's survival the immediate priority was to rebuild the organisation's natural support base — the Arts Council and all regional music/arts organisations. Music Network had to reduce the dissatisfaction felt by these and attempt to increase their levels of motivation, identification and sense of shared objectives. The organisation had to build a profile which would reflect a change in its approach. It needed to be seen as a body involved in the development of music at a national level through the support of comprehensive local music development. This involved a shift from a general perception of the organisation as simply a mechanism for providing concert tours. Such a change was essential in order to win support for changes in existing programmes as well as the introduction of a range of new programmes; to make the case for additional funding from a range of sources; and to build synergies with other organisations.

To achieve these changes in the external communications of Music Network, the organisation began a process of close liaison

with the Arts Council and the Arts Council's Music Officer during every stage of the change process. Improvements in the measurable performance of Music Network's existing programmes were documented and communicated to Arts Council members and staff. The regional partner base was immediately extended to include the voluntary sector and, following on the consultation process, a series of targeted meetings/co-operative ventures were organised with strongly disaffected regional music promoters in order to develop positive relations. An annual series of regional promoter forums with partner organisations was introduced, thus increasing opportunities for two way communication. An annual music promoter forum was established in 1993. This provides an opportunity for networking, discussion, feedback and recommendations and has helped to redefine the role of Music Network within a large part of the broader music community. The development of specific policies in contemporary Irish music and the employment of Irish musicians have been communicated both in general terms and in a targeted way to the communities concerned. In addition, the Music Network Board of Directors was expanded to broaden the credibility of the organisation and give access to an extended range of networks in important sectors. A new corporate identity helped to project an image which reflected the "new" organisation along with the appointment of an Information Services/Public Relations Manager as soon as resources allowed. A reasonable budget is now allocated to this programme area. In addition to targeted communications, significant attention is now given to general publicity for Music Network and all of its activities.

Internal Communications. Change in Music Network's internal communications was required as a result of increased staffing, the increased size of the Board and the greater diversity of backgrounds in the staff and board members of the organisation.

A shift was required from a largely informal system concerned with operational detail to a more formal structure with a clearer division of function between policy/strategy and operational matters. A conscious commitment was made to open, participative methods of communication as a means of developing a new organisational culture. A reduced number of Board meetings concentrated on the main policy and strategy matters. Detailed written staff reports on all programme areas are supplied to enable the

Board to have a monitoring function. A smaller management committee meets more regularly as required to consider matters of detail. The introduction of the organisation's evaluation and planning process as detailed above, a staff performance appraisal system, weekly staff meetings and an open-door management style have also contributed to this necessary formalisation of procedures.

Human Resources

Between 1986 and 1991, the Director was the only employee of Music Network. This role combined managerial and all basic administrative functions. Occasionally students on work experience were available to the organisation. Music Network was not computerised. The voluntary Board was initially made up of three members and subsequently expanded to five members. The diverse nature of the role and the detailed focus of the work undertaken by the single staff member affected the quality and development of any one area of work. This was further aggravated by the lack of computerisation of the organisation which resulted in part-time management and expensive administration. Insufficient staff attention could be given to policy and strategy concerns. The role of the Board reflected this. Strategic management could not be undertaken without additional staffing. Staffing had not hitherto been considered a priority area due to the narrow interpretation of the organisation's brief and the basic shortage of core resources. This was a policy issue which maintained a vicious circle.

The immediate computerisation of the organisation allowed more time for "reflective space", organisational review and strategic planning. A strategic management function was incorporated into the role of the Chief Executive, requiring a focus on staffing and resourcing as long-term priority areas. Also there was a need to employ additional, high quality staff to enable more work area specialisation, programme/work development and improved organisational efficiency and effectiveness.

A number of limiting forces hindered the achievement of the required changes. There was a mismatch between the incremental approach to grant-aid increase and the strategic planning/funding requirements of a development organisation like the "new" Music Network. Furthermore, the six-year-old image of Music Network as a "one-man band" supplying a single product service was difficult to change. A diminishing but persistent

culture still existed among poorly funded organisations and their funders that resources should be spent directly on programme areas only. The accepted ethos could be described as one of "shoestrings, sacrifices, short termism and stress".

In late 1992 a recent graduate was employed under a government employment scheme following a brief period of work experience. A third member was similarly employed in 1993. These were initially employed as administrative staff and subsequently as managers of the growing performance programmes and the information/public relations programmes. In 1995 three new staff members were employed. Two recent graduates were employed (initially through government training grant support) as dedicated assistants to the performance and information/public relations areas. The third, an experienced development worker, was employed as the Regional Development Manager. The resources for this position came directly from the organisation's increased budget. In 1994/95 the role of the Chief Executive shifted towards strategic management, external relations, artistic direction, human resource management, financial management and, in particular, the sourcing of additional resources. From 1997 onwards, the plan is to employ further support staff in strategic management, regional development and fundraising.

Human Resources Management Policy. The evolution of Music Network's human resource management policy and approach has been shaped by the underlying values and organisational culture of Music Network, the quality of the people employed and their high levels of intrinsic motivation and the constraints on the organisation.

In terms of recruitment and selection, there is a strong value system underlying the operation of the organisation and informing its culture. This places a high priority on human values (i.e. to treat people with proper respect whether internal to the organisation or external — see sections on internal communication and remuneration, reward and support). The type of employees sought are of high calibre and potential management quality — with and without experience. The nature of Music Network and its stage of development (rapid growth) requires a management style which locates decision-making as "locally" as possible. It seeks to pool ideas and bring as many minds as possible to bear

on organisational problems. Music Network staff therefore need to be creative, responsible initiative-takers. Staff must be highly committed to the organisation and to the achievement of its aims. Employees must be able to work as a team and be capable of self-management. The organisation's recruitment and selection processes aim to involve other members of staff in order to develop awareness of the issues and difficulties involved; to develop a sense of joint ownership and "team"; and to develop the skills of the organisation's staff.

Within this process it is considered important to involve staff with external expertise. This is to avoid the domination of a narrow internal perspective within the organisation due to the lack of alternative views being included in discussions and decision-making. Such "groupthink" would reduce the organisation's capacity to innovate and be objective.

Staff training and development occurs both formally and informally. New staff are "placed" in close working situations/relations with experienced staff to aid their induction into the organisation. Staff are encouraged to take responsibility. Mistakes are used as opportunities for review and as "learning experiences", avoiding the development of a risk-averse culture of fear, and encouraging innovation, initiative and openness. (Indeed this happens almost automatically as a result of the type of people employed.)

Inexperienced staff spend periods working in all programme areas. This develops familiarity with the organisation, its needs and issues and linkages of programme areas. It also creates a "flexible" staff in terms of reallocation of responsibilities. It enables the identification of strengths and preferences in relation to different areas of work (thus facilitating career development). It also aids the development of a cross-disciplinary approach to organisational issues and the integration of the work of the organisation.

To date performance appraisal of staff has been based on the individual work areas. This process is currently in transition and is under review as a team is being developed within most programme areas. Performance appraisal is an integral part of the general planning and evaluation cycle of the organisation. It results in the identification of specific and individual staff training and development needs which are subsequently provided in-house or using external resources. Mentoring is also used by the

organisation (both formally and informally) using internal and external mentors.

Since there are severe limitations on the financial resources of the organisation, the area of remuneration and reward has required some degree of creativity. The management style of the organisation aims to be supportive and developmental rather than monitoring. Music Network believes that it must invest in the proper payment of its staff in order to keep its quality, trained personnel and to maintain and reward high levels of motivation. The organisation is also conscious of the need to provide career development opportunities. This means that roles are redesigned and expanded to meet skills and personal development needs, and internal mobility is encouraged. The role and work of individual staff members is acknowledged internally and publicly whenever possible as a matter of organisational policy. The titles given to all staff seek to reflect the high levels of ability, initiative and managerial skills built into all roles. There is a high degree of consciousness of this aspect due both to the larger proportion of young women employed and the prevalence of sexism and ageism often experienced by this group in their dealings with the "outside world". A positive work environment is seen as important. Regular opportunities which are semi-social are sought to develop this, for example staff meetings, organisational reviews, training, the annual Board dinner etc. In addition the organisation seeks to provide a healthy and comfortable work space. Music Network's offices are based in Dublin Castle.

Gender consciousness is an issue for staffing in the organisation because it is felt that organisational efficiency/effectiveness is best achieved through the optimum balance of a wide range of personal styles and backgrounds in the staff. There is also a need for the creation of balance in the organisation in order to avoid projecting an image of a male-led/female-staffed hierarchical organisation. This last point has become a particular issue for Music Network since at each stage of recruitment of new staff to the organisation all newly appointed members have been female. This is in spite of an intention to maintain gender balance on the staff. At all times the deciding principle of the best person for the job has resulted in the current gender imbalance. Currently the Chief Executive is the only male member of staff (1996). The gender balance of the Board is five women and four men. The current Chairperson of the Board is a woman.

Finance

1986–91. The early financial structure of the organisation was very simple. Originally it had two sources of income: Arts Council grant-aid and fee income from its subsidised concert touring programme. During the first five years some small additional but irregular income was sourced from other funding bodies and occasional commercial sponsorship. The spending of the organisation consisted of a single staff salary with small administrative overheads while the remainder of the budget was spent on the concert touring programme. Within this major expenditure area a particularly high percentage was spent on the design and production of publicity material.

The average annual budget for the five-year period 1987–91 (compared with 1996) is shown in Table 7.1.

TABLE 7.1: AVERAGED BREAKDOWN OF ANNUAL BUDGETS 1987–91 COMPARED WITH 1996

	Averages 1987–91	*1996 Comparison*
Annual budget	£86,005	£471,258
of which:		
Arts Council Grant	£64,750 (75%)	£200,000 (42%)
Programme income	£14,075 (16%)	£107,780 (23%)
Other funding	£300 (0%)	£33,878 (7%)
Commercial sponsorship	£2,600 (3%)	£113,100 (24%)
Borrowing/deficit funding	£4,280 (5%)	£16,500 (4%)

The Problems. Above all the principle financial problem was an enormous shortage of resources. The annual budget was completely inadequate for an organisation with such a broad national brief. There was also a lack of diversity of income sources: too many eggs in one basket. The particularly heavy reliance on Arts Council funding had its own specific difficulties:

- The traditional incremental nature of Arts Council funding increases meant that significant increases required were unlikely in the short term.

- This was likely to be exacerbated by a traditional weakness of music in overall Arts Council funding.

- By far the biggest difficulty in relation to this is the Council's funding cycle — annual grant aid decisions generally made in the course of the year concerned. This makes anything except short-term planning extremely difficult. Planning substantial growth and change becomes virtually impossible. This problem is compounded even further in Music Network's case by the normal planning cycle of professional performance programmes. Financial commitments are made between eighteen months and two years in advance. Since this area represents such a large amount of Music Network spending the difficulties are obvious.

Apart from state funding, fee income from the performance service was very small and was largely static in real terms. Rates of subsidy were very high, showed little sign of decrease and there was no explicit agenda for reduction with individual local organisations. The slow growth and low levels of touring activity produced very little increase in income and attempts at other funding were on a small scale and produced irregular funding. There was no clear strategy to build in regular programme funding from these sources.

Of the ongoing attempts to source corporate sponsorship, those which were successful were small scale. They provided some sponsorship in kind but were once-off. No long-term relationships were built with sponsors. The most financially productive sponsorship achieved was for a rock music promotion project. This was a controversial and previously untouched area of activity for the organisation and seems to have been a practical failure with no long term benefits. It was a sponsor-led rather than a Music Network-led initiative and was not congruent with the organisation's strategic role.

While there had been one attempt to take a more strategic approach in partnership with a PR agency, this did not produce any results in the short term and was abandoned. This exception apart, the approach to sponsorship seems to have been short term, project by project, with little evidence of a more long-term approach to acquire ongoing substantial sponsorship.

Many aspects of the organisation were therefore run on a shoestring — this perhaps was indicative of the prevalent arts organisation culture at the time and was both unproductive and inefficient. For example, one staff member doing a huge range of tasks

on senior salary meant that staffing costs for routine tasks were very high and time for managerial tasks very limited. In contrast, the focus on product image resulted in a very large percentage of scarce resources being spent on the design and production of printed publicity material (16 per cent of total budget in 1991). Charitable status or section 32 status (1984 Finance Act) had not been acquired to facilitate other fund raising.

Changes Required. The organisation review identified the need for a massive and rapid growth in resources; maximisation of existing income sources; and the establishment of new, sustainable income streams. To achieve these aims, priorities had to be on securing the largest amounts of sustainable, ongoing funding. A clear, target-led resourcing strategy was required. Substantial skilled staff time and resources had to be dedicated to securing resources and the performance, corporate image and reputation of the organisation had to be improved in order to make Music Network more fundable and sponsorable. In the short term there were no extra resources available to address these urgent requirements. Resources had to be found from within existing budgets which were already largely committed.

1992: Survival. Nineteen ninety-two was concerned with maximising the efficiency of the existing programme in order to produce more activity in more places. This was primarily geared to ensuring ongoing and increased Arts Council funding for the "new" organisation. The flexibility to do this within the constraints named above was achieved by restructuring the printing/design budget, cutting it by approximately half and initiating a process of reduction of subsidy levels to partner organisations. An outline resourcing strategy for 1993-95 was prepared and agreed by the Board.

1993–95: Laying the Foundations. During 1993–95, the drive to dramatically increase the range and level of Music Network's activities continued. Attention was focused on increasing funding from existing sources. This began with the Arts Council which was asked to fund medium-term plans and staffing with a later "add-on value". The net unit cost of existing programmes was reduced by a combination of cost savings and increases in programme income due to reductions in subsidy levels. Other fund-

ing sources were also targeted and growth achieved: support from the Irish Music Rights Organisation, various cultural institutes and support in kind from the Office of Public Works in the form of office accommodation were all valuable. The corporate image of the organisation was addressed and a corporate sponsorship strategy with the aim of producing sponsorship income from 1996 onwards was devised. The expansion of the board enabled the more effective targeting and accessing of potential corporate sponsors as well as improving the corporate image of the organisation. Charitable status and section 32 approval were both secured. Finally outline strategies for increases in income from 1996/97 onwards were developed.

1996: A Different Plane. The success of the different strategies adopted in the previous three years produced significant results by 1996. Table 7.2 shows an analysis of resourcing growth. The Arts Council's own funding and its funding of Music in Table 7.3 are provided by way of setting the context for developments. The Music Network analysis includes funding and sponsorship in kind. As the table demonstrates, the annual budget of the organisation has increased over 1992 levels by 446 per cent to £471,000 in 1996.

This is now coming from a much greater variety of sources, with a consequent lessening of reliance on any one. The Arts Council's grant has increased to £200,000. This represents an increase of 260 per cent on 1992 levels. In spite of this increase, the proportion of budget represented by Council funding has decreased from 76 per cent to 42 per cent during the same period. Programme income has increased with service levels and funding from other sources has increased significantly. In addition to those previously mentioned, the Arts Council of Northern Ireland has also become an important funder.

The corporate sponsorship strategy has been particularly successful. The ESB (Electricity Supply Board) had become Music Network's sole corporate sponsor for the period 1996–98. The amount of money involved is very significant for Music Network and is one of the largest ever Irish arts sponsorships. The size and medium-term nature of the sponsorship has partially reduced the difficulties created by Arts Council annual funding structures.

Table 7.2: Music Network Resourcing, 1987–96 (in IR£)

	1987	1988	1989	1990	1991	1992	1993	1994	1995	1996
Annual budget	64,614	86,945	79,949	100,960	97,559	103,575	140,115	182,800	285,543	471,258
Of which:										
Arts Council Grant	53,400	61,500	65,900	71,500	71,450	78,750	88,000	94,500	130,000	200,000
Arts Co. Grant as %	83%	71%	82%	71%	73%	76%	63%	52%	46%	42%
Other funding	0	0	0	0	1,500	6,500	5,200	16,000	38,677	33,878
Programme income	11,214	12,445	14,049	15,460	17,209	18,325	36,115	43,000	48,866	107,780
Sponsorship*	0	13,000	0	0	0	0	10,800	16,400	33,000	113,100
Deficit funding	—	—	—	14,000	7,400	—	—	12,900	35,000	16,500

* Includes support-in-kind

Table 7.3: Arts Council Resourcing of Music, 1987–96 (in IR£)

	1987	1988	1989	1990	1991	1992	1993	1994	1995	1996
Council Budget (millions)	6.4	6.5	6.8	9.5	10.0	10.2	11.6	13.2	16.3	18.4
Overall music allocation	307,000	486,528	494,815	596,000	733,000	693,000	683,000	767,000	1,276,000	1,443,000
Music allocation as %	4.8%	7.5%	7.3%	6.3%	7.4%	6.8%	5.9%	5.8%	7.8%	7.8%

Music Network seeks to operate with maximum efficiency and effectiveness in all programme areas. At the same time a considerable proportion of resources is invested in activities which will produce medium- and long-term results. This is particularly the case in resourcing growth. Substantial growth requires investment for up to two years in advance of the income coming on stream.

CONCLUSION

It can be suggested that the survival and development of Music Network has been achieved through a management approach which has had two main underlying principles: one based around envisioning and another around evaluation and evolution. In both of these widespread and ongoing consultation has been in-built.

First the organisation needed to have a clear and comprehensive understanding of the deficit which it was established to address. It has also developed a coherent vision of the desired end result. Finally it has established a better understanding of the role of the organisation. This insight has been based on wide consultation and the use of multiple information sources. It forms the basis of the explicit mission statement and policy framework of the organisation and the foundation for planning, action and evaluation by the organisation.

Of particular importance are ongoing, two-way communication/feedback/evaluation mechanisms with the "outside" world. These have ensured the environmental sensitivity of the organisation and its ability to respond to external change. In turn they have fed into the development of coherent, clear plans with measurable objectives and have also helped to build support for the organisation in a wide range of important constituencies.

Particular management emphasis has been placed on investment in human resources and in information technology. The development of clear, measurable medium- and long-term financial strategies also underlies all plans and has been of central importance.

Outstanding Issues

While there has been a successful turnaround of the organisation in the period 1992–96, there are a number of significant internal and external issues confronting Music Network as it faces into the future.

Music Network, having reached a significantly different organ-isational plane within the last year needs now to reinvent itself again, as it did in 1992. This will require a period of evaluation to ensure that the emerging new structures and activities are the op-timum ones to meet Music Network's brief. This process will re-quire considerable consultation and objective reflection. Making space for this in an environment of rapid expansion and change must be a priority.

While resourcing has been greatly improved, the current level of resources available to Music Network is still dramatically short of what is required to enable the organisation to carry out the brief it was allocated by the Arts Council. The gap between the vision of musically developed regions and the current reality in most parts of Ireland, while shrinking, remains very large.

The skilled human and organisational resources required to fill this gap can be provided by the Music Network development model of local organisations working in a planned, partnership framework being supported and serviced by Music Network and other agencies. However, the financial resources are currently not available to meet the overall national need.

It seems logical that the development of music access for local populations should be funded primarily from local sources. This is certainly the model Music Network would prefer. Currently, government in Ireland is highly centralised with negligible local funds available for anything but basic services. It seems inevitable (but not necessarily imminent) that this must change and when it does, the resourcing issue will need to be concentrated at local level by local organisations. In the interim the emphasis for Music Network remains at national level with Government and the Arts Council.

EPILOGUE

Looking back on the five-year change process that has trans-formed Music Network, there are a number of matters worth noting.

While the change process identified widespread weaknesses in the early organisation, these were at least partly environmental, reflecting both the newness of the organisation and what might be termed the managerial culture in the arts at the time. All em-bryonic organisations take some time to settle and establish

direction. As an offshoot of the Arts Council, Music Network was initially very dependent. Its national music development brief was not reflected in its core grant and no one-person organisation could possibly address this issue.

The culture of the time required that scarce resources should be seen to be directed at immediately visible product and results with a profound distrust of "administration" costs. This combined with the annual funding mechanism positively discouraged a strategic long-term planning approach, rendering organisational development very difficult.

The importance of a securely based policy and careful development planning is apparent from the case history. Initial survival depended on making the existing model more efficient. Risks, though necessary, were calculated. The very rapid growth which followed was vital to achieve the critical mass and economies of scale to address development issues fully.

The attraction of investment resources was key to this growth stage. Against the odds, it was decided to build the organisation before the necessary funding was secure. This was seen as the only way to break the Catch 22 dilemma: funders needed to be convinced by results while results needed funds! A leap of faith was required, though one which was based on the organisation's own confidence in the quality and solidity of its analysis and plans. Initially the organisation made the investment itself, using significant deficit funding in 1994 and 1995 to ensure a large increase in its annual budget by 1996.

These stages were safely negotiated through a soundly planned approach which involved widespread consultation, long-term strategic planning, clearly focused short-term planning and structured management practices. The preparedness to act in an entrepreneurial fashion at critical times was an added requirement. In the dynamic evolution of an arts organisation, the frameworks provided by this strategic approach furnished secure points of reference in a sea of unpredictability, while at the operational level, the more short-term plans drew clear route maps to reach the various staging points on the way to long-term goals. Contrary to popular belief, such a structure enables flexibility, not rigidity and ultimately reduces the risk of making bad decisions under pressure.

Good technique in itself does not make a good artist; however, it enables the release of the artist's creativity. Good arts manage-

ment is a process of creative problem solving. Policy, planning and management technique will not necessarily improve the creativity of management solutions but it will certainly ensure that creative solutions can be made to work.

PART THREE

MARKETING IN THE CULTURAL SECTOR

MARKETING THE ARTS: FROM PARADIGM TO PLAN

Paul O'Sullivan

WHAT KIND OF MARKETING?

At the outset a myth may be laid to rest or at least temporarily disabled. The myth is a potent and pervasive grandchild of Romanticism and it insists that the worlds of the Arts and of Commerce are not just mutually exclusive domains, but rather are forces in fundamental opposition, generating tension in the life of the individual as well as in the life of society.

Take the case of Joyce, the giant of Modernism, representing in many respects the quintessential figure of twentieth-century man. A wanderer across the darkening European landscape of the 1920s and 1930s, his life and consciousness, just as much as his art, represent something of the fractured world inhabited by the post-war generation.

When Joyce created a new style of hero for his less than heroic age, his diffident Everyman would be an early exemplar of an emerging profession. Bloom is one of the first advertising men in fiction, harbinger of a trade which has had a pervasive influence on the social reality of the unfolding century.

It comes as no surprise then that the artist should have taken an interest in the emerging technology of cinema. He who set himself to forge the conscience of his race also took it on himself to forge a modest future as an entrepreneur. His adventures as a businessman back in Dublin in 1909, as partner and proprietor in the Volta cinema, were less than successful. Had it been otherwise we can never guess what fortune and an access to cinema might have made of Joyce. Ultimately, ". . . he wasn't able for the electricians. They ran rings around him". His practical organisational skills clearly were not up to his talent as a market trend spotter,

but it is clear that his fetch on modernity encompassed not just his writing and his interest in cinema but also perhaps a more general appetite for the market place — exemplified also by his early attempts to import Irish tweeds to Trieste as Costello (1992) has described.

The somewhat predictable outcome of his commercial adventures does tend to reinforce the stereotype of the creative and the marketing impulses as polar opposites. Perhaps the chronically improvident Joyce was always destined to be an unlikely candidate for marketing success but he is in fact only one in a long line of creative artists — writers in particular — for whom the commercial and creative instincts seemed to be dual expressions of a common life force.

Ian Watt, in *The Rise of the Novel*, shrewdly observed that the comforting click of the cash register provided a contrapuntal harmony in the fiction of Defoe and Fielding, and it is true that the business side of publishing has held a fatal allure for many authors — Scott and Balzac spring immediately to mind. More surprisingly, Anthony Cronin (1996) in his biography of Beckett, offers a tantalising glimpse of the austere sage as a young man seeking a job as an advertising copywriter.

And if the novel as a form rose partly on the back of capitalism it is not unique in that respect. All of the collaborative arts — where a mix of skills and talents must be marshalled and resourced in order to bring a project to artistic realisation quite apart from bringing it to audience attention — are dependent on their relationship with the world of commerce. A troop of medieval players and a twentieth-century film project share a commercial dimension which requires that resources be deployed to meet a market opportunity, however unconscious or informal the process. The Artist need not always be The Loser. The boy from Stratford who earned his first London living holding the heads of horses did after all die an acknowledged commercial success. The Eastern European migrant glove sellers and peddlers who invented Hollywood may not have created an optimal or even a very good system, but they did put in place an infrastructure which moved the cinema from Nickelodeon curiosity to pervasive mass medium in the space of just 15 years.

Having thus praised famous men let us acknowledge that the myth of the fundamental opposition of arts and marketing is

sometimes no more than just that. Somewhat less tractable may be other fallacies whereby marketing is seen as a synonym for publicity and planning is viewed as necessarily bureaucratic and therefore an anathema to the instincts of the artist.

But in the first instance it may be useful to pursue a working definition of marketing and to identify a planning framework within which the various claims of art and commerce might co-exist without undue tension.

The Marketer as "Mixer"

In the traditional view of marketing, the marketer was seen as someone who diagnosed problems and "mixed" ingredients to provide solutions, somewhat in the manner of a television chef. These ingredients were generally considered to be Product (including the notion of service and the augmented product), Price (including payment methods), Place (representing the distribution system for the product and including where and how it may be accessed) and Promotion (including all the marketing communications activity involved in advertising, public relations, sales promotion and selling).

This admittedly crude formulation reduces the complexity of marketing management problems to a matter of "four Ps". Much of the development of marketing theory even as late as the mid-1980s involved the identification and addition of further ingredients which were thought to require individual attention and the suggestion of ways in which they might be incorporated into whatever recipe was currently being assembled. Factors such as the socio-political and regulatory environments might thus be subsumed under convenient umbrella titles such as "Politics", thereby adding a fifth "P" and so on. Though exhibiting a deplorable tendency to abuse language and concept in pursuit of alphabetic symmetry, these formulations did have some utility for students and even for practitioners and served their purpose in the heyday of mass consumer marketing.

However, this general approach does suggest a managerial paradigm where, in effect, marketers "manage" consumers and "do things" to them — and it must be acknowledged that some of these things would today be regarded as wasteful, nasty and unacceptable. In a more service-oriented economy the balance of power might be regarded as having been partly redressed and the primacy of consumers is now an acknowledged reality for the

competing product and service providers who desire their pa-
tronage. Gummesson (1987) has castigated the "service myopia"
of marketers who have been unable and unwilling to see the po-
tential transaction from the consumer's point of view. His views
have gained considerable ground and have formed the basis of
the approach now known as Relationship Marketing.

In the case of the arts there was always a fundamental problem
with the "4 Ps" managerial approach in that the ultimate Product
— and one can sense the reader wince — has a quasi-theological
status. While an arts organisation, a festival or a gallery can com-
fortably be marketed as "Product", the core and essence of the
activity, i.e. the artistic expression, creation or performance sits far
less comfortably in this framework. This suggests that there is a
definite limitation to the repertoire of marketing actions which are
possible. There will be a very different consistency to a "mix"
where three of the ingredients lie in the secular domain and are
open to any manipulation which marketing theorists and practi-
tioners can devise but the fourth ingredient is sacred and some-
how inviolable. It has to expected that there will be very different
tensions between the ingredients in such a mix as compared to the
tensions and balances achieved in conventional product market-
ing.

In a very real sense the arts remain and perhaps need to remain
"production-led" in apparent contradiction to the central tenet of
marketing as a body of theory and a management practice. Per-
haps there is a need to acknowledge here the limits of marketing,
as Hirschman (1983) has argued.

Towards an Alternative Paradigm
That sense of limitation and even of threat has inhibited the up-
take of marketing management approaches amongst the arts
community. The resistance here would seem to go beyond the
general resistance experienced in the non-profit sector, which also
came late to marketing as a management approach. The Arts
Council of Great Britain strategy formulation process (1992) re-
ported the view of arts marketing officers, in organisations receiv-
ing subsidy, that there was a lack of faith in their sector in the ca-
pacity of marketing to deliver solutions.

Others might argue that the solutions available are undesir-
able. They point to the excesses of the heritage industry as typical
of the damage a marketing approach can bring. Worthwhile

projects sit side by side with offensive effusions which offer an affront to the authenticity and integrity of the rural life and values that they purportedly celebrate.

Some individuals working in culturally-grounded areas are beginning to take a less hostile view of the marketing process. At a recent forum *Influencing the Market Place* for *Craft*, Pamela Johnson (1996:64) argued that:

> Marketing is itself a form of cultural practice, in that being a professional craftsperson is about working to shape the world in which you operate . . . it is important for practitioners to identify the terms of reference appropriate to their activities.

Undoubtedly this is a benign view which will be greeted with scepticism by those who demand that art must always insist on its otherness from mammon.

Perhaps some of the difficulty over the past twenty years lies with a style of marketing which has been somewhat insensitively imported from the world of fast moving consumer goods. Jude Kelly, Artistic Director of the West Yorkshire Playhouse, argues with a degree of passion that:

> For a while the vocabulary of arts marketing was redolent with the kind of language you would expect from Littlewoods catalogues. It didn't contain the generosity of the language of art itself. You almost need an "event " culture — a sense that every performance, every encounter with art, is unique and special. But being open 52 weeks of the year means you fall into thinking of it not as one event, even though that is how the customer sees it. There needs to be a phenomenal amount of attention to the personal; but unless you take that attitude as your ideal in all your marketing you are not reflecting the character of what you are talking about. You need to harness the technology, but you must get the balance right. Nobody is saying electricity should never have been invented, but there is a beauty in candlelight (quoted in Hill, O'Sullivan & O'Sullivan, 1995:xiii).

Getting the balance right is in fact the issue. In fairness there has been considerable progress on the marketing side of the problem.

Kotler and Armstrong's definition of marketing as "a social and managerial process by which individuals and groups obtain what they need and want through creating and exchanging products and value with others" (1987:3) provides a formulation which seems to have the scope and flexibility to accommodate

arts related needs from the level of the individual artist to that of a major promotional organisation.

In particular, there is an implicit recognition of the mutuality of need, of the fact that value is exchanged in both directions and that the process is both social and managerial. This is very much in harmony with the relationship marketing approach which may offer a more meaningful and productive paradigm for the marketing of arts. Marketing planning activity might usefully be structured around the relationship approach and directed towards the processes which create, maintain and enhance relationships.

The relationship approach is grounded in a recognition that it makes far more sense to put effort into the retention of customers than to continually seek to capture new customers in a competitive market. Customer retention obviously implies keeping existing purchasers happy and Berry (1993) has advocated a number of what he terms "relationship strategies". These include enhancing the core service, customisation of the approach, augmenting the service wherever possible, pricing on the basis of relationships and concerted internal marketing to one's own staff and organisation as a means of delivering service quality to the customer interacting with them. Many arts organisations have both formally and informally adopted these practices on an ad hoc basis. The relationship marketing approach suggests a concerted, policy-driven adoption of these practices which will imply a change in the way the organisation regards — and behaves towards — the customer. Successful arts organisation as varied as the South Bank Organisation, the Royal Opera and Newcastle's Northern Sinfonia have adopted some or all these approaches with marked degrees of success. Many Irish arts venues have sought to augment the core offering by improving ambience, facilities and communications and some have introduced a degree of relationship pricing.

In an industrial marketing context, Turnbull and Wilson (1989) argue that the establishment of long-term buyer–seller relationships is facilitated through the "creation of structural and social bonds" between the players. It can be argued that the relationship between an arts event or venue, an individual playwright, a theatre or dance company and the audience is potentially characterised by psychological investment, overt affiliation and a degree of loyalty flowing from beyond the footlights. Participation in the arts may represent an important arena for self-actualisation by

audience members and may be seen as a defining aspect of their lifestyles. The willingness of audience members to affiliate psychologically with an arts venue or organisation is frequently not capitalised upon by creating structural bonds between the parties. The means to do so are very much in the hands of the arts marketer as the ability to conduct in-depth identification research on audiences is readily available. Database technology provides the means to store, retrieve and utilise box-office and audience feedback information though there can be a tendency on the part of some organisations to use that information in a very traditional managerial mode, i.e. to target audience members as if they were a part of a lumpen consumer mass no more worthy of care, attention and a real two-way relationship than the purchasers of cans of beans.

If the relationship marketing approach is to be adopted as a strategic option by an arts organisation, it is important that the marketing officer involved bears in mind the kind of qualities that are associated with everyday human relationships — mutuality, emotional investment, trust, concern for the other's long-term interest, giving priority to the other's needs — and endeavour to apply those values in the planning, creation and implementation of effective marketing programmes.

Ultimately there must be a realisation of what marketing can and cannot do. Marketing can build the queues seeking entry to the Turner or Cézanne events. Marketing can bring the world to Galway in mid-July, providing that a festival of quality with a distinctive atmosphere is available to be marketed. Marketing can fill cinema seats, sell subscriptions and finance artistic projects. It can build relationships with loyal patrons and committed sponsors. It can bring the attention of the individual or even the individual himself, to the treasures of Tutankhamun.

But what it cannot do directly is to create any such treasures or even guarantee their preservation.

This is true at the micro level of the individual production. Delgado (1995:48) has observed that the public policy agenda for European theatre must include the need to "protect new work from immediate market demands". Ó hOisín (1991:45) has pointed out that there is a price to be paid for the huge interest which sponsors are now directing toward the creative arts as marketing communication vehicles:

Effectively, sponsors will want input into all aspects of running an
arts event. As well as marketing and publicity, in many cases
sponsors will want an input into decisions on artistic content. This
is because, contrary to the views of many arts administrators,
marketing does not just involve selling what has already been
produced.

It is wise to remember that in the more robust arena of sports
marketing, product and media sponsors have frequently altered
the starting times of events, have insisted that cricket be played
under flood light, and have even attempted to redesign world cup
soccer as a game of four quarters to provide sponsors with further
advertising opportunities.

At the macro level, Joe Durkan (1994:10) has observed in rela-
tion to the economics of the arts in Ireland:

Contemporary arts have the potential to add to the existing stock,
and provide potential benefits to future generations as well as the
existing generation. If it were left to the market to decide, since the
current generation can not, in general, charge future generations
for future benefits, the level and extent of contemporary arts
would be less. Finally, if left to markets, much of what does sur-
vive in the world of the arts might not have survived.

The other side of the equation does deserve expression also. A
playwright, a modern dance promoter or an organiser of a cul-
tural festival will, when confronted with a lack of audience and
highly perishable wares, gladly embrace whatever assistance pro-
fessional marketing can offer. Talent will not necessarily "out" of
its own volition. It is the distinctive competence and the distinc-
tive task of a planned approach by marketers to help nurture and
fulfil the potential of talent by bringing it to its audience.
Achieving the balance between arts and commerce is made con-
siderably easier in the case of the numerous arts organisations
who define their mission and their existence in terms of a particu-
lar audience. Socially-committed groups such as CAFE, TEAM,
and the Passion Machine have defined their own agenda in terms
of what is essentially a target market, a strategy which allows the
full potential of the marketing approach to be employed.

Thus in many areas of artistic endeavour there is an implicit
acceptance that marketing is at the very least a necessary part of
the mix of skills and perhaps even the sine qua non for both the
artistic realisation and the commercial success of the project.

When such marketing is grounded on sound audience definition and systematically planned around relationship building processes the results can be spectacular.

WHAT KIND OF MARKETING PLANNING?

Planning is a recognised approach by managers in order to optimise performance and resource use. A planning process seeks to bring organisation and direction to business decision-making and implementation, and to direct managers towards a clarification of their aims and objectives.

A manager of an arts event, venue or organisation with responsibility for building business through marketing activity will seek to improve general performance by looking at a range of options and alternatives before deciding on one or more of them; then will detail out what needs to be done to make this happen; and given that all of this will be taking place in the real world, will then cost each of the actions within the framework of the available resources.

"This process," according to Malcolm McDonald (1995:20), "can be defined as marketing planning, which is the planned application of marketing resources to achieve marketing objectives". In essence, then, marketing planning "involves the setting of marketing objectives and the formulation of plans for achieving them".

The planning approach has been adopted less widely than one might initially surmise even amongst firms in mainstream goods and services areas. A 1991 study of marketing practice in the Republic of Ireland and Northern Ireland (O'Sullivan et al) found that 39 per cent of the sample in the Republic (100 companies) and 62 per cent of firms in Northern Ireland (100 companies) had no marketing plan. At least half of the "marketing plans" were merely sales plans and many of the plans lacked a significant degree of formality rendering them less useful as strategic guides. Earlier studies in the UK as reported by Greenley (1987) indicated a similar poor showing.

It is not surprising then that Clancy et al (1995:158) found that 82 per cent of the 72 theatre organisations which they surveyed did not have a marketing plan and only 11 per cent had a marketing plan which covered a period of three years or more. The issues covered in the marketing plan "were primarily advertising/ promotion strategy (22 per cent of all organisations), repertoire

strategy (17 per cent) and touring and pricing strategy (14 per cent each)". The absence of real marketing planning raises serious questions given that 72 per cent of the respondents employed a person with specific responsibility for marketing/promotion and/or publicity.

One should, perhaps, therefore have modest expectations of what arts organisations of various types can achieve by way of progress in adopting planning systems. This is especially so given the nature of their work, the types of mission they pursue, and the fact that most of these organisations are minuscule in scale. One might expect some resistance to systematic approaches and an over-reliance on, for instance, flair. Thus it is more likely that promotional opportunism will be employed rather than the more pedestrian planning, scheduling and budgeting of a formal marketing communications campaign. "Planning" might well appear to be a restrictive and rigid process which locks one in to set procedures whereas the arts community may value fluid and immediate responses to contingencies as they arise.

The issue is exemplified by the favoured term for a promoter/manager in the world of the arts. The "impresario" — with its connotations of flamboyance, buccaneering and risk-taking — suggests a world that is unorthodox and larger than life. By way of contrast, the manager-as-planner seems constrained, conservative and uncongenial and the kind of time horizons implied in planning may seem unrealistic in the light of the short-term nature of many projects.

Planning — The Pros
Planning gives a focus or thrust to management activity and the marketing planning process should ensure the clarification and achievement of objectives with the optimum deployment of resources. Decision-making should be immediately improved for a number of reasons.

In the first instance, generation of the widest possible range of relevant options in terms of both strategy and tactics can, in itself, cut down on bad decision-making. The planning process can facilitate the introduction and formal adoption of creative thinking and decision-making tools. Furthermore, the plan will provide both a framework for making choices and criteria for deciding between alternative courses of action. Decision-making will thus be less dependent on ad hoc approaches and there will be a

rational basis for choosing courses of action, whether artistic, market-related or financial.

The planning process also helps to integrate and reconcile objectives at different levels of decision-making. Thus marketing objectives (e.g. to pursue a particular audience, media profile or sponsor) are developed in the context of the strategic objectives and the overall mission of the gallery, festival or theatre company and should be in harmony with it. This helps to tighten thought processes and promotes internal communication.

At an operational level planning will bring a productive level of order and discipline to, for instance, routine meetings and day-to-day decision-making. There are no arts organisations with a surfeit of resources and the planning process is vital to ensure that best use is made of what is actually available. The organisation or event can get real value out of thinking issues through and "measuring twice before cutting once".

Finally, the planning process delivers real benefit by professionalising the organisation's activities, image and interactions. The external world of decision-makers — funding agents, sponsors, venue owners, banks — are all reassured when they experience the kind of apparent rationality, logic and order that people in suits find comforting. They can interact with an arts community along dimensions with which they themselves are already familiar.

And the Cons

There is, however, no merit in planning as an activity in its own right with little connection to real applications in the world of day-to-day problem-solving. In small businesses of all kinds one can find plans mouldering in a filing cabinet or gathering dust on a shelf because they were brought into being by feasibility study grants, the requirements of a funding agent or the availability of subsidised consultancy services. Plans offer no value if they are not organic and dynamic in character — that is, growing out of real need, subject to ongoing review, permeated by the values and mission of the organisation, and guiding fluid decision-making rather than providing rigid prescription. Above all they must be championed by the commitment of the leaders of the arts organisation.

Strategic or Tactical Planning?
There is a general acceptance that the overall plan should be
strategic in character rather than operational or tactical. However,
some managers will wrongly seek to build a strategic plan by ex-
tending and building up a series of tactical plans over a number
of years. Adding a programme and some promotional ideas for
next year to a programme and some promotional ideas that seem
useful for this year does not amount to strategic thinking. It may
be useful to distinguish clearly between the two types of planning
activity.

Put simply, objectives raise major "what?" questions and stra-
tegic thinking seeks to provide the "what?" answers. What mar-
kets? What broad lines of approach? What predictable changes in
the market and what can we do about exploiting them? Strategy
is only concerned with "how" at the broad level of answering
"how do we get there"-type questions. Strategy is concerned with
the medium to longer term and will focus strongly on a situation
review which will encompass the evaluation of environmental
factors and changes; the realistic appraisal of competences and
strengths; and an identification of the critical factors needed for
success.

The time-frame of strategic planning will normally involve
detailed planning on a three-year horizon, with sketching of sce-
narios beyond that for perhaps a further two years.

That is probably as far as the time frame can extend. In a world
where uncertainty is a given, only the truly reckless will seek to
predict the market conditions of the distant future or their own
potential to respond to such conditions at a future time. Any
given external factor may change over that time framework in
ways which are wholly unpredictable. Whereas we may know
that less Americans will travel abroad in the next presidential
election year or that the number of third level students in full-
time education will expand by a given percentage by the year
2000, other possible influences on the arts audience are less pre-
dictable.

Thus Section 35 legislation altered the financing base for film
production dramatically and in a way which could not have been
predicted two years previously. The partial withdrawal of the tax-
break altered the conditions under which a financial package
might be assembled. If one attempts to factor in this change, it be-
comes evident that there is no simple causal relationship between

the policy change and its possible effects. Film-making may in fact, paradoxically, see an increase in activity in the immediate two-year period following the tax change with a particular increase in the activity of indigenous film-makers arising from the project development lead-time of productions and the knock-on effects of improved infrastructure.

Similarly, huge oscillations in interest rates over the last six years have had their impact on the financing required for a variety of projects and the audience-based break-even points required to sustain activities.

A strategic plan will thus seek to track trends and the dynamics that drive them, on a three-to-five year time-frame, with a degree of confidence but can do little meaningful beyond that.

Tactical Planning

Tactical plans will be operational in character, will seek to detail out actions over the next twelve months and perhaps the two succeeding years and will seek to answer in a detailed way the "how?" questions which are posed by the strategic decisions. Tactics belong to a world of much greater certainty and, provided the strategic thinking has been rigorous, creative and thorough, tactical decisions will tend to fall relatively easily into place.

THE MARKETING PLANNING PROCESS

If planning can deliver on even some of the benefits indicated above, then a sensitive and realistic application of the process should produce measurable results for an arts organisation. The marketing planning process has been documented by a range of authors and McDonald has been responsible for more iterations of, and variations on, the main theme than most other commentators on this side of the Atlantic. He states that "conceptually the process is very simple" and is universally agreed by the experts (1995:20).

The process is diagramatically represented in Figure 8.1 where the blocks of activity do represent fairly well-defined steps. The dotted lines suggest the interdependence of the steps in the way they fluidly influence one another as well as the need to continually revisit and modify earlier assumptions and decisions in the light of subsequent analysis and debate.

FIGURE 8.1: THE MARKETING PLANNING PROCESS

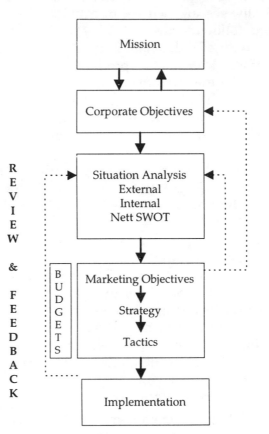

The process will generally result in a document which will contain:

- A mission statement
- Corporate or organisational objectives
- A situation analysis/audit which identifies Opportunities and Threats in the external environment as well as internal Strengths and Weaknesses
- An analysis of critical success factors
- Specific marketing objectives and strategies to achieve them
- The tactics required to realise those objectives at an operational level

- Budget and resources required

- A schedule for implementation

- A feedback and review mechanism.

The Mission

The setting of marketing objectives which are the focus of a marketing plan clearly only make sense if they are derived from the general organisational (or the individual artist's personal) objectives, which in turn spring out of the sense of mission.

For some 30 years, marketers have been concerned with defining a sense of overall mission and the obsession with mission statement is perhaps one of the more visible contributions that marketing has made to current management literature. In a celebrated 1960 piece in the *Harvard Business Review*, Theodore Levitt raised the issue of "Marketing Myopia" — a short-sightedness that limits the vision of actors and prevents them exploring the full business potential of which they are capable. Banks, for instance, traditionally saw themselves as museums for dead money and regarded their importunate clients as both suspicious and potentially deviant.

Contemporary bankers now see themselves as retailers who sell money-related services and who regard the rest of us as desirable potential customers. Our willingness to take up an increasing range of financial products represents the current path to prosperity for the bank and we are worth "fighting over", as opposed to "fighting off", as was the traditional view.

A mission statement attempts to define the business, preferably in terms of the public it is going to serve. It should say something about the distinctive competences of the proposer and suggest something of the actions which might be expected by an observer. There is no problem in having a philosophical or aspirational tone to the mission statement (the "vision" thing) providing it is immediately translatable into concrete business objectives, which in turn strongly suggest very realistic objectives for the marketing programme.

"Motherhood"-type statements should be avoided. These bear very little relation to any perceived behaviour, any visible set of values or any likely future achievement of the utterer.

Motherhood statements are meaningless because they provide no guide for action, no assistance for setting direction and no ultimate framework for testing decisions. In short, they provoke scepticism verging on derision and confirm the worst predictions of the arts purists.

It will help a lot if the mission statement is resonant and memorable. It certainly has to be believable, reflecting the reality of the organisation and its ambitions. If people internally and externally cannot subscribe to it, it will have no potential to motivate and energise those at whom it is aimed.

A number of mission-type statements are represented in Figure 8.2, though it must be stressed that a number of the respondents did not formally conceive of the statement as encompassing "mission" but rather as a statement of general aims or objectives. It is interesting to speculate as to which of these statements would provide a meaningful introduction to the organisation for the proverbial visiting Martian. Which statements enfranchise and empower the organisation positively; which provide a guide for decision-making; and which provide a rallying point for members and staff?

FIGURE 8.2: STATEMENTS OF OBJECTIVE AND MISSION

"The central objectives of the organisation are: to provide affordable workspace for artists in a professional environment; to provide a public space in our gallery and our Atrium areas to exhibit art; to foster awareness and sensitivity to art and to the business of artists through the education programme; to develop links with appropriate organisations internationally, through studio and exhibition exchange programmes and to provide a forum for dialogue about contemporary art issues." — *Temple Bar Gallery & Studio.*

"Our main aim is to fully promote and protect our artists' interests, both at home and abroad, to ensure sales and promotion through regular exhibitions and to provide them with an excellent administrative back-up service to achieve these goals. The second objective is to continually develop the gallery–customer relationship by hosting top quality exhibitions and by ensuring a professional, efficient and reliable service to both private and corporate buyers." — *Solomon Gallery.*

"To promote and encourage business sponsorship of the arts. To represent the interests of its members and provide them with relevant services and to foster mutually beneficial business/arts alliances." — *COTHU.*

"CAFE is committed to achieving social and cultural equality through creative action. Social equality is the right of everyone to an equal share in the country's wealth and resources. Cultural equality is the right of equal access to the means of cultural production, distribution and reception. The two are linked and cannot be achieved in isolation from each other. We recognise the importance of widespread collective creativity as a force for change within society." — *CAFE.*

"Our mission is to honour those artists whose work has made an outstanding contribution to the arts in Ireland, and to encourage and assist members in devoting their energies fully to their art." — *Aosdána.*

"To create within society an awareness, understanding and involvement in the visual arts through policies and programmes which are both innovative and inclusive." — The Irish Museum of Modern Art.

"Putting the arts to work for the community in a way that is relevant and exciting." — *City Arts Centre.*

"To provide, develop or discover opportunities that will allow talented unknowns to utilise their skills and achieve their potential in a professional environment."— *The Wrap Studio.*

With acknowledgement and thanks to each of the organisations.

Situation Analysis 1 — The External Audit

The situation analysis involves a process by which an arts organisation gathers information about its environment and the dynamics of that environment, and reviews its own internal competencies and capabilities. These twin audits (i.e. external and internal) should amount to a comprehensive analysis of the situation in

which the organisation finds itself. In effect, it is an attempt to state with clarity and objectivity "where we are now" prior to the business of identifying "where we should be going" and "how we can get there". Such an analysis will seek to produce an objective, systematic critique.

Elaborate and grandiose scenario-building will have little relevance to the real needs of most Irish arts organisations. Macro factors in the environment may genuinely have impact on their activities, particularly given the volatility of certain social and economic factors and the dramatic nature of some of the short-term changes we experience. Common sense would dictate, however, that many of the macro trends lie outside the planning scope of some localised arts initiatives and may be relevant only when the organisations are contemplating long-term capital commitments. Planning activity, it must be remembered, has no value if it has no focus or relevance.

The external audit seeks to examine the various environments or frameworks within which the organisation operates. These affect its current performance and are likely to continue to do so in the immediate future but its ability to influence them is, by definition, limited. These environments are likely to include the broad social and economic environment, the political and legal framework of actions and the technological changes which are likely to have impact on the organisation, its policies and its strategies.

All of these environments are dynamic and rapidly changing and it is important to identify and understand the "drivers" which are at work and where possible to predict the future trajectory of change. In effect the planner is a trend spotter.

Social and cultural factors give an example of this dynamism. There is rapid, even dramatic, demographic change currently taking place in Ireland. Central Statistics Office data indicates, for instance, that live births declined rapidly from 79,000 per annum in 1989 to approximately 50,000 in 1995. Already the impact of such change is being felt in primary schools and from 1997 will be felt in the second-level education system. Our received view of a country with an exceptionally youthful population may change dramatically and rapidly. The "greying" of the Irish population has already commenced with the bulk of the population now past the median age.

This might appear to be bad news for kindergartens, for children's book publishers and for theatre groups who regard schools

as their primary market. Companies making children's television programmes and/or spin-off merchandise may be looking at a much smaller market numerically. However, other factors come into play to complicate the issue. For instance, the smaller size of the nuclear family unit, especially in an era of generally rising middle class incomes, will dramatically alter the level of spend per child.

Thus imaginative events targeted at a primary school audience, such as the very successful children's series in the National Concert Hall, were heavily subscribed and could have been sold out many times over. The essential rule would seem to be that families have less children but are spending far more on their cultural development and on their leisure pursuits.

It is important when evaluating trends to recognise that the interplay of factors may produce complex and not immediately predictable outcomes. The tourist industry is set to grow strongly over the next six to seven years driven by European money and state and private investment, suggesting a further demand-pull on arts provision. The outcome of all of this investment may be an infrastructure of hotels, heritage centres and perhaps even arts facilities.

However, it may only be possible to meet the demands of the tourist market through deflecting investment away from genuine creativity toward pastiche fabrications for the heritage industry. Theatres may be full but the actual repertoire may be stifling real innovation.

Technological change may well be the most dynamic factor of all, but in its interplay with social and economic realities it is often the most difficult to predict and the outcomes are never the result of simple causal relationships. For instance, it is recognised that there will be a proliferation of television provision with a trebling of the total volume of television broadcast in Europe over the next five years. The digital technology revolution will create up to 500 new European stations. Already in the Republic of Ireland we have a third terrestrial station on the air with the possibility of a fourth, private station in the offing. Overspill of European stations will create intense competition for viewers.

The past decade has seen the pattern of consumption of television, video and film altering but not in the ways that might have been predicted. The rise of home video might have been thought to have signalled the demise of cinema. The large-screen medium

has, however, proved resilient and we have seen a raft of investments in cinema complexes which offer a standard of projection, comfort and ancillary service that would have been undreamt of in a previous generation. Similarly, the projected demand for television product may swamp screens with standard format American programming or may, alternatively, stimulate television and film production by local independents on a scale not yet envisaged. This will be dependent on appropriate strategies, structures and distribution systems being put in place.

The main environmental factors may be summarised as belonging to the following groups:

Economic Factors

- Levels of wealth and employment in society create and modify demand. Marketers may have to adjust the nature, the scale, the access and the pricing of their offerings in response to these factors.

- Disposable income is a key issue and may be difficult to predict. The distribution of household budget spend alters because of levels of employment and sociocultural change and even because of fiscal policy. Thus the average Irish household has shifted its spending pattern on basic foodstuffs over the past fifteen years but might rapidly shift back in response to recessionary conditions.

- Discretionary income, upon which arts participation often depends, may be even more difficult to quantify. Discretionary spending may be strongly driven by fiscal policy in relation to interest rates. This would suggest, in the current low interest climate, that a flood of highly discretionary additional spending is available. However, this has to be balanced against the dramatic increase in the size of the average mortgage. At the end of the day, the affluent dual-income couples, upon whom many arts organisers depend, may feel they have less rather than more cash available.

- General recession will alter the conditions of one of the most important markets for arts organisations, namely, the corporate sponsorship market. The willingness of companies to invest in sponsorship will be directly affected by recessionary conditions in their own sectors. It is almost an axiom that marketing

communication budgets are among the first to be cut in a recession and the softer edge of such budgets, i.e. public relations spending and sponsorship, may be the first victims of a downturn. This introduces a note of instability into even the longest-standing corporate sponsorship relationships, a fact attested by numerous painful Irish examples.

Social Factors

- Demography, including population trends, rate of family formation, average family size, birth rate, separation and divorce rates are all likely to influence the size of market segments which arts organisations have decided to target.

- Changes in social patterns including greater foreign travel, participation in higher education, growth of the service economy, the increase in numbers of women at work and continuing at work, the arrival of a leisure economy and the "greying" of the population also affect such segments.

- International tourism and general population mobility creates both the conditions and the mass participation which have "driven" major arts festivals and niche events (e.g. Galway, Edinburgh, Listowel Writers' Week, Yeats' Summer School) and major single theme events such as the Dublin Theatre Festival or the Cannes Film Festival.

- Changing urban geography and demography are producing changing patterns of movement which have seen the night time emptying of the inner city over the last thirty years. To counter such movement, public policy initiatives such as in Temple Bar have created a dynamic which has attracted movement, markets and events into inner-city areas.

The Policy Framework

- Public policy initiatives and a greater public involvement in the funding of arts initiatives is an important element in determining total arts provision and market satisfaction. Policy changes arising from changes in government or changes in direction can have dramatic effect as instanced by the influence of Thatcherite policies on higher education and public arts participation in Britain in the late 1980s.

The Market

Ultimately, the environmental audit is concerned with the identification and quantification of markets, and with the analysis of the "drivers" present in the market. An organisation can have a number of distinct target markets including audiences, mediators, gatekeepers and distributors, funding agents and commercial sponsors. Consideration of all relevant target markets is essential for meaningful planning. The discussion below will concentrate on the audience as a primary market, to illustrate the issues, but the examination of any market may usefully be conducted in terms of market definition, market size, market trends and market segmentation.

Markets can be defined in terms of the segments of which they are made up, each segment consisting of customers with similar needs. By analysing the characteristics and needs of each segment the marketer can determine which offerings are likely to succeed, the communication channels which should be employed and the distribution system which should be accessed. The analysis therefore needs to examine both the behaviours and the attributes of the customers.

The simplest approach to market definition normally involves the choice of one or more segmentation variables and an analysis of the market according to those segments. For an arts marketer, a basic starting point would be a segmentation based on those who have a participation record in the arts, with sub-segments based on the intensity of participation or the spread of activities. The fundamental problem is to identify those who participate in the activity. For many marketing officers the task has to be conducted on a blind basis, using available techniques from mass-marketing, to determine likely market segments where a response can be predicted.

Demographic characteristics, sociographic characteristics, previous purchase patterns and other available data can help us to identify those with a propensity to purchase. The problem for the marketer is in fact quite frequently one of accessing data.

Key sources might include Joint National Readership and Joint National Listenership research. These are surveys which are implemented on a regular basis by professional market research houses, to determine who is reading or listening to various media products. The respondents are also questioned about their purchasing and participation patterns across a range of issues

because media owners are interested in the potential advertising revenues that can be gained from targeting such customers. Questions are asked in relation to arts and sports participation as well as the media habits of the individuals (Table 8.1). A knowledge of the consumption and use of media and other information sources can be particularly important to the arts marketer as it will assist future targeting and the economical use of advertising and promotion budgets

A more recent survey instrument available in Ireland is the Target Group Index (TGI) which seeks to relate media consumption habits to detailed purchasing patterns. While this product is new in the Irish market it does promise relatively tight segmentation as the data builds up.

Many arts audiences are tiny in relation to the overall national consumer market. It can therefore be quite difficult, in generalised surveys, to specify the market segments which are most likely to participate or subscribe to an arts event. One of the more effective tools for arts marketers, therefore, will be database marketing techniques, i.e. the utilisation of existing or previous sales information in order to target the potential audience for future events.

Database marketing has grown in sophistication with the advent of better information technology and better software and it is now commonplace for arts marketers to maintain what is essentially a file on those who are most likely to purchase again in the future. The direct marketing industry has created a list-making and selling business and lists are regularly generated based upon a variety of consumption and lifestyle habits. An arts organisation can put in place a system for logging existing purchasers. Many purchasers may in fact agree to be patrons for a nominal sum or may put their name down for a mailing list for regular notification of forthcoming events or annual catalogues or indeed may utilise telephone booking or credit card booking for their purchasing.

The information generated in this way is invaluable and should be logged and retained for subsequent use. The relationship marketing approach is based fundamentally on the principle of customer retention and there is ample evidence to show that this is particularly important in the arts market. Utilising the information does require a shift in the organisation's own attitude. The customers must be regarded as long-term partners and must

be treated as such. Loyalty-building and customisation become key strategies.

In summary, an arts audience is a valuable market information resource and arts organisations need to be more active in gathering data about existing audiences and their consumption trends, together with their attitudes towards the event and the likelihood of repeat purchase. Every arts organisation or event organiser needs to understand the audience as well as possible and relatively simple data-gathering techniques can create the basis of market identification and segmentation.

Markets change continually in response to change in economic, social and other factors. Without change all markets ultimately stagnate. Audiences grow tired or switch their allegiances and events lose contact with market place demand. Change represents opportunity rather than threat. Without change there are no possibilities of developing new arts organisations, new performances, new venues and new events. For instance, it is difficult to conceive of major regional arts centres/companies like the Hawks Well, Druid or Red Kettle coming into being in the conditions of the 1950s, or indeed the 1960s, in Ireland.

The Competition

For many arts organisations in a region or a town where there has previously been no structured arts activity, the notion of direct competition might seem irrelevant. However, it must be recognised that any arts event — a gallery opening, a theatre event, a visiting orchestra — all compete for the attention of a public who are offered many options in terms of the expenditure of their time and money and who are subject to continual blandishment by a range of service and product providers. The major competition is often not with arts events or venues of a similar quality but rather with other lifestyle options that every citizen has (see Table 8.1).

Going to the theatre may involve effort to book tickets, travel to a remote — or city centre — venue and difficulties with parking. If the result of all this effort is an indifferent experience, the theatre-goer may very quickly evaluate other possible entertainment options as offering perhaps less risk even if they ultimately may offer less satisfaction. The arts marketer will also have to compete with other forms of live entertainment and other forms of art activity given that the audience pool is limited and common

TABLE 8.1: PARTICIPATION IN LEISURE ACTIVITIES

Leisure Activities	Past Month (%)
Listened to car radio	82
Visited Cinema	25
Visited Theatre	7
Visited Concert	9
Dined Out	55
Did garden	47
Did DIY	33
Bought Record	34
Hired Video	50
Lottery/Lotto	74
Played sport/keep-fit	44

Source: JNLR 1996 in Foley (1996:96).

to a number of the arts. Arts organisations are often in direct competition with one another for the available audience and this is likely to be accentuated at times of intense activity as during a festival, but it is also a feature of routine arts provision.

While the primary market is probably the pool of potential audience members, it must be recognised that arts organisations have a variety of other publics who may be equally important. Access to an audience is frequently achieved through media exposure and journalists, feature writers, critics and arts columnists may constitute an important public in themselves. The funding of arts events is often dependent upon both private sponsorship and the support of public bodies and specifiers and decision-makers in both types of organisation may very well constitute a key target market.

The competition for the attention of each of these groups needs to be defined, analysed and counteracted where necessary. A local arts organisation may report with frustration that their approach to the local branch bank or to a local firm for sponsorship support met with surprisingly little success because other competing events have beaten them to the sponsor. A knowledge of what the target required and how one's competitors are likely to fulfil that requirement is a necessary preliminary to any marketing activity. The bank may make its decisions at regional level, as part of an annual budget process. Competitors may in fact have superior knowledge and access and therefore a far better chance of releasing funds. The local firm may have made a commitment to

remain with a competitor's project over a planned period of years and may feel that it will not be in their interest, nor in the interest of the event they currently support, to begin to dilute that commitment.

Situation Analysis 2 — The Internal Audit
The internal audit is concerned with evaluating the present state of readiness of the organisation in terms of its strengths and weaknesses and its ability to fulfil marketing objectives. This will normally involve an objective, analytic review of the marketing resources available within the company including a review of staff who have a dedicated role and function in this area. The audit will seek to review structures, the location of authority and responsibility and the level of co-ordination of activities. It will question whether advertising, public relations, event publicity, sponsorship, database management, and customer service are fully co-ordinated, with all of the processes driven by a coherent philosophy, such as relationship building and maintenance.

The audit will establish what the responsibilities of individual staff members are, the levels of their skills and the training needs they may have. It will seek to review budgets and make judgements about the distribution of resources. For instance, there may not be a dedicated marketing budget in many organisations. These regularly spend 98 per cent of their resources on overheads and production costs and expect that a mere one or two percent of budget will inform and attract an audience in a highly competitive environment. A US film distributor has often decided to give marketing support to a chosen vehicle at a level of spend equal to the original production costs. An independent Irish film-maker, however, who achieves the miracle of national distribution, will generally find that their proposed shoestring budget will do little to drum up an audience. The "isle is full of noises" and it is hard to be heard amidst the clamour for the attention of the individual customer.

Current marketing activities should be evaluated and where necessary revamped as part of the internal audit. The deployment of product, price, place, promotion decisions, the mixing of these elements, and the level of success achieved all need to be carefully evaluated. Product-related issues include the nature, range, frequency and quality of productions, exhibitions, public events and ambiences. Objectivity may be difficult to achieve in the analysis

but success can be measured against a variety of criteria including ticket sales and critical review, as well as by structured feedback from audiences via questionnaires and specially created focus groups.

Pricing should be reviewed in relation to revenue generated but also in relation to issues of access, target segmentation, relationship-building and ancillary merchandising to a variety of audience types. There is a significant international literature which demonstrates that careful manipulation of price can in fact improve access and yet increase the overall yield to the event organiser. Careful analysis of the audience by time of day, day of week, season of year, nature of seat purchased and mode of purchase will in fact demonstrate that there are some very price-sensitive audience segments and others which are less so. A portfolio of price and seat offerings can emerge as a strategic response, which will capitalise on this situation.

Promotion may seem synonymous with the business of marketing to many arts organisations. However, it must be recognised that promotional effort will generally be wasteful without adequate definition of target markets, a strategy to achieve specific objectives and an overall sense of mission. The promotion audit will normally consist of a review of activity and effort related to advertising, public relations, sales promotion and perhaps some personal selling.

The SWOT

For many people faced with the task of conducting an external and internal audit the technique known as SWOT analysis provides a useful approach which can help to simplify and summarise the issues and point toward necessary and relevant conclusions. A SWOT analysis involves the identification of the opportunities and threats in the external environment together with an evaluation of the strengths and weaknesses of the organisation itself in relation to those opportunities and threats.

Far too often this kind of analysis throws up an empty and meaningless list. It must be remembered that strengths are only strengths if they deliver competitive advantage in relation to a specific market. Endless lists of features which are imagined to be strengths are both fatuous and irrelevant. Equally, many weaknesses are so self-evident that they hardly need enumeration. A paucity of resources is common to all arts organisations and is

therefore a fact of life. It only becomes a weakness in relation to the attainment of specific objectives which have been identified as either opportunities to be exploited or threats to be avoided. Merely listing these problems may deflect attention from the real, disabling weaknesses of an organisation. These can often arise from a lack of direction, a lack of internal management skill, inadequate control systems and the absence of a planning culture.

Equally, the "opportunities" must be related to the position the organisation finds itself in at this point in time and to the realistic chance of attaining some of the goals which the analysis has identified. Thus the key question may not relate to major opportunities but rather the gaps in the current servicing of subsidiary opportunities. We may not be able to tackle the major opportunity but there could be knock-on effects which will create opportunities at our scale of activity and at our point in the distribution system. The prospect of mounting a major show in a theatre festival may be utterly beyond the resources, the capacity, and the organisational capability of a new small semi-professional theatre company. However the "fringe" which is likely to grow up around such a festival will generate its own excitement and its own audience with expectations appropriate to the kind of show which may be within the budgetary and artistic capability of the company.

Nett Outcomes

Meaningless lists and extensive documents which provide no clues towards the path ahead are therefore of little use. A SWOT analysis can end up concluding that "on the one hand . . . but on the other hand . . .", etc. This spurious balancing act can often paralyse action and certainly does little to galvanise it.

A useful way of challenging the utility of a SWOT is to ask what nett outcomes are available. The focus will then shift from the balanced polarities of strength and weakness, opportunity and threat, to an evaluation of what the yield from the exercise ought to be. Often this yield can be usefully expressed as a list of critical success factors (CSF), a shortlist of things we need to have in place and actions we begin to need to take in order to have a realistic chance of realising the overall mission.

Determining Objectives

An objective is a statement of what one wants to achieve and it should always be realistic, specific and, if at all possible, quantifiable. In stating an objective it is important to recognise that there is very little use in generalised statements or the expression of pipe dreams. Objectives should generally be time-defined so that the effectiveness of actions taken can be measured.

For instance, if an organisation hires (on salary and commission) a sponsorship development officer it will be well advised to set ambitious but realistic objectives. These will be expressed in quantitative terms within a defined time horizon and will be highly specific in terms of the target groups. The objective might be to obtain an additional £120,000 sponsorship by 1 September 1997 in order to ensure the success of the winter season of performances which are scheduled to commence on 1 December 1997. The quantification of the objective allows one to determine what scale of action may be necessary.

If the costs associated with the sponsorship drive, i.e. salary, overheads, telephones, literature, print and open evenings amount to a total of £45,000, the nett yield is going to be considerably less than the gross sum targeted. A sensitivity analysis can often be attached to a quantified objective. This is a simple technique where we speculate on the effects of various levels of achievement of the objective. If, for instance, we raise £100,000 rather than £120,000 and the overheads remain constant, we may find that the nett sum is insufficient to achieve the artistic objectives which it is meant to support. In a doomsday scenario the yield from the sponsorship drive could be less than the costs associated with it and it is vital that such judgements can be made at the outset.

Quantifying the objectives may therefore direct us toward evaluating alternative strategies and tactics. If, for instance, we determine that a full-time sponsorship officer will only produce a nett benefit of £55,000 but a voluntary drive by our advisory committee could produce a nett of £35,000, we may decide that the services of the full-time employee could be far better spent. The full-time employee might then be directed towards subscription development, increasing the roll of patrons or developing and implementing an overall marketing strategy.

Marketing Strategies

The marketing strategies adopted are likely to lie in one or more of the following areas of decision:

- To enter or leave a particular market

- To target or cease targeting a particular market segment

- To create alliances which will take one into new markets, new promotional platforms or new distribution systems

- To specialise and focus one's activities and/or to rationalise the existing range of activity

- To change the product range and overall portfolio of offerings in the programme

- To augment the product in new ways

- To change delivery strategy (e.g. take an art show on tour or theatre into the community)

- To change the overall posture towards the audience and patrons through a change in service level and internal marketing

- To improve administrative and support services

- To devise new pricing strategies

- To change the approach to communication, advertising and promotion

- To invest in new capital facilities etc.

It should be noted that these strategies are designed to achieve objectives which are specifically related to the market place. Ultimately they will all serve to make the organisation more profitable or successful in whatever terms it measures that success (normally stated as a corporate objective) but their specific focus is towards market place outcomes.

Tactics and the Detailed Plan

The marketing strategies will inform the setting of specific objectives relating to product, price, place and promotion. In turn, the setting of these objectives will suggest strategies in each of the individual areas. This should then result in the documentation of

a programme of actions required to realise the strategy, i.e. a production plan, a pricing plan, a promotion plan etc. Figure 8.3 represents the stages involved in moving from the strategy to the detailed plans. At every level the available options are shaped by decisions made at previous levels and previous decisions may be revisited critically on a number of occasions in the light of discussions of later stages.

FIGURE 8.3: FROM OVERALL STRATEGY TO DETAILED PLANS

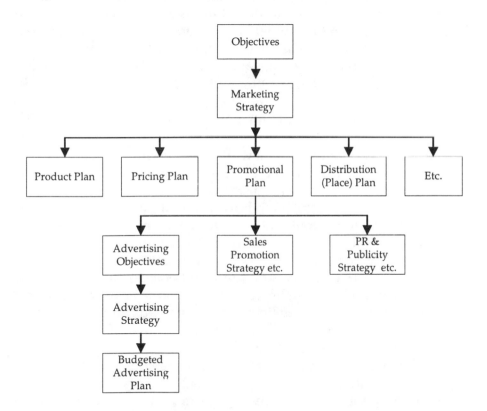

The Promotion Plan. Communication will only be effective if specific objectives are set in relation to the target group and if the needs of the audience are planned for and met. Gallery owners have long been expert in creating excitement and value-added through catalogues, selective previews and innovative openings,

but there is evidence to suggest that inadequate research and a less than strategic approach has sometimes meant poor outcomes in terms of media coverage and purchases.

The promotion plan should address the availability of communication channels and promotional tools. Channels are normally thought of as being either *impersonal* or *personal* and the latter have particular importance for the arts.

Personal Channels. Because of the perceived status of audience members and their level of affiliation to the art form, personal influence can be a crucial factor in building the audience. Opinion leaders need to be identified and communication effort directed toward them. These will include professional critics and columnists but also other professional communicators. It is a truism that in Ireland a favourable mention by Gay Byrne[1] can build an audience for a show as can unsolicited and spontaneous recommendations from a range of other media and public figures. The opinion leadership phenomenon is so powerful and pervasive that many car manufacturers will give a prominent sports person or media figure free use of a vehicle as a means of influencing the general public's attitude towards that marque.

It should be remembered, however, that opinion leadership is not a dichotomous trait and that we are all, in our various social networks and reference groups, potential influencers of other people. It can be argued that "word of mouth" is the most important and effective means of building audience for any form of live show or film in the Dublin area, and a marketer may well direct their advertising and publicity budget towards stimulating positive word of mouth, for instance, through advertisements which stimulate word of mouth transactions.

Personal communication in the form of selling and negotiation can also be an important part of overall communication strategy. Front-of-house activity represents an important part of the total quality experienced by customers and appropriately high levels of customer service should be defined and trained for. Active selling and negotiation is usually an integral part of the process of pitching and landing sponsorship support. The rules of business-to-business selling apply here. Quite often the decision-maker can only be accessed through a variety of gate-keepers and will take

[1] Popular Irish broadcaster

advice from a range of influencers. The sales pitch must take account of the needs of each of these types of individual and will normally have to be well-documented, professionally-presented and carried through with a high level of technical negotiation skill.

Impersonal Channels. Impersonal communication channels include advertising, public relations or publicity, in-house point-of-sales displays, exhibition materials and sales promotion. The repertoire may now also include direct marketing media as a means of delivering, shaping or targeting messages. The communication mix will consist of the optimal use of these various tools, either singly or in combination, within the budgeted resources. It should be remembered that advertising has generally less to do with creating actual sales than with creating awareness, interest and desire prior to the business of the sale. An additional stimulus, beyond advertising, is often required in order to create the "sale".

Clear definition of the advertising objectives which are to be achieved with the individual target groups will lead to creative and media proposals which may be generated in-house or through a relationship with a professional agency. The latter choice does involve expense but the pay-off in placement efficiency, exploitation of available media opportunities and creative and design quality, is well worth considering. Whether in-house or agency-assisted, quality control of the creative execution and formal media scheduling of messages is mandatory.

Publicity is one of the major tools used by arts marketers but much of the visible activity is unprofessional, ineffective and wasteful of the opportunities accessed. The professional needs of journalists must be taken on board in drafting, timing and delivering press releases and press packs. Much arts-related publicity-seeking aims at raw exposure and little else and insufficient thought goes into the kind of messages that ought to be conveyed concerning the general positioning of the event or organisation. Very little effective promotion results from pure happenstance and a careful, co-ordinated plan utilising the available resources, contacts and goodwill can achieve far more than one-off indulgent publicity gimmicks. While Behan's dictum that "there is no such thing as bad publicity" may have a germ of truth, it is important to recognise that a single publicity vehicle will generally not achieve the objectives with all of the necessary target groups.

An approach which achieves a useful notoriety and thus builds awareness with the general public may also be responsible for "turning off" a major sponsor at a crucial stage in a negotiation.

Sales promotion, now generally referred to as "below the line" communication, includes all promotional activity which does not directly involve the buying or accessing of media time and space. Sales promotion normally involves a specific offer to a well-defined target group, providing an incentive in return for their action, within a specific time period. Traditionally it has been viewed as short-term blandishment aimed at producing immediate action (usually a purchase) on the part of the receiver. While there do exist examples of more strategic uses of sales promotion, it should be borne in mind that some activities may have a product-demeaning effect. This is particularly the case if the promotion is overly insistent and it certainly will not be helpful to relationship-building. All kinds of discounting, gift and token giving, bonus point scheming and special offering can be regarded as sales promotion.

There is always a risk that the sales promotion will run counter to the standard price/quality perceptions that we associate with high status arts events. However, some imaginative sales promotions have been put in place, such as the National Concert Hall 1995/96 season which combined the branding of individual segments of its programme with price incentivisation for serial booking. While the approach was over-complex and not totally successful it represented an imaginative strategy that could pay major dividends.

The Product Plan. The product may be considered to be the core product or the augmented version; it may be regarded as the single event or the programme of events throughout a season or a year; it may ultimately be seen as the total portfolio of possible offerings. Difficulties arising from the status of the core product have already been discussed. It follows that the greatest flexibility for product development and innovation may lie in the area of the augmented product.

Extended opening hours, lunch time or off-peak opening, extending the day or the week's opening, enhancing front-of-house, restaurant, bar and crèche facilities and providing premium facilities for sponsors are all possible product modification and extension options.

The physical quality of the venue is an essential part of the augmented product as experienced by the customer. An excellent show in a poor venue with poor lighting and heating and an unwelcoming ambience will do little for the success of the core product.

Seasonal programming policy may also be part of the product issue. Customers may require a different type of show at different stages of the year and programmes schedulers may very well need to review current policies.

The Pricing Plan. For many arts organisations, pricing is based on custom and practice and a sense of what the traffic will bear. Few organisations have brought basic accounting procedures to bear in their approach nor have they scientifically identified the factors which should be considered when setting a price. Boardman (1978) identifies a number of factors which influence theatre pricing including the auditorium, the show, the market, the budget and the decisions driving ticket sales. This can be a useful enough starting point as it indicates the issues which pricing needs to comprehend, but a marketer should always approach the issue by asking what might be achieved through the use of price as a positive marketing tool.

Pricing policies offer more marketing flexibility in both strategic and tactical terms than is often recognised. Price manipulation, grounded in professional audience research and informed by overall costing and budgetary approaches, can provide an effective marketing technique. There is a need to preserve price/quality perceptions and relationships and there is probably little opportunity for gaining competitive advantage on a broad front. Nevertheless, there is a repertoire of pricing effects which can be exploited. Market penetration in the all important youth and children's markets — a key determinant of future arts participation as demonstrated by Andreasen and Belk (1980) — can be facilitated by a policy of low initial prices, given the likelihood of there being some price elasticity in the demand pattern.

The Distribution Plan. The "place" or "distribution" plan is concerned with issues of access and availability of arts products to their potential target market. Classic distribution planning with strategic and tactical choice of channels (wholesale and retail) is obviously relevant to the marketing of books, magazines, records,

videos and spin-off merchandise. Accessing a distribution net-
work nationally and internationally is obviously vital to film
makers and TV producers and the distributors' power to provide
the key outlets where the audience can access the product will
determine success and failure.

All of these issues belong within a frame of reference which in-
forms decisions relating to the movement of goods and services in
general. As such, a range of strategic and tactical tools — selective
versus general distribution, specialist distribution linked to spe-
cialist pricing, the recruitment of channel intermediaries for pro-
motional support — are well understood and available to the
marketer.

Arts marketing can also benefit from novel and flexible ap-
proaches. Distribution/pricing policies such as the introduction of
credit-card booking; distribution/promotional policies such as the
public sponsorship of Kathy Prendergast at the Venice Biennale;
and distribution/sponsorship policies such as the Arts Coun-
cil/Aer Lingus Art Flight Scheme indicate the range of possibili-
ties. Information technology provides a new way of distributing
material to audiences and databases can be the key to building
loyal relationships. They can also serve as a distribution system
for promoting the talents of actors and performers of all kinds as
in the case of Interactive Casting Universal — who offer a per-
former database with on-line distribution in the UK and who
have entered the Irish market with a similar product on video.

Channel conflict refers to the tensions and conflicts which may
arise in a distribution system because of the varying agendas of
the channel members. The relative power of different parties in a
channel will always be an inherent source of conflict as is evident
in the mass consumer market in the power struggles of manufac-
turers and retailers. Thus the interests of a theatre company and a
venue owner may not always be fully in harmony even though
they both have the shared ultimate goal of attracting the maxi-
mum audience. The resolution of channel conflict can be achieved
through good forward planning and the adoption of a "win-win"
approach by the parties.

An Alternative Formulation
The seemingly complex steps involved in moving from objectives
through strategy to detailed plans to implementation may be

off-putting to arts marketers. An alternative way of creating and tracking that process is suggested in Figure 8.4 below.

FIGURE 8.4: THE MARKETING PROCESS

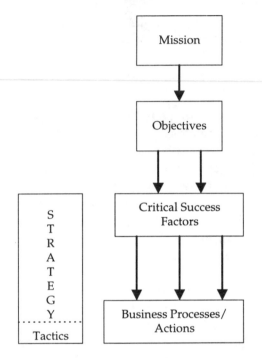

Having completed a situation analysis and defined the objectives, an arts organisation might determine that there are seven or eight factors which are critical to realising the mission by way of exploiting opportunities or fending off the disaster posed by external threats and internal weakness. A plan recently developed for a small semi-professional arts organisation included the following statement of critical success factors (CSFs):

- We need to have adequate financing.
- We need to have a permanent staff resource with marketing skills and training.
- We need to have a stable lease on the premises that we have had ad hoc use of.
- We need to have a body of patrons representing local community business and voluntary organisation interests.

- We need to develop a strong appropriate image throughout the region and the seeds of a national image.
- We need to set up relationships with competent business people in our immediate locality who can offer support, guidance and finance.
- We need to have strong links with relevant external organisations such as the County Development Team and the Arts Council.
- We need to improve relationships with the major local radio station which has tended to ignore us in the past.

This list arises from an analysis based upon a previous SWOT. A total of 22 different business processes or actions were identified which were judged to be necessary in order to positively realise each of the CSFs. Each action should be assigned a quality rating (on a scale of one to five or A to E) which will reflect the efficiency with which the action or process is already being carried out by us. Actions which are not yet in place or are only recently initiated will attract a rating of (E) and those already performed at a level of excellence will attract a rating of (A).

Each critical success factor will have at least one business process or action necessary for its achievement. More usually there will be a group of such actions which together will be sufficient for the purpose of achieving the critical success factor. It is also likely that each business action will have an influence or impact on a number of critical success factors and this will allow some sense of priority in terms of initiating, supporting and resourcing these business actions. Certain actions will clearly be seen as extremely important because they drive more than one critical success factor. For example:

Critical Success Factor	*Business Process / Actions*
We need to have adequate financing	Operate a full-time fund-raising office
	Organise fund-raising events
	Set up patronage scheme
	Set up priority ticket booking facility
	Conduct analysis of seat purchase patterns with a view to creating a pricing structure to exploit corporate business.

DOCUMENTING THE PLAN

A good marketing plan is a perfect example of the iceberg principle, i.e. one-eighth of the pain, the effort, the analysis and the judgement appears above the surface. Yet, in a sense, all of the issues are adequately represented in the shape of the strategy and the implementation framework is clearly specified. All of the data and thought processes need not be communicated to every audience. Therefore a clear sense of who the members of that audience are, what their values are and how best to communicate with them should inform the actual writing of the plan. That readership may include the bank manager, the accountant, a funding officer in a national arts organisation, critics, patrons, members and subscribers and a variety of other stakeholders.

A plan which is clear, realistic and communicates its message in straightforward jargon-free terms; which captures the sense of purpose and vision of an organisation; and documents realistic judgements regarding strategies, tactics and resources can have immensely beneficial impact on a wide range of readers.

It is important to have clarity of structure and to provide a record of the relevant processes which have been pursued in creating the plan.

An example of such a structure might be:

- A clear statement of mission avoiding the worst forms of abstraction and pomposity that plague mission statements

- Succinctly expressed outcomes of the marketing audit presented as nett outcomes with the main relevant points of the SWOT analysis present as a backup. A clear statement of the marketing objectives and of the strategies will follow and this might usefully be detailed in terms of the critical success factors required to achieve those objectives

- A set of tactical marketing plans relating to product, price, distribution, promotion and the management of the political, legal and regulatory environment. These plans have to be fully integrated, they have to service the mission and objectives, and they must be mutually supportive. There is little point in developing a strong promotional campaign if the logistics of the opening night collapse completely. Equally, there is little point in generating huge interest among a youth market if only five discounted tickets are available each night for a major venue

- Each tactic should be costed and related back to an overall marketing budget. A total budget should appear in the plan and a simple implementation schedule involving the business actions required, the processes which need to be initiated and the time-frame in which they will be actually implemented needs to be formally stated

- Proposals for evaluation, measurement and review will complete the structure of the plan.

THE INDIVIDUAL ARTIST AND THE PLANNED APPROACH

The approach which has been described in this chapter has been illustrated with organisational and institutional examples. Nevertheless, the broad thrust of marketing planning and the individual principles which have been detailed are generally applicable in the case of the individual artist.

An organisation will usually have a number of individuals with various levels of formal training in marketing and general business skills with the possibility of hiring-in skills as required. The individual artist, by way of contrast, often feels alone in a commercial world whose rules seem rigid and unfriendly. There is a growing realisation that individual creative artists do require a relevant and well-focused training in business techniques as part of their overall formation. The recent Statcom Report has shown that even in commercially-oriented areas such as film-making, business development skills are at a premium. A forthcoming study by O'Sullivan and Gibbons demonstrates that the vast majority of Irish visual artists, applied artists and designers feel they have had inadequate training in business and that their skills base needs serious enhancement.

For the individual artist the issues of mission and strategy are crucial. Paradoxically, the timescale addressed by the individual may have to extend over a much longer period than that addressed by the organisation. The individual artist must often think in terms of shaping a career across a decade or more. Even a cursory analysis of major artistic names who have achieved creative and commercial success will reveal a planning principle at work. The successes are not achieved by accident but are the outcome of a clear strategy in relation to building up a record of performance, publication or exhibition, as the case may be.

Promotion is a controllable variable but the distribution decision may well appear to be outside the control of the artist and a key factor in frustrating the individual's achievement. A playwright may need to access an agent — who in turn will access a production company, who in their turn will have to access venues — in order for new work to reach an audience. Their fate will lie in the hands of a variety of individuals who will see artistic compromise as a legitimate commercial tactic and whose sense of urgency about their work may diminish rapidly over time. The sense of powerlessness might be best compared to the role of primary producer rather than to the roles of manufacturer, distributor or retailer in conventional business terms. Nevertheless, many of the strategies available for channel management and tactics used for conflict resolution are directly and productively applicable to the case of the individual artist.

A LAST WORD

Marketing resources can be cleverly marshalled by both organisations and individuals even when they cannot afford professional expertise or provide publicity budgets. Expert help may be available from public bodies, regional arts organisers, and staff in universities and colleges. The more strategically alert organisation will take this issue into consideration when inviting members onto its board. A number of theatres have thus been able to acquire the services of some of the best advertising and public relations talent in the country.

Too often in the past, arts organisations were slow to exploit available supports or to call on the expertise present in local firms. It should be realised that many of those working in marketing, advertising, PR and direct marketing show a real commitment towards the arts in terms of their own cultural interests, evident in their involvement in commentary, critique, production or routine participation. O'Casey's Captain Boyle expresses a universal hunger when he poses the question "What is the stars Joxer, what is the stars?". And almost everybody, whatever their walk in life, recognises that art provides one of the few possibilities of a transcendent answer. That remains a powerful and beguiling appeal, from which no-one ever achieves total exemption.

References

Andreasen, A.R. & Belk, R.W. (1980), "Predictors of Attendance at the Performing Arts", *Journal of Consumer Research*, vol. 7, 112–119.

Armstrong, G. & Kotler, P. (1987), *Marketing: An Introduction*, London: Prentice Hall.

Berry, L.L. (1983), "Relationship Marketing" in *Emerging Perspectives on Services Marketing*, (Berry, L.L., Shostack, G.L. and Upah, G.D. eds.), Chicago, IL: American Marketing Association, 25–28.

Boardman, J. (1978), "Pricing and Concessions" in *The CORT Marketing Manual, Volume 2*, (Robbins, G. & Verwey, P. eds.) London: TMA /CORT/Arts Council.

Clancy, P., Brannick T., MacDevitt, D. & O'Connell, A. (1995), "Theatre in Ireland" in *Views of Theatre in Ireland* (Report of the Arts Council Theatre Review), Dublin: An Chomhairle Ealaíon/The Arts Council.

Costello, P. (1992), *James Joyce — The Years of Growth*, Cork: Mercier.

Cronin, A.(1996), *Samuel Beckett: The Last Modernist*, London: Harper Collins.

Delgado, E. (1995) "The Music the Stranger Hears" in *Views of Theatre in Ireland* (Report of the Arts Council Theatre Review), Dublin: An Chomhairle Ealaíon/The Arts Council.

Durkan, J. (1994), *The Economics of the Arts in Ireland*, Dublin: The Arts Council.

FAS Training and Employment Authority (1995), *Statcom Report on Training Needs to 2000*, Dublin: FAS.

Foley, E. (1996), *The Irish Market — A Profile*, Dublin: The Marketing Institute, 96.

Greenley, G. (1987), "An Exposition of Empirical Research into Marketing Planning", *Journal of Marketing Management*, vol. 3 ,no. 1.

Gummesson, E. (1987), "The New Marketing — Developing Long-Term Interactive Relationships", *Long Range Planning*, vol. 20, no. 4, 10–20.

Hill, E., O'Sullivan, C. & O'Sullivan, T. (1995), *Creative Arts Marketing*, Oxford: Butterworth Heinemann.

Hirschman, E.C. (1983), "Aesthetics, Ideologies and the Limits of the Marketing Concept", *Journal of Marketing*, vol. 47 (Summer 1993), 45–55.

Johnson, P. (1996), Quoted in "Report on Influencing the Market Place" in *Crafts* — March–April, 64.

Levitt, T. (1960), "Marketing Myopia", *Harvard Business Review*, July–August 1960, 45–56.

McDonald, M. (1995), *Marketing Plans*, Oxford: Butterworth Heinemann.

Ó hOisín, E. (1991), "Sport on the Sidelines", in *Circa*, no. 71, 43–45.

O'Sullivan, P.J, Butler, P., Demmick, D., Fennell, T. & Flood P. (1991), "Marketing Practice: The Republic of Ireland and Northern Ireland, Dublin & Belfast", Co-Operation North, Third Study Series: Report No. 3.

O'Sullivan, P.J. & Gibbons, A. (Forthcoming), *Professional Practice Needs of Artists*, Dublin: Arthouse/Vita.

Turnbull, P.W. & Wilson, D.T. (1989), "Developing and Protecting Profitable Customer Relationships", *Industrial Marketing Management*, no. 18, 233–238.

9

MARKETING THE ARTS:
THE MANAGER'S PERSPECTIVE

Joe Dennehy

Recognising the somewhat problematic status which it holds in arts management, a colloquium was convened in June 1996 to get a sense of how Irish arts managers feel about certain key issues in marketing. Moderated by Joe Dennehy (Lecturer in Marketing Economics, Faculty of Business, Dublin Institute of Technology) the meeting brought together managers from the music, film, theatre and visual arts worlds and was later supplemented by some interviews. A list of participants is given at the end of the chapter.

A stronger commercial awareness and a greater focus on the customer is becoming evident in Irish arts organisations. However, because of their typically small size, marketing tends frequently to be part of the general manager's direct responsibility. This often means that marketing issues are directly incorporated into the general manager's overall plan and are closely associated with promotion. Arthur Lappin of Groundwork Productions[1]: "The knee-jerk reaction of any arts organisation is to spend money on promotion rather than marketing, a gut instinct to always sell the next show."

This approach results in a dearth of comprehensive and written marketing plans or a view that plans, even when written, have to be very flexible. Nor, it would seem, do they always come with an adequate budget to support them. However, the absence of a written marketing plan does not mean that many, or indeed all, of its components are absent, even if they do not appear in the form of a document. For example, many organisations have a

[1] Dublin theatre production company until 1996.

mission statement which is either explicit or, as is often the case in the arts, expressed in the vision of a founder or a charismatic leader. These mission statements are usually couched in terms of an artistic policy, such as that of Wexford Festival Opera, "to specialise in rare or unjustly neglected opera".

In pursuit of those mission statements, arts organisations often set themselves objectives and employ strategies and tactics which would sit comfortably in a standard marketing plan. Marketers would suggest that it is preferable in pursuit of a mission statement to develop a comprehensive written marketing plan and to allocate an appropriate budget. There is a feeling, however, within the industry that the arts are unique and are better organised by instinct and intuition. Indications are that some elements of both approaches are in evidence, with a tendency to move more towards the former.

This chapter sets out to examine some issues relating to marketing the arts in Ireland, through the eyes of a number of arts administrators who informally discuss their views and experiences.

MARKETING: IS IT HAPPENING IN THE ARTS?

Universally regarded as one of the success stories of Irish arts marketing, it is hardly surprising that the Wexford Festival Opera takes a customer-oriented approach. Jerome Hynes as Chief Executive takes responsibility for marketing:

> Recognising that the artistic experience is central, the responsibility of general managers is to create the environment within which that experience can work most effectively and within which audiences can enjoy it most efficiently and most pleasantly. Our responsibility is about everything from the moment they make the first inquiry to the moment they leave the theatre: to ensure the total experience is a good one.

Not surprisingly, a similar approach is taken by the Gate Theatre, another widely acknowledged success story in the marketing of the performing arts. The first Marketing Manager appointed in Irish theatre in 1984, Deputy Director Marie Rooney, still includes marketing in her responsibilities:

> When the programme is being chosen there is always an eye on what the public wants, there's always some element that is a selling element. Shows are of a very high standard — and of inter-

est; it's what people want to see. And we try to make sure that the people coming in are happy and comfortable.

Arthur Lappin was faced with the challenge of producing unsubsidised high-quality mainstage drama in the 1,200-seat Gaiety Theatre. He is keenly aware of the difficulty of allocating a proportion of meagre resources to marketing, in a situation where commercial theatre is inadequately capitalised and whose very viability, he believes, is greatly in question:

> We do have a Marketing Director in place but the elements of marketing that we've been able to get involved in are low-cost exercises like analysing credit card returns and trying to establish audience profiles, as well as advertising and promotion exercises. I don't think we've ever been in a situation where we could dedicate a certain proportion of our overall budget to marketing. A key problem is that the available amount of generic marketing information relating to theatre is very little; without this you can't have a focused campaign for one venue or one style of production.

A theatrical experience that did catch the public imagination during the 1980s was the Passion Machine. "Although we didn't have a marketing plan, what Passion Machine would have been doing in the first four years of the SFX[2] was classic niche marketing", says John Sutton, who managed the business side of the group, including marketing.

> To the best of my knowledge, not many independent theatre companies have a marketing plan or a sense of who their audience is and, with some obvious and well-known exceptions, I don't see many examples of good marketing in the industry. You don't come across remotely the same sophistication in terms of marketing, communication, fund-raising etc. in the cultural/arts sector that you come across in third world development organisations like Trócaire and environmental urban renewal operations like Temple Bar Properties or even in housing and homeless organisations like Focus Point — they're far more developed and sophisticated.

Although the performing arts tend to dominate discussions about the role of marketing in the arts, it is an issue that impacts sharply on all other artforms. Norah Norton, until recently Chief Executive of the National Sculpture Factory in Cork and now

[2] Saint Francis Xavier centre, a hall in Dublin's North inner city.

Chief Executive of Temple Bar Gallery and Studios, Dublin, with responsibility for marketing, says:

> For galleries and arts organisations I would certainly see a role for marketing. There definitely is a move to bring more people into the arts and bring the arts to more people. A lot of organisations have developed an incredibly good instinct for marketing, from the National Gallery on. In terms of marketing, I think the major aim of the visual arts is to raise the awareness of more people.

The Temple Bar Music Centre in Dublin provides a wide range of facilities to allow musicians to develop their artform. Paddy Dunning:

> People get confused about the difference between marketing and promotion. Marketing as far as we are concerned is mainly client-focused: dealing with them, bettering the product and giving them what they are looking for. We have a marketing person to market the building, so people are aware of what we do and aware that we are open for business. This person's job, for the first twelve months, is to give us a high profile, to allow us to operate efficiently and effectively.

Hot Press magazine would be regarded by many as playing a significant role in the extraordinary development of the Irish music industry in recent years. Its General Manager, Jackie Hayden, says:

> I've noticed a huge change in the last fifteen years in the attitude of musicians to marketing and commercial issues. They used to be very wary of things like sponsorship, afraid they would have to wear the T-shirt or drink the product etc. But bit by bit the barriers were broken down when they saw it working. Now you have the situation where there are very few musicians who wouldn't happily accept sponsorship from anybody and, unfortunately, if any of them make any mistake at all, it's to go about looking for it in the wrong way. They see it as charity rather than a business decision on behalf of the sponsor.

Because of its segmented nature it can be very difficult to apply a comprehensive marketing approach in the film industry in Ireland. Jane Doolin is Chief Executive of Clarence Pictures Ltd., one

of the most successful small Irish independent distribution companies, and is responsible for marketing:

> I suppose the background is that most European production is financed a lot out of television whereas American production is financed out of distribution. There is a different mind set. The Americans have already thought about their audience before they start whereas here we tend to think "well, we've got the money, great" and then at the end we have a product but we don't know what to do with it, because we have never actually thought it through. Film makers can't bear the idea but it is a new product every time and you have to shift it. I think the film industry in Ireland is becoming more commercially aware but it is going to take time.

ARTISTIC POLICY AND COMMERCIAL IMPERATIVE: AN IRRECONCILABLE CONFLICT?

In spite of popular belief, there is a high degree of unanimity among the arts administration community that the conflict between artistic and commercial policies is more apparent than real. Jerome Hynes seems to reflect a widely-held view:

> In my own view the conflict between the artistic and commercial sides is overstated. Many of the techniques employed in marketing manufactured goods and services are applicable also to the arts. However, I would argue that a feature of the arts market that is probably unique is that the artistic product is central. We can never forget that what we are is an artistic organisation.

This view is supported by John Sutton:

> There must be a partnership between the artistic director and general manager. The frustration comes if the artistic director believes he or she should be doing the manager's job or worse, if the general manager is actually a frustrated artistic director. Then there is a clash as opposed to a partnership.

Norah Norton acknowledges the potential for conflict and believes the language used is very important:

> Art is a very difficult area in which to talk about marketing purely and simply because it is not a market-led profession. Words like product and marketing are suspect words to artists. But you can talk about exactly the same things using different words: you can

express it in terms of mediating the work, promoting the work to a new constituency. There are all sorts of ways that you can talk to an artist about actually marketing their work.

PRODUCT: DIFFERENT IN THE ARTS?

To speak of product in the arts is naturally somewhat complex, since there are often a number of products or experiences involved at the one time. Marie Rooney states:

> The artistic experience is, of course, the main product. The Gate has a tradition going back to 1928 of presenting the best of European and Irish theatre. But the Gate is also somewhere you have a night out, in a place you are familiar with, at home in. For example, as part of that approach, we built the bar in 1987. We realised that, in looking forward, people's idea of a night out was changing, that standards had risen, that when they go somewhere they expect to be able to get a drink. There is also a plan to build a cloakroom and a shop so that we can start merchandising.

Wexford Festival Opera is clearly very much an overall experience. According to Jerome Hynes:

> It is the total experience that matters. Impressions will be given and value will be added by everything we do, be it box office or bar services or whatever. But the first thing is that the artistic product has to be there and it has to be of a sufficient quality that people will want to repeat the experience. Wexford now has a niche in world opera: it is the place where you will see unjustly neglected opera. Of our audience, 34 per cent travel from overseas because they will see productions here of things that they will not see elsewhere.

> Two years ago a guy came to me in the foyer and said, "Goodnight Mr. Hynes, it's my final night of the festival. I haven't enjoyed any of your productions this year." I took a step back. He carried on to say, "but I don't regret the experience at all and I will be back next year". What he essentially was saying was that he was prepared to risk with us what we were prepared to risk. None of the performances had worked for him that year but it wasn't going to put him off. Our brand hopefully was such that, if we put our name to it, it had a reasonable chance of success. But you're only as good as your last festival. We could lose that overnight too.

The Temple Bar Music Centre's main customers are the artists themselves; it is essentially a service provider for young musicians:

> This building is a platform for people to come in and get trained, perform or rehearse. What we are trying to do with the facilities and the services we provide is allow bands to use them to assist with the development of their artform. For instance, they can rehearse here, write their music here and record here. In terms of how they market themselves, each artist is different: compare Mary Black with Boyzone. All the record companies, management teams and promoters market their own artists individually through launches, press stories etc.

The Sculpture Factory also provides services to artists.

> Artists hire space to work in the Factory and that means use of the equipment etc. It has become a very good place for artists to work in. It is a lot more than just the industrial equipment. It is a total service really. The attitude in there is: any help you can give, give it. The Sculpture Factory also provides services to a wide range of customers: administrative, consultancy, sculpture maintenance, corporate exhibitions.

> But, of course, the artistic experience is always at the centre of things. As an artist, it is your personal meaning that you are expressing and if you are awfully lucky, people out there will see and understand it and buy it. In many cases now a lot of artists are not making to sell anymore, they do it to reach people, to experience things. Installation art is not always for sale and performance art is not for sale, a lot of the most exciting artists survive on grants, subsidies and doing other work in between.

PROMOTION: WHERE THE MARKETING BUDGET USUALLY GOES!

"Marketing budgets" in arts organisations are often directed primarily towards promotional activities. However, it is interesting to note cases, for example the Wexford Festival Opera, where the focus is very much on direct marketing; arguably a holistic marketing approach in itself in that it focuses on developing an individual, long-term relationship with each customer. In this its direct application to the arts is clear.

Jerome Hynes outlined the Wexford approach:

We had a job to do because we decided we would double capacity and extend the festival. We decided there was a market there to develop the audiences, so we obviously had to think very carefully about how we would market the festival with the limited budget that exists. What we're trying to do is reach people and convert them to the idea of attending opera, or specifically to the idea of attending Wexford. We're selling an entire experience for people and, hopefully, one they would want to repeat.

That fitted perfectly with my belief, in relation to the arts in general but particularly opera, in direct marketing. So all of our very limited budget which you could describe as marketing — about 3.5 per cent of our total budget — is essentially spent on direct marketing. This has to do with quality of brochure, distribution, access to lists, building up our own lists, building up our own information base in terms of the people who attend the festival.

So, our concentration is on direct marketing, accessing and developing new audiences and fortunately for us in the last couple of years it has worked and paid enormous dividends. What we've been able to do is build a loyalty amongst an audience who, hopefully, if they enjoy the experience, will want to repeat it and therefore become regular attenders. I know it's easier for us, for instance, because we're on a once-a-year-basis but I also do believe that it's something that arts organisations and particularly theatres could actually use and probably don't use effectively enough.

One of the things I got into, because it's the usual arts cheap marketing, was newspaper reader offers or broadcast offers. They were a very effective way of both putting out the Wexford message and also selling seats. Also, we piggy-backed on five of the key Opera Houses in the UK with a 250,000 piece mailout: we were in all of their mailouts in 1991 with 250,000 brochures, specially designed, specially directed towards the UK market. We had a very specific three-day offer, from five different airports in the UK. Obviously, we could look at the numbers that replied to that and we could actually say "that is business bought directly as a result of this piece of direct marketing".

In Ireland we had a specific offer for holders of Access credit cards. Again it was a quarter of a million pieces. One thing we don't do is buy or sell lists. We have our own list and we're very strict about not allowing our list out to anybody else and therefore we don't ask anybody else for their list.

Whilst direct marketing is in its infancy in Ireland, similar techniques were being employed a decade ago by the Passion Machine, as John Sutton recalled:

> I think the Passion Machine was successful because what we would have been doing in the first four years in the SFX was classic niche marketing; it wasn't mass marketing. We were literally building from a thousand people at a production to about six or seven thousand. We were lengthening the runs, we hadn't yet transferred out to the Olympia and even when we did, a big run was 60-70,000 people.
>
> What we were doing was basically working through mediums like direct mail, except our direct mail would have been a whole network of community groups and school groups. We would have been targeting young adults which would have included anything from 17 to 25 year olds, although after a couple of years we began concentrating out of the schools and more into the non-formal educational sector. We had someone who worked on it, to develop that sector.
>
> We did leaflet drops in Drumcondra[3] and all the immediate area. A survey we did at the time showed that 20 per cent of the audience came from walking distance of the hall. The other thing was that we took theatre on to the billboards, in 1984. We were the first people to do that and that would have come out of my SFX hat. My experience would have been rock and roll and band promotion and doing the poster and getting into PR, because they were the only affordable avenues.
>
> Another device we exploited was free samples. Apparently, Proctor and Gamble, who are the largest advertisers in the world, spend more money giving away free samples than they do on paid ads. The technique we used was to target particular groups of individuals — like salespeople working in shoe shops or whatever. If you get people in a selling capacity, for example if they're helping someone to try on a shoe, they need something to talk about to their customer. Taxi drivers are the classic case.
>
> The reason we used the free-sample technique was that the kind of plays we were doing required a certain dynamic with the audience. You couldn't really enjoy them if you were one of five people in a three hundred seat theatre. So we would "paper" the second

[3] North Dublin suburb.

or third nights which got us to the weekend and also it was the word of mouth over that weekend and into the next weekend. It's a very valuable technique as long as the product is good: then the audience grows on that word of mouth.

We had a show, *Home* by Paul Mercier, which had done a wonderful run in the SFX for three weeks. I was certain it had the legs to run for eight weeks in the Olympia, playing to that *Brownbread*[4] audience from the previous year. Literally eight days before the opening of the show it had sold 150 tickets and this was for a 1,000 seater theatre for eight weeks. Panic was breaking out and I said, "this is a wonderful show. I'm going to stuff the first five nights and word of mouth will carry it".

I printed up 10,000 free vouchers, going off some notional one-in-five or one-in-eight take-up, which is what had happened at the SFX. For two days the team gave out these vouchers in the shops all around the North inner city, avoiding the Southside. There was a little bit of panic in the Olympia when they discovered it was two free tickets and not two for the price of one but I said, "No, no point in that, they're not going to come for that". So we sat back and waited — on the opening night we had to turn away 2,500 people. But I remember Peter Sheridan coming up the next day and saying, "I drove past the Olympia last night, it was brilliant!".

It took us eleven nights to honour all the vouchers, but it took in £250,000 and just about paid for itself. I revealed this to the Arts Council. I said that *Home* had played to 59,000 people but unfortunately 19,000 of them were free but it really, really worked. They were not pleased!

We found in our experience that word of mouth was the crucial thing and hence the free samples. It was cheap and affordable. Goodwill was also built up. It helped to develop a relationship on an ongoing basis. The big difference between now and ten years ago is that now I could be much more targeted and sophisticated about it and influence the word of mouth, whereas we were doing it in a fairly naïve blanket way.

Arthur Lappin feels that theatre in Ireland, both commercial and subsidised, faces a very difficult situation at present. Among the reasons for this are the competing attractions which offer a more complete and enjoyable "night out", along with the failure to

[4] Another Passion Machine production, written by Roddy Doyle.

attract younger audiences, probably due to a key failure "to invest in the experience of the arts of young people".

> I'm more interested in generic marketing for the area of theatre. I think one of the biggest problems has been the lack of co-operation which has existed traditionally among theatres, both subsidised and unsubsidised. There has been a small breakthrough recently in relation to the joint panel advertisement in the *Irish Times*. This is terribly sensible and should have happened 20 years ago. If there were very significant in-depth marketing profiles done of theatre-going as an activity in Dublin, covering all the theatres, I believe there would be a generic continuity in the information we would glean. A really good database of consumer profiles, especially for theatre would be invaluable. It probably wouldn't reverse the current malaise, given the gap that has opened up in the last three years, but it would mean theatres would have to spend less on blanket promotions such as expensive press advertising, where most of the people who read it haven't the vaguest interest.

> Groundwork would have prided itself early on in having approached the production of commercial theatre in as professional and planned a way as any company had done in the period before. We did a lot of things for the first time, not so much marketing as advertising. We do analyse where our audience comes from, not in a very scientific way but I think we have a fairly clear idea. We use all sorts of things like "Shop and Save" which does allow you to focus on where a certain kind of suburban sale is coming from. That's almost dried up now, it's generating nothing. That's more advertising, I think, than marketing. The advertising message we put on the bank ATMs got a huge response.

> I've argued for a long time that theatres should set up four or six of these big poster sites on major routes into the city and use them, not just for the shows that are on but the message that "A night out in the theatre is a good experience". But I think theatres need to do a lot about making it a better experience. Many aspects of going to the theatre are actually not enjoyable, such as getting a drink at the interval or after the show. People have too many other choices offering these options in more comfortable surroundings.

> Another promotion we tried in the Gaiety was a subscription campaign where we packaged four plays in a season and tried to sell them. We targeted people that we knew were repeat business from our credit card lists but the take-up was negligible.

Since a number of people have suggested it as an ideal theatre for subscription selling, it is perhaps ironic that this technique is not favoured by the 371-seat Gate Theatre. Marie Rooney states:

> We decided a long time ago not to go that route. If you look at subscription houses in America, and we've toured there quite a few times, what you get is theatres with empty seats which have been paid for. The experience for the rest of the people in the auditorium is not a good one. You will sell your tickets in advance but you'll have people who won't be able to make the show and you won't be able to release the ticket for cancellations.
>
> At the Gate, if people have booked by telephone and not paid by credit card, we allow them to collect tickets up to 7.15 p.m. As a result, very often when you come into the Gate to collect your tickets there is a line of people queuing for cancellations. The immediate impression is that this is a hot ticket. It's becoming precious even before you see the show. And then when you go in, generally speaking, it's a full house and actors are getting the reaction which is so necessary for the process. It doesn't really matter to your actors that the tickets have been paid for if the seats are empty. They're not getting the required input from the audience.
>
> At the moment our box office isn't computerised. Happily we have a decision now to go ahead with it. This is great because it means obviously that I can get a lot more data. It's extremely important because it's very difficult to work without it.
>
> I think it would be very good for everybody to get together and do a "Go to the Theatre" campaign, although it would be tricky because there are so many theatres. What I would like to do here is have a "Go to the Gate" campaign. What we generally have to do is a show by show campaign because we don't have that money to put into a campaign which just says "go to the Gate" no matter what's on.

Direct marketing isn't applicable only to theatre, as Norah Norton has proved:

> Direct marketing to local authorities was an important area for us. When I saw capital projects appearing in the papers I wrote directly to whoever was mentioned as chief engineer to congratulate them and explain all about the "One Percent for Arts" scheme. This scheme allows them to allocate 1 per cent of any capital project to buy art. That got a good response because it was targeted and arrived as the money was flowing rather than at any old time.

If you work well with the councils and mediate the situation well, the potential is unlimited. We also initiated a programme of sculpture maintenance that we marketed to local authorities. One of these led to producing a sculpture trail leaflet for Dún Laoghaire/Rathdown, an idea which is now being marketed to other local authorities.

The Corporate Exhibition scheme was one form of promotion, which developed new audiences for the work and also provided a useful source of revenue. We put five pieces on plinths into a corporation for £700 a year and changed it three times a year. Very occasionally an anatomically correct piece would cause some controversy! We sold a lot of art through those exhibitions to people who mightn't normally have bought art.

We had very good coverage in the arts journals because we were running very interesting programmes. We never missed a PR opportunity of any sort. We got the *Echo*[5] which is not known for its high art interest, to do a big thing on public sculpture and how it affects people, asking why money is being spent on sculpture and not on filling pot holes and people loved it. Even controversy raises peoples' awareness. We had a big controversy over the Pépinière programme. Four young European artists working in the Factory had an exhibition in the Crawford and one of the journalists started a big "is this art?" controversy. It was brilliant because it went on for weeks. We appreciated it and the artists appreciated it because it got people going to look and the comments from the man on the street were very favourable. People are more open than they are given credit for.

With a comprehensive and highly impressive state of the art range of facilities and equipment, the Temple Bar Music Centre constitutes a valuable promotional asset in itself, as Paddy Dunning clearly appreciates:

The venue itself is used as a marketing tool. The Temple Bar Blues Festival, for instance, is being launched here and also the Heineken Green Energy Music Festival. As a result of those launches the Temple Bar Music Centre will receive press and promotion. It will automatically be marketed and advertised. The Music Centre is used as a launch platform for anything to do with music. Performance here is used as a marketing tool for rock bands, traditional

[5] An evening newspaper.

music bands, etc. And that is exactly what we hope to be, a plat-
form, a springboard, a showcase facility.

We market this Music Centre on a national and international level.
Marketing happens usually in our industry through straight-
forward advertising and also networking. Because it is a music
centre we have been working on establishing a network and con-
tacts with agents and promoters abroad. The people who use the
music centre can then avail of these contacts. To get a product sold
in Australia or America, you need a record contract or a publish-
ing contract or you need to have an agent to book you out in those
territories. You have to go to the conferences, trade fairs and trade
shows. Anywhere there is a trade show happening, there is poten-
tial there.

I think when U2 started to snowball people saw that the potential
is there, even though we are on a small island, to get a band to-
gether and sell that product all over the world. This is where the
Irish Trade Board comes into play and also the IDA, Forbairt.[6]
They are trying to assist with managers who have products to sell
abroad. This has proved to be quite successful so far, with lots of
bands getting off this island, being assisted by the Trade Board
and meeting people in Europe, Australia, Asia and America. For
instance, various companies are trying to establish a European
Tour network, whereby Irish bands can get into an already estab-
lished network of festivals.

As well as reflecting and influencing trends in the music industry,
Hot Press has been very effective in promoting itself as a magazine
over many years. According to Jackie Hayden:

We would regard ourselves as very active in marketing *Hot Press*.
We're constantly marketing but we do it on the run. We don't have
the resources to sit down and make an annual plan and a lot of it
we do by instinct. That's possibly due to our management struc-
ture which is very flat. Probably instinctively we avoid bureauc-
racy as much as possible. We tend to have meetings on the run. I
think we make great use of our time that way. We're constantly
watching out for opportunities to get the *Hot Press* name out to as
many people as possible. It would be nice if we could sit down
and take three months to plan a marketing campaign but at no
stage do we ever know we have the money to do that, so we're

[6] Irish industrial development agencies.

always doing it when we feel either we have to do it or we come up with a good idea.

As a small independent distributor, Clarence Pictures has to make some very sharp calculations on the promotional budget to allocate each film. Jane Doolin says:

> You can't leave any stone unturned when you have less money and a tough picture. The job is to go for as much editorial as possible, getting talent in, trying to push that side of it. You're also trying to get tie-ins, to get sponsors and things like that. They stick their name on the ticket and you do a thing with FM 104 radio or something for free tickets and the screenings then give you word of mouth.

> On some films you can be very lucky and have a casting crew available to work for you. On others, for example, *Secrets and Lies* we had nobody and we were left trying to generate things. On *Kids*, Larry Clark, the director, came over and did a load of interviews for us and then we were able to get the whole controversial thing going, having people screaming at Gerry Ryan[7] or something, getting him all excited and having phone-ins.

Promotional material is another area where the differences between American and European productions tend to become obvious.

> One thing I still have problems with, especially with Irish and UK films, is that in the smaller-scale productions, they won't even have proper sets of stills at the end of the film. So when you come to putting something out, you are left with trying to do posters, put together press kits etc. Now the press are used to having full sets of notes, press kits, good stills, colour, black and white. Television people are used to having electronic press kits with interviews of actors. It's not actually that much to think about it in production. I know because my background was initially in production.

[7] Radio chat show.

PRICING: A SENSITIVE ISSUE IN THE ARTS?

Arthur Lappin states:

> Our pricing policy is sometimes, very rarely, dictated by the con-
> tent of the show we are doing. If previews indicated the show
> might do well if we charged lower seat prices we would consider
> doing so. But by and large the experience is that, for successful
> shows, the dearer seats sell first. I think if there's price resistance
> there's usually something wrong on the stage. If people are willing
> to pay £15 they are likely to pay £17, although I know you can
> push that to a limit too.

He recognises that pricing in the arts is connected, not only to
demand but to the question of access:

> Hilton Edwards had a great tenet years ago and I think it is as
> valid today as it was then. "There should always be a row of seats
> for a shilling". If people didn't have money and desperately
> wanted to see the show there was always a row of seats for them.
> If there's public money involved and indeed even if there isn't, I
> think it would be very foolish to ignore the socio-economic aspects
> of what you are selling.

> I think having a range of cheaper seats, maybe on certain nights of
> the week, so that if people want a decent seat and don't want to
> pay more than £8 or £9, is perhaps similar to Hilton's old idea. You
> can find though, if a show isn't doing well and you offer a very
> good deal on Monday and Tuesday nights, that the people who
> would normally go on Saturday night switch to the Monday in-
> stead. It's costing you money."

Passion Machine experienced a rather higher level of price sensi-
tivity in its efforts to build an audience. John Sutton explains:

> We had a tiered ticket price, even though it was fairly straightfor-
> ward — maybe four different levels. But it would all have been
> cheaper than city centre theatre. For the regular theatregoers in the
> audience their expectation would have been that they would pay
> less up in the SFX than in the Abbey. Also, of course, the access is-
> sue would have been a paramount thing with us.

PLACE/DISTRIBUTION: BARRIERS, ACCESS AND AUDIENCE

Because of the nature of service provision, especially in the arts,
the issue of place/distribution is more complex than for goods.

For Norah Norton an important element in the distribution strategy of the Sculpture Factory was to bring the work to new audiences in as many ways as possible, such as use of the 1 per cent scheme throughout the country. Temple Bar Gallery offers new opportunities:

> I know one of the joys for me of working in Temple Bar Gallery is that we actually have a shop window. It's important that people feel free to come in. There are things that might be done like putting up welcoming signs. In a way it is sinning against the religions of the public art galleries. But maybe they are sins that need to be committed. Any barriers should be removed. Working with the staff matters too because you would be surprised how important ethos is. It's a very strange ephemeral thing. It is important that the invigilators know about what we are actually doing, know about the artist's work that they are invigilating. We are recruiting some long-term unemployed people from the inner city to be invigilators. I don't know if that will make any difference, one way or the other.

> I hope to have a summer and a Christmas show of members' work in the atrium gallery. That is a way of promoting the artists' work and also creating more public and arts community awareness of the studio side of what we do. The gallery is the public face.

> Overall, I think there have been vast improvements. When I was growing up, you crept into a gallery and the doorman watched you suspiciously. Nowadays, people have put cafes into galleries, fashion shows are run in galleries. Galleries are being made much more accessible to a wider audience.

As a distributor the key issue for Jane Doolin in relation to distribution channels is whether a film can go "wide", that is, go beyond the restricted arthouse circuit. In this she is dependent to a large extent on the response of a very wide and varied selection of film exhibitors, who also give her a lot of feedback:

> They know their audiences very well. Some of the smaller ones have a very loyal audience. They were terrified of *Trainspotting* so we played cities first and then slowly filtered into the rest of the country. They are used to us because I very rarely have films that don't have something, either sex or violence or a gay film etc. They are used to me ringing and they have actually got less scared, I think, because we have tried to play these films out of town. *Kids* has played in Portrush, it is going to play in Sligo and places like

that. Before, nobody would have even rung to see if they wanted
it.

Sometimes they are not the best judges of a movie and how it is
going to perform, if they are a bit scared of it. That is why you
have to push and promote it. You have to believe in it and prove
them wrong. "Frankly, I don't care if you hate *Trainspotting* but
will your audience go?" But there is a good working relationship
between us all I think. In fact, we have had a cinema date thing for
the past three years, which is three days where all the distributors
get together and we run three days of movies for all the exhibitors
around the country.

Overall the situation has changed a lot in the last few years:

When I did *December Bride*, it was in the Lighthouse,[8] it was out
with Albert Kelly in Harold's Cross, it was in Monaghan and it did
independent cinemas and we did really well. But if I had a Tal-
laght or a Coolock[9] at the time we could have really shifted it. By
the time it came to *Into The West* we hit the UCIs which hadn't
happened before and that started to change the market. The cine-
mas started to get upgraded, even the smaller independents
started to open more screens. So what is available to the public is
not a grimy, dirty experience anymore. Cinemas are clean, nice.
The multiplexes, of course, have been a key factor. They have
really shaken everybody up.

One of the biggest continuing problems is foreign language films.
The only one that did work was *La Haine*. It actually worked in
Cork and Galway and the Screen (Dublin) but in the main it is
very difficult to shift a foreign language film outside of Dublin be-
cause there isn't a Lighthouse in Galway, Cork, Limerick, or what-
ever and the audience is there. I mean, we are talking about uni-
versity cities.

For Paddy Dunning, distribution and place are intimately com-
bined:

The reason this building was built was because of a need for mu-
sicians to rehearse somewhere; there is a need for bands to play,
for personnel to be trained and a need for information. So we have
in the last five years put together a plan that will deal with some

[8] Art house cinema in Dublin, closed 1996.

[9] New multiplex cinemas.

of those requirements. We have rehearsal studios, recording studios, training rooms and editing facilities.

One of our major facilities is a television studio cum venue. The independent production companies who rent this facility out bring in the bands and record them for television. They normally sell to European and American TV networks, RTE, Channel 4, TV3 and Teilifís na Gaeilge[10].

We are trying to promote music through the medium of television. The problem with bands playing at the moment is that they are playing to a small audience. A lot of effort is put into that but in terms of economics, compared to the effort they have put in they should get an awful lot more out of it. If these performances were recorded for television, they would also have another product that would be on CD and video. They could then sell it in video shops, send it to other record companies and also send it to the television stations.

In terms of the music itself as an art form, touring is, of course, an important element in distribution:

Traditional bands now seem to be making a lot of money by touring America. Initially, rock music was the commercial end of the industry but now traditional music, folk music and world music have found a market. They are doing very well but the new acts need to be nurtured, they need better facilities.

Touring is also one aspect of the distribution system for theatre. The Gate has toured widely over many years, including a recent major Beckett Festival in New York. According to Marie Rooney:

We are bringing 19 Beckett plays to the Lincoln Center's Festival for the Performing Arts. These will run in two theatres over a two-week period, with a company of 49. The event has generated a huge amount of press interest. We've had a film crew over from New York and a journalist from the *New York Times* is coming over for three days, they're doing a big feature. Of course, all of this helps very much to raise the profile.

[10] A new Irish language television channel which began broadcasting in late 1996.

This profile and the branding that goes with it have helped shelter the Gate from the chill wind of competition from alternative attractions, including cinema:

> Attendance has been very good over the years, averaging 80 per cent to 90 per cent of capacity, 95 per cent one year. We are fortunate because we have an audience in the Gate. These are people who come to see a lot of shows in the year. We must be aware of them, they are our main support and they are quite loyal.

> But, of course, we are anxious to build on the audience, to get a younger profile. We did *Decadence* with Stephen Berkoff. That drew a new audience. Young people who had never been to the Gate came to see him because he had been in a major movie and because he's so controversial. It was a nightmare for me. We packed every night but there was hardly any advance booking. They came up just like they were coming to the cinema. He then came back to direct *Salome* which also got a great mix into the theatre.

The Passion Machine was also very successful in establishing a unique brand and attracting a broader audience, in spite of what John Sutton saw as the difficulty of their marketing proposition:

> Will you come out on a winter's night, to a cold hall on the edge of an inner-city ghetto and come see a play that you probably have heard little about and you certainly won't know any of the cast or the writers? The way Passion Machine developed an audience was parallel to the way a band develops a following. The audience was broader than the usual theatre audience but probably 50 per cent of them were going to plays already. But the one thing we all noticed is that in the SFX the average age was 25–35. When we moved to the Olympia it went up by 10 or 15 years but I suspect they thought they were going to *Run for your Wife*, etc.

> When we were putting on our first piece, a drama with music, we went down to the Project[11] and enquired if it was possible to put our work on there because we were looking at this enormous place, the SFX and saying we can't make a go of it here. The SFX had been bingo on Saturday nights and rehearsals for the National Symphony Orchestra and now it had become this rock-and-roll place and bingo but it certainly wasn't known for plays. So we

[11] Avant-garde arts venue, Dublin city centre.

explored that over maybe 18 months before deciding where to go with our musical.

Eventually we decided to put it on in the SFX ourselves. What was defining there was that putting it on in that place gave a certain identity to the work — it very much placed it in a context. And we had this idea of what the Americans used to call theatre in the community as opposed to community theatre. We were saying that we're professional. We're going to provide a product and we're going to put it on a particular platform. What's exciting here is where it is, what kind of people we're going to bring in. We very actively went out after our audience, using very similar techniques to those used by bands, poster, PR etc. By the time we left the SFX the audience was up to about 10,000. Its success was because it was niche marketing. This helped overcome a lot of the barriers to theatre-going.

Jerome Hynes regards these barriers as a key issue:

For instance, somebody who rings a box office, it may be the only experience they have of direct contact with the organisation. Therefore the way in which they are dealt with is very important. We all know about the box-office people who hide the house and don't tell you what seats are available or make it difficult for you to get in and all that sort of stuff. "Should you really be coming here at all — I'm not sure if it's actually for you?" Where you walk away feeling a little bit uncomfortable, or you arrive for the show feeling uncomfortable. So it's always important that that first contact is good.

A lot of the barriers are very simple. For example, where is the theatre, is it easy to get there, is it easy to park, can I get a bus there? That first experience is very important, it's like doing a recce. If you can break that barrier once it makes it much easier to get somebody back again. When thinking about barriers you must put yourself in the shoes of the customer. What you've got to say is "OK, that brochure is fine from our point of view" and then go around the far side and read it as a customer and say "can I understand it?". You've got to test-market it, put it out to people and say "do you understand that — what's missing?" One of the things we do in our brochure is indicate how to get to Wexford both from within and from outside of Ireland, with details of travel and accommodation. I remember Peter Jones, English National Opera, said to me in my first year that one of his frustrations was whether to fly into Dublin or Waterford, whether to hire a car,

where to stay. He said, "that might sound awful stupid but in fact it's barrier, barrier, barrier". If it's that difficult for him, working in Opera and with a whole team of secretaries, what chance has the ordinary customer?

Arthur Lappin agrees:

> That sacred-cow syndrome that theatre still has is also a problem. I asked someone who's working with me at the moment how many of her friends went to the theatre. She said, "well it's so much more difficult. You have to book and you have to pick up the tickets." Now it's not actually that difficult to buy tickets for the theatre but that's the way it's perceived. There are perception problems there which I think a good marketing campaign for theatre in general would be very valuable in addressing.
>
> And such a campaign should also celebrate the diversity of theatre. You can see *Six Characters in Search of an Author* in the Abbey, which is probably the only time in this generation you'll get to see that play professionally produced. There's great theatre going on in this city, night in and night out but I think somehow the public have a sense that it's a less enjoyable night out, it's harder work to go to the theatre than it is to go to the cinema, particularly for that younger generation coming up.

EARNED VERSUS UNEARNED INCOME: A BALANCING ACT?

John Sutton believes that earned income should be a central issue for arts organisations:

> Arts organisations need some sort of signpost that earned income has to be looked at and seriously looked at and that automatically pushes you into marketing.
>
> When we were starting out in the 1980s the Arts Council was your mantra and if you could get in there and get your relationship going, that was it. You were in the system. I'm not aware of any groups in the independent sector who have really fundamentally replaced that relationship or developed other substantial twin-track sources of funds.
>
> In the mid-1980s, I went on a fact-finding mission to the Citizens' Theatre in the Gorbals, in inner-city Glasgow. They had put together a deal with their funding agency, whereby the more customers, the more grant-aid they got. They were running this admissions policy of 50p or £1 to see a professionally produced

classic version of *Hamlet*, which was visually stunning. But their yardstick in terms of one of their key funders, was "more people, more money". The feeling in Passion Machine was that we were penalised in the grant-aid divvy-out because we were getting people in.

Having worked in the Arts Council before moving into commercial theatre, Arthur Lappin appreciates the complexities of the subsidy debate:

I think the commercial imperative in subsidised operations is absolutely important. Subsidy tends to sap the type of entrepreneurial energy which is as vital, perhaps more vital, to the subsidised sector as it is to the commercial one.

However, looking at it from a subsidiser's point of view, obviously there is a need for certain organisations to exist that don't have to have such a high concern for that. The classic example is the Peacock within the Abbey, where Irish language drama in particular is very highly subsidised.

The issue that arises there is not to say "stop doing Irish language drama" but rather to understand what resources are actually being allocated to what. The point is that it should be done on a planned and methodical basis, so that you know what you are spending the money on and why.

PERSONNEL: THE KEY TO SUCCESS

Possibly one of the most striking indications of a move to a customer-centred approach in arts organisations is the apparently widely accepted belief in a high degree of staff involvement. The focus on the customer is very obvious in Jerome Hynes' approach to staff involvement:

For example, we use a lot of volunteers as front of house staff but what we say is you're volunteers but you're not amateurs. You're offering a professional service. We provide a quality of service course. It works very well in that people learn from it but also that it allows people to share their experiences and learn from each other. Right through the organisation we talk about this thing of individual personal service, without it being, dare I say it, American, without it being false.

A similar approach is taken in the Temple Bar Music Centre. Paddy Dunning explains:

> We have a policy of always helping your co-worker, your colleague, advising each other, etc. There is a good vibe with a good working atmosphere. The staff are a key element of the success of this Centre. If you do not like me, you won't come back, so it needs a particular type of person interested in service. We are committed to ongoing training for the staff, which we are doing with FÁS under community employment programmes.

In the Sculpture Factory, Norah Norton was totally committed to the idea of complete staff involvement at all levels:

> Everybody came to management meetings and good ideas came from all sources, including the caretaker. It was totally open, everybody had an input. I believe strongly in this consensus approach. It has a direct impact on the ethos of the organisation. It also leads to an incredible group dynamic where people cross lines to help each other out. I believed it was also important to develop an ethos which was extraordinarily artist-friendly. It was something I felt the entire personnel had to work at. At the end of meetings I used to say to them, "why are we here? — we're here to serve artists". It sounds very dumb and Disneyish but people do forget and you can't afford that!

List of Participants

Jane Doolin, Chief Executive, Clarence Pictures Ltd.

Paddy Dunning, Managing Director, Temple Bar Music Centre, Dublin

Jackie Hayden, General Manager, *Hot Press* magazine

Jerome Hynes, Chief Executive, Wexford Festival Opera

Arthur Lappin, Film Producer and former Chief Executive, Groundwork Productions

Norah Norton, National Sculpture Factory, Cork and Temple Bar Gallery and Studios, Dublin

Marie Rooney, Deputy Director, Gate Theatre, Dublin

John Sutton, Founder member and Managing Director of Passion Machine, 1984–91.

10

ARTS MARKETING: A REVIEW OF RESEARCH AND ISSUES

Emer Ní Bhrádaigh

Marketing is not an activity with which those working in the cultural sector have an easy affinity: many fear that the influence of market forces in the first place, and the implementation of marketing techniques in the second, will be detrimental to the cultural or artistic product. Some of these fears are legitimate, but judicious use of marketing strategies and tools should lead to greater stability and viability in the sector.

There are many reasons for the delay in applying marketing concepts to the arts and cultural sector: these include a lack of resourcing; a dearth of professional managerial and business skills; an understanding of marketing that is limited to promotion and public relations; and the belief that marketing will have a negative effect on artistic creativity and lead to "products" which satisfy only the lowest common denominator. So marketing strategies and tools which have already been widely developed and used in the fast-moving consumer goods sector have not been seen to have application in the cultural sector. Nor has the cultural sector been as comprehensively addressed by marketing and business academics. Bridging this gap between arts and cultural practitioners and managers and marketing practitioners/ academics is an exercise which should deliver many mutual benefits.

Involvement and commitment are required from the state, educational establishments and from cultural organisations themselves to enable the arts sector to benefit from good practice in arts marketing. Those cultural organisations which have adopted marketing strategies and tools have benefited greatly in terms of larger audiences and closer relationships with that audience, and have not necessarily been adversely affected from the

artistic/cultural point of view. Washington Opera's price differ-
entiation strategy, the collective marketing of cultural events in
Amsterdam through the Uitburo, and the segmentation analysis
of art gallery visitors in Australia are all instructive in this regard.
The success of these and other organisations will be discussed
later in this chapter.

DEFINITION AND DEVELOPMENT OF MARKETING

Definition

Kotler's (1994:13) definition of marketing is:

> A social and managerial process by which individuals and groups
> obtain what they need and want through creating, offering and
> exchanging products and value with others.

This definition emphasises the notions of exchange, relationships
and delivery of value. While these basic concepts can be applied
to most sectors, modification is required when moving from its
use in branded fast-moving consumer goods (FMCGs) such as
washing powder, to services such as health care or education and
to the cultural sector. The major difficulty which these latter sec-
tors experience with such a transfer resides in the central market-
ing notion that products are created to suit the customer. For the
arts community, this would be to dilute the cultural product, or
worse, to ignore the creative expression of the artist by placing an
excessive emphasis on the perceived needs or wants of the cus-
tomer. A balance has to be attained between the cultural or artistic
product and the public's desires and needs. In the arts sector, the
starting point is the cultural or artistic product — the core product
— and then one goes on to address the attendant issues — the
augmented product. In the performing arts, for example, the play
is the core product. The augmented product includes the promo-
tion, pricing, ticket selling, parking and catering facilities, issues
of image, etc.; in other words, the whole set of benefits or value
package, as perceived by the consumer. Marketing of culture and
arts needs to safeguard the core product, while modifying the
non-core elements of the augmented product.

Another difficulty is in defining value. It may be easily defined
in physical products which serve a particular function or supply a
specific need — such as a bar of chocolate or a chair — however,
difficulties arise in cases where the consumer is heavily involved

in the purchase of the product or service and where there is a high degree of subjectivity with potentially different interpretations of the same product. There is a need to look more closely at the actual wants and needs and to allow for different and complex perceptions of what constitutes value.

Even in what would seem to be relatively straightforward decisions such as the purchase of a car, value considerations are important. Cost, size, and comfort matter but decisions are also made on the basis of less tangible factors like reputations for reliability, style, image, the personality of the purchaser, and identity issues. A potential customer will perceive a product as having a certain image or personality and will choose that product if they identify with it.

The reasons for attending a play can range from celebrating a birthday, to wanting a night out, wishing to see a particular play or actor, or adding to an already well-informed involvement in theatre. The value an audience member derives from attending the play is not limited to the play itself (the core product) but also embraces the overall experience and interaction with the theatre — from the advance notices of the play, to the booking facilities, the parking facilities, the foyer and cloakroom and the bar service at the interval — the augmented product.

This more complete understanding of what constitutes value for money has been very successfully applied by the Washington Opera in the US which totally revamped its pricing strategy. This organisation's box office revenue makes up 57 per cent of its total income, the balance of revenue (43 per cent) coming from contributions and grants. (It should be noted that the funding framework in the US is very different to that of Europe where there is a much higher dependency on public subsidy.) Rather than implement the usual across-the-board 5–6 per cent increase in ticket prices, a detailed analysis was carried out of the overall value of each seat at the Opera. This analysis went beyond taking account of such issues as sightlines and proximity to the stage to include the day of attendance and the time the booking was made. Nine different pricing levels were introduced in this theatre of 2,200 seats. The exercise actually resulted in the lowering of prices on 30 per cent of the seats, thus improving access to an art form which is often perceived as expensive and elitist. There was no decrease at all in subscription renewals even on those seats which showed an increase of more than 50 per cent in ticket prices.

Overall subscription renewal rose from a previous average of 70 per cent to 94 per cent during the year the new ticketing system was introduced. The essential change here was a more defined segmentation of the market into particular groups, and a more sophisticated calculation of the perceived value of the overall experience — extending beyond the artistic (core) product to the augmented product. The result was an 8–9 per cent increase in ticket revenue overall (Legaretta, 1994).

Development of Arts Marketing

Although marketing activity goes back to the beginning of any kind of trading and barter, marketing theory has developed mainly over the last five decades. While the theoretical basis of marketing is based on economics, the science has evolved largely through embracing such other sciences as sociology, psychology, communications and consumer behaviour. Much of this development has derived from considerations which one might well term "cultural" in that they involve studies of human and social behaviour: lifestyles, attitudes, consumption patterns, opinion leaders, personality, economic and political influences, etc. The challenge for the cultural sector is to reclaim the analysis and interpretation of culture and human behaviour for its own benefit.

As a discipline, marketing is now at the stage where there is increasing emphasis on studying its application to particular economic sectors. This started largely with FMCGs — the Persils and Coca Colas of the world. The next sectors to benefit from this application were industrial and service sectors like computers and transport. Following closely were the non-profit services such as education and healthcare. It was at this time too, in the 1980s, that the arts and cultural sectors began to integrate marketing concepts into their activities, and that marketing academics began to research the sector (Colbert, 1994:13).

Various definitions of marketing culture and the arts have been put forward:

> The aim of arts marketing is to bring an appropriate number of people, drawn from the widest possible range of social background, economic condition and age, into an appropriate form of contact with the artist and in so doing to arrive at the best financial outcome that is compatible with the achievements of that aim (Diggle, 1994:25).

Diggle approaches marketing from an arts background, starting with the artistic creation, and applying marketing in order to realise an artistic goal: that of bringing art to the public. His perspective gives less active consideration to the public's tastes, opinions, needs or wants. If an organisation's mission is to bring more people into contact with the arts, then those people and their wants (in the broad sense) need to be given more priority. Giving limited consideration to the customers' wants will be to the long-term detriment of the cultural organisation, as customers are less likely to feel wanted or welcome or to feel they have received value in exchange for their investment. Diggle's interpretation of marketing is to promote given performances and to entice as wide a population as possible to attend. But marketing extends beyond this limited definition to include market research and market segmentation. Promotion is just one element of what is termed the marketing mix (product, price, promotion, place).

Colbert's (1994:14) definition is more comprehensive:

> the art of reaching those market segments likely to be interested in the product while adjusting to the product the commercial variables — price, place and promotion — to put the product in contact with a sufficient number of consumers and to reach the objectives consistent with the mission of the cultural enterprise.

This definition acknowledges the importance of defending artistic creativity and cultural identity, but it also recognises the importance of engaging and communicating with the consumer — whether purchaser, visitor, audience member, or participant. It starts with a given product — the artist's creation — and then considers the consumer's point of view.

Hill, O'Sullivan & O'Sullivan (1995:xii) also recognise the importance of a broader approach conceding that "writings about arts marketing have tended to be tactical, concentrating on particular areas of marketing technique (such as pricing and promotion) rather than on a holistic account". They go on to say that:

> Marketing is not a veneer that can be applied to existing decisions to make them successful. It needs to be involved from the earliest stages of planning to connect the organisation with its customers (1995:x).

Hirschman's Three Market Segments

Hirschman (1983) had earlier addressed the problem of applying traditional marketing concepts to artists and ideologues, stating that the difficulty lies in their motivation — to develop independently of others' needs and opinions. An artist strives to create, to be individual, to create for the creation's sake, rather than to fulfil some external utilitarian or functional requirement. It is argued that the creative person can be oriented towards three audiences or market segments: (a) the self — in order to fulfil oneself; (b) peers and industry professionals — in order to gain respect or recognition; and (c) the public at large — in order to gain commercial success. The problem arises in the relative importance of each of these market segments, and in recognising that each requires a different strategy.

FIGURE 10.1: HIRSCHMAN'S THREE MARKET SEGMENTS

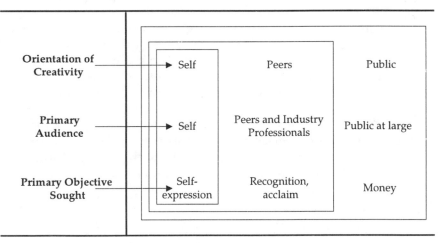

Source: Adapted from Hirschman, Elizabeth C. (1983), "Aesthetics, Ideologies and the Limits of the Marketing Concept", *Journal of Marketing*, vol. 47 (Summer), p49. Use authorised by the American Marketing Association.

Marketing and audience development require an orientation to the third segment — the public at large. In an industry such as the cultural sector which encourages creativity and in particular self and/or peer orientation, there is a danger that the commercial orientation may be inadequately addressed. It is not uncommon to find that mailing lists may only include friends and fellow professionals, to the neglect of regular audience members or visitors.

Advertising of theatrical productions may assume a prior knowledge and understanding of the production, and act largely as an information service for those already committed to the venue or theatre company rather than aimed at attracting new audience members (Hardy, 1981:13).

Hirschman also argues that by their very nature, artistic products — abstract, subjectively experienced, non-utilitarian, unique and holistic — pose problems for the application of traditional market research and marketing techniques. Consumers have difficulty in arriving at an objective evaluation of individual elements of an artistic product, or at a judgement that one product is better than another. It is concluded that "the major impact that aesthetic and ideological products have on consumers' lives in both an individual and collective sense suggests strongly a rationale for their investigation" (Hirschman, 1983:53–4), and that we "should not attempt to reconstruct them to suit our marketing assumptions, rather marketing concepts and technologies should be modified to fit their essence" (1983:54).

MARKETING IN THE CULTURAL SECTOR

The Tension between Marketing and Cultural/Artistic Integrity

Without sufficient knowledge and understanding of the consumer (purchaser, audience member, participant, tourist etc.), the appropriate *augmented* product cannot be adequately developed by the supplier. A common fault in the application of marketing concepts to the cultural sector is parachuting in of inexpert or insensitive marketing consultants on a consultancy basis. As Duffy (1994:82) states: "Emphasis on 'marketing the product' or 'product effectiveness' may lead to oversimplification, or worse, to the bogus history which the 'industrialisation' of heritage encourages." He goes on to recall an American tourism consultant concluding that Carrickfergus Castle was "built all wrong"! It is for these very reasons that a twin-track approach to development is required — increased academic research in marketing culture and the arts, and an increased understanding of marketing among those engaged in the cultural sector.

This tension between the two sectors is particularly evident in relation to the development and preservation of minority cultures.

The research study *Ó Bhonn Aníos*[1] — *a Tourism Strategy for the Gaeltacht* (Convery et al., 1994) looked at the development of tourism in the Gaeltacht (Irish language-speaking) areas of the west coast of Ireland. The need for sensitivity is clearly articulated, the Gaeltacht being not only "a place apart, a cultural mecca" (1994:9), needing an approach which ensured that visitors get the message that "the Gaeltacht is different, somewhat special and fragile, both culturally and physically, and needs to be cherished" (1994:12).

The challenge lies in marrying the objectives of Hirschman's first market segment — the self — with the third segment — the public at large. This may not be attainable in all circumstances, and can often be exacerbated by an inadequate appreciation of the range of concerns which are relevant to marketing. Hardy (1981: 15) discusses a fairly common instance of this: "The political power in theatres is usually vested in the Artistic Director who sees his role as deciding on the programme mix and he views the task of the Marketing Officer as selling tickets." An understanding that marketing is more than selling or promotion should lead to a recognition that the marketing function is essential to the definition of objectives and the overall presentation of the (augmented) product.

Marketing Skills Gap in the Irish Cultural Sector

Clancy's study (1994) revealed overall a marked weakness in business and managerial skills within the cultural sector, the majority of those employed in managerial/business positions in the arts having come from an arts or humanities education. By and large the business skills of culture managers have been learned either on-the-job or on short in-service training courses. The relative absence of skilled marketing graduates within the sector means that expertise is not developed and grown from within, but is brought in piecemeal through the use of consultants on an ad hoc basis.

The lack of recognition of the importance of marketing — at least implicitly — is further illustrated by the level at which arts managers rank management tasks: managing relationships with audiences is ranked at number 14 (in a listing of 18 tasks), well below managing relationships with national institutions/funding

[1] *From the Bottom Up.*

agencies (5), managing relationships with artists (8) and managing relationships with their own governing bodies (10) (Clancy, 1994). Such an ordering would be highly unusual in the majority of more consumer-oriented companies.

The high ranking of the relationship with funding bodies seems to reflect both the uncertainties of long-term funding (An Chomhairle Ealaíon, 1994), but also perhaps a general feeling that the arts deserve to and should be publicly funded. The importance of the arts for social, cultural and economic development, and therefore the need for it to be publicly funded, is not disputed. However, the over-reliance on public funding (relationship with national institutions/funding agencies) and the limited use of fully integrated strategic and operational marketing needs to be addressed.

Advertising and public relations activities constitute the most common marketing tools used in the cultural sector. While these are key elements, we have seen that the other elements of the marketing mix (product, price and place or distribution) are inadequately addressed. This limited use of marketing can be partly attributed to lack of understanding of and training in marketing, resource constraints, or a belief that no more is required.

A further indication of this limited definition of marketing, if one is needed, is to be found in *Views of Theatre in Ireland 1995*: 82 per cent of the organisations had no marketing plan, and of the 28 per cent that did, the issues primarily covered were advertising and promotion (An Chomhairle Ealaíon, 1995:158). In addition, over one third (36 per cent) of organisations never conducted any market research. Only 11 per cent of the sample commissioned market research, while the balance of 53 per cent opted to use in-house personnel to conduct the research.

State Support for Marketing

The mission statements of both Arts Councils in Ireland emphasise the need for greater access to the arts and underline the importance of the relationship between artists and audiences. Recent audience surveys also reflect this concern (Clancy et al., 1994:99). This reflects the concerns identified by Hirschman's third market segment — the public, rather than only the artist him/herself and the artist's peers. If the true ideal of a state arts council is to get more people involved in the arts or in the consumption of cultural

products and services, this last segment must be addressed and the vital role of marketing in achieving these aims should be underpinned by a strong policy commitment and a corresponding investment in the development of appropriate expertise.

Specific investment in marketing has been a key criterion in the development of other industry sectors, in Ireland and in other EU states. Irish state agencies charged with supporting other sectors such as An Bord Tráchtála, Forbairt, An Bord Bia and Bord Fáilte have recognised the validity and the particular importance of marketing as a distinct function within the overall operation and development of a sector. Grant-in-aid in these sectors is related to the marketability of a product/service. The role of state support is particularly important at the start-up phase of new businesses and in sectors characterised by small enterprises. This often takes the form of marketing advisory services, or the fostering of a marketing orientation, either by including marketing activities as a core part of the application procedure, or by providing for the sharing of marketing expertise among small complementary organisations. This strategy should be applied in the cultural sector in tandem with the current criteria.

Applying a marketing orientation and philosophy in an organisation is a long-term process, as the aim is to build a strong product, identity and orientation. Hence the need for long-term investment. All too often expenditure in marketing, because of its intangibility, is seen as an expense rather than as an investment. Marketing should not be equated to sales — which is a short-term activity, frequently based on maximising the short-term benefits for the seller. The phenomenal success of the American film industry world-wide — 80 per cent of films seen by Europeans are produced in Hollywood (Quinn, 1995:388) — is to a large extent attributable to the investment in the marketing of the industry and of its products.

Strategic Alliances

Strategic co-operative alliances are commonplace in other industry sectors, and can also deliver marketing benefits for cultural organisations. Complementary organisations can share knowledge, resources and expenses, realise economies of scale, open up new audiences for each other. The Uitburo in Amsterdam is a marketing consortium which markets the events and productions of subscribing arts and cultural organisations. It has built up a

wealth of market knowledge and marketing skills, and is recognised by the population of the city as the distribution channel through which to access cultural events.

Scheff and Kotler (1996) give a number of examples of successful collaborations both within the cultural sector and also with non-cultural organisations. The American Symphony Orchestra in New York City has collaborated with Concordia Orchestra, sharing management and administration teams, but retaining their own identities (via stationery, logo etc.). In this way, they have managed to create a cross-over between their respective audiences. The Afro-American Historical and Cultural Museum in Philadelphia has operated as a gateway into the arts for many in the black community, thus providing numerous co-operation opportunities for community and cultural groups.

Alliances or collaborations are not limited to within the cultural sector itself. The far-reaching effects of the arts sector on the economic, social, cultural and international development of Ireland can only be realised through alliances with bodies such as Bord Fáilte, An Bord Tráchtála, Local Government, educational institutions, as well as commercial sponsors. The key point with a strategic alliance is that it is an equal partnership with benefits for both parties: a win-win relationship. Without this equality, a dependency can develop. There are various examples of organisations which exploit the cultural sector for their own advantage. On a European level, Mac Craith (1994:154) states that:

> a number of tourism boards in European regions, including for example Wales and Scotland, but also non-Celtic language areas such as Friesland, have already recognised a positive correlation between the active promotion of minority languages and the growth in tourism-related development.

However, culture/tourism collaboration in the past has had some negative outcomes, despite the considerable potential of strategic alliances in this area. Such failures may be attributed in part to problems associated with marketing. Among the reasons for the failure of the Celtworld project, which attempted to present an accessible dignified package of Celtic mythology and heritage, was the insufficient attention paid to the marketing aspects — one of the ultimate keys to the long-term viability of any project. Problems included insufficient market research to predict accurate visitor numbers, and the level of repeat visits. Repeat visits were

always highly unlikely given the lack of depth in the designed product. Furthermore, the required high level of one-visit-only visitors, which would have compensated for the low level of repeat visits, was unachievable due to the low population density of the area and its peripheral location.

Such failures can be avoided through the creation of strategic long-term links. Only in this way can the disparate, often conflicting aims and concerns of the different sectors engaged in the alliance be addressed and considered.

CONCLUSION

This chapter is an attempt to bridge the gap between practitioners in the cultural sector and marketing practitioners. Its aim has been to create an appreciation of the importance and the benefits of marketing for the cultural sector. It recognises that marketing needs to be applied in the context of the problems particular to the cultural sector — primarily that purely commercial yardsticks cannot be applied without due consideration for cultural and artistic implications. However, it proposes that many of the problems of the cultural sector (such as lack of funding, and fragmentation) could be solved through the knowledgeable application of marketing concepts.

References

An Chomhairle Ealaíon/Arts Council (1994), *The Arts Plan 1995–1997*, Dublin.

An Chomhairle Ealaíon/Arts Council (1995), *Views of Theatre in Ireland*, Dublin.

Clancy, Paula (1994), *Managing the Cultural Sector*, Dublin: Oak Tree Press.

Clancy, Paula, Drury, M., Kelly, A., Brannick, T. & Pratschke, S. (1994), *The Public and the Arts*, Dublin: The Arts Council and the Graduate School of Business, UCD.

Colbert, François (1994), *Marketing Culture and the Arts*, Montréal: Gaëtan Morin Éditeur.

Convery, Frank J., Flanagan, S., Keane M., & Ó Cinnéide, M. (1994), *Ó Bhonn Aníos: A Tourism Strategy for the Gaeltacht*, An Daingean: An Sagart.

Diggle, Keith (1994), *Arts Marketing*, London: Rheingold Publishing Ltd.

Duffy, Patrick (1994), "Conflicts in Heritage and Tourism" in *Culture, Tourism and Development: The Case of Ireland*, (Kochel, Ullrich ed.), Liverpool: Liverpool University Press.

Hardy, L.C. (1981), "Theatre Objectives and Marketing Planning", *European Journal of Marketing*, 15, 4, 3–16.

Hill, Elizabeth., O'Sullivan, C., & O'Sullivan, T. (1995), *Creative Arts Marketing*, Oxford: Butterworth-Heinemann.

Hirschman, Elizabeth C. (1983), "Aesthetics, Ideologies and the Limits of the Marketing Concept", *Journal of Marketing*, vol. 47. (Summer 1983), 45–55.

Kotler, Philip (1994), *Marketing Management: Analysis, Planning, Implementation and Control* (8th edition), Engelwood Cliffs, NJ: Prentice Hall.

Legaretta, Jimmy (1994), "Something to Sing About at the Washington Opera", *Scorecard*™, *The Revenue Management Quarterly* Aeronomics Incorporated, Georgia, Fourth Quarter, 6–7, 13.

MacCraith, Máiréad (1994), "Tourism and the Irish Language: Problems and Prospects" in *Culture, Tourism and Development: The Case of Ireland*, (Kochel, Ullrich ed.), Liverpool: Liverpool University Press.

Quinn, Bernadette (1995), "Conference Review — The Economy of the Arts: Managing the Growth of Cultural Industries, Dublin, 1-3 December 1994", *European Journal of Cultural Policy*, vol. 1, no. 2, 385–390.

Scheff, Joanne & Kotler, Philip (1996), "How the Arts Can Prosper through Strategic Collaborations", *Harvard Business Review*, January/February, 52–62.

PART FOUR

PARTICIPATION AND CONSUMPTION PATTERNS

11

ARTS POLICIES, STRUCTURES
AND PARTICIPATION[1]

Paula Clancy

There are a number of broad cultural and social policy developments which are claiming attention in developed countries and have an impact on cultural practices. The concept of access for all and associated cultural interventions aimed at democratising culture by increasing horizontal and vertical access, both across the social classes and across the different regions within the nation state, is now a commonly stated objective of cultural interventions.

The impact of technological development on changing cultural practice must also be into taken account. The enormous and increasing popularity, particularly among young people, of what might be described as the personal culture centre, located in the home and equipped with television, radio, video, hi-fi is a major issue for cultural policy makers. As this trend continues to develop, policy makers are framing plans for a future which has been defined in terms of "the privatisation of pleasure" (Mulgan & Warpole, 1986). Rapidly growing, easy and inexpensive access to technology has even greater significance in relation to the arts in a society with high levels of unemployment and enforced leisure.

A third issue concerns a new strand in cultural policy which flows from changes in the economic circumstances in developed countries and which has been defined as "instrumental" cultural policy (Vestheim, 1994). This involves using cultural ventures and investments as a means to achieve goals in areas other than the cultural. Such goals can relate to investment and profit, attracting tourism, creating employment, or urban renewal. Their instrumental aspect lies in emphasising culture and cultural ventures as means rather than ends in themselves. New alliances between the

arts, public administration and private financial interests are emerging both in Europe and the USA to give effect to this type of policy. Many of these cultural initiatives are innovative and imaginative and are likely to have an impact on future policy decisions and participation patterns. One concern is that while the strategy is a useful one in economic terms, it may actually work against those policy initiatives aimed at increasing access across the social classes. In this regard the British experience has been that the cultural benefit is largely to those who already possess a high level of economic and cultural capital. (Lewis, 1990; Lim, 1993).

The relationship between these developments in cultural policy and changing patterns of cultural participation are clearly of interest both to policy makers and to cultural managers. The trend towards use of instrumental cultural policy initiatives may as yet be indiscernible in its impact on patterns of cultural participation. However, interventions which aim to bring about increased access, together with radical changes in the use of home-based technology, are now well established and the impact of these developments on public participation in the arts in different countries merit examination.

In doing so a number of factors must be considered and taken into account. Notwithstanding the broad similarities across countries and regions in relation to key issues likely to have an important impact on cultural practice, there are also many differences. Distinct models of cultural policy result in different structures and alternative ways of managing culture. Variation in definitions of art and culture also exists between countries. Genres change and the dividing line between high and popular arts can become blurred. Distinctions between amateur and professional practices in the field of culture are always somewhat ambiguous. How different countries react to these changes will vary.

An added difficulty to making cross-national comparisons is the relative absence of *any* kind of data. A review of the research carried out both on the behavioural issues of participation and consumption of the arts as well as attitudinal data on the role of the arts in society indicates a general dearth of useful and relevant information from many countries. This is particularly true when we look at attitudes to and perceptions of the role and value of the arts and the concomitant area of attitudes to the significance of the arts in community, economic and social life.

However, where descriptions and analyses of trends and patterns of cultural participation and consumption provide a general outline of a given situation some comparison is possible and was attempted as part of a study of participation in the arts in Ireland, conducted during 1994. A primary concern of that study was to contextualise the findings of a survey of patterns of participation in the arts, whether through attendance at live events, consumption through home-based technologies, participation in amateur activities or purchase of arts goods, as well as attitudes to the arts and their role in society. This was done in three ways: comparisons were made with findings of an earlier Irish (1981) survey (Kavanagh and Sinnott, 1983); Irish arts policy developments were analysed and considered as explanatory factors for identified changes and, where possible and relevant, comparisons were made with trends and patterns of participation in other countries. It is with this latter comparative aspect that this chapter is particularly concerned.

COUNTRIES COMPARED

A number of countries were initially selected for particular review in the context of the Irish research. France was chosen because, in many ways, it represents a model of good practice in terms of cultural activity and expenditure and thus provides a benchmark for assessment of other countries. Belgium, Scotland, Denmark, Finland and New Zealand were chosen because of similarities of population scale with Ireland. Northern Ireland, Wales and Great Britain in general were also chosen because of their proximity to the Republic of Ireland and also because of similarities of administrative structure, language and cultural norms. A preliminary examination of a number of these countries was carried out : three of these (Belgium, Denmark and New Zealand) were not pursued since they were found not to have comparable research material available.

From this review, results of research carried out in the six countries, Finland, France, Scotland, Great Britain, Northern Ireland, and Wales, were chosen for particular attention because the types of survey they have carried out are sufficiently comparable in design to the Irish context. A similar interest can be discerned in describing and analysing the numbers of people participating in cultural life and activities, in analysing attitudes and behaviour and in drawing conclusions from this analysis. However, as in the

Irish case, reference to the particular structures and policies governing arts practice is important in making sensitive cross-national comparisons. Before discussing cultural practices in the compared countries, therefore, the structures and policies of the different countries are briefly described.

Ireland

As is the case in Britain and, indeed, in most English-language countries, the "arms-length" arts council is the primary mechanism used by the State to fund the arts in Ireland. (Hillman-Chartrand and McCaughey, 1984). Responsibility for the arts in Ireland now rests with the Department of Arts, Culture and the Gaeltacht. Prior to its establishment in 1993, there was no dedicated government department in Ireland responsible for the arts and for policies related to them[2]. In the early 1990s the Irish Arts Council moved from being the single agency in the field of cultural development to being one of a number of bodies sharing a concern for the arts as part of their remit.

The Arts Council, under legislation culminating in the Arts Act, 1973, has wide-ranging responsibilities for the arts in Ireland and as such its policies and practices have a major impact on arts practices in Ireland. The 1951 Act, which established the Council, is described as "An Act to stimulate public interest in and to promote the knowledge, appreciation and practice of the arts". The Council consists of a chairperson and 16 members appointed by the Minister for Arts, Culture and the Gaeltacht. It has a full-time executive with a Director and a number of officers who have specific responsibilities for particular artforms. One of the principal functions of the Council is the administration of state funding for the arts. There was an overall increase of 70 per cent in funding between 1987 and 1992 (Arts Council Annual Report, 1992). However, the percentage increase was from a very low base. Other sources of funding for the arts exist through state-supported employment schemes as well as some funding from local authorities for arts activity in the relevant area, although the proportion of funding for the arts provided through local authorities in Ireland is minuscule relative to other countries, including Britain. This low level of local-authority funding reflects the position of Ireland as a country with an extremely high degree of centralisation of political and administrative structures.

The first survey of participation in the arts in Ireland was conducted in 1981 (Kavanagh and Sinnott, 1983). At the time of that report the Arts Council emphasised its role in supporting the individual artist and in preserving the dignity of the artist in society. The Council acknowledged the barriers of attitude and access to greater participation in the arts which had been identified by the survey and committed itself to the task of breaking these barriers and creating "the greatest possible participation in the arts in Ireland to the benefit of the individual, the community and the country as a whole". (Arts Council Annual Report, 1983).

Four important areas of Arts Council policy, as it has developed since the study conducted in 1981, can be identified. First, a continuing concern for the concept of excellence is clearly expressed in much of the literature and in public statements issued by the Council. Second, there is an acknowledgement of the several issues relating to cultural democratisation: vertical and horizontal access, regionalisation, decentralisation, community opportunity. Third is the commitment of the Arts Council to the broad area of education. Finally, specific initiatives taken by the Council from time to time in the past decade have been directed at provision and practice within certain art forms.

Since the early 1980s and up to the period of the study of participation, the Council has extended its brief substantially in the community, regional and European context. There has been a shift in emphasis from the centralised, Dublin-driven concept of arts development to the local and regional bases where there is increasing support given to initiatives of all kinds. Artistic activity is increasingly embedded within local authority areas and the need for outside imports has diminished somewhat. In addition, many of the reports, commissioned by the Council throughout the 1980s are cross-disciplinary, illustrating a recognition of the interdependency of the various artforms in terms of development and growth.

Finland

Finland is a member of the Nordic family of social welfare states which is characterised by networks of public cultural services, publicly financed systems of cultural institutions and public support for the arts and cultural practices. Cultural affairs are under

the competence of the Ministry of Education where an Arts Direc-
torate was originally located. Legislation in 1967 established a
central arts committee along with eight expert State art commit-
tees and provincial arts committees. Artists, cultural organisations
and arts institutions are represented on these committees and
thus have a role in planning and decision-making as well as in the
promotion of arts activities. The role of the expert committees is to
promote creative and performing artistic work, knowledge of the
arts and amateur arts activities and current relevant research. The
system is coherent and inter-linked from central to provincial and
municipal government. In a reorganisation at the Department of
Education (Niinikangas, 1991) the Arts Directorate has become
the Cultural Directorate, which together with the departments of
sport and youth now make up the cultural policy division.

Cultural democracy has been a policy objective since the mid-
1970s and municipal cultural boards, charged with the task of or-
ganising and channelling cultural activities and events, became
mandatory in 1981. This reflects the Finnish tradition of a strong
system of local administration allied with a strong central gov-
ernment. In the 1980s and 1990s questions relating to cultural in-
dustry and new technology have been key issues in Finland as
they have been elsewhere in Europe.

Great Britain

As is the case in Ireland, in Britain responsibility for arts and cul-
ture is divided among different government departments, local
authorities and quangos, e.g. the Arts Council, the British Film
Institute and the Crafts Council. The manner in which the Arts
Council is positioned to act as a buffer between government and
the arts community, described as the "arm's length" principle,
seems to imply that power and responsibility lie with independ-
ent organisations. In practice, however, finance comes from cen-
tral and local government. Public support for the arts is chan-
nelled through a number of diverse agencies whose responsibili-
ties can overlap. There is sometimes a significant difference in the
level of support coming from various local authorities. The un-
tidiness of the system does mean that there is no single control-
ling bureaucracy. Since 1979 there has been a shift in government
policy for the arts away from the welfare model of arts provision

which characterised the post-war period and towards an enterprise model (Bennett & Palka, 1994).

It is worth noting a statement from the British Arts Council that they are "seeking above all to promote high standards and to enhance access to the arts in society" (Arts Council of Great Britain, 1993a). The Arts Council of England, together with the Scottish and Welsh Arts Councils and Regional Arts Boards have laid out their policy objectives for the nineties in the corporate plan, operating as they are "in the current uncertain economic climate". Policy has been developed in the light of recommendations contained in *A Creative Future*, published in early 1993 (Arts Council of Great Britain, 1993b). These recommendations were based on discussion documents, a public attitudes survey and meetings held throughout the country and were welcomed by Lord Palumbo, then Chairman of the Council, as providing a clear map of the way forward. Significant changes in organisational terms are: a new "integrated system" of Arts Council and Regional Arts Boards; and, from April 1994, the transformation of the Scottish and Welsh Arts Councils into wholly autonomous organisations, accountable to the Secretaries of State for Scotland and Wales respectively. The reformed Arts Council of Northern Ireland (1994) came into existence on 1 January 1994 and became fully operational on 1 April 1994. There will, in the future, be new partnerships at local, regional and national level.

France

In France state involvement in the arts dates back to the *ancien régime*. Great cultural institutions like the Comédie Française and the Académie Royale de la Musique which later became the Opéra, relied on the monarch in the seventeenth and eighteenth centuries. The new Republic simply nationalised the already existing cultural institutions.

In 1959 André Malraux was appointed to the first Ministry of Culture, taking over responsibility for this area from the Ministry of Education. He espoused a policy of decentralisation with some limited amount of success — the *Maisons de la Culture*, planned for every *département*, only materialised in sixteen locations and the issue of cultural democratisation was not properly addressed in the ensuing period.

Although decentralisation continues to be a major plank in French cultural policy, the construction of major projects has kept funds locked in Paris. The Council of Europe, which has been evaluating the cultural policies of its member states since 1985, noted in 1991 that there had been only a limited transfer of funds away from the capital. France has no national cultural council to advise on cultural objectives and provide a panel of experts to be consulted on a general cultural policy. It is the Minister of Culture alone who selects and launches projects according to the budget allocated to him by government. A former Minister of Culture, François Léotard, stated in 1991: "There has been a certain continuity from Malraux to the present day . . . but political contexts and the personal approaches of the different ministers lend specific hues to their policies and lead them to place particular emphasis on certain themes or modes of action" (Council for Cultural Co-operation, 1991:45). However, the Ministry of Culture budget (including communication) only accounts for one-quarter of public spending on culture; other government departments provide another 19 per cent and local authorities (regions, departments and communes) some 55 per cent (Council for Cultural Co-operation, 1991).

The French, particularly under former Minister Jack Lang, have been more dramatically successful, since 1981, in recognising forms of mass culture which had long been spurned: fashion, gastronomy, comics. The theme became one of cultures in the plural and at an everyday level. This had the advantage of attracting participation, particularly of the young, but also excited critical comment on a policy which was seen by some to be reducing the concept of artistic experience to the mundane.

COMPARISONS OF CULTURAL PARTICIPATION

The above-described differences of both policy and expenditure on the arts in the compared countries demand that comparisons of actual cultural practice be treated with sensitivity. They must also be treated with some caution for a number of reasons: the different time periods (ranging from 1989 to 1994) in which the surveys were conducted in the different countries; possible differences in statistical techniques applied; and the fact that the question format and range of arts activities on which data was collected were not identical. Nonetheless, the similarities which exist between the countries, together with the degree of

commonality of research approach in all cases is sufficient to allow reasonable confidence that useful comparisons are possible.

Attendance

A comparison (Table 11.1) between Ireland, Great Britain as a whole, Wales and Northern Ireland, shows that aggregate attendances in Ireland (83 per cent) are around the norm for these countries and considerably higher than in Northern Ireland and Wales. In Great Britain as a whole, the figure was 79 per cent. The figures for Northern Ireland and Wales are much lower at 56 per cent and 54 per cent respectively. It must be noted, however, that some of this disparity may be accounted for in that a smaller number of events were included in the surveys of Northern Ireland and Wales, 12 events in each case, compared with Great Britain as a whole (28) or Ireland (17). In the overall study of Great Britain attendance for Wales was 74 per cent.

In the Irish study (see Table 11.2), a comparison of aggregate attendances in 1994 at those artforms for which data was collected in 1981 showed that overall attendance was up from 60 per cent to 78 per cent. This increase was found for all artforms, with one exception.

In the case of some artforms the increase is quite dramatic. For example, the proportion of those attending a performance of popular music (broadly defined) jumped from 17 per cent in 1981 to 39 per cent in 1994, while attendance at an exhibition of paintings or sculpture has almost trebled, with an increase from 8 per cent in 1981 to 23 per cent in 1994. This increase in attendance at live events across all artforms is impressive given that the 1981 survey had concluded that support for these kinds of event was "relatively low" and did not "suggest a healthy situation" (Kavanagh & Sinnott 1983).

TABLE 11.1: AGGREGATE ATTENDANCE AT ARTS EVENTS IN SELECTED COUNTRIES*

Country	Population
Ireland	83
Finland	80
Great Britain (including Scotland and Wales)	79
Wales	56
Northern Ireland	54

Sources: Clancy et al., 1994; Arts Council of Great Britain, 1991; Tomlinson, 1993; Marketing Research Consultancy (Ireland) Ltd., 1991; Liikkanen & Paakkoned, 1994.
* percentage of representative sample of total population of each country.

In Finland, almost 80 per cent of the population take part in at least one event per annum. In general, cultural events in Finland are considered to be a minority interest with between 5 per cent and 44 per cent of the adult population taking part in any one of the compared events. This does not vary greatly from the Irish pattern where participation in any one individual artform ranges from 2 per cent to 54 per cent of the population surveyed. As such participation in the arts in Finland is regarded as "entirely satisfactory" (Liikkannen 1995). What is of interest in the Finnish case, however, is that the attendance rates for many of the activities on which information was gathered are in decline. For example, throughout the 1980s, audiences in the theatre and at cinemas dwindled. Opera-going has also been on the decline, while museums and concerts attract about the same numbers of people as they did ten years ago.

The exception to this general decline is attendance at art exhibitions/museums, where there has been a slight increase from 40 per cent in 1981 to 44 per cent in 1994. It should also be noted that the aggregate figures for particular artform categories such as concerts mask considerable variation in the proportion of those attending different types of concerts. For example, the figures for pop and rock and light music concerts were up on those for 1981 and there was an increase in the popularity of jazz concerts.

TABLE 11.2: COMPARISON OF PATTERNS OF ATTENDANCE AT
SELECTED ARTS EVENTS IN SELECTED COUNTRIES*

	Ireland (1994)	Great Britain (1991)	Scotland (1991)	Wales (1993)	N. Ireland (1991)	Finland (1991)	France (1989)
Cinema	54	45	57	38	35	35	49
Play/ Theatre	37	24	35	19	Up to 20	37	14**
Popular Music	22	18	31	18	17	—	—
Classical Music	14	11	15	—	4	17	9
Opera	6	7	14	6	2	4	3
Art Exhibitions	23	48	37	—	7	44	23

Sources: Clancy et al., 1994; Arts Council of Great Britain, 1991; Scottish Arts
Council, 1991; Tomlinson, 1993; Marketing Research Consultancy (Ireland) Ltd.,
1991; Liikkanen & Paakkoned, 1994; Department of Studies and Future Trends,
1989b.
* percentage of representative sample of total population of each country.
** refers to professional theatre only.

The findings of the French studies indicate that cultural practices
are gradually becoming more widespread. However, despite ef-
forts at democratisation, what might be considered as "high"
cultural outings remain a minority interest and have not increased
in a significant way since 1973 (i.e. no increase of more than three
percentage points): for example, 3 per cent attend opera at least
once a year, 9 per cent classical music performances and 14 per
cent the professional theatre.

Although there is some variation in overall attendance levels, a
broadly similar pattern emerges across the compared countries,
both in relation to the relative popularity of individual artforms
or cultural practices and also the important relationships of the
different sociodemographic variables with behaviour.

Popularity of Individual Artforms

Cinema-going is the predominant activity in all countries in terms
of both penetration and frequency. Plays and/or theatre going,
performances of popular music and exhibitions were in the sec-
ond grouping in all countries (France is the exception in relation
to theatre attendance). In all studies reviewed, events such as per-
formances of classical music and opera were very much a minor-
ity interest. (See Table 11.2).

Occupational Class

The Irish studies, both in 1981 and 1994, highlighted the impor-
tance of occupational class in determining the level and type of
cultural activity and further showed that by 1994 there was rela-
tively little closing of the gaps which were apparent in 1981. From
an analysis of the 1994 data, social class was isolated as an ex-
planatory variable, independent of other variables such as loca-
tion, gender, education or age.

 Despite a common policy emphasis of increasing access across
the social classes, this factor was also found to be of importance in
the studies of other countries. The main conclusion of the Scottish
study, for example, was that social class was the primary deter-
minant of attendance at arts activities. Class influenced frequency
of cinema attendance, with those in non-manual occupations
having higher attendance rates. It was also the main determinant
of attendance at exhibitions: 75 per cent of lower socioeconomic
groups compared to 31 per cent of higher socio-economic groups
never attended. Social class was also the most important dis-
criminator with regard to attending plays.

 In Great Britain overall, it was found that interest and atten-
dance in arts activities is highly correlated with both social class
and education. Attendance is at 91 per cent for those in the higher
occupational class groupings and decreases consistently to a low
of 58 per cent of those in the lowest. As in Ireland this pattern is
consistent and is independent of artform.

 In Finland, where there are no actual cultural programmes in
favour of specific population groups defined in terms of social
background, participation is higher among students and middle
and senior management than among the farming and blue-collar
populations, although comparison with data collected in 1981
indicates that the gap between the social classes is narrowing
with slightly less participation by the better-educated, more

privileged population groups. In France those who regularly attend cultural events, as in the other compared countries, continue to be from higher occupational classes and are better educated.

Regional Variations

The pattern with regard to regional and geographic differences is less uniform. In Ireland, an urban/rural gap in attendance levels, described in the 1981 study, was still in evidence in 1994. Nonetheless, differences in aggregate attendances between the rural and urban populations had decreased from 15 percentage point in 1981 to 11 in 1994, although in the case of some individual events the gap was found to have marginally increased.

However, using a sophisticated statistical technique[3] the Irish study revealed that region rather than an urban/rural divide per se is one of the critical factors which has an independent impact on involvement with the arts. In particular, significant differences were found between those living in Dublin, the capital city, and elsewhere, although it should be noted that between 1981 and 1994, there is also evidence of some "catching up" from other provinces. The exceptions to this overall finding are those dimensions of popular culture associated with events, programmes or products of traditional music and dance and country and western music.

The relatively low involvement of those living outside Dublin is also found for categories of audience for the home-based media as well as for live events. This finding suggests that questions of access are more complex than any individual issue of availability of infrastructure, education or financial resources (although each of these has an independent importance). In Great Britain, similarly, attendance is highest among those living in London, while in France, attendances of those living in Paris are above the national average.

It is reasonable to speculate that a number of reasons combine to account for the predominance of a nation's capital city. First, there is the existence of a range of permanent facilities and occasional opportunities in a capital city, not as easily available elsewhere in the country. In addition, the capital city is likely to be a prime location for the working arts community and cultural industries like television, film and popular music together with a high level of investment in the arts relative to other regions and

cities. Finally, large cities have a very high proportion of their population who are not native to the city. Away from home and from the social patterns of small and medium scale communities, there is likely to be a greater reliance upon culture and entertainment for distraction and social intercourse.

In Scotland, those living in rural areas of the country were less likely to attend as frequently as their urban counterparts. Cinema attendance was deemed to be particularly affected by location but in Great Britain as a whole no differences in aggregate attendance were found between urban and rural areas, although there were some differences in attendance at the cinema.

In Finland, while specific comparisons of urban and rural dwellers or across regions are not available it is argued that "the density of the networks of cultural institutions has also facilitated the dissemination of cultural products and enhanced the democratisation of culture. The availability of an ample supply of high-quality, easily identifiable cultural facilities, not only in city centres but all over the towns and cities, undeniably places cultural activities within reach of the largest number. The authorities have clearly counted on these institutions to reduce geographic and social inequalities." (Liikkannen, 1995:122)

Age

The overall picture in relation to the age profile of those involved in the arts in Ireland and which is consistent with the findings of the studies of all compared countries is that of people who are middle-aged and/or older. The exceptions to this trend are those who are associated with the more popular arts which include rock/pop music, jazz/blues music and film, where the age profile is that of younger people.

In Scotland, age was found to be an important discriminator, with those aged over 45 years being less likely to attend a cinema. The younger the respondent the greater the popularity of cinema attendance. Age was also an important factor in determining likelihood of going to a rock or pop concert, with 35 years apparently being the age threshold for this activity.

In Great Britain attendance at all types of event tends to decline with increasing age. In general, cinema/films and musical events (particularly pop) appeal more to the young while the more visual performing arts (plays, musicals, opera, ballet etc.) are more the province of the 35–64 year olds.

In Finland, variations in the proportion of attendance among the different age groups is easily discernible, with a certain increase in participation in the over-45 age group and a simultaneous decrease in the under-25 age group, For example, among theatre-goers the decline in numbers attending is only among those under 45. In the older age groups, frequency of theatre-going remains at its previous level. Opera-going is also characteristically a leisure activity for the middle-aged population: the frequency of opera-going is highest in the 35–64 age group.

Films remain primarily a leisure activity for young people: four out of five in the 15–24 age group had been to the cinema during the six months prior to being interviewed. Similarly, the proportion of young people going to pop and rock concerts has increased, and in dance, there is no variation at all between the different age groups.

In France, attendance at arts events is more likely among older people. The percentage of young people (those between 15 and 24) attending is falling for five of the six "high" cultural events on which this kind of information was gathered, whereas the percentage of 40–59 year olds is rising.

The Home-Based Audience

As is the case throughout western Europe, access to television has become virtually universal in the countries examined (See Table 11.3) and there has been a massive increase in the use of home-based entertainment technology which provides the audience with much greater levels of control of the media, i.e., increased ownership of multi-sets and videos. For example, in Ireland, in 1988, VCR penetration was 26 per cent of households, while multi-set penetration was 16 per cent. By 1994, VCR penetration had increased to 59 per cent with multi-set penetration increasing to 29 per cent (Meenaghan, 1995).

Since 1980, there has been a massive growth in the number of television stations broadcasting in Europe and it is predicted that there will be some 500 television stations servicing the European market by the year 2000. Associated with this growth is a three-fold expansion in the number of broadcast hours (Meenaghan, 1995).

TABLE 11.3: OWNERSHIP OF ITEMS OF CONSUMER ELECTRONICS,
1990/91

% of Total Households	Radio	Cassette Recorder	CD Player	Personal Stereo	Colour TV	Video Recorder
France	98	76	23	37	94	35
Ireland	–	72	17	43	98	56
United Kingdom	90	67	20	37	98	58
Finland	69	85	19	37	94	46
EU Average	**89**	**72**	**20**	**30**	**96**	**41**

Source: Adapted from Euromonitor, European Marketing Data and Statistics, 1996, 31st edition and reproduced in Lambkin, 1996.

In Ireland, by 1994, consumption of all artforms inside the home was significantly higher than outside. For example, while more than one-third (37 per cent) attended a play, 45 per cent reported that they watched or listened to a play on television or radio. Similarly, almost 90 per cent of the population watch film on television and/or video whereas just 54 per cent attend a cinema.

Patterns in the use of home-based technology as a means of accessing the arts are broadly similar in Great Britain as a whole and Scotland to those found in Ireland, although in Scotland a higher proportion watch plays and rock/pop music than is the case in Ireland.

The same order of preference for artforms is evident with more than 80 per cent of the population in all of the compared countries reporting that they watch films on television. Plays are the next most popular, with a slightly smaller proportion watching plays on television in Ireland (45 per cent), compared with Great Britain (47 per cent) and Scotland (54 per cent).

Significantly, the conclusion reached about the impact of television and other electronic media on disposition to going out to take part in cultural activities in Great Britain and Scotland is that these activities are complementary and that access to these artforms on television may in fact act as a stimulant to a broader interest in the arts. In the survey of the population in Great Britain, in response to a direct question, 21 per cent said that this was the case. In Ireland, the increasing access to electronic media has not damaged attendances since in virtually all cases, attendances at live events have increased. From further analysis in the Irish case of those who . attend both live events and use home-based

technology it is clear that for the majority of people who attend live events of a particular artform, home-based technology is used as an additional medium rather than as a replacement for actual attendance.

TABLE 11.4: COMPARISON OF USE OF HOME-BASED TECHNOLOGY AS A MEANS OF ACCESSING THE ARTS FOR SELECTED ARTFORMS IN IRELAND, GREAT BRITAIN AND SCOTLAND*

	Ireland**	Great Britain***	Scotland**
Films	89	86	83
Plays	45	47	54
Rock/Pop Music	41	-	45
Jazz	18	8	-
Opera	13	11	9
Ballet	7	11	7
Arts Review	33	-	-

Sources: Clancy, et al., 1994; Arts Council of Great Britain, 1991; Scottish Arts Council, 1991.
* percentages of representative sample of total population in each country
** refers to use of both television and video
*** refers to use of television only.

The impact of technology is given a more negative interpretation in the case of Finland and France, where the increasing popularity of home-based entertainment is regarded as responsible for a declining interest in at least some artforms. During the 1980s in Finland, large numbers have bought not only the latest television models but also VCRs, home computers, better sound reproduction systems, etc., and the field of electronic mass communication saw significant changes including a much greater degree of consumer choice. The declining interest in attending live cultural events or of going out to performances in theatres or cinemas has been attributed, at least in part, to this increased use of home-based technology, which is particularly noticeable among the younger age groups.

A similar pattern is discernible in France where there has been a shift from reading books, attending shows and cultural visits to audio-visual activity and from written word to the screen over the fifteen years between 1973 and 1989. This has been related not just to access to home-based technology but to an end to public

monopoly of broadcasting and increased channel and programme choice. Watching television is now the top leisure activity of the French — 73 per cent claim to watch daily — and is comparable to Finland where 70 per cent watch on a daily basis and to Ireland where the proportion watching daily is even higher at 82 per cent.

Participation in Amateur Activities

Comparisons of levels of participation in the arts (even at the aggregate) across the compared countries must be treated with caution as the wording of questions differed slightly and different ranges of activities were used in the different studies. Notwithstanding these caveats, there are some interesting differences worth noting.

Although the Irish study used a very broad definition of activity only 35 per cent reported participation. This gives Ireland the lowest level of active involvement of all the countries except Finland which registered a level of only 30 per cent involvement in 1991, a decrease of 7 percentage points on the 1981 figures. The other countries ranged from 47 per cent to 53 per cent.

In Northern Ireland, more than one-third of the sample said that they were a member of a group involving arts activities and more than a quarter participate as performers. Although this is indicative of a relatively high level of participation it is not really comparable with the other studies as the form of question is too different.

Many more people in Scotland are involved in photography (39 per cent) and making crafts (28 per cent) than is the case in Ireland where no individual activity can boast participation by more than 8 per cent of the population.

Attitudes to the Arts

In Scotland, there is significant support for the arts in terms both of their intrinsic value and the contribution they make to the social and economic life of an area. A similar pattern is found in Great Britain where this support was found to be related to social class. Both groups of respondents agree with their Irish counterparts that the arts contribute to the tourism sector and that contemporary artistic and cultural activities are an asset to society. They also express strong agreement with the socially cohesive role art and cultural activities play in local communities. British and Irish respondents are in clear agreement that family attitudes are

crucial in determining appreciation of the arts. The Scottish sample also supported this view, but less strongly.

While the Irish respondents were unequivocal in their belief in the importance of arts education in school, both the Scottish and British samples were more divided on the role this had in determining adult attitudes.

As in the Irish study, considerable support was found for funding artistic and cultural activity in the British and Scottish surveys. Only a minority of the Scottish sample agreed with a statement objecting to public money being spent on the arts and cultural activities in their local areas.

Again in the Scottish study, social class was found to be the primary influence on respondents' attitudes to the arts, with those in the higher occupational classes being consistently more positive towards arts and cultural activities. However, there are interesting differences between attendees and non-attendees, the former having, in general, more positive, critical and differentiated views than the latter.

SUMMARY AND CONCLUSION

In this chapter the relationship between cultural policy, structures for cultural administration and patterns of cultural participation have been explored. The analysis is necessarily tentative, not only because of the huge constraints on inter-country comparisons outlined earlier in the chapter, but also because of the difficulties of specifying causal relationships between identifiable policy interventions and resulting alterations in participation within a country. However, to the extent that comparison is possible, the analysis identifies some common trends in the countries compared. Of particular note is the continuing importance of the influence of social class on levels of participation in cultural and arts events, notwithstanding a common commitment to promoting cultural democracy. The degree of social-class distinction is even more pronounced in those areas of the arts which are most heavily subsidised by state-funding, i.e. those traditionally defined as the "high" arts.

While common patterns in regional and urban/rural disparities are less discernible across countries there is evidence that living in or close to a nation's capital city is an important determinant of likelihood of cultural participation.

The relative lack of interest in attendance at certain types of live arts events by younger people also has important policy implications for the future of such events. In all of the countries examined, it was seen that there is an increasing use of home-based technology in the population in general and some evidence that the use of home-based technology for accessing the arts is higher among the younger population groups. While interpretations of the impact of these trends on participation in live cultural events varies from country to country there is at least some cause for concern about these developments.

Notes

[1] The material contained in this chapter is taken directly from the more extensive research described in *The Public and the Arts* (Clancy et al., 1994) and is re-presented here in an edited and, where possible, updated format, with additional material focusing on comparisons with selected countries.

[2] Up to 1993, the arts came under the remit of the Department of the Taoiseach (Prime Minister).

[3] The detailed analysis of the 1994 data included factor analysis. For the study a principal components analysis followed by a varimax rotation was considered to be the most appropriate. For full description of the technique see Clancy, et al. (1994), Appendix 2 — Research Methodology pp. 122–123.

References

Arts Council of Great Britain (1991), "RSGB Omnibus Arts Survey: Report on a Survey on Arts and Cultural Activities in Great Britain", London: Arts Council of Great Britain.

Arts Council/An Chomairle Ealaíon, (1982, 1992) *Annual Reports*, Dublin: The Arts Council.

Arts Council of Great Britain (1993a), *Arts Council Corporate Plan 1993/94–1995/96*, London: Arts Council of Great Britain.

Arts Council of Great Britain (1993b), *A Creative Future: The Way Forward for the Arts, Crafts and Media in England*, London: HMSO.

Bennett, O. & Palka, A. (1994), "Cultural Policy Research: A Regional Perspective", Report for West Midlands Arts (Unpublished).

Clancy, P., Drury, M., Kelly, A., Brannick, T., & Pratschke, S., (1994) *The Public and the Arts: A Survey of Behaviour and Attitudes in Ireland*, Dublin: The Arts Council.

Council for Cultural Co-operation (1991), *Cultural Policy in France*, Strasbourg: Council of Europe.

Department of Studies and Future Trends (1989a), *Les pratiques culturelles des francais — enquete 1988-89*, Paris: Ministry of Culture.

Department of Studies and Future Trends (1989b), *Les pratiques culturelles des francais 1973-1989*, Paris: Ministry of Culture.

Hillman-Chartrand, H., & McCaughey, C. (1984), "The Arms Length Principle and the Arts — An International Perspective: Past, Present and Future" in *Who's to Pay for the Arts?* (Cummings and Schuster (eds.)), New York, NY: ACA Books.

Kavanagh, D. & Sinnott, R. (1983), *Audiences, Acquisitions and Amateurs — Participation in the Arts*, Dublin: The Arts Council.

Lambkin, M. (1996), *The Irish Consumer Market — A Guidebook for Marketing Professions*, Dublin: The Marketing Society.

Lewis, J. (1990), *Art, Culture and Enterprise*, London: Comedia/Routledge.

Liikkanen, M. (1995), "Participation in Cultural Life" in *Cultural Policy in Finland*, National Report, Helsinki: The Arts Council of Finland, Research and Information Unit.

Liikkanen M & Paakkoned, H. (eds.) (1994), *Culture of the Everyday, Leisure and Cultural Participation in 1981 and 1991*, Helsinki: Statistics Finland.

Lim, H. (1993), "Cultural Strategies for Revitalising the City: A Review and Evaluation" in *Journal of the Regional Studies Association*, vol. 27, no. 6.

Marketing Research Consultancy (Ireland) Ltd. (1991), "Survey of Public Attitudes towards the Arts in Northern Ireland", Marketing Research Consultancy (Ireland) Ltd.

Meenaghan, T. (1995) "Marketing Communications in Transition" in *Marketing Communications in Ireland*, Meenaghan, T. and O'Sullivan, P., (eds.), Dublin: Oak Tree Press.

Mulgan, G. & Warpole, K. (1986), *Saturday Night or Sunday Morning*, London: Comedia.

Niinikangas, V. (1991), *Vain Yski Toivomus in Kulttuuri Tutkimus*, University of Jyvaskyla.

Scottish Arts Council (1991), *Arts for a New Century — A Charter for the Arts in Scotland: Report of a Survey of Participation in and Attitudes towards the Arts in Scotland*, Scottish Arts Council.

Tomlinson, R. (1993), *Marketing the Arts in Wales: Report on the Beaufort Research Results*, Welsh Arts Council.

Vestheim, G. (1994), "Instrumental Cultural Policy in Scandinavian Countries: Critical Historical Perspective" in *The European Journal of Cultural Policy*, vol. 1, no. 1.

12

CONSUMPTION IN THE ARTS AND CULTURAL INDUSTRIES: RECENT TRENDS IN THE UK

Andrew Feist

The twentieth century has witnessed little less than a radical re-casting of how we fill our leisure time. To what we might call "traditional" forms of cultural consumption have been added the products of the new cultural industries. Exactly which factors have resulted in the current mix of consumption patterns, and which factors will determine future change, are subject to constant speculation. It is the very complexity of consumption in the arts and leisure sectors which makes any change subject to a range of different interpretations. Gold (1980:150) noted:

> The inadequate analytical and data foundations of arts policy affect a wide range of policy issues, but they seem to be especially severe with respect to demand. The unwelcome reality is that our understanding of the factors which function as determinants of arts demand is still severely limited. Recognition of this problem does not seem to be widespread nor is its correction regarded as urgent.

Gold writes from an American perspective, and her specific concern relates to the arts rather than culture as it is more broadly defined. Moreover, there have been significant developments in arts policy and research over the course of the 1980s and early 1990s. Yet the fundamental point she makes — that we know relatively little about the determinants of demand in the arts and the cultural sector — remains largely unchallenged. This chapter examines recent trends in consumption of cultural products in the UK and explores a number of theoretical issues around the relationship between the arts and cultural industries, and patterns of change in consumption.

RECENT CHANGES IN PATTERNS OF CONSUMPTION: USING NATIONAL DATA

Little material is collected on a UK-wide level through regular statistical surveys of behaviour or spending. Data on consumer spending on the arts and other cultural products are collected through the Family Expenditure Survey (FES), a survey of household spending, and this material provides a useful starting point. The category which covers spending on admissions to performing arts events is broad, covering "theatres, concerts, circuses, amateur shows, etc." Grossing up the figure for spending per household to estimate spending per annum gives a figure of around £700 million in 1994. Table 12.1 gives figures for average spending per household per week under selected cultural headings for the period 1989–95.

TABLE 12.1: AVERAGE HOUSEHOLD SPENDING PER WEEK ON SELECTED CULTURAL PRODUCTS IN THE UK, 1989–95*

	1989	1990	1991	1992	1993	1994**	1995**
	Average spending per household per week, £						
Books etc.	0.90	1.04	1.11	1.00	1.21	1.24	1.12
CDs, tapes	0.69	0.73	0.88	1.05	0.99	1.14	0.95
Cinema admissions	0.16	0.17	0.19	0.19	0.24	0.26	0.27
Theatres, concerts etc.	0.35	0.41	0.51	0.55	0.50	0.57	0.61
Admissions to dances, nightclubs, museums etc.	0.70	0.79	0.81	0.88	1.08	0.80	0.77

Source: Family Expenditure Survey data.
* Note that the standard error varies between different categories of expenditure and from year to year.
**As from 1994, FES data were presented on a financial year basis, i.e. the figures for 1994 and 1995 refer to 1994/95 and 1995/96 respectively.

Exactly how useful these spending statistics are on their own is open to discussion. Many of the things we are most interested in are actually quite subtle changes in demand, and clearly the breadth of the FES categories is not helpful in this respect. Furthermore, since the FES is a survey of household spending it does not make any allowance for spending by overseas visitors, which

as we consider later, can be significant. All data on consumer spending on the arts and cultural products require deflating by an appropriate price or cost index if one is hoping to measure change in the volume of attendances, and in some cases, such as books, the highly heterogeneous nature of the product makes it difficult to identify the appropriate deflator (Feist and Hutchison, 1989a). There is ample evidence of a real terms increase in spending per household on admissions to "Theatres etc.". However, this increase may simply be a function of increases in average prices beyond the rate of inflation (see Table 12.2) rather than an indication of increased consumption.

Some of the limitations of consumer expenditure data are ameliorated in general surveys of *participation* in the arts and other activity. Since the mid-1980s, the Arts Council of Great Britain and its successor body the Arts Council of England have bought into regular surveys of adult behaviour in this area. The BMRB International Target Group Index (TGI) provides baseline data on participation in the arts under a limited, and broadly constant, number of headings ("plays", "art galleries and exhibitions", "classical music", "ballet", "opera" and "contemporary dance"). Table 12.3 presents TGI for selected categories over a number of years across the period 1986/87 – 1994/95.[1]

The data reveal a range of experiences across different areas of activities. On the basis of these data, opera appears to have undergone a sustained increase in attendance (up 26 per cent across the period), while ballet has fared even better (up 29 per cent). While the number of people claiming to attend "plays" and "classical concerts" has remained broadly constant, the most conspicuous downward trend appears to have been in the field of contemporary dance (down 14 per cent across the period).

The limitations of using regularly collected large sample size participation-based surveys as a means of understanding changes in consumption are worth exploring. First, it is only possible to make broad inferences from such data on the *frequency* of attendance in a given year. Participation data taken from surveys such as the TGI include questions on the broad frequency of attending arts events, and we know that multiple attendance is a key feature of those who attend arts events.[2]

TABLE 12.2: INDICES OF AVERAGE TICKET YIELDS FOR SELECTED ARTS AND OTHER ACTIVITIES IN THE UK, AT CONSTANT 1986/87 PRICES (INDICES AT CONSTANT PRICES, 1986/87=100)

	86/87	87/88	88/89	89/90	90/91	91/92	92/93	93/94	94/95	Actual Average Ticket Yield 93/94 (£s)
English repertory theatres — home-based[1]	100	102.7	105.0	113.6	114.2	125.6	127.6	132.2	129.3	7.84
English repertory theatres — tours-in[2]	100	111.0	127.6	136.8	134.1	—	—	143.3	146.9	8.54
National companies — RSC[3]	100	109.5	106.6	114.4	—	110.8	118.9	125.1	124.5	15.64
National companies — RNT[4]	100	106.6	107.0	107.0	—	121.2	132.7	130.4	125.3	13.04
Society of London Theatre[5]	100	104.6	106.0	107.6	110.1	114.6	115.9	119.5	121.1	18.74

[1] Arts Council of England. Home-based/joint productions in main house auditoria at a constant sample of 36 building-based theatres in England in receipt of Arts Council/RAB/RAA funding.

[2] Arts Council home-based/joint productions in main house auditoria. Note that these data are based on two series: a constant basket of 36 building-based theatres, 1986/87 to 1990/91; and *all* building-based theatres in receipt of revenue funding 1991/92 to 1994/95. Consequently the two sets of figures are not strictly comparable

[3] Arts Council. Average ticket yield based on all performances including touring and the Newcastle season.

[4] Arts Council. Average ticket yield based on all performances excluding platform performances, standing tickets and touring.

[5] Society of London Theatre/City University. Average ticket yield for all performances in Society of London Theatre venues. Includes opera and dance. Calendar year data 1986/87 = 1986.

TABLE 12.2 (CONTINUED)

	86/87	87/88	88/89	89/90	90/91	91/92	92/93	93/94	94/95	Actual Average Ticket Yield 93/94 (£s)
Cinema [6]	100	104.5	100.4	100.9	105.3	111.4	112.7	110.8	109.2	3.11
Opera — ROH [7]	100	121.2	126.8	149.3	172.4	179.2	193.3	171.0	193.7	49.39
Opera — ENO [8]	100	107.2	112.2	127.2	131.2	138.2	143.2	149.4	148.7	21.64
Dance — large-scale [9]	100	107.3	116.7	123.0	136.7	148.9	155.6	145.2	148.2	19.61
Football — Premier League [10]	100	110.7	116.0	122.8	134.0	149.7	167.7	173.2	—	9.18

[6] Up to 1991/92: Feist & Eckstein, *Cultural Trends 1991: 13*, London: Policy Studies Institute; *BFI Film and Television Yearbooks* (London: British Film Institute) thereafter. The figure for 1986 is an estimate. It has been calculated on the basis of the relationship between the known asking price for tickets in London's West End in 1986 and 1987 and known average ticket yield for Great Britain as a whole in 1987. Calendar year data. 1986/87= 1986.

[7] Royal Opera House. Arts Council.

[8] English National Opera. Arts Council.

[9] Arts Council. Main scale performances by Royal Ballet, Birmingham Royal Ballet and English National Ballet.

[10] The Football Trust (1995), *Digest of Football Statistics*, 1986/87 to 1993/94, Leicester: University of Leicester. The Premier League, formerly the Football Association First Division, came into being during the 1992/93 Season. Figures relate to a weighted average of admission receipts per spectator including season ticket receipts.

TABLE 12.3: INDICES OF THE ADULT POPULATION "ATTENDING THESE
DAYS" IN SELECTED ARTS AND CULTURAL ACTIVITIES, GREAT
BRITAIN, 1986/87–1994/95 (INDICES: 1986/87=100)

	86/87	87/88	90/91	91/92	92/93	93/94	94/95
Attend these days:							
Plays	100	107	106	102	100	105	108
Ballet	100	104	109	111	105	120	129
Opera	100	103	113	112	119	125	126
Classical music	100	101	107	100	99	104	103
Art galleries/art exhibitions	100	103	104	102	99	105	104
Contemporary dance	100	90	87	77	81	81	86

Source: Data derived from BMRB International Target Group Index data pub-
lished in Arts Council of Great Britain annual report 1993/94 and Arts Council
of England annual report 1994/95.

Attendance at orchestral concerts offers a good example of the
problems that multiple attendance creates. The *Review of National
Orchestral Provision* (BBC/Arts Council, 1994) made reference to
data revealing that of the 12 per cent claiming to attend classical
concerts "nowadays", two-thirds attend more than once a year.
Indeed, those attending five times or more per year account for
almost 56 per cent of attendances. It is conceivable that, while not
indicating much in the way of substantial change in the overall
percentage of the population attending, the data presented in Ta-
ble 12.3 may conceal substantial fluctuations in the *number* of at-
tendances by those claiming to attend in any given period. A sig-
nificant reduction in the frequency of participation by the most
active group of individuals might have particularly severe conse-
quences for arts organisations.

A second issue relates to the coverage of the data. Two groups
are excluded from the findings: overseas tourists, since the data
are based on a sample of resident adults; and, self-evidently, par-
ticipation by children.[3] On the other hand, the very inclusive na-
ture of questions on attendances makes it seem likely that TGI
data includes resident adults' attendances at art galleries, exhibi-
tions, concerts and so on, undertaken *at any location* (include cul-
tural visits undertaken while overseas). Given the rise in cultural
tourism in recent years, this may not be an insignificant factor
within changing patterns of demand. Of course, for those

interested in obtaining measures of the level of individual involvement in the arts *per se*, the inclusion of overseas visits is not an issue. It is, however, an issue for researchers intent on extrapolating the number of *attendances* in Great Britain rather than the number of *attenders*, and can potentially lead to overestimation of the size of the domestic market for certain sectors. Bearing this in mind, it is possible that the percentage of the population attending arts events at home and overseas would increase while domestic attendance levels are simultaneously falling.

A further limitation stems from the blanket nature of the data coverage. Some commentators mistakenly interpret figures from participation surveys as indicative of the health or otherwise of, for example, the market for the "professional theatre", or, with even more alleged precision, "the subsidised theatre sector". Such surveys are simply not, and are not in any way designed to be, as subtle as that. In some cultural activities, we can be certain, notwithstanding the points noted above, what the data relate to. Participation data on the cinema cover, by and large, the commercial mainstream and specialist cinema sectors; there is relatively little in the way of a parallel voluntary sector, except in the form of film societies. In opera, drama and classical music, the same is simply not true. There is ample evidence to suggest that amateur activities account for a large percentage of total "activity" in these sectors (Hutchison and Feist, 1992). Most surveys do not, however, attempt to discriminate between "amateur" and "professional" performances.

Last and by no means least are the well-known problems associated with recalling the detail of attendances at specific types of arts events over a relatively long period. Not only is there the likelihood of genuine error in an individual recalling attendance details, but detailed research into participation-based studies has also suggested the existence of a "halo" effect whereby respondents are reluctant to admit to interviewers (or via questionnaires) a low level of actual involvement in the arts, and consequently overstate their involvement.

While they are both clearly important in understanding the overall dimensions of involvement in specific arts and leisure activities, it is clear from the above that consumer spending and participation data can only highlight part of the picture when trying to measure more subtle changes in demand for the arts and cultural activities over time.

A whole different set of issues arise when examining and comparing attendance data across the range of cultural activities which are collected by arts and cultural sector organisations. Participation and spending data, as we have seen, are concerned with the involvement of the resident (usually adult) population in cultural activities regardless of the location of that event.

Data derived from box-office returns and other similar sources reflect something quite different since they more accurately reflect the current size of the domestic market in terms of the number of attendances/visits. They are not effective at identifying the number of individual attenders/visitors.

The next section examines in more detail changes in the pattern of attendances in the cinema sector, theatre, museums and galleries and attempts to explain the principal factors underlying change in each case.

Cinema Attendances

In their excellent investigation into the post-War cinema audience, Docherty et al. (1987), explored the underlying factors responsible for the demise in cinema-going, and in doing so noted a transformation in the pattern of attending based on a wide range of social and economic factors. The redistribution of population in the post-war period was not matched by changes to the cinema infrastructure. Moreover, consumerism and the development of alternative leisure activities reduced the once omnipotent role of the cinema. While not irrelevant, the authors place growth of television ownership as a substitute activity, as a more limited factor. They noted:

> Going to the cinema is merely a small part of most people's lives. As a habit it depends on factors such as work, family, education and social class. . . . The decline of the cinema and the recent transformation of the class base of attendance are related to major social transformations in the ecology of cities, in levels and patterns of employment, changes in family patterns, changes in education, and the development of technologies for delivering moving images (Docherty et al., 1987:32).

The resurgence in attendances at the cinema has been one of the most clear-cut changes in cultural consumption of the second half of the 1980s and by and large has continued well into the 1990s.

Although official data collection on cinema attendances and box-office data ceased in 1984, other statistical sources can be utilised to build up a reasonable picture of trends in aggregate cinema attendances.

The history of the renaissance of domestic cinema attendances has been well documented. It has been noted above that the very nature of cinema exhibition makes it easier to measure than other cultural sectors. Aggregate attendances at the cinema in the UK increased from a low point of 54 million in 1984 to 124 million in 1994, an increase of 130 per cent. A variety of factors have been offered to explain the increase. This resurgence in cinema-going coincided almost exactly with the most extensive investment in new infrastructure since the 1930s. The gradual introduction of multiplex cinemas has been largely credited with being a central factor in stimulating the revival in attendance numbers. The first multiplex venue opened in 1985 in Milton Keynes; by 1994, multiple screen venues accounted for almost 40 per cent of total screen capacity (British Film Institute, 1995).

The video, so long perceived as a threat to movie-going, has also been credited with part of the success in restoring cinema audiences, by reinvigorating a more widespread interest in the film as a cultural product. Research into the profile of "high" consumers of video has indicated that they also tend to be frequent "cinema-goers".[4]

The wider impact of economic and demographic change, reflecting the findings of Docherty et al. on post-war cinema audiences have also played their part. Between 1984 and 1994, the total number of UK cinema screens increased by 55 per cent from 1,271 to 1,969; cinema sites on the other hand increased from 660 to 734, an increase of 11 per cent (British Film Institute, 1995). While the opening of new cinema facilities has been important in stimulating higher attendances, it is clearly only one of a range of factors which have created a more favourable climate for attendance. The virtual doubling in annual cinema attendances has reflected improvements in marketing, and the additional flexibility afforded by the multiplex to respond to market changes. Moreover, the *product* remains central to the cinema sector's ability to increase and sustain attendances. As one commentator noted when reviewing the UK sector in 1991:

... out of 285 films released during the year ... five ... represented 26 per cent of the total number of admissions. The market has been more or less product-driven for many years, but cinemagoers have now become more selective in their choice of film (the recession being one contributing factor), to an extent that threatens the "average" film in the theatrical market.[5]

It is clear that single blockbuster films can have a pivotal role in determining the total level of cinema attendances in any given year. The film *The Silence of the Lambs* was felt to have been largely responsible for boosting attendances in 1991. This was evident from an analysis of seasonal movements in cinema admissions in 1991. In general, cinema attendances in June tend to be at their low point. However, 1991 was exceptional: seasonally adjusted figures for the month of June 1991 gave total attendances of 11.2 million compared to the previous June when the equivalent figure was 6.4 million (Eckstein and Feist, 1992:64–5) Arguably, the arrival of the multiplex has allowed exhibitors to fully exploit the market potential of popular films in a way which simultaneously does not penalise them for accepting new product. This has provided multiplex operators with an opportunity to maximise income and optimise the length of run for a particular film.

The Theatre

A quick examination of recent trends in attendances for professional theatre performances would emphasise the diversity of the product on offer. This in itself contributes to an extremely heterogeneous market and tends to make generalisations difficult to sustain. Estimated total paid attendances for performances at Society of London Theatre and Theatrical Management Association venues was close to 21.6 million, generating box office receipts of £331 million in 1994/95. Deducting opera and dance performances leaves attendance figures of just under 19 million and box office receipts of £273 million (Arts Council of England, 1996). At the broadest level, the first observation to make on the overall pattern of change in attendances at the theatre is that there appear to be two distinct markets: the West End of London and the remainder of the country.[6] Generally, the West End has been characterised by a steady upward drift in aggregate visitor numbers; total attendances in 1995 were 11.94 million (Gardiner, 1996). Part of this growth has been linked to the health of the overseas tourist

market; audience profiles confirm that visitors to West End productions include a high proportion of overseas visitors and domestic tourists (Gardiner, 1992) and several commentators have pointed out that changes in aggregate attendances at West End performances in London are in some considerable part determined by the relative health of the overseas tourist market (which is itself a function of a range of factors) (Kapinski, 1988).

While this division between London and the rest represents a gross over-simplification (there are some locations outside London such as Stratford-upon-Avon and Edinburgh which rely heavily on overseas visitors), the general pattern of attendance at regional theatres has been in marked contrast to the West End. An analysis of operational data for a constant "basket" of building based theatre companies funded by the Regional Arts Boards reveal that the number of performances given has fluctuated only slightly during the course of the period 1986/87 – 1994/95[7]. There has however been a steady decline in average and total paid attendances at performances by these companies. Average attendances have fallen by 13 per cent over the period (Table 12.4). Only two years (1990/91 and 1992/93) bucked an otherwise consistently downward trend (Arts Council of England, 1996).

TABLE 12.4: GRANT-AIDED PRODUCING THEATRES IN ENGLAND: KEY INDICATORS, 1986/87 TO 1994/95*

	No. of Venues in Sample	No. of Performances	Seats Sold (000s)	Average Attendance	Index of Average Attendance 1986/87=100
1986/87	36	8,774	3,264	372	100
1987/88	36	8,692	3,206	369	99
1988/89	36	8,667	3,148	363	98
1989/90	36	8,785	3,076	350	94
1990/91	36	8,440	3,009	357	96
1991/92	36	8,130	2,802	345	93
1992/93	35	8,359	2,922	350	94
1993/94	35	8,380	2,864	342	92
1994/95	36	8,733	2,829	324	87

Source: Arts Council of England, 1996.
* Home-based main house performances at a constant group of theatres in receipt of Arts Council/RAB grant aid.

Museums and Galleries

Like cinema, the museums and galleries sector has seen important adjustments in the physical infrastructure over recent years. While no definitive figure exists, current estimates suggest that there are between 2,000 and 2,500 museums and galleries in the UK (Davies, 1994). In terms of the overall size and infrastructure, there has been a marked increase in the number of new museums and galleries in the UK over the last two decades. This growth has been linked closely to the expansion of the independent museum sector.[8] A survey covering 279 independent museums in membership of the Association of Independent Museums revealed that 103 (37 per cent of the total) had opened by 1980 and 1989 (Feist and Hutchison, 1989b). Growth is, however, by no means confined to the independent museums sector and there have been notable openings and expansion within national and local authority museums also.[9] While the opening of new museums has been a significant factor in the changing museums landscape, the comparison with the cinema sector is only partially valid. The closing of existing cinema sites which has followed in the wake of some multiplex developments does not have a parallel in the museums sector. Nonetheless, new museum openings have provided an important stimulus to overall attendance levels.

Considerable debate exists about the precise number of museum and gallery visits in any given years (Davies, 1994). The problem of data collection in the museums and galleries sector is exacerbated by the presence of a considerable number of free-entry museums where data collected on attendance levels *may* be collated in a less-than-rigorous fashion. The standard source for data on museums and galleries attendances is the annual publication by the British Tourist Authority, *Sightseeing in the UK*, which includes attendance data compiled from around 1,800 museums and galleries. These institutions yielded aggregate attendances of just over 79 million in 1992. Davies has argued that this figure is an under-estimate of the total number of visits. As an alternative to the *Sightseeing in the UK* data, Davies has used a multiplier against data from participation surveys to estimate the total number of visits, and combined this figure with estimates of visits by children and overseas visitors. Using this approach, he produces a revised market estimate of 110 million visits.[10]

TABLE 12.5: INDICES OF ATTENDANCES AT MUSEUMS AND GALLERIES
IN ENGLAND (INDICES OF TOTAL ATTENDANCES, 1976=100)

	'76	'82	'83	'84	'85	'86	'87	'88	'89	'90	'91	'92
Constant sample	100	96	99	100	103	100	103	105	106	111	113	115
All museums	100	97	101	105	109	107	110	113	115	121	123	128

Source: Davies, 1994; British Tourist Authority, 1992.

The actual size of the market is arguably of less interest than the changes taking place within it. Table 12.5 indicates the pattern of growth at a constant sample of English museums against a sample which includes new museums. The impact of new museum openings is clear. While total visits increased by 28 per cent 1976–92, corresponding figures for a constant sample increased by only 15 per cent. A second interesting feature is the temporary dip in attendances evident in both indices in 1986. We have already noted that visits to the West End theatre are affected by changes in the aggregate number of overseas tourists; the same effects appear to have influenced museum visits. Given what is known about the profile of museum attenders and the prevalence of overseas visitors, this should be of little surprise: some 21 per cent of museum visits are made by overseas visitors (British Tourist Authority, 1992) and for certain national institutions, UK-resident visitors are in a minority.[11] What it also suggests, however, is the important role played by overseas tourist visits as one of the motors for expanding total demand for museum visits.

A third important factor determining the overall pattern of attendances at museums and galleries has been the move towards entrance charges in place of free admission, particularly among the national museums and galleries. As one might expect, the imposition of charges does clearly reduce attendance levels, at least initially. It has been suggested that part of the apparent reduction after the introduction of charging is simply a reflection of improved data collection on visits replacing "guesstimates". For those national museums and galleries which introduced charging at their main buildings between 1979 and 1988, attendances have fallen from 13.1 million to 8.3 million; conversely, those establishments which have maintained free admission policies

recorded an increase from 8.4 million to 11.3 million (Feist & Hutchison, 1989b). What is also clear from data on those museums introducing charges for admission is the subsequent impact of special exhibitions on raising visitor numbers.

THE IMPORTANCE OF PRICE, ARTISTIC AND TECHNOLOGICAL INNOVATION

Few would disagree with the assertion that understanding the complexities of cultural consumption requires an appreciation of the multitude of factors which influence demand and supply of any product at a particular time. Even within any product group, the product itself is not uniform. It is perhaps then of no surprise that only a handful of commentators have attempted to bring together a holistic vision of trends in cultural consumption, and the way in which they interact.

Bennett (1991) provides a starting point in examining the interaction between patterns of consumption in the cultural sector in the UK. He focused on the fact that in the face of limited public sector funding for culture, and the ever-expanding impact of cheap, convenient, and technologically driven cultural industries, the traditional cultural sector will suffer. Bennett (1991:300) states:

> . . . the personal cultural centre [is] based in the home, and it's well equipped: with TV (terrestrial and satellite) radio, video, hi-fi, and whatever else technology can produce. It's safe . . . comfortable . . . convenient . . . cheap. Arts organisations find themselves in a double bind: they are inadequately supported by an inadequate system, and are thrown back on the market place where they encounter increasingly fierce competition from the cultural industries.

As noted above, performing arts organisations have moved to increase average ticket prices and raise earned income at rates which have been much faster than the cost of living. This, along with the growth of sponsorship, was seen as one of the key characteristics of the grant-aided sector from the mid-1970s to the mid-1990s.

As ticket prices for traditional artform areas have appeared to soar, so the cost of the products of the cultural industries, and its associated hardware, have increased at a slower rate, remained static or even fallen.

TABLE 12.6: PRICING: INDICES TAKEN FROM THE COMPONENT PARTS
OF THE RETAIL PRICE INDEX (INDICES, JANUARY 1987=100)

	Repertory Theatres*	Audio-visual Equipment	Tapes and Discs	Books and Newspapers	Entertainment and Other Recreation**	Restaurant Meals
1987	100.0	100.0	100.0	100.0	100.0	100.0
1989	115.7	90.5	98.3	120.7	122.4	117.5
1990	135.0	89.5	100.5	131.2	134.7	127.1
1991	148.8	87.3	107.3	142.0	153.1	139.1
1992	171.5	83.2	111.7	152.2	168.4	180.7
1993	179.7	81.7	113.8	158.2	180.7	154.6
1994	196.4	76.8	115.2	160.3	193.6	160.5
1995	190.3	72.9	115.6	165.5	203.3	166.8

Source: Office of National Statistics; Arts Council of England.
* Average ticket yield for home-based productions in main houses. Index at current prices, 1986/87 = calendar year 1987.
** The figures for calendar years 1987 and 1988 were 102.7 and 112.3 respectively.

But what evidence is there to confirm or deny that real terms price increases in the traditional sector have been important in restraining demand?

Over two decades of research into the impact of price on the decision to attend has revealed a fairly consistent pattern. The Arts Council of Great Britain report of the *Committee of Enquiry into Seat Prices* (1973), published at the end of a period when real average ticket prices for subsidised theatre had actually fallen, provided some of the first British evidence that substantial increases in ticket prices did not appear to choke off demand. The pattern of pricing was reversed in the 1980s. In virtually all areas of the subsidised arts, ticket prices increased at a rate in excess of both retail prices and average earnings, with little apparent effect on demand. This trend has continued, at least until very recently, into the 1990s (see Table 12.6).

More recent research on the relative importance of price and attendance has tended to confirm the limited importance of price in the context of the decision-making process: the majority of consumers are product-sensitive rather than price-sensitive. Various market research surveys have identified few respondents who spontaneously mention price as a factor influencing decisions to attend. Millward Brown's (1991) work on pricing in the arts found

that less than 2 per cent of respondents spontaneously mentioned price as a reason for non-attendance; the RSGB Arts Omnibus survey (1991) revealed only 4 per cent of respondents mentioning price as a barrier to attendance.

There are, however, important qualifications to this statement. Among certain sub-groups of current attenders there *is* price sensitivity. In such cases, price *may* result in a conscious decision to reduce the frequency of attendance or, in certain cases, prevent consumption altogether.

In his review of pricing research during the 1980s, Blamires (1992:377) remarks that:

> the decision process commences (usually) with receipt of sufficient interesting information about an event to trigger a desire to attend. That is, it does *not* commence with a desire to "go out this evening", followed by a trade-off of alternative events . . . against price and other criteria. Knowing the benefits of attending that specific event . . . the price is consulted and measured against perceived *value*.

Consequently for most non-attenders, rejection takes place prior to the consideration of price in the decision-making process.

Before leaving the issue of price, it is worth noting some research that has examined the relationship between the cost of participation in sport in Scotland, by Coalter (1993). A controlled study of the effect of price changes at selected sports centres in Scotland yielded broadly similar results to those arising out of Millward Brown's (1991) work on the arts. It was found (Coalter, 1993:180) that:

> for most participants and non-participants, the cost of entrance to a range of common sport and physical recreations has a relatively low salience in the decision to participate or not. In particular, current non-participants do not appear to view the cost of admission as a major deterrent.

However, Coalter was keen to point out that this fact should *not* be taken as evidence that demand for sport and recreation is inherently inelastic. The same applies to the cost of attendance at arts events but with more force. While it may not be possible to identify price as the principal hurdle for those with a desire to attend, this is not necessarily the whole story.

A more recent refinement to the debate about the relative importance of price has pointed to the lack of sensitivity within certain price bands for attendance compared to a reluctance to cross such bands. Research into price bands and the presence of inelasticity *within* certain price bands has been conducted by Blamires (1995) on the basis of audience surveys. Interestingly, however, the importance of "price bands" is lent support in research by Huntingdon (1993). His work on the pricing structures and box-office income of a group of Arts Council-funded building-based companies suggested that venues operating tiered (as opposed to single price) pricing structures were more likely to return higher box-office revenues.

We may conclude, therefore, that as a barrier to attendance, price appears to have only limited influence; there are many other factors which affect the decision to attend. These observations do not, however, invalidate Bennett's (sober) assessment of the current position of the traditional arts. Bennett's concern is with relative change in price (what we might call the "price disadvantage") facing the traditional sector *vis à vis* the products of the cultural industries, both over time and in the context of perceived competitor products. He is also rightly concerned about the effect of the increasing ease and convenience of consumption of the products of the cultural industries. The contrast with the traditional sector is considerable and appears to be growing.

A different perspective on the inter-relationships between the arts and the products of the cultural industries comes from the economist Heilbrun (1993). Heilbrun has explored an interesting analytical framework with which to approach the various fortunes within the arts. His approach has been to differentiate cultural activities on the basis of the extent to which they can indulge in "technological innovation" and "artistic innovation". Those cultural activities which are characterised by high levels of artistic innovation are likely to be able to sustain and even expand audiences in the face of ever-increasing demands on leisure time; those art forms where artistic innovation is limited and where technological innovation has brought about the substitution of competing goods face a less promising future.

There is a central, and arguably attractive, logic to Heilbrun's approach. The empirical evidence on which Heilbrun based his assertions suggests that this may be a useful analytical approach. He provides evidence to underpin his argument by comparing

trends in attendances and performances within different artforms in the United States. Of all the traditional artforms, it is symphony concerts which appear to have struggled most to retain their audiences during the 1980s and Heilbrun cites a decline in both performances and attendances at symphony concerts during the 1980s. Certainly, there is evidence to support the view that symphony orchestras have experienced problems with the process of innovation in the artistic field. As Heilbrun argues for the US, it is clear that the compositional output of the last 20 years has done little to change the eighteenth-, nineteenth- and early twentieth-century bias of the repertoire of orchestras. Furthermore, the advent of high quality digital recordings has only served to harm the traditional concert-going audience by providing them with an adequate substitute good.

Whether this equates to a lack of innovation is less clear-cut. Artistic innovation has arguably taken place in the form of the locations in which orchestras now play (as the trend towards outdoor concert-giving is clearly evident). Moreover, the implication that all modern composition is without a concert-hall audience is not tenable. Perhaps most significant is an observation which strikes at the very heart of Heilbrun's thesis. Some have argued that it is the very conservatism of the classical music repertoire — its ability to fulfil a role as a form of risk aversion — which is central to its attraction among those parts of the population which are generally "risk averse".

Heilbrun's observations on the importance of innovation in determining the relative health of the demand for particular forms of cultural consumption, require qualification, particularly in the UK context. We have already noted that audiences for contemporary dance, one area where innovation is high, appear to have suffered in recent years. For information, Table 12.7 indicates the proportion of new work among a range of different art forms in the UK. However, these are not comparable data and much more work would be necessary to consider the applicability of Heilbrun's theory in the UK.

One general weakness of Heilbrun's argument would, however, appear to be neglect of supply-side issues. Relatively little work has been done on the importance of supply-side factors influencing patterns of demand for the arts and cultural products. This is still a rather striking gap in the research literature, given

that many arts funding bodies' *raison d'être* is primarily to increase the supply of artistic product (Khakee & Nilsson, 1980).

TABLE 12.7: NEW WORK BY TYPE OF ARTFORM

	"New work" as a Percentage of Total Performances
Orchestral performances:	
London orchestras*	2%
Regional orchestras*	4%
Regional chamber orchestras*	7%
BBC orchestras*	11%
Grant-aided theatre†	21%
Opera‡	6%

* 1991/1992 data. Performances of works written post 1982. Data taken from BBC/Arts Council *Review of National Orchestral Provision*. Figures based on all UK performances including studio performances

† 1994/95 data.

‡ Principal grant-aided opera performances, 1991. Performances of work composed post-1945. Taken from an analysis of opera data given in Feist and Eckstein (1991).

CONCLUSION

This chapter has attempted to explore the problems in measuring the market for arts activities and the products of the cultural industries. It has examined some of the factors determining demand and considered some of the arguments which have been developed over the relative importance of price and innovation within the consumption of cultural goods. The aim has not been to present a holistic picture of the determinants of demand (one could write a volume on the importance of taste formation in patterns of consumption). The over-riding message is that while we should never underestimate the complexity of demand for the arts and products of the cultural industries, we should be urged to make further strides in unravelling the many factors that influence patterns of consumption. Only then will we be clear about the most appropriate points of policy intervention.

Notes

[1] These data are taken from the Target Group Index (TGI) conducted by British Market Research Bureau, which collects information from around 25,000 adults in England, Wales and Scotland. Data are also collected on attendance at "Jazz" performances although the inclusion of a new classification, "Pop/Rock", in 1991/92 may have influenced the recording of events formerly classified under "Jazz". Because of this discontinuity the data are excluded.

[2] The prevalence of subscription schemes in certain performing arts areas reflect this.

[3] Note, however, some surveys such as that undertaken by CAVIAR on cinema consumption do include individuals aged seven and over. Furthermore, the Arts Council of England will be publishing the findings of an attitudinal and behavioural survey of 11–16 year olds, surveyed in school, from research conducted by MORI.

[4] Docherty et al (1987) noted this from their research and there is clear evidence from similar data held by CAVIAR (see *Cultural Trends 1990:6* p 26).

[5] *Screen International*, 24 January 1992, p. 10. Comment by Maj-Britt Kirchner, Managing Director of Warner Brothers (UK).

[6] See, for instance, Kapinski (1988) and Feist & Eckstein (1991). Changes in attendances at performances in London's West End closely mirror changes in aggregate visits from overseas to the UK. As a result they are sensitive to such factors as changes in the exchange rate and international incidents.

[7] There has, however, been a particularly marked reduction in studio performances. Although fluctuating widely in several years, home-based studio performances fell by one quarter between 1986/87 and 1994/95.

[8] An independent museum is one which is outside the directly funded local-government sector and the centrally funded National Museums.

[9] For instance, the National Museum of Photography, Film and Television which opened in 1984, the Liverpool Tate in 1988 and the St Ives Tate.

[10] Davies makes no account for the fact that the participation data, taken from the Arts Council of Great Britain's Omnibus Survey conducted by Research Surveys of Great Britain, includes by default visits made overseas. This would seem to question the base data from which Davies establishes an estimate of UK adult attendances.

[11] According to figures from an NOP survey of five national collections, only 46 per cent of visitors were UK-resident. Data quoted in Eckstein J (1993).

References

Arts Council of England Annual Report, 1994/95.

Arts Council of England (1996), *A Statistical Profile of the Professional Drama Sector in England — An Appendix to the Drama White Paper*, London: Arts Council of England.

Arts Council of Great Britain Annual Reports, 1986/87–1993/94.

Arts Council of Great Britain (1973), *Report of the Committee of Enquiry into Seat Prices*, London: Arts Council of Great Britain.

Arts Council of Great Britain (1991), RSGB Omnibus Survey — *Report on a Survey of Arts and Cultural Activities in Great Britain*, London: Arts Council of Great Britain.

BBC/Arts Council (1994), *Review of National Orchestral Provision*, London: Arts Council of Great Britain/BBC.

Bennett, O. (1991), "British Cultural Policies 1970–1990", *Boekmancahier*, No. 9, September 1991, pp293-301.

Blamires, C. (1992), "What Price Entertainment", *Journal of the Market Research Society*, vol. 34, no. 4, October 1992.

Blamires, C. (1995), *Pricing Research Report* — Prepared by AIM/Decision Modelling Consultancy for the Arts Council of England, London: Arts Council of England.

Blamires, C. (1995), *Haymarket Theatre, Basingstoke: Pricing Study* — prepared by AIM/Decision Modelling Consultancy for the Arts Council of England, London: Arts Council of England.

British Film Institute (1995), *Film and Television Handbook 1996*, London: British Film Institute.

British Tourist Authority (various years), *Sightseeing in the UK*, London: British Tourist Authority.

Coalter, F. (1993), "Sports participation: prices or priorities?", *Leisure Studies*, vol. 12, no. 3, July 1993, 171–182.

Cultural Trends 1990: 6, London: Policy Studies Institute.

Davies, S. (1994), *By Popular Demand — A strategic analysis of the market potential for museums and art galleries in the UK*, London: Museums and Galleries Commission.

Docherty, D., Morrison, D. & Tracey, M. (1987), *The Last Picture Show — Britain's changing film audiences*, London: British Film Institute.

Eckstein, J. & Feist, A. (1992), *Cultural Trends 1992: No. 13*, London: Policy Studies Institute, 64–65.

Eckstein, J. (1993), *Cultural Trends 1993: No. 19*, London: Policy Studies Institute.

Family Spending — A Report of the 1993 Family Expenditure Survey, (1994), London: HMSO.

Feist, A. & Eckstein, J. (1991), *Cultural Trends 1991: No. 11*, London: Policy Studies Institute.

Feist, A. & Hutchinson, R. (a), *Cultural Trends 1989: No. 2*, London: Policy Studies Institute.

Feist, A & Hutchinson, R. (b), *Cultural Trends 1989: No. 4*, London: Policy Studies Institute.

Gardiner, C. (1992), *The West End Theatre Audience 1990/91*, London: City University/Society of West End Theatre.

Gardiner, C. (1996), *Society of London Theatre Box Office Data Report 1995*, London: City University/Society of London Theatre.

Gold, S. (1980), "Determinants of Arts Demand: Some Hypotheses, Evidence and Policy Implications", in Hendon, W. et al (eds.), *Economic Policy for the Arts*, Abt, 150–160.

Heilbrun, J. (1993), "Innovation in art, innovation in technology and the future of the live arts", *Journal of Cultural Economics*, vol. 17, no. 1, 89–98.

Huntingdon, P. (1993), "Ticket pricing policy and box-office revenue", *Journal of Cultural Economics*, vol. 17, no. 1, 71–87.

Hutchison, R. & Feist, A. (1992), *The Amateur Arts in the UK*. London: Policy Studies Institute.

Kapinski, J.H. (1988), "Tourism's contribution to the demand for London's lively arts", *Applied Economics*, no. 20, 957–968.

Khakee, A. & Nilsson, G. (1980), "Is the supply of cultural events an indicator of their demand? Music and Theatre in Sweden" in Hendon, W. et al (eds.) *Economic Policy for the Arts*, Abt, 272–282.

Millward Brown International (1991), *Pricing in the Arts 1990*, Warwick: Millard Brown International.

Screen International, 24 January 1992, 10.

PART FIVE

INNOVATIVE ASPECTS OF CONTEMPORARY
ARTS PRACTICE

13

MANAGEMENT, THE ARTS AND INNOVATION

Mary Cloake

In recent years, innovation has emerged as a key issue for arts managers. This chapter looks at only a small element of the complex relationship between innovation, the arts and arts management. The chapter discusses briefly the innovative nature of the arts and examines the nature of innovation in the management of high-technology industries, where high rates of continuous innovation are identified as the norm. Then it asks if it is appropriate to transfer structures for innovation from these sectors to the management of the arts. A specific example is given in the management of local arts development with particular reference to the pilot training project, Artform, as one attempt to establish local structures for arts innovation.

DEFINITIONS OF INNOVATION

From the 1935, Chambers Twentieth Century Dictionary definition:

> **Innovate**, in'o-vat, *v.t.* to introduce something new. — *v.i.* to introduce novelties: to make changes. — *n.s.* **innovation**

The word innovation has come to have a very specific meaning in the context of the technological environment of the late twentieth century:

> Three separate processes can be identified in technical progress: invention, innovation and imitation. . . . An invention is the discovery of a new production technique, good or service and is often distinct from the initial scientific discovery which ultimately leads to the invention. . . . The act of invention may be a chance event and be characterized by many failed attempts; the success of an

invention may be the result of the superior knowledge and abilities of the inventors. . . . An innovation is the development of an invention so that it is actually used or produced in the economy. It has been suggested that inventions are often relatively inexpensive, though difficult, to discover, whilst the process of innovation is often relatively expensive. Finally, new production techniques and goods and services may be imitated by other firms (Peirson, 1988:846).

INNOVATION IN THE ARTS

In the arts we are familiar with the concept of artistic innovation which refers to new practices or uses in the form or content of a particular artistic medium. Innovation in this context implies that the artist has a new and inventive idea but also the relevant technical expertise to execute it in the chosen medium. Imaginative and creative ideas must be realised within the discipline or medium of an art form so that formal innovation can result.

Since the Romantic period, innovation has become, arguably, a defining characteristic of the arts:

> From Romanticism, modernism gets its emphasis on originality, on the need to make things "new" — to be perpetually innovative at the level of both form and content. It is their perpetual restlessness and formal innovation, among other things, that have put Joyce and Picasso at the centre of modernist art and literature (Scholes, 1995).

And in terms of more recent movements in the arts, the question of the innovative quality of an art work has become even more important:

> Controversy has been a characteristic feature of the concept of art. But it may be said that today it is in a state of crisis unlike any that existed before. Almost daily we are confronted with new kinds of objects or performances which challenge our notions of what art is or ought to be. Such traditional qualities as beauty, aesthetic experience and "the imitation of nature" have come under challenge, and even the minimal requirement that a work of art should be a *work* — an object made by human hands — has been flouted. But as these qualities have fallen away, one other quality, that of innovation, has taken on a new importance. "The essence of art", according to the painter Dubuffet, "is novelty . . . the only system favourable to art is permanent revolution" (Hanfling, 1992:3).

Innovation in the arts happens when an artist expresses ideas within the traditional discipline of their own chosen medium or media in ways relevant to the changed circumstances of the present. Works may be socially aware or seek only to say something about the medium in which they are cast. The "changing circumstances of the present" may therefore refer to social change or to technological change which offers new ways of working in a particular medium. The concept of the "traditional discipline" of the medium may be deliberately ignored, subverted or challenged (for example, by the merging of several disciplines). However, it is at this point of cross-over between tradition and the contemporary that innovation in terms of form or content takes place. Sometimes the innovation may be incremental and part of a slow development of new artistic movements. On occasion the innovation is fundamental and can change the nature of the art form, having a major impact on how the arts in that medium are perceived. Once made, however, the innovation itself becomes part of the historical tradition of the art form, which, though changed and adapted, will again be challenged anew.

There are many examples. When the social and technological advances of the early twentieth century took place, in particular the development of film, a new set of experiences were created which needed new forms to describe and express them. The huge formal innovations in the visual arts and literature in this period reflect attempts to do this. The concept of a multiplicity of points of view, which grew from the influence of cinema, became important. This phenomenon was one of a range of influences on the work of James Joyce.

James Joyce worked within a literary tradition which encompassed the panoramic social realism of Zola, which is found as a major influence in *Dubliners*, and the Bildungsroman tradition which he adapted to his own experience in *Portrait of the Artist*. A major innovation in terms of the novel *Ulysses*, however, grew out of his desire to "forge in the smithy of my soul the uncreated conscience of my race" and thereby to adapt the form of the novel to reflect the reality and idioms of his own experience of contemporary Dublin. He perceived a need to represent Dublin society of the time to itself and to the world in a way that was honest and invited reflection and self-criticism. This was innovation in terms of content. For this representation he chose a consciousness that

moves between the individual, the social and the authorial point of view and thus in formal terms he revolutionised the novel.

To cite a more contemporary example, the innovation of Roddy Doyle's technique of novel writing emerged through an application of idiomatic forms of speech, serving to represent the experience of language without the filter of the conventions of narrative description or scene setting. Just as Doyle's intention to represent the voices of the unvoiced could be seen as innovation, so each generation needs to find anew its expression and mode of expression.

The emergence of new ways of describing arts practices, such as community arts, stemmed from such a need and the shift in this view of arts practice from the site of value in the product to the site of value in the process was based on the need to ascribe the social and cultural value of the aesthetic experience of making art to the "non-artist" in individual and collective terms. Most recently, computer technology has opened up new possibilities for the artist, and the term multimedia has gained a new currency reflecting the multiplicity of combinations of form now available.

INNOVATION AND ARTS MANAGEMENT

Is there anything we as arts managers can learn about our own work practices from working in a sector of which one of the defining characteristics is innovation ?

If innovation is a *sine qua non* of the arts, then there is a particular responsibility to establish structures, climates, organisations and contexts within which the continuously innovative process of making art can take place. This might happen on a number of levels, from the national policy of the Department of Arts and Culture to the small arts organisation and the individual administrator. This support of the artistic process by the individual arts manager has become more important in today's environment of complex technologies, when artists may need to work with administrators, managers and technical experts to achieve their vision.

It seems, however, to be an unduly narrow conception of innovation in the arts sector to limit it to the work of the individual artist. There are now other, process-based models of making art which need to be resourced and supported and the question of innovation also needs to be considered in relation to these. But the

importance of innovation is not limited to the production of new arts products and processes. In management literature, the narrow conception of innovation as simply an issue of the research and development of new products or technologies has been replaced by the use of the word to describe a dynamic influencing all aspects of the production process. Similarly, innovation can be applied to the management, organisation and development of the arts, even though in the arts and cultural sector "there is a widespread view that the management job is different in important respects to that of managers in other sectors" (Clancy, 1994:3). Further research in this area might discover if there is competitive advantage for the arts manager and the arts organisation in the area of innovation.

In looking for models of innovation in management, the focus is often placed on private sector and particularly high technology manufacturing. It has often been argued that the level of innovation and commitment to innovation in these sectors, is far higher than in the public sector (Senge, 1993; Angel, 1994). Reich (1991) argues that this current tendency toward accelerated innovation, particularly in the high-technology sector, arises out of a profound and widely experienced crisis of profitability in manufacturing systems in advanced industrial economies leading to considerable pressure to innovate. The high technology industries are marked by their ability to innovate because of their flexibility: they can adapt quickly to changing circumstances in the environment. It may be useful, in discussing innovation in arts management and arts development, to make comparison with the processes and systems by which it is achieved in highly innovative sectors elsewhere.

INNOVATION AND MANAGEMENT

What does management literature have to say about innovation, particularly in the context of these sectors which are characterised by high levels of innovation ?

Characteristics of Innovation

The first point of basic agreement in most material written on innovation is that it is a clearly identifiable process which can be managed, although it is not visible or concrete in the way that production or assembly-line processes are. Simply described,

there are three elements to this process: the generation of new ideas, the "harvesting" of ideas and the development and implementation of these ideas (Adair, 1996). Another point of agreement is that innovation is as often about small, incremental changes and improvements as major advances. Innovation is frequently part of a continuous process of gradual or incremental adaptation to changing circumstances which can be described as evolutionary rather than revolutionary (Adair, 1996; Graham and Senge, 1980).

Once viewed as merely a single and independent aspect of the manufacturing process — a discrete activity concerned with the research and development of new products — the concept of innovation has now been extended to all aspects of the organisation and structure of production systems, from production processes, ways of organising work to new patterns of employment and labour relations. These elements are often summarised as "The Value Chain" as shown in Figure 13.1.

FIGURE 13.1: THE VALUE CHAIN

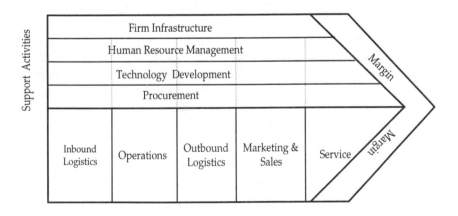

Primary Activities

Source: Porter 1985:37.

The concept of *continuous innovation* across all these functions is now an accepted priority in many management environments. Indeed, some commentators have claimed that the capacity to generate continuous innovation is becoming the sole determinant

of the organisational and territorial structure of many major in-
dustries. (Angel, 1994; Senge, 1993).

A key impetus to innovation is the need for change. This
change may be a response to unforeseen changes in the external
environment or planned in terms of making appropriate changes
within an organisation. An example from the manufacturing sec-
tor can illustrate. A major environmental change is the general
shift from the existence of mass markets to the development of a
proliferation of low-volume, specialised, niche markets for goods.
New products are now likely to be developed with specific mar-
kets in mind and the image of mass production and subsequent
mass marketing to a passive, unidentified and expanding range of
consumers is no longer an accurate representation of the envi-
ronment of the manufacturing sector. Attempts to adapt to this
change have led to the culture of continuous innovation becoming
a key characteristic of the manufacturing sector.

Early responses to this shift tended to treat the changing
structure of markets as an external phenomenon, a dynamic that
firms responded to rather than created. More recent theoretical
work (Angel, 1994) has shown that the creation and management
of market demand is a central internal moment within the dy-
namic of continuous innovation: the ability of firms to continually
develop and deploy new technologies is dependent on a parallel
capability to create and sustain uses for these technologies.
"Continuous innovation requires the simultaneous and coordi-
nated generation of new technologies and new markets" (Angel,
1994:14). Thus the concept of continuous innovation has come to
extend beyond the traditional realm of control of the individual
organisation.

The Nature of the Innovation Process

Much of what has been written about the nature of the innovation
process can be summarised by the epithet: *individuals have new
ideas, innovation requires teams.*

New ideas. Attempts have been made to define and describe the
notion of creativity itself, to ask what makes people get ideas?
Such debates are outside the scope of this chapter, but two themes
emerge: synthesis and analogy. In *The Act of Creation* (1964), Ar-
thur Koestler (quoted in Adair, 1996:69) coined the new word

"bisociation" to describe the essence of creativity as putting together two unconnected facts or ideas to form a single idea. The idea of synthesis as creativity can be illustrated by reference to Karl Marx, whose fundamental innovations in political and economic analysis were based on his combination of Hegel's theories of dialectic analysis with ideas of economic and material determinism which he encountered elsewhere. (This concept of creativity as synthesis is consistent with definitions of formal artistic innovation: the synthesis of formal tradition with contemporary circumstances yields the new idea; the perception and technical achievement of the idea by the artist brings it to realisation.)

Some writers on innovation emphasise the importance of analogical thinking to creativity and hence to innovation (Adair, 1996). Various examples are cited such as inventions which have been based on nature. Radar, for example, came from studying the uses of reflected soundwaves from bats. The built-in seam weakness of the peapod suggested a way of opening cigarette packages, a method now used widely in the packaging industry. The case of the early eighteenth century agriculturalist Jethro Tull is also an example. He developed a drill enabling seeds to be sown mechanically and spaced so that cultivation between the rows was possible in the growth period. Tull was an organist, and it was the principle of the organ which gave him his new idea. With reference to this type of thinking, the arts themselves can be seen as various types of metaphor, as "repositories of human experience symbolised in word, sound, movement and image" (Drury 1989:11). To be familiar with the arts, therefore, seems to suggest a familiarity or facility with symbolism, metaphor and allegory and perhaps, by extension, a practiced ability or increased willingness to think in terms of analogies.

Innovation. In terms of the process of innovation, however, the generation of new ideas is only a preliminary stage: the process as a whole includes the refining and development of ideas to the stage where they become innovative. This has been described in commercial terms as a process of "overcoming obstacles that separate new ideas from the market place". The processes by which this refinement and development takes place may vary but are based around the single principle of interaction between the creative individual and a group dynamic. There are many views

and examples of the ways in which this interaction can be encouraged, structured and organised. The concept that "many ideas grow better when transplanted into another mind than in the one where they sprang up" (Oliver Wendell Holmes Jr., quoted in Adair, 1996:78) underpins many of the approaches.

Much of the literature on innovation focuses on the various forms these groupings have taken, the type of organisational structures which have arisen as a result and the key characteristics of successful groupings. Attention has been paid to these groupings as part of a search for new organisational and territorial forms that facilitate innovation.

Forms of Innovation Groups. The types of groups formed for innovation purposes may be divided into three broad categories. These are: multi-dimensional product teams within an organisation; partnerships and alliances between organisations; and territorial-based groups such as clusters and agglomerations.

Multi-Dimensional Project Teams. In the context of the individual organisation, the primary agents of innovation and new technology development are multi-dimensional project teams, often working within an open organisational structure of which decentralised decision making is a key characteristic. Flexibility and the capacity to adapt quickly to change are key prerequisites for innovation. The concept of "localness" informs the move towards decentralisation: local actors often have more current information on customer preferences, competitor actions and market trends. They are in a better position to respond quickly and to manage the continuous adaptation that change demands.

The innovation teams are usually drawn from across the normal departmental structures of an organisation, with specialists representing the design, production, sales, marketing and other appropriate functions. Membership may vary with the specific task or issue at hand. These innovation teams are separated from the normal organisational reporting structures and individuals within the group may be a member of two or more teams, the organisation working on the basis of a matrix structure with the traditional vertical reporting lines being augmented by lateral or horizontal relationships. Matrix organisations are, however, normally transitional. There is a tendency for an organisation to revert to an emphasis on one element of its operational priorities

(Adair, 1996). Innovation teams work most successfully, therefore, when put together with a definite life-span to address a specific objective.

The distinctive competence of the individual members of the team is also a fundamentally important characteristic. The necessity of having a mix of complementary expertise is repeatedly emphasised. Multiple mental models which arise from diverse spheres of training and experience bring multiple perspectives to bear on the issue at hand, allowing creative thinking to emerge from seeing and making connections. It is also essential that there is a common commitment to achieving the group objective (Senge, 1993).

Partnerships and Alliances. There has been a trend in restructuring for innovation in the high-technology sector towards increased dependence on external sources of technological knowledge and manufacturing capability. Typically, outside dependence or "externalisation" involves the establishment of network relations among firms whether in the form of strategic alliances and partnership agreements or in the form of informal co-operation and mutual dependence (Angel, 1994). There is now a growing body of literature suggesting that such partnerships are becoming increasingly common in many technologically dynamic sectors of production (Contractor & Lorange, 1988; Link & Bauer, 1989; Mowery, 1988; Mytelka, 1990). The majority of firms in most major manufacturing sectors are now enmeshed in a complex network of research, technology development, production and marketing alliances.

"Strategic alliance" and "manufacturing partnership" are ill-defined concepts that are applied in the literature to a wide variety of formal and informal co-operative relations. At the same time, there is little agreement on what constitutes the "strategic" component of alliances. Angel (1994) argues that alliances are strategic, as opposed to opportunistic, if the organisational forms of partner firms are predicated on an alliance-based structure, that is, if it is necessary for the firm's core activities that partnerships are formed with firms possessing complementary expertise. The proliferation of strategic alliances and partnership agreements has therefore been accompanied by a tendency towards greater specialisation. Resources are concentrated on developing a high level of distinctive competence within the individual firm: other

expertise is sourced through partnership. Indeed, experience has shown that partnerships work best for innovation when the achievement of common objectives is dependent upon the existence of complementary assets or expertise, so that each partner maintains a distinct area of competitive advantage (Angel, 1994: 129). This concept of distinctive competence is important for the optimum structure of partnerships.

Many sectors which have had experience of partnerships (Reich & Mankin, 1986) have sometimes found partnerships to be mutually disadvantageous because they were poorly structured. Many were based around expectations of short-term gain (such as quick access to investment capital) rather than the development of a long-term structure to share the risk and cost of addressing joint opportunities and problems in new ways. These were marked by a one-way flow of technology and information and by a tendency for collaborative relations to collapse into competition. Williamson (1985) and others have argued that the problems of appropriation and knowledge protection are powerful disincentives to partnership.

Parkhe (1993) suggests that the key analytical issues for the partners are trust, reciprocity, and forbearance. Partnerships have to be structured so that the opportunities for, and gains from, malfeasance are outweighed by the benefits of continuing the alliance. The tendency in well-structured partnership has been to combine the common (or generic) expertise generated by the partnership with specialist complementary assets or expertise, so that each partner maintains a distinct area of competitive advantage. Contractual disagreement is often avoided through the selection of partners who possess different specialisations. In some manufacturing partnerships, for example, the partners may specialise in different geographic markets. It is important then that the key structure underpinning the partnership is one of the separation and acknowledgement of generic and specialist expertise (Jorde & Teece, 1990:83). Three broad areas of competence can be identified as characteristic of high-technology manufacturing industry, namely, product technology, production/process technology, and geographic market. Successful partnership agreements involve a combination of these different areas of competence.

Agreements among firms in this sector address all types of manufacturing activities, from marketing to research and production. At the same time, there is considerable variation in the level

of interaction and mutual commitment involved in these agreements, ranging from arms-length, one-time transactions to long-term partnerships. Partnerships with a lower level of interaction are administrative in character and, once established, do not usually require continuous detailed communication among the partner firms. Partnerships which involve the highest level of interaction require commitments of resources to maintain open and frequent channels of communication.

The motivation for forming inter-firm partnerships has been to cut costs and share risks in a volatile environment. Recent research has found that at present the durability of existing partnerships is uncertain, dependent on the ability of the firms to generate new technologies (i.e. to innovate) from the co-operative venture and to avoid direct competition with one another.

Territorial Approaches. The third type of innovation grouping is that based on regional or geographic proximity. A key topic of interest within sectors which have restructured to enhance their innovation capability is the informal process of learning and information exchange within and among firms. This reduces the costs of learning and accelerates the pace at which information flows within the sector. This drive to accelerate information flows leads to a tendency towards the regionalisation of production systems within a series of specialised industrial agglomerations or industrial districts. Dosi et al. (1988) have indicated that the ability of some sectors to innovate is distinctly local and regional in character — based on knowledge of a tacit kind, embedded in the skills and experiences of workers, institutions, and communities — and not easily transferable across national and regional boundaries.

APPLYING THESE APPROACHES TO THE ARTS

Is it problematic applying approaches to structures for innovation from the private sector to the arts ? It is argued here that it is possible to apply these models usefully as long as the complexities of the arts sector are not over-simplified.

In the private sector the relationships along the value chain are straightforward, in that although, as we have seen, there is increasing interaction between the processes, it is still possible to define the relationship with the customer as essentially about

"making a sale" (Pick, 1980). The arts sector, however, presents problems for this model. The concept of the artist as producer and the audience as customer has developed beyond this simplistic distinction in recent arts practice. New ways of making art and challenges to the traditional dichotomy of artist and audience mean that there are now available many types of experience of making and receiving art. Apart from the individual artist with a high level of expertise, commitment and experience in the making of art, art is often made collectively and can be made by people without formal training. The domain of the arts could therefore be described as a series of experiences characterised by varying degrees of participation in producing the artistic experience, from artist(s) delivering the work through to the audience which also contributes to the production by actively responding to it. The experience of the work may be either individual or collective. If we take *individual/collective* on an axis and *artist/audience* on another we can conceptually "plot" where various experiences lie:

FIGURE 13.2: EXPERIENCES OF ART: INDIVIDUAL OR COLLECTIVE; ARTIST OR AUDIENCE

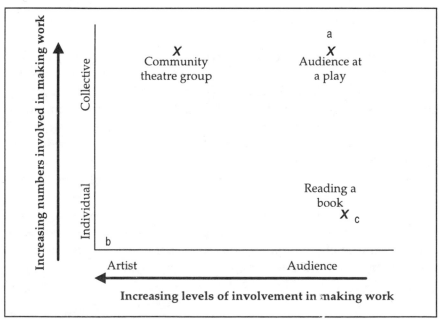

An audience at a traditional play will be positioned at "a" as it is a collective experience of receiving art (although the reception may be very active and not passive), The individual artist will be at "b". An experience of reading a book may be at "c" (although reading a book is often more than an individual experience when it becomes the subject of discussion or when it is read aloud).

There is another variable which further complicates this domain of the arts manager — that of expertise and experience. In *Art and the Ordinary* Ciaran Benson (1989) states "There is a difference of degree rather than kind between artists and non-artists". It is possible to conceive of these degrees of difference in conceptual terms on an axis called *commitment/experience/expertise*. This gives a three-dimensional picture of the complexity of the potential domain of the arts sector where the variables of *individual/collective* and *artist/audience* are further augmented by a third variable — *commitment/expertise/experience*, at one end of which is "committed and informed" and at the other is "first time experience". This *expertise/commitment* axis applies equally to artists and audiences (see Figure 13.3).

The arts manager may need to work at a number of points within this domain or "task environment". In applying models for structures for innovation, the complexity of this domain needs to be incorporated.

In traditional management terms, this complexity means that there are any number of distinct "markets" or target groups for various arts goods and services — in other words, in common with markets generally, the arts world has become fragmented into a series of specialist niche areas. In terms of innovation in arts practice, therefore, the development of teams, groupings or partnerships of key players around specific points within this "task environment" would seem to offer a way of establishing structures for innovation.

In presenting this approach, a further degree of complexity must be acknowledged in that easy application of economic models can be challenged by the role of the arts as personal and social expression undetermined by business values.

FIGURE 13.3: EXPERIENCES OF ART: INDIVIDUAL OR COLLECTIVE; ARTIST OR AUDIENCE; MORE EXPERIENCED OR LESS EXPERIENCED

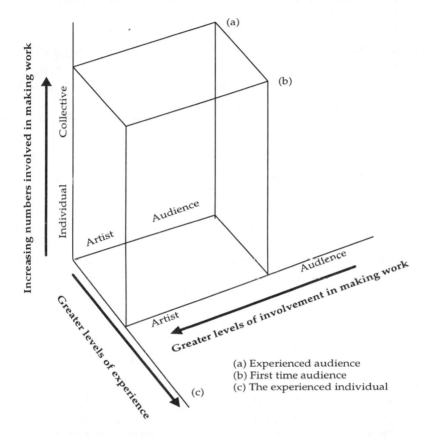

(a) Experienced audience
(b) First time audience
(c) The experienced individual

It is useful to apply these approaches to the area of local arts development, where one pioneering attempt was made to establish such structures for innovation. Opportunities were created to foster the development of various groupings around key problems and opportunities in this sphere leading to the emergence of the Artform project which was intended to explore the creation of new organisational forms.

Artform was established when a consortium of organisations with an interest in arts-related training — The Arts Council, National Youth Council of Ireland and University College Dublin's Arts Administration Studies — secured funding under the EU

Euroform Programme to address the training needs of three spe-
cialist groups of locally-based professional arts and development
workers. These were: localauthority arts officers, community de-
velopment personnel attached to local authorities, and youth-
work professionals from within the youth-services sector. The
point of common interest across the consortium was local arts de-
velopment.

There are many potential parallels between local arts devel-
opment and the high-technology manufacturing sector. Like this
sector, the local arts development environment is a complex one,
consisting of a proliferation of low volume and specialised poten-
tial "markets" or "target groups", operating within a complex
general environment of public- and private-sector interests. To
draw further parallels with the private sector, the ability of the
arts at local level to develop continually and create new and in-
teresting types of art is dependent, to some extent, on a parallel
capability to create and sustain uses for this art. Continuous inno-
vation in the arts environment may be said to require the simul-
taneous and coordinated generation of new work in the arts,
alongside new processes of responding to the arts.

Earlier models of local arts development allow only for the
segmentation of local arts development practice into a bifurcated
form, with one segment orientated towards the artist and the art-
work and the other towards organising efficient and low-cost
ways to distribute the artwork to "receiving" audiences. The slow
rate of growth of an "events-based" model of development such
as this with stratified audiences and little integration of the arts
into other key local concerns such as education, community and
economic development suggested that new approaches were
needed. These included new organisational forms which allowed
the establishment of much closer co-operative links amongst
audiences, communities, youth and community workers, tourism
and business interests, the arts development worker and the
artist.

New Organisational Forms. The three major innovation group-
ings discussed above (project teams, partnerships and territorial
forms) could be applied to the arts, and the key characteristics of
successful groupings are potentially similar.

Project Teams. In terms of Multi-Dimensional Product/Project Teams, for small arts organisations and individual arts officers working in local arts development, the concept of a project team combining arts specialists working in different functions in the arts is one which has for some time been considered key to the success of innovation. One of the key objectives of the initial proposal by the Arts Council to Euroform was to develop ways in which the geographic isolation of arts officers from other arts specialists could be addressed. The concept emerged of small project-based teams, linking one or two working artists with an arts officer to develop ways of addressing the needs of makers of art in combination with ways of addressing the needs of potential audiences. The notion of the artist as an isolated individual separate from society is one which is gradually being augmented in local arts development by new forms of relationship between the artist, the arts centre or arts officer, and the community. The Artist in Residence scheme is one such reflection of a new dynamic interaction generating both greater participation in the arts and a more empowered role for the artist. The recent growth in the commissioning of new work by arts centres and arts officers is also part of these new relationships. The result can be seen in terms of innovations in the art work, in the participation process and in the way the arts are distributed or marketed.

Partnerships. "Strategic alliance" and "partnership" are concepts which are as badly defined in the arts sector as elsewhere. Angel's definition (1994:132), which suggests that "alliances are strategic, as opposed to opportunistic, if the organisational forms of partners are predicated on the existence of alliances" can be applied equally in the arts and culture field. Here the trend towards increased specialisation of statutory bodies and other organisations presupposes the ability to form partnerships with agencies possessing complementary expertise. For example, the Arts Council recognises that certain needs in the area of arts education and training can be best met through partnerships with specialist training providers, such as UCD in the case of the Artform consortium or more broadly with the Department of Education.

Just as in the private sector, agreements or alliances in the arts can take place at lower or higher levels of interaction and commitment, and may vary from arms-length, one-time transactions

to long-term partnership. Again, as in Reich's (1991) analysis, many arts sector partnerships may not work out to be mutually advantageous because they are structured around expectations of short-term gain rather than the development of a long-term structure to share the risk and cost of addressing joint opportunities and problems in new ways. The idea underpinning partnerships and alliances in the arts is to create a set of organised relations among specialised agencies and to provide individuals and organisations access to a wide variety of expertise, capabilities and networks.

In relation to complementary specialisms in local arts development, expertise in the arts can be combined with specialised expertise in youth work and community work to generate new or client-specific (target group-specific) processes in youth arts and community arts. In discussing the expertise-sharing base of partnerships, the division of competence into three broad areas is useful also for local arts development. These can be identified in this sector as arts-specific expertise, process-based or development-related expertise and geographic/audience-related knowledge

Territorial Forms. The clustering and agglomeration of arts-related expertise, facilities and infrastructure have for some time been considered a pre-requisite for arts development at local level.

The Artform project was created as an attempt to explore possibilities around these groupings, through a programme of training and support for inter-agency networking.

ARTFORM

Although conceptualised as a training project, Artform can be more accurately described, in retrospect, as an attempt to establish a "general process of continuous innovation" within the structures and systems of local arts development.

In the project proposal to Euroform, a key descriptive adjective was "innovation" (Euroform Project Proposal, 1992). The innovative qualities ascribed to Artform were attributed largely to the possibilities for synergy emerging from the existence of the consortium. It was recognised by the constituent partners that the achievement of their individual objectives for local development (i.e. in terms of arts, youth and community priorities) could potentially be enhanced and costs reduced by co-operation and collaboration. First of all, a partnership between the consortium

members would achieve the objective of securing funds and identifying areas of training which could be commissioned and supplied in common. Therefore, the imperative of reducing costs and sharing risks, which we have seen as one of the important conditions often preceding successful innovation in the private sector, existed in relation to the Artform consortium. Secondly, the consortium was aware that possibilities existed for co-operation at local level between practitioners and agencies and it was felt that this might lead to new approaches and solutions in terms of local arts, community and youth development practice.

The project was one of considerable ambition and scope, hoping to address a very broad range of training needs across a number of widely differing target groups (many of which had sub-group variations in age, experience and ability) whilst at the same time developing new methodologies for so doing. There was also a significant European dimension with several international partners.

Objectives

Artform's main objectives were:

- To supplement the skills of county and city arts organisers as the professionals primarily charged with developing the arts at local level

- To develop the arts-enabling skills of professional youth workers and provide arts-specific training for a number of young adult voluntary youth leaders

- To train community development workers from a range of services wanting to examine the definition, purpose and practice of the arts as part of local development

- To create a setting in which inter-institutional networking could take place (Tanham, 1994).

The initial approach to networking was via the teaching programme which arranged for frequent contact between the three groups. However, it became apparent that the objective of stimulating greater co-operation and communication between the three different groups could not be met solely by participants sharing

common course work. It was agreed to create a pilot network
with the four participants in the Artform project who came from
County Louth. This pilot project was set up within the timeframe
of the main Artform programme and ran on as an extension to the
project.

The objective was to test the value and practicality of inter-
agency networking as a mechanism for developing innovative
models of local arts development.

The Structure of the Network

A feature of the Artform network was its inter-agency mix, repre-
senting community development and arts development interests.

On a cursory analysis, the pilot project had mixed success. The
first phase of the project involved extending the network from its
original four members to nine. The original four members were a
community worker employed by the local authority in Dundalk,
two community workers employed by voluntary sector organisa-
tions in Dundalk and the director of the arts centre in Drogheda.
The new members were the curator of the Dundalk Museum, the
recreation and amenity officer from the local authority, the county
librarian, the Dundalk branch librarian and the arts officer with
the local authority in Dundalk.

It took a considerable time for the group to develop a series of
common objectives. The process of inviting, negotiating and inte-
grating the new networking partners was extensive and time con-
suming. There were considerable pressures and constraints on the
members of the network, as several of their host organisations
were undergoing major organisational change. The established
structure and support frameworks at workplaces for network
members varied considerably, which affected participation levels.
In the initial stages there was no formal relationship between the
network and the agencies involved. Consequently a situation
emerged where the network was more central to the work of
some than to others.

The network developed a project plan and set about creating a
preliminary database of community groups and organisations
which had expressed an interest in arts activities, with a view to
gathering essential information for planning pilot initiatives. This
database was effectively created by pooling and collating existing
lists and known contacts (though not necessarily known to each

of the network members which in itself constituted an information exchange within the network). It organised a series of meetings with the key groups, and this formed the basis for an audit of arts needs in the Dundalk and Drogheda areas. These groups were:

- Travellers Group (Dundalk)

- Travellers' Women's Group Muirhevnamor Estate (Dundalk)

- "The House" Cox's Demesne Estate (Dundalk)

- Women's Group Muirhevnamor Parish (Dundalk)

- ISPCC Drogheda.

These meetings prompted three pilot initiatives :

- Visual Arts Project — an artist-in-residence style project with the ISPCC, Drogheda and the women's and youth group of Muirhevnamor estate; also aimed at primary schools in Drogheda

- Drama Project — a series of drama workshops, also with "residency" approach aimed at a mix of settled and traveller groups (adult and youth) at Muirhevnamor estate

- Newsletter — covering arts events, information etc. for the Louth area.

These projects were successfully completed and evaluated, but the whole process of working in a collaborative grouping was found to be challenging by all involved. While the group said at the outset that it did not want to be "funding-led" it was later conceded that the funding with its inherent responsibilities created an incentive, particularly in times of organisational and conceptual difficulty.

Such a description of the Louth project, however, does not accurately reflect the considerable value of the pilot in the development of new organisational structures for innovation in local arts development. The project established a precedent which can inform the application of the "groupings" approaches to innovation discussed above to local arts development. If we apply the key characteristics of successful innovation groupings to the

experience of the Louth project a series of recommendations for an approach to innovation in local arts development can be made.

Innovation Groupings: Multi-dimensional Teams and Partnerships

Both these types of groupings need to subscribe to the fundamental principle of strategic alliances: the need for mutual co-dependence in terms of expertise. In structuring groups for innovation and partnership in local arts development a three-stranded approach, based on specialist expertise, for example, in community, youth and the arts will allow the potential for development of programmes based on a combination of specialist expertise to emerge.

The Artform experience has shown that the methodology of networking is effective only if it is linked to the central key objectives of the network members. The desire or necessity for an innovative solution to specific problems or challenges is necessary to ensure full commitment by all parties to a network or partnership.

Considered under the Angel (1994) criteria for successful partnerships, gains from a network or grouping must be deemed sufficient by network members to outweigh the cost of investing time and precious resources (particularly in human terms) in a sector where great demands are often placed on a number of the members. The acknowledgement that the Artform funding was a major incentive to continue with the network at times of operational difficulty supports this view, in relation to the Louth project.

The extension of the membership of the Louth network made the foregoing conditions of clear common objectives difficult to meet. A large number of new projects in the group with immediate and individual needs made it difficult for the network itself to realise its own organisational objectives. As stated above, it is only when individual organisational priorities are further advanced by membership of the group that group objectives will be achieved.

In relation to local arts development, innovation groups are most appropriate for dealing with specific problems and goals. The theory of continuous innovation implies that the work of partnerships and networks should be task-orientated, with room to refigure the configuration of partnerships, teams, groups and

networks according to the issue to be addressed. Accordingly, the Louth Network could have built on its capacity to identify specific areas of concern within its range of membership and diversified further had the network been able to sustain itself beyond the Artform funding time-frame.

The fact that there was no formal relationship between the network and the agencies involved suggests that the link between the organisational objectives of the sponsoring organisations and the innovative possibilities of the networking group had not been made. The models of creative teams and innovative groups in the private sector are predicated upon organisational support, and structures that facilitate dialogue.

Territorial Forms

In several important respects the Artform project gave an opportunity to break with previously dominant, sectoral patterns of arts development drawing on new types of knowledge and skills and potentially providing a new basis for durable regional cultural (and by extension economic and social) growth and development. Artform has shown that the development of the arts in the regions is not only a question of infrastructure but also can be influenced by issues of communication and learning that are central to the emerging dynamic of innovation. Attempts to enhance the development of new contemporary art works, and to inspire latent creativity through new forms of interaction in particular areas, supports the idea of "locational concentration". This suggests a situation where there is a local infrastructure supported by a concentrated base of expertise and a constant flow of information about artistic and related services.

Many new initiatives are emerging at grass-roots level which need to be developed to "innovation" stage by the type of groupings, on a base of complementary expertise, suggested by the Artform project.

The Artform model not only suggests formalised ways in which training could be offered and research undertaken, but also highlights the importance of informal processes of learning and information exchange within and between organisations and individuals.

One of the major strengths of the network was the link created between community development and the arts. At both theoretical and practical level, this has paved the way for subsequent development in this area. The network could be described as a pioneering project which set up systems for innovation but could not establish enduring structures to sustain the impetus to innovate.

However, to give new vigour to arts development the systems need to nurture organic integration between all the various local development processes. This can only be sustained by a dynamic relationship between institutional structures and on-the-ground initiatives centred around a core of continuous innovation.

References

Adair, J. (1996), *Effective Innovation*, London: Pan.

Angel, D. (1994), *Restructuring for Innovation: The Remaking of the US Semiconductor Industry*, New York and London: The Guilford Press.

Benson C. (1989), "Art and the Ordinary" in *Art and the Ordinary: the Report of the ACE Project*, Dublin: An Chomhairle Ealaíon.

Contractor, F., and Lorange B. (eds.) (1988), *Collaborative Strategies in International Business*, Lexington, MA: Lexington Books.

Clancy, P. (1994), "Evaluation of Artform: Reports to the Management Committee 1–4", Unpublished Report, Dublin: UCD Graduate School of Business.

Dosi, G., Freeman, C., Nelson, R., Silverbert, G. & Soete, L. (eds.) (1988), *Technical Change and Economic Theory*, London: Pinter.

Drury, M. (1989), Introduction to *The Arts Council and Education 1979 –1989*, Dublin: An Chomhairle Ealaíon.

Euroform Project Proposal (1992), Unpublished draft submission, Dublin: An Chomhairle Ealaion.

Graham, A.K. & Senge, P. (1980), "A Long Wave Hypothesis of Innovation", *Technological Forecasting and Social Change*: 283-311.

Hanfling, O. (1992), *Philosophical Aesthetics*, Oxford: Blackwell/Open University.

Jorde, T., and Teece, D. (1990), "Innovation and Co-operation: Implications for Competition and Anti-trust", *Journal of Economic Perspectives,* no. 4.

Link, A. & Bauer, L. (1989), *Cooperative Research in US Manufacturing.* Lexington, MA: Lexington Books.

Mowery, D. (1988), *International Collaborative Ventures in US Manufacturing,* Cambridge, MA: Ballinger.

Mytelka, L. (1990), *Strategic Partnerships: States, Firms and International Competition,* London: Pinter.

Parkhe, A. (1993), "'Messy' research, methodological predispositions, and theory development in international joint ventures", *Academy of Management Review* no. 18.

Peirson, J. in Bullock, A. et al. (1988), *The Fontana Dictionary of Modern Thought,* London: Fontana: 846.

Pick, J. (1980), *Arts Administration,* New York: Methuen Inc.

Porter, M. (1985), *Competitive Advantage, Creating and Sustaining Superior Performance,* New York: The Free Press.

Reich, R. (1991), *The Work of Nations,* New York: Knopf.

Reich, R. & Mankin, E. (1986), "Joint ventures with Japan give away our future", *Harvard Business Review 86*: 78–85.

Scholes, R. (1995), *Picasso and Joyce,* unpublished essay.

Senge, P. (1993), *The Fifth Discipline: The Art and Practice of the Learning Organisation,* London: Century Business.

Tanham, G. (1994), Artform Project Report, Unpublished Report, Euroform.

Williamson, O. (1985), *The Economic Institutions of Capitalism: Firms, Markets and Relational Contracting,* New York: Free Press.

14

NETWORKS: NEW TOOLS FOR INNOVATION AND EXPLORATION

Louise Scott

> In a global market place . . . the more sustainable, competitive advantages . . . [come from] working in an international context, building flexibility, sharing information and developing collective know-how into a world-wide network. Faster and better learning within organisations is a large part of the evolving competitive logic. In order to develop these capabilities, people from different cultures have to be able to communicate, negotiate, compromise and understand each others' values and world views (Hoecklin, 1995:ix).

Networking is an innovative tool for the cultural manager. What follows covers the definition of a network, either formally constituted or informally conceived; shows why networking, whether locally or internationally, is of growing importance to the arts manager; and outlines some of the management implications of networking. It attempts to explain how networking is a vital response to our increasingly fragmented working and social environments, a tool that can offer a sense of stability in a changing professional environment and even, in some cases, provide a lifeline to arts managers and their organisations.

The focus is particularly on the Informal European Theatre Meeting (IETM), a network of just over 300 members, founded in the early 1980s by a small group of friends and colleagues. IETM brings together individuals from around Europe and further afield who are professionally involved in the contemporary performing arts.

WHAT IS A NETWORK?

Networks have been described as "a dynamic system of communication, co-operation and partnership between individuals and groups" (Bassand and Gallande, 1991:28), or, more simply ". . . at the beginning, it is just a circle of colleagues, individuals motivated to do something together" (Dragicevic Sesic & Stojkovic, 1996:40).

The concept of the network is found in transport, telecommunications, politics, biology, business and sociology. Cultural networks are normally seen as a sub-category of social networks, that is, organisations bringing people together around themes or common interests (Burmeister et al., 1993). Analogies with the other kinds of networks, however, may usefully inform aspects of arts networking. For example, like transport networks, they facilitate movement and the crossing of borders; like electronic networks, they enhance communications; like social networks, they enable mutual support; like political or issue-led networks, they may help drive change through strategic alliances; and like corporate networking, they cut across rigid organisational structures enabling faster routes to results.

Although networking has been around for centuries — it has been said that the renaissance was built upon it — the rise in profile of networks as professionals tools can perhaps be attributed to the rise in cultural and identity politics in the post-1960s western world. It was at this time that the politics of gender, race and sexuality and the ecology and autonomy movements finally overturned traditional notions of empowerment linked purely to class boundaries. For the first time, individuals from a wide range of social positions and lifestyles came together as a political and social force grouped by aspiration rather than by the traditional social and economic frameworks of class and wealth. This is a shift which has been seen as heralding a final transition from the modern or capitalist era to the post-modern or more individualistic or market-led age (Hebdige, 1992). Networks as boundary-crossing devices as well as a response to fragmentation can be seen as a reflection of these changes. Whether formally or informally constituted, networks are very much of our times.

Networks then, either as an informal group of colleagues or friends or a formally constituted organisation, can be found everywhere: locally, regionally, nationally and internationally. Whether a regular informal gathering in a small town between

people who are trying to tackle issues of common concern, or a major annual international conference of professionals, each has its own dynamic and a relevance for both the groups and individuals involved. As non-hierarchical co-operation frameworks, they are increasingly viewed as important tools for professionals in all sectors. In the arts sector, for example, cutbacks in arts funding world-wide bring major challenges for arts managers on a daily basis: this gives rise to the need to share the burden with colleagues, to explore solutions, to share resources, to form alliances and develop co-productions. One of the ways to do this is through networking.

Networks take many forms, shapes and sizes: an informal meeting of artists and others coming together to discuss how they can collectively combat a growing tide of racism in their German city; a group of "arts-in-hospitals" officers in the south of England sharing models of practice and exchanging ideas and experiences; a national association of local authority arts officers in France; or a group of managers of former industrial spaces, now arts centres, across Europe, looking at how they can encourage youngsters in their areas to express themselves positively through cultural activity.

Local initiatives may evolve differently, with a group of contacts remaining simply informal; or they may become more formalised by holding regular meetings or even constituting themselves legally, thus enabling the new network to apply for grants, organise activities or employ a co-ordinator. A network often evolves by someone just picking up the phone to get an opinion on an idea from a number of different people; by deciding to go out and begin to network with other organisations working locally, to find new allies and partners; through "working the room" at a conference; in a more formalised context where identified network "members" meet more regularly to discuss points of common interest or concern; or by joining an already established network.

In whatever context it takes place, networking is an innovative, proactive approach which connects the arts manager to their local environment, integrating the organisation and its work into a context that is wider than just the arts. It creates an opportunity to find like minds in unexpected places, be it in other sectors or other parts of the world. It opens the door to new ideas and new resources, and as such can enhance organisational effectiveness. It

is the corollary to the bounded spheres of financial and administrative control, offering arts managers unforeseen and often unquantifiable benefits through unstructured and open-ended explorations. As such, it can never simply be replaced by lists of names and phone numbers, or communication through e-mail or the Internet, although these have other kinds of uses and advantages.

It is the personal and social interaction that gives value to the notion of connectedness which animates cultural networks. This non-mechanistic approach is neatly summarised by Steve Jobs, one of the world's most influential technological pioneers, who master-minded the Apple Macintosh computer and currently works in the ground-breaking area of electronic animation:

> We live in an information economy, but I don't believe we live in an information society. . . . I used to think technology could help education; I've probably spearheaded giving away more computer equipment to schools than anybody else on the planet. But I have come to the inevitable conclusion that the problem is not one that technology can hope to solve; what's wrong with education cannot be fixed with technology . . . it's a socio-political problem (Jobs, 1996: 96).

As Jobs is suggesting, it is the human dimension that is valuable.

That said, electronic networking, either on private subscription-based networks, or openly on the Internet, is on the increase. This is not, therefore, to say that the European Computer Network for the Arts (ECNA) which provides a common space for arts networks to share information and resources on the Internet, or EuropeJazzNet (EJN), which links those engaged professionally in contemporary music and jazz through electronic mail and shared databases, are not valid networking tools; rather:

> in spite of, or maybe because of, the increasing number of sophisticated communication tools which are all very impersonal and cold (faxes, computers, e-mail, the Internet, etc.), there is a growing need for a "warm" personal kind of communication. Both types of communication, the warm and the cold, are exciting,

useful and rich tools for the exchange of information and know-how. But they are very much complementary.[1]

WHAT KINDS OF NETWORKING?

Before going on to look in more detail at some of the advantages that networking brings to the arts manager, it is useful to survey briefly some of the different kinds of networks around today. Different terms are used to describe networks: meeting; clearing house; sectoral alliance; lobby; coalition; umbrella; platform (Dragicevic Sesic and Stojkovic, 1996:40). Generally speaking, cultural networks can be broken down into four broad categories:

1. **European cultural networks.** Cultural networks come together for a commonly recognised purpose, with each member sharing a sense of mission. Either sectoral or cross-sectoral, they are characterised by their openness, flexibility, inter-activity, and dynamism, and driven by a willingness of members to share and learn from one another. They therefore depend on face-to-face contact, which may be reinforced by publications and computer networking. Non-hierarchical in character, they allow authority and communication to travel from side to side amongst members. These highly innovative networks are the subject of this chapter.

2. **Transnational professional associations.** These are sectoral representative associations, such as actors' unions or artists' councils, whose main goal is to present members' interests to a higher authority such as a government or a European agency. Delegates tend to be elected or formally appointed, with a hierarchy of representation from local to national to European/ international level. In these bodies authority and information flow up and down the line in a formalised pattern rather than from side to side.

3. **Networked information outposts and institutions.** Organisations wishing to promote their own interests at an international level may create a "network" of information outposts. Mirroring the structure of the institution that set them up, information and/or authority tend "to travel one way, from the top

[1] Hilde Teuchies, Board Member, European Forum for the Arts and Heritage, at a London Arts Board internal seminar, 23 November 1993.

down, and information, in a limited way, from side to side"
(Staines, 1996:7). Such networked outposts would include the
British Council network of offices or the European Commis-
sion's MEDIA Desk and Antennae network.

4. **Trans-national cultural projects**. Collaborative projects involv-
 ing several partners may be the outcome of networking. They
 may also be the result of recently formed one-off partnerships
 which are expedient in the short term to realise mutually de-
 sirable project ideas. Some programmes, particularly those of
 the European Commission, promote this type of collaboration
 by offering grants for trans-national projects. Technical Assis-
 tance Offices at the European Commission may even play the
 part of dating agency by putting project leaders in touch with
 other similar projects or potential partner organisations in
 other European member states, for example, a Greek, German
 and UK trans-national project supported by the PROGRESS
 programme whose aim is to tackle poverty and social exclu-
 sion in Europe. Here partners explore innovative models that
 work individually at local level, exchange ideas on new solu-
 tions to recurring problems, take these innovative methods
 back and adapt and apply them to local needs, spreading in-
 novation in a direct and practical way. While some partner-
 ships may flourish into longer-term collaboration, others may
 find themselves ill-matched and the collaboration may disinte-
 grate once its object has been realised.

A EUROPEAN NETWORK: THE IETM AS A CASE STUDY

The following is a brief history and description of the Informal
European Theatre Meeting as an organisation, intended to give a
sense of how networks start, grow and operate and to outline the
benefits as described by network members.

A handful of colleagues and friends from different countries
paused for a glass of wine one afternoon in 1980 during the
Polverigi festival in Italy where they were viewing work. From
different backgrounds, speaking different languages but in the
same line of work — directing contemporary arts festivals — they
began to reflect on the challenges they were facing in their work,
airing their concerns and ideas with others who shared a similar
philosophy both in their approach to art and their dealings with
artists. The following year, one of the group suggested another

meeting during the festival; this time some of the original group brought along a few friends who they felt might be interested and able to contribute. These informal gatherings continued throughout the decade at different festivals, as the list of those who came along grew.

In the late 1980s, the difficulty of organising an informal meeting for over a hundred people became apparent and the director of the Flemish Theatre Institute (one of the original Polverigi gathering) offered the part-time services of one of his members of staff as a permanent contact point for the meeting. In 1991, the "Informal European Theatre Meeting" as it had become known was legally established with a full-time co-ordinator responsible for setting up the meetings, putting together a newsletter and fund-raising.

Today IETM has some 320 members from about 40 different countries, mainly in Europe, working as festival directors, theatre, cultural or arts centre managers, independent producers, event organisers, company managers, writers or artistic directors. IETM emphasises that it is the individuals, not their organisations, who are members, and numbers are growing steadily.

Today, according to its mission statement:

> IETM exists to facilitate, amongst its members, the exchange of information on the production, presentation and distribution of contemporary theatre, dance and related performing arts. These objectives are realised through meetings, publications and other forms of communication (IETM, 1994a).

IETM members pay an annual subscription fee on a sliding scale according to their annual turnover. In return the network offers:

- A three-day annual meeting, usually in March, which is attended by about 400 people, both members and non-members, and at which there is also an opportunity to view work specific to the city in which it takes place as well as international work

- An open forum meeting for members only, taking place over two to three days, usually in November, also with performances

- An East–West meeting for 30–60 people, members and non-members. This is a two- to three-day meeting and happens at different times of the year.

During meetings, which are divided into plenary and theme-based workshop sessions, there are ample breaks for discussions between individuals or micro-networks as well as for chance encounters.

Members travel to meetings at their own expense and may invite IETM to meet in their city or town. Throughout the year, networking is also facilitated through a newsletter, publications and electronic media; however, the emphasis in the network is on personal contact. The organisational structure of IETM is typical of a European cultural network of this type. It comprises:

• The membership

• The management board (Executive Committee) made up of IETM members

• The network co-ordination team or secretariat (full-time co-ordinator, part-time assistant and part-time accountant).

In addition, a 20-person Council of IETM members meets four times a year to deliberate on issues of wider concern to the membership. IETM is essentially a large framework for contact and connection — whether this is done at the meetings themselves, through the publications, or via the home pages on the Internet, co-ordinated in turn by the European Computer Network for the Arts.

In a recent survey in which members were asked to give their three most important reasons for becoming members of IETM, 69 per cent of respondents said that they had joined to make as many new contacts as possible; 50 per cent to find partners for European projects; 37 per cent to promote their organisation in Europe; 28 per cent to enjoy a platform for reflection; 27 per cent to meet new people whom they might not otherwise meet; 24 per cent to have a voice for the performing arts in Europe. Other reasons given for joining included: to spend time with like-minded people who shared their values; to focus on topics of particular interest in the working groups; and to use the opportunity of the bigger meeting space to meet in a micro-network (Scott, 1996).

The network's strength as an organisation seems to derive from the fact that as a model it has developed from the ground up, created and managed by the people who currently use it. This has not been achieved without difficulty — the shift from an informal, mutual support group to more of an association structure

creates conflicts within the management power structures and in relation to funding, because of differing visions of the development of the network (Handy, 1992). Nevertheless, as witnessed by the growing membership, it continues to meet a real need which is not confined to one region, country, linguistic zone or profession.

WHY ENGAGE IN NETWORKING?

An IETM member, Melanie Harris of North-West Playwrights, Manchester, UK, states:

> What I loved about my first meeting was finding my sense of discovery again: I felt as if I had stumbled into an astonishing collection of individuals who were not embarrassed to talk about the importance of making Art — indeed had even gathered together from all over Europe expressly to talk about their involvement in theatre and dance. And everyone seemed so friendly and kind and interested in my contribution. I was impressed by the intellectual rigour of many of the discussions — particularly since people were usually talking in their second or third language. I cannot tell you how rare it is in England to find a forum in which Art, ideas and the future are discussed with any seriousness. It is always about money and how impossible everything is. IETM is a network rich in possibility. I have grown personally and professionally through my contact with the network. The value to me and my organisation is unquantifiable. (IETM, 1994b: 249–50).

The debates and the opportunity to share concerns and ideas more widely with new colleagues and friends outside the office can act, as testified by the above, as a liberation from the local and national focus, allowing the cultural manager to step out of the daily routine and get a fresh perspective on creative and organisational issues. This process can be facilitated by joining an existing network which provides a short-cut to connecting with the "right" people, those with whom common interests and concerns can be shared. Below are some of the benefits of networking or being a regular member of a network.

Innovation

The very philosophy of networking is one of exploring together rather than competing against. (The Latin origin of the word "compete" is *competere* which means literally to seek together, not to work against.) Networking opens the way for new perspec-

tives, new ideas, new solutions, for following instincts, taking risks in a way that is often not possible in the day-to-day business of management; networks themselves are by their very nature creative organisations. As one networker puts it, the process is "highly professional and 'free' [in the sense of open and unstructured] — it's an unusual combination"; another believes that networks offer "the possibility of meeting ever new ideas, ways and faces without the pressures of having to adhere to them or reject them at once" (Scott, 1996: Appendix C).

Resources

Networkers can access the accumulated experience and resources of all other members of the network. This may take the form of sharing or exchanging information, expertise, equipment, staff or trainees or supporting one another in times of crisis, whether through listening, suggesting solutions or offering more direct kinds of support.

Organisations, such as the Gulliver network, based in Amsterdam, have been set up specifically as a clearing house for skills, resources and information on an East-West axis. Gulliver's origins spring from the founder's extensive network of contacts between artists and intellectuals throughout Europe. So a theatre with some free rehearsal space in August can paste up a notice (electronically, through a newsletter or through the national contacts) offering this space free instead of letting it stand empty; an arts manager looking for work experience can sign up; a company with a used set and props can offer them to others rather than dispose of them; etc. There is scope for giving, receiving and exchanging everything from equipment to expertise.

Writing about networking for independent arts organisations in Ljubljana in Slovenia, Sylvie Myerson observed the following:

> While networking may not necessarily be the key to lack of funding, it may quite often facilitate the process of producing a work by making information readily accessible and establishing a barter system, where resources and services are exchanged between various partners. For example, the few rehearsal and performance spaces available to independents in Ljubljana are both expensive and under imminent threat of being restituted [to the State]. Audiences in Ljubljana are unaccustomed to going out of their way to attend an art event or performance and given the present context it is unlikely that spaces will be coming up for development in the

> center of town. . . . Possible solutions to these problems rest on the principles of exchange, partnership and networking: work spaces could be obtained at least temporarily by using the artwork to give visibility to the person or business providing the facilities; audiences could be retrained to attend events in unusual locations by publicising in the press, and through the most basic form of networking, "word of mouth". (Heer and Myerson, 1995:70)

But as already observed, effective networking does not need a formal structure. Stressing how networking occurs in small and modest stages but can lead to major improvements, Cee Brown of Art Matter Inc, a private foundation which gives grants to visual artists, tells this anecdote:

> I met someone [living in Budapest] who was trying to start the first lesbian and gay film and video festival. Basically she contacted me here because she needed $1,500 to complete the project. So we made a grant to her . . . and it was a complete, unadulterated success. Every screening was sold out. . . . And that came from networking: she attended a workshop, she heard me talk, we kept in touch with each other. . . . I'm hopeful that there will be other things . . . sometimes the right drop of information can produce results that are immeasurable in the future. (quoted in Heer and Myerson, 1995:71)

Professional Development

Networking offers access to a wide range of professionals and their accumulated expertise, experience and knowledge. Network meetings may comprise debates, workshops and discussions covering technical, legal, political, philosophical and practical issues, all discussed from a variety of viewpoints, reflecting the range of members present. This results in the "university of life" effect — creating an informal training ground for professional development in a dynamic environment.

The Butterfly Effect Network (BEN), a micro-network which grew out of contacts made within the Informal European Theatre Meeting decided to capitalise on the potential for sharing knowledge and skills. As well as organising a joint project, BEN's members arrange "training" sessions just before or after IETM meetings or other events which the network partners will be attending. While all work in some way with dance, performance or combined arts, the members are very different in profile — a pro-

duction company in the UK, a festival in Vienna, an arts venue in Belgium, a dance workshop in Portugal, a production house in Slovenia. Training/information sessions might be, for example, on the topic of arts marketing, on distribution in central and eastern Europe or on raising private sponsorship.

Mutual Support

Networks can offer a major support structure by providing access to professionals facing similar challenges. Most arts administrators share financial, practical, political or other problems, although the form they take and the local solutions found may differ radically. Being able to access colleagues, many of whom may have more experience or can give a fresh insight into a local situation by virtue of having an outside view, can be crucial.

Corina Suteu, a board member of the Forum of Cultural Networks states:

> One always comes back to the question "Why do we need networks? What is the real reason that brings people together in these meeting points? Of course we need to share, to be informed and to know one another. But I believe that the incredible growth of networks within the arts sector in recent years is, above all, linked to a strong need amongst professionals in the cultural sector to feel "protected" from an environment which seems to them to feel increasingly hostile and inflexible" (quoted in Staines, 1996:2).

Innovative, contemporary dance is relatively new both to audiences and funders in the Czech Republic where Tanec Praha — a contemporary dance festival — was established in the early 1990s. As it struggled to stabilise in the shifting political, legal and financial environment of the new republic, it was hard to convince public funders to stay on board, even though audiences continued to grow annually. When Yvona Kreuzmannová, director of Tanec Praha, was told that their public funding would shortly be cut due to the diminishing public arts budget, she decided to send a circular to her fellow IETM members explaining the situation and asking them to write letters of support which she could take to her funders. She received a widespread response from network members, some of whom knew the festival personally, some of whom were familiar with the programme and some of whom appreciated from their own experience what Tanec Praha stood for artistically and politically. So impressed were the funders by how

well-regarded the festival was by major professional figures throughout Europe and further afield, that they retracted their decision and Tanec Praha retained its grant.

Furthermore, at local level, Tanec Praha is part of a network of Prague-based arts professionals, working to educate the city and the state about the pressing needs of innovative arts organisations in the new climate; needs such as a suitable legal framework for non-profit organisations (there is no such legal status yet), or for tax incentives for private sponsors to compensate for public funding cutbacks. Thus networking can be an important lobbying tool for artists and arts professionals.

Short Cuts

Joining a network is a short cut to making many useful or appropriate contacts simultaneously, whether locally or further afield. Travel costs are thus reduced — one network meeting can lead to several contacts. Moreover, network meetings are peopled by individuals who are already open to meeting others, to exchange new ideas. Ritsaert ten Cate, a long-time member of IETM says:

> In Budapest [at the IETM annual meeting] I asked Andreas Neumann why he, as a kind of super-producer, handling star directors and groups from around the world, turned up faithfully at IETM meetings. "Because of meeting people, listening, sniffing out moods and getting new ideas," he said. (IETM, 1994b: 293–4)

Inter-cultural Co-operation

An arts festival director in Munich noted during a panel on inter-cultural co-operation at an IETM meeting that he was far more interested in talking to an African choreographer working on new dance forms in South Africa than he was in chatting to his next door neighbour, with whom apparently he had everything culturally in common, but who had no interest in the performing arts.

Indeed, language is usually the smallest barrier to communication. Networks have been described as "on-going, active workshops in inter-cultural communication" (Staines, 1996:10). Fuelled by a spirit of enquiry, networkers can be seen at meetings helping each other out with translation and explanation, keen to understand one another's work despite the technical difficulty of not sharing a first, or even second, language. So networks can provide a dynamic forum for individuals from a myriad of backgrounds, organisations and countries to explore their visions, their similarities and their differences in a spirit of enquiry and mutual respect.

By linking individuals across different kinds of frontiers, networks in some sense may become alternative families, grouping people who share similar interests or values regardless of linguistic, ethnic, religious or organisational differences; hence the often strong feelings that come through individual accounts of the value of networking. This is perhaps most evident in those networks which have grown up spontaneously to meet a particular need, rather than those which have been engineered from above — although this is not to say that these cannot also work. Essentially, each member contributes something to the culture of the network, even if they only participate for one or two days a year at a network meeting.

Environmental Awareness

The network gives the locally-based organisation and the individual a vital line into wider environmental information through informal feed-back. An analogy is provided by Petr Nedoma, director of the Rudolfinum Gallery — one of the major modern art spaces in Prague. He observed that prior to 1989, under the former regime, Czech art was to some extent put on a pedestal. Since most international contemporary art work was not allowed into the country, Czech art was shown to the public without its wider international context, so the viewing public was unable to evaluate it fully. Now, when organising major exhibitions in the city he often integrates some examples of Czech art into his exhibitions to give the public a critical sense of how this relates to larger movements in the art scene.

To summarise, networks are comprised of people working first at a local level. Highly motivated and open to new ideas, they draw additional strength, inspiration and energy from outside the

local context, then directly plough it back in when they return to base. Networking adds value in this way to cultural management: bringing the local to the international level and the international to the local level — in contrast to more hierarchically structured organisations where energies are focused upwards but not drawn back down into the local context.

> Everybody looks at the world from behind the windows of a cultural home and everybody prefers to act as if people from other countries have something special about them (a national character) but home is normal. Unfortunately, there is no normal position in cultural matters. This is an uncomfortable message, as uncomfortable as Galileo Galilei's claim in the seventeenth century that the Earth is not the centre of the universe. (Hofstede, 1994:235)

HOW TO NETWORK

Networking requires effort: you only get something out of it if you put something in. It requires an open state of mind and a personal contribution to the process of asking, enquiring and listening actively. Field (quoted in Harvey, 1995:103) in a recent study on networking, has identified the key skills required to make participation in a network worthwhile as:

- Time, energy and commitment
- A sense of common purpose
- Trust
- Flexibility of working method
- Personal skills
- An agreed spectrum of interest
- Willingness to share.

MANAGEMENT AND NETWORKING

We need to distinguish between the management of the network — in a formally constituted network this would be done by a secretariat or in a less formally organised network perhaps by a volunteer member — and the act of networking, or being a member of a network. The co-ordination of a network requires standard management practices: planning, control, evaluation; a business

plan, fund-raising strategies, marketing etc. Although formally
constituted networks tend to have a very small management,
even with a large membership, they are very much like any other
organisation. The secretariat's role is to create the best possible
networking opportunities: to leave adequate space for members
to create their own contacts rather than to control the member-
ship's activities. This might mean programming free sessions into
a three day meeting, allowing members the chance to connect; an
open meeting; longer breaks between more formal sessions; an
opportunity for micro-network meetings within a larger network;
or visits to performances or exhibitions which have been pro-
grammed around the meeting. Equally there might be more fo-
cused networking through a series of theme-based workshops, or
by focusing the overall meeting on a specific topic.

This distinction between the means (the organisation and pro-
gramme of the network, i.e. the management) and the ends
(meeting, networking between members, i.e. the product) is im-
portant (Perrow, 1961). What makes networks innovative is their
openness and the opportunity they provide for the individual to
participate on an equal level with colleagues, to have an acknowl-
edged ownership in a new organisation, to be a stakeholder in it.
This also means that networks as a rule will tend to have evolv-
ing, emergent strategies, moving forward incrementally rather
than strategically (Minzberg and Waters, 1989; Quinn, 1989; John-
son, 1989).

Networks tend to be consensus-led. Since their organisational
structures are founded on informality and trust, there should be
no need for a rigid representational structure — and those joining
a network should not expect to find such a structure. This princi-
ple of consensus-versus-democracy was nicely summed up by an
IETM member from the Czech Republic in a discussion on the
constitution of the Forum of European Networks:

> In the years when I was not able to travel outside Czechoslovakia
> to see performances, but I wanted to show innovative contempo-
> rary work at my theatre, I had to learn to trust the views of my
> colleagues in other countries. If they recommended a piece they
> had seen or programmed a new work, then, because I knew we
> shared the same vision for our artistic work, I felt that I could risk
> bringing that piece to my theatre. Now when we are discussing
> how to organise this network, it is the same thing. I do not need to
> scrutinise what my colleagues are doing on the management

committee. I do not even want to vote. They are my colleagues and I trust them to make the kind of decision I would make (Ondrej Hrab, IETM Member, speaking at the Forum of Networks Meeting, Annaghmakerig, Ireland 1992).

IMPLICATIONS FOR NETWORKERS

Doubts are often expressed about the validity of networking, in particular when it involves travel, notably travel abroad. It is true that this often takes time and money (travel to meetings, membership fees, etc.) — resources which are in short supply in most arts organisations. For these reasons, there may be negative reactions from staff members or local funders who see it as outside of and additional to daily work rather than an important avenue to innovation.

Talking about the situation in Lithuania in the early 1990s, Daiva Dapsiene flagged major obstacles to networking — local and international — in her country, some of which are common to all networkers and others which are specific to her country's economic and political situation (Heer and Myerson, 1995:65). Networking required:

> . . . time, energy, money, of which there is very little in a time of upheaval. Networking also requires planning which is very difficult when a country is in transition. Finally Lithuanian professionals feel a strong distrust towards institutionalised unions . . . which were used for ideological control under the Soviet regime and are associated with the totalitarian past.

In Lithuania, theatre directors, divided by competition and distrust, were unwilling to set up a national network even though a number of them had been involved in international initiatives. She eventually succeeded in bringing them together through focusing on themes of mutual interest and they went on to form the Association of Theatre Leaders whose main role is to lobby government on areas of mutual concern. The next big obstacle to networking was the economic impossibility of travel beyond borders. In these cases initiatives taken by networks such as IETM or organisations such as the International Theatre Institute (ITI) have helped subsidise the participation of those facing severe economic difficulties at network meetings.

Gradually, support for networks and networking is increasing, particularly at European level, and this enables their more confident development. European Culture Ministers in 1991 passed a Resolution voicing collective support for trans-border initiatives and their importance for cultural life in Europe. This means that networks have been included in the Kaleidoscope scheme which funds European arts and cultural initiatives, so that young networks and innovative trans-national cultural projects (which may later develop into network organisations) can find support. However, support for individual networkers is still scarce and network support is still often project-based.

Some organisations, however, have recognised that process-based activity is as important as product-based activity, and the European Cultural Foundation has set up the APEX scheme to support East–East and East–West travel for individuals working in the arts — both practitioners and managers. However, at national and local level, support for networkers and networks varies. There are a handful of *Go and See* funds and some funds for innovative or international work, but as yet, funds for networking are scarce. Short-termism, the demand for immediate value for money and a preference for quantitative indicators of success undermine essential aspects of networking: its continuity, the creation and maintenance of a conceptual rather than physical structure, the recognition that it is a place of beginnings not ends. As the IETM co-ordinator Mary Ann de Vlieg puts it:

> Networking is by definition a loose, vague, disobedient concept. The anarchic duplication of the component parts of a thing in various places, and the freedom of those parts to collaborate and be productive amongst themselves without a central direction — this does not lend itself to the requirements of today's quantifiable culture, led by long-term inflexible plans with previewed results. (quoted in Staines, 1996:14)

Indeed, networks "have been forced to package their activities in project form with short-term objectives and short-term gains. Networking is a long-term process which yields increasing returns with time and close attention." (Staines, 1996:14) That said, some attempts have been made to measure the economic and other positive benefits of networking (Brouhaha International,

1995) but widespread recognition and approval from local sources is still a few steps away. By and large the main support for networks comes from those within the arts community who invest time and money in a process which they consider valuable.

The value and benefits of networking have been covered in some detail. It now remains only to comment on its motivational dimension. At a time when the arts are suffering public service cutbacks on both sides of the Atlantic, there is a danger that the spirit which has inspired artistic activity, enterprise and innovation will also falter. Such a danger is exacerbated by the fact that many artists, arts administrators and managers work on their own in relatively small organisations. These forces of public gloom and isolation must be countered if the arts are to continue to fulfil their vital role in society. Deprived of those motivational forces — such as, for instance, the profit motive — which inspire and animate other sectors, the arts community must draw strength and inspiration from the ideas which are its very currency. Networking is above all a means to access those ideas and to give renewal to a sector of which innovation is of necessity the cornerstone.

NOTE:

There are an increasing number of networks which the arts professional can join. Many of these will be listed in the new edition of *Arts Networking in Europe* (second edition) edited by Rod Fisher, to be published in early 1997 by the Arts Council of England. Finding the "right" network in a guide, however, is not so easy, as it is hard to convey the "culture" and "feel" of the individual organisations through objective, factual information, and reasons for participating in networks may be rather more subjective. To give an idea of the diversity of networks in Europe, a short listing of some of the better known networks is given below:

- BEN — micro-network of organisations exchanging arts skills and organising projects

- CEREC — network of organisations working in the field of sponsorship

- CIRCLE — network of cultural researchers in Europe

- ECNA — hub providing and managing an Internet space for arts organisations

- EFAH — network of representative organisations lobbying on European policy and arts

- EFWMF — network of world-wide music festivals

- EJN — network of professionals engaged in contemporary music and jazz work

- ELIA — network of arts education schools and organisations in Europe

- ENCATC — network of cultural administration training centres in Europe

- ENPAIC — network of performing arts information centres in Europe

- ETN — network of centres specialising in textiles

- EU Net Art — network for arts and young people in Europe

- European Network of Literary Translation Colleges

- Forum of Networks — network of networks in Europe

- FORUM — network of heritage associations

- IETM — network of professionals engaged in contemporary performing arts

- NEMO — network of museums organisations in Europe

- PEARLE — network of performing arts employers in Europe

- Pépinières — network of artists residencies in Europe

- Res-Artis — network of historical buildings housing cultural centres

- TransEuropeHalles — network of managers of arts centres, formerly industrial buildings

Alternatively, profiles, contact information and a database of members is provided for all 40 members of the Forum of Networks on DACOR's Internet site at http://www.ecna.org/dacor

References

Bassand, M. and Gallande, B. (1991) "Dynamique des réseaux et société" in CADMOS *Nouvelle Revue Européenne*, no. 56, winter, 28–9.

Brouhaha International (1995), "Template and Guidance notes on Evaluating the Economic Impact of Arts Organisations on the Local Economy (ADLE II)", Liverpool, (unpublished).

Burmeister, K. et al. (1993), "Cultural Networks in Europe", (unpublished study carried out for the European Commission in Brussels).

Dragicevic Sesic, M. and Stojkovic, B. (1996), *Cultural Management Handbook — Part 1: Arts Management and Administration*, Belgrade: Clio.

Fisher, R. (1992), *Arts Networking in Europe*, London: Arts Council of Great Britain.

Forum of Networks Meeting (1992), Annamakerrig, Ireland

Handy, C. (1992), "Types of Voluntary Organisations" in *Issues in Voluntary and Non-profit Management*, (Batsleer. J., Cornforth, C., & Paton, R. eds.), Wokingham: Addison-Wesley in association with the Open University, 13–18.

Harvey, B. (1995), *Networking in Europe: A Guide to European Voluntary Organisations*, London: NCVO Publications.

Hebdige, M. (1992), "After the Masses" in *Managing the External Environment: A Strategic Perspective* (Mercer, D., ed.), London: Sage Publications, 166–174.

Heer, B. & Myerson, S. (1995), *Management Tools: A Workbook for Arts Professionals in East and Central Europe*, New York: Institute of International Education.

Hoecklin, L. (1995), *Managing Cultural Differences: Strategies for Competitive Advantage*, London: Economist Intelligence Unit.

Hofstede, G. (1994), *Cultures and Organisations: Inter-cultural Cooperation and its Importance for Survival*, London: Harper Collins.

Informal European Theatre Meeting (IETM) (1994a), Information Sheet for New Members, Brussels: IETM.

Informal European Theatre Meeting (IETM) (1994b), Handbook of Network Membership Profiles. Brussels: IETM.

Jobs, S. (1996), Interview in *Wired* magazine, February 1996.

Johnson, G. (1989), "Rethinking incrementalism" in *Readings in Strategic Management*, (Asch, D. & Bowman, C. eds.), London: Macmillan, 37–56.

Mintzberg, H. & Waters, J.A. (1989), "Of Strategies Deliberate and Emergent" in *Readings in Strategic Management* (Asch, D. & Bowman, C., eds.), London: Macmillan, 4–19.

Perrow, C. (1961), "The Analysis of Goals in Complex Organisations", *American Sociological Review*, vol. 26, (Dec) 854–6.

Quinn, J.B. (1989), "Managing Strategic Change" in *Readings in Strategic Management*, (Asch, D. and Bowman, C., eds.), London: Macmillan, 20–36.

Scott, L. (1996), Evaluating network meetings in the Informal European Theatre Meeting (unpublished MBA thesis).

Staines, J. (1996), *Working Groups: Network Solutions for Cultural Cooperation in Europe*, Brussels: European Forum for Arts and Heritage.

15

"CULTURAL PROJECT" MANAGEMENT AND CULTURAL DEMOCRACY IN A NORDIC CONTEXT

Anne Marit Waade

Translated by Birthe Kibsgaard and Arendse Lillesoee

COPENHAGEN '96 — EUROPEAN CITY OF CULTURE

Preparations for Copenhagen '96, European City of Culture took several years to complete. As a large-scale event which took as its starting point the diverse and complex cultural life of today, the scope and range of its activities were a result of the initiatives and active participation of the citizens of Copenhagen. "External projects" accounted for 90 per cent of the budget for Copenhagen '96 and applications were open to any artist, club or group with an idea for an event or a project. In addition to this, Copenhagen '96 generated its own projects. However, the year's events were mainly composed of projects initiated and carried out by Danish artists, cultural activists and ordinary people[1].

Copenhagen '96 can be viewed as a huge staging of Danish cultural policy, the leitmotif of which was this "broad" cultural concept which found expression in a wide range of events and projects. There is a risk in such a full programme that art itself or quality concerns might be submerged in a wave of spectacular projects designed primarily to attract press attention. Copenhagen '96, however, was infused with a spirit of cultural democracy which it tried to realise through practical cultural activities and projects. Its underlying aim was to strengthen innovation and stimulate new thinking in art and culture, and in this way to reinforce the artistic production of Denmark.

At a time when the ideals of the welfare state are being dismantled along with a weakening, as a result, of the principle of cultural democracy, the artist and the cultural institution fear

obliteration in an environment which prizes profit-making, marketing and a more commercial orientation generally. Taking Copenhagen '96 as our case study, it is proposed in this chapter to discuss the relationship between cultural projects and cultural democracy. The management of such projects will be placed in the context of theoretical reflection on the condition of the individual in modern society as well as general cultural trends.

CULTURAL PROJECTS

Cultural workers currently use what we term cultural projects as a way of presenting and mediating the arts and culture. While public funds are spent mainly on established and conventional arts and cultural institutions, there is little room for new initiatives. Such stasis is challenged by cultural projects.

The concept of cultural projects[2] includes both artistic and more general projects which have a specific objective and are limited in time. Such projects are innovative and easily cross the border between conventions, institutions and various art forms. As a new way of working in Denmark, this approach has given rise to important political discussions. These centre on how to ensure financial support and the most favourable conditions for innovative art, as well as how to ensure the artistic quality of cultural projects. It is recognised too that many established cultural institutions feel threatened by such projects. In general, cultural projects seem to attract more public attention (including media attention) simply because the concept is new and different.

Many cultural projects have an international dimension and as such may develop new cultural and aesthetic forms and methodologies characterised by pluralism, variety and diversity. Not alone are the forms of aesthetic expression changing but also the means by which art and culture are being organised and renewed. Hence the interest of project work.

The following examples from Copenhagen '96 illustrate clearly what is meant by a cultural project.

ArtGenda is a huge Baltic biennial event for young artists initiated by the organisers of Copenhagen '96. The organisers invited 12 cities to present artworks produced for this special event in the fields of dance, architecture, design, music and film. The project was innovative in several ways: it constituted a newly established co-operative venture between various cities in the Baltic area and involved politicians, bureaucrats and artists; about 1,000 artists

participated as well as several hundred local and central organisers; and it addressed the political as well as the artistic. The organisers focused on the selection of artists and the establishment and maintenance of contact and communication between organisers in Copenhagen and local authorities, with the aim of strengthening the democratic decision-making processes while still attending to artistic needs. The general theme of *ArtGenda* was "Home — Homeless". Thus the project is in a sense, an aesthetic and cultural investigation of a changing Europe.

Aaben By (Open City) was another such cultural project. An external project of Copenhagen '96, it was initiated by a group of young people who took sole responsibility for its organisation. Aimed at furthering international (cultural) exchange, the project used an office in Copenhagen as a clearing house. An open invitation was issued to all comers and all types of projects, e.g. contact between school classes, or trade unions and cities who wish to forge links across frontiers. The project was thus a seed bed for other cultural projects.

The management of projects such as these is characterised by flexibility, enthusiasm and dynamic ways of collaborating. Generally speaking, such projects fall into one of three categories: artistic, socio-cultural and projects which further general education and understanding among peoples. The project worker's capacity for innovative and imaginative thinking, for initiative and for sustained energy and commitment are all essential to the success of the project. The project worker's personal skills become as important as their professional training.

Cultural projects challenge current cultural policy. They also challenge arts managers and cultural workers and extend the demands made on their professional qualifications and personal abilities. What are these demands and how do they differ from those experienced by the manager of an established arts institution or by a cultural secretary working for a local authority? Before examining these issues, we outline the concept of cultural modernity as a distinctive characteristic of contemporary society, since this has a significant impact on any assessment of the cultural manager's role and competence, as well as on the role of those authorities charged with educating cultural workers and financing art and culture in general.

CULTURAL MODERNITY AND CULTURAL TRENDS

Henrik Kaare Nielsen in *Kultur og Modernitet* (Culture and Modernity, 1993) outlines how the autonomous youth culture that has characterised the development of modern capitalist societies, especially since the 1950s, involves collective forms of organising and represents a new situation with which young people have to cope. This cultural modernity is characterised by *individualisation*, *differentiation* and *pluralism*, and specific cultural behaviour is no longer associated with particular social classes or categories. Nielsen focuses on what he calls the *culturalisation* process with special reference to young people in the cities who use cultural activities as a means of finding and testing their personal identity. Within this paradigm, every individual, in a constant and continuous way, has to establish and seek their own changing identity. This contrasts with the earlier belief that one's identity and sense of belonging was defined by the family or one's profession.

Such ideas about individual liberation and the processes of seeking one's identity are central to Nielsen's theories:

> The ambivalence of individualisation is now the main driving force in this new, differentiated culturalisation process. Caught between on the one hand, unlimited opportunity and on the other, the painful loss of orientation and fixed points, individuals must continually scan their lifeworlds for material which helps them to form a new social and cultural identity — which will compensate for their losses while assisting them in exploring the freedom that the new individualisation portends (Nielsen, 1993a:18).

The liberation of the individual is linked with the differentiation and secularisation of society. The individual lives in ambivalence: on the one hand, they try to establish a meaningful existence. On the other hand, they enjoy the freedom and the endless choice which are implicit in the concept of liberation. Each individual is alone in trying to find a connection between culture and society, between their own identity and the kind of society in which they live. This process is continuous and related to the complexity of the search for identity (Nielsen, 1993).

These identity-searching processes are fundamental to Nielsen's description of culturalisation which essentially constitutes an attempt to build bridges and find connections between the individual and society, between society and culture. Aesthetics and culture become a tool in creating identity and meaning in life.

Thus culturalisation trends represent a new historical and social form.

How is this culturalisation process made manifest? It may be evident in the need for young people to stage and bring attention to themselves as, for example, in Karaoke games in discos; through creative and self-developing activities such as drama workshops, safaris in Nepal or gypsy singing at the local school. All these activities are part of the endless process of trying to find one's *self*, to make close friends and partners, to cure stress or find the internal voice, to feel oneself as a *body* and a *person*. The huge masses of people who, despite little or no previous interest in the arts, flock to experience major art events such as a Van Gogh exhibition or to hear Pavarotti sing, or who participate in spectacular and innovative projects and happenings created by young enterprising people, are further manifestations of this phenomenon. The culturalisation trend can also be traced in the efforts of smaller local authorities to create a focus through devising spectacles about local or national heroes in order to form a united cultural identity.

Thomas Ziehe, a German social psychologist, in the book *Ambivalens og Mangfoldighed* (Ambivalences and Multiplicity, 1991) raises similar issues. For him people live in a state of ambivalence, divided between a sense of loss and disengagement in terms of identity: people must choose between a life-denying and a life-enhancing reaction to the crises and challenges of cultural modernity. Ziehe describes new ways of reacting which help the individual endure the modern: first of all, a widespread conventionalism, which permits one to close one's eyes to change; secondly, a neo-conservative counter-offensive which arrogantly attempts to challenge the modern while in its own way exploiting it and urging it on; and finally, the cultural-searching processes[3] which attempt to relate to the modern so as to render it more tolerable and maybe even productive. These searching processes can be retrogressive and concerned primarily with preservation as in neo-conservatism, or can also be liberating — note, for instance, how postmodernism as an artistic expression tosses arts conventions and signs into the air as if they were without meaning or coherence. But the basic fact, as far as cultural development is concerned, is that individualisation and self-reflection are now more important as action-motivating factors.

> More and more our culture provides us with the knowledge
> through which, almost like a video camera, we are able to observe,
> reflect, represent and comment on ourselves. We have more and
> more secondary experiences at our disposal. By this is meant ex-
> periences which are culturally transferred and which precede ac-
> tion (Ziehe, 1991:12).

The collective movements and sub-cultures of the 1960s and 1970s
were characterised by strong feelings of community and the af-
firmation of personal identity. The postmodern wave of the 1980s
merely replaced the search for identity with a search for intensity.
The late 1980s and the reality of the 1990s look somewhat differ-
ent:

> The new tendencies, which are — perhaps — reflected, are charac-
> terised . . . by being able to take over cultural modernity in its
> complementary aspects and by attempting to *live* the ambivalences
> and make them productive (Nielsen, 1993a:37).

During the 1980s, as a result of the boom in the service sector, new
economically strong groups without traditions grew up in urban
communities. The "yuppie culture" stepped up culture consump-
tion; the culture industry became strong and brought with it a be-
lief in individualism. The sponsorship of culture established links
between economic life and cultural institutions. Public authorities
turned towards more economic calculations and financial support
for culture became dependent on private co-funding, the arts and
culture being seen as having taken on the instrumental role of
strengthening trade, job creation and tourism. At the same time,
art and culture became important elements in people's search for
identity and affiliation.

The 1990s show that the yuppie culture has suffered a quiet
death and the enthusiasm for privatisation and the instrumentali-
sation of cultural investment has moderated. But the identity-
seeking processes persist. Art and culture have become important
consumer goods but they have also become a means of self-
investigation and of shaping one's identity. The culturalisation
tendencies of the 1990s show how one can *live* the ambivalences
while cultural liberation offers positive potential for life and self-
realisation.

Participation in cultural activities becomes essential and aes-
thetic reflection facilitates these search processes. The significance
of culture is greater than ever and modern cultural policy faces

important challenges. The welfare state, as we know it in the Nordic countries, provides a good foundation for cultural democracy encompassing, as it does, both the will to "participate" and a broad interpretation of the concept of culture. It has become clear that cultural policy, which is based only on instrumentalisation and motivated by socio-economic factors, alone reduces art and culture to a secondary role.

CULTURAL DEMOCRACY AND MODERN CULTURAL POLICY

Concerned as it is with public arts and culture subsidy, the state has a major role to play in the formulation of cultural policy. Harry Hillmann-Chartrand has identified four of the roles played by the state: as *facilitator, patron, architect* and *engineer* (Hillmann-Chartrand & McCaughey, 1989:43–80).

When the State acts as *facilitator,* subsidy is usually in the form of a tax reduction for those who donate gifts for artistic activity. This model prevails in the US where the role of the state is by and large indirect and does not extend to discussions of quality, or such issues as the degree of priority accorded to the arts and artists. It attempts to ensure variety while minimising state intervention in favour of market forces.

The state as *patron* (as in Great Britain or Ireland) supports art through one or several "arm's-length" arts councils and/or arts funds. Government decides how much public money should be spent but does not select which institutions and artists it should be spent on. This decision is up to the Arts Council, made up of art experts and artists, appointed by government. Most arts councils foster primarily the promotion of the "professional" arts while the financial status of artists and arts bodies depends on their ability to attract the public, on the taste of private donors and on support from the Arts Council.

In the *architect* model (Central Europe and Scandinavia), the state plays a governing role in the promotion of art and culture, for instance through a Ministry of Cultural Affairs, or a cultural department. The decision to support artists and cultural institutions is made by bureaucrats and the tendency is to promote art and culture which reflect the wishes of society, as well as allocating support in accordance with social welfare measures. The financial status of cultural institutions is almost totally dependent on direct government support.

In the *engineer* model, the state owns the artistic means of pro-
duction and promotes only art which complies with political exi-
gencies. The countries of the former Eastern Europe (before the
fall of communism) are representative of this cultural-political
model. Decisions on support are made by political commissioners
and the primary objective is political. The financial status of art-
ists depends on their membership of official unions recognised by
political parties.

Each model is based on political and cultural traditions which
have developed historically. In practice, however, a blending of
the various models takes place. While the Scandinavian countries
follow the architect model, there are also elements of other mod-
els, for instance, that of patron as in the case of the Danish *Kultur-
fonden*, *Teaterrædet* and *Musikrædet* which are governed according
to the "arm's length" principle. The strength of the architect role
is that artists and cultural institutions are relieved of the pressure
to achieve popular success (through sales or sponsorship). Its
weakness may be its tendency, through permanent subsidy for
institutions and artists, towards artistic stagnation. Also, in this
model cultural policy rests on a basic dilemma: on the one hand,
the support of artistic quality and on the other considerations of
social welfare (for example, addressing the needs of the unem-
ployed, or of marginal groups). This cultural-political dilemma
can be avoided by choosing one of two routes: either a goal-
directed arts policy and re-adjustment towards the patron model,
or a regular instrumentalisation policy defining one or several
welfare/political objectives for cultural policy, such as, for in-
stance, the strengthening of local communities. On the other
hand, this dilemma, by compelling discussion on cultural policy
issues and attitudes, gives an elasticity to the cultural-political
concept and model.

The overall objective of Scandinavian cultural policy over the
past 20 years has been the decentralisation of power and the
strengthening of local districts. The welfare model aimed to se-
cure democracy and social harmony so that as many people as
possible could benefit from cultural provision. In continuation of
the decentralisation principle, several Scandinavian countries
have made cultural administration statutory in every district and
county. This has given rise to a lot of bureaucracy in the area of
cultural management.

The main principles of European cultural policy after World War II are encapsulated in the notions of the *democratisation of culture* and *cultural democracy*.

> As part of the restoration of the European democracies after World War II, a cultural policy strategy was chosen which aimed at *democratising culture*. It was recognised that only a very limited audience participated in the cultural activities supported by the arts-subsidy policy which had evolved. Roughly, this audience consisted of those who earned the most money and had the highest education. . . . Consequently, it became a central goal of the emerging cultural policy to enable the general public to benefit from cultural affairs. Access to art institutions was to be facilitated. The art objects were to be moved out to where people were living (Langsted, 1990:5ff).

Such impulses towards democratisation are evident in state arts institutions which tour the districts (e.g. *Riksteatret* and *Rikskonserterne* in Norway); the establishment of regional cultural institutions; price reductions for special groups (e.g. student discount): all of which are aimed at enabling as many people as possible to experience professional art of high quality. This cultural-political strategy was built on a concept of *unitary culture*; the professional, established, "fine arts" culture deeply rooted in the refined culture of the bourgeoisie. The desired effects did not transpire, and despite energetic efforts only the usual well-educated and well-to-do classes participated in these activities. The new principle of *cultural democracy*, aimed at including all cultural manifestations and all classes, was launched.

> There are, indeed, many cultures, sub-cultures, each with its own language and internal rules. That is to say, this concept of culture is based on *cultural pluralism*. It also argues for extending the concept of culture. According to the cultural democracy strategy, all the different cultures in a society must be given real opportunities to be heard, through expressing themselves artistically and symbolically (Langsted (ed.), 1990:18).

Cultural democracy as an ideal is based on a pluralist concept of culture as something which interacts with other areas such as social policy, school policy, town planning, etc. Cultural democracy means cultural development: culture is no longer static but rather a continuous social process. Today, cultural reality is characterised

by the central role of the mass media and the increasing role of
the swelling middle class as the main bearers of culture.

Cultural policy is concerned with the adjustment of the pro-
duction, distribution and consumption of art and culture. How-
ever, other elements also determine aspects of this adjustment.
Market mechanisms, fashion waves and the population's cultural
habits and social needs also influence cultural policy. The cultural
industries, the audience, artists, the cultural institutions and the
public cultural sector all participate in the cultural-political game
of power. The objective of public cultural policy is to rise above all
of these participants and to create macro-level strategies which
will determine, for instance, the extent to which market mecha-
nisms, artists' needs, or local political goals are to decide cultural
practice.

In the media the large cultural institutions complain about re-
ductions and strained circumstances, reinforcing the message of a
budgetary squeeze on culture. The reality is that today more
people are competing for the same funds. The demand for techni-
cal and professional staff is increasing and budgets are growing.
In addition, many new institutions appear, large and small, some
private, some public and some a mix of both. The issue of cultural
funding is being eagerly discussed in public as well as in private
organisations. Though a small part of the total national budget
(less than 1 per cent in Denmark), culture is linked to political
values and is frequently debated by the average citizen. Some-
times the discussion may centre on basic principles, such as qual-
ity, decentralisation, the number of people to benefit from fund-
ing, or whether to give the production or the presentation of art a
higher priority.

It is true that, generally speaking, the concept of culture has
been widened — even watered down. General education, libraries
and sports facilities are all seen as part of cultural affairs. So gen-
eral has it become that now the word "art" has been more or less
erased from political documents and has evaporated in many dis-
cussions of cultural affairs.

Moreover, myths about financial growth arising from cultural
investment are such that local politicians have staked enormous
sums of money on the development and presentation of art, in the
hope that these investments would yield a benefit in other areas,
(such as tourism, jobs and trade)[4]. The extended cultural concept,
the cultural boom and the cultural industries phenomenon,

described above, have all helped to create a growing cultural sector. Public expenditure on culture has gradually increased and cultural policy has had a wide-ranging impact. Fundamental discussions on how to implement cultural democracy have drowned in administrative reorganisations, budgetary subtitles and cultural-economic myths.

Generally speaking, the justification for public cultural policy has moved from *democratisation* to increasing *instrumentalisation*. The question is whether it is possible to unite these two principles in an overall cultural policy. If we take the idea of cultural democracy seriously, we must find a way of administering cultural funds and organising cultural work so as to leave room for all kinds of initiatives, big or small; inside or outside of established institutions; initiatives taken by professional or non-professional groups; representing traditional or non-traditional ways of producing and communicating art and culture.

The example of Copenhagen '96 has already been cited to illustrate in practice the implementation of a policy based on the notion of cultural democracy. Also, the newly established national fund in Denmark, *Kulturfonden* (The Cultural Fund),[5] administered by a committee of experts, set up by the Ministry of Cultural Affairs (in accordance with the arm's length principle) to support innovative projects which might cross traditional boundaries — projects which allow professionals and non-professionals to work together on an intensive artistic or cultural event over a specific period — is encouraging of new ideas from whatever source. *Kulturfonden* has meant that project work already in existence has become more visible and focused. At the same time there is a need for qualified personnel to plan and prepare projects and develop detailed proposals. The creation of *Kulturfonden* has underlined the relevance and interest of cultural projects.

Kulturhus Aarhus offers yet another model: the municipality of Aarhus has established an open workshop and service centre for young, non-institutionalised artists and cultural workers who have a project they wish to carry out and who need premises, access to a phone, a fax or a computer; who want professional counselling; and who want to exchange experiences and meet other people working on similar projects. *Kulturhus Aarhus*, which opened in January 1995, is already in big demand. Young unemployed cultural workers work side-by-side with professional and more experienced artists. Some people use the building as their

daily workplace and their full-time occupation; others use it in their spare time. *Kulturhus Aarhus* has at its disposal stages and venues for theatre performances, concerts and exhibitions and a café which serves as an informal meeting place for young artists and cultural workers. *Kulturhus Aarhus* also offers courses and tuition, so that the young artists in Aarhus can receive further qualifications.

These two examples may be seen as concrete initiatives towards establishing cultural democracy. Joern Langsted, Professor at the University of Aarhus, points out that even though the two strategies (democratisation of culture and cultural democracy) may seem contradictory, it is essential that they are *both* present in a modern cultural policy. This double strategy includes the notion of a *multi-centred cultural life*, where the various cultural institutions and cultural initiatives should be regarded as being of equal rank.

A modern cultural policy includes several strategies and initiatives.

1. Securing better conditions and greater freedom for art

 * The production and presentation of creative art must be given a high priority in order to create a strong backbone for cultural life.

 * Democratisation of cultural institutions as independent bodies with artistic freedom and free from any political interference

2. Creating strategies for cultural learning processes

 * Democratising access to art and culture

 * Creating room for debates, cultural exchange, artistic cooperation, cultural projects etc., making creativity, communication and innovative thinking possible

 * Qualifying the individual, creating actors (and not passive receivers) in cultural life

 * Making use of the possibilities of the mass media and information technology

3. Demanding quality for art as well as for culture

- The criteria of quality have to be continuously debated in public

- The essential criteria of art and culture in the 1990s must be that they reflect modern culture and examine the relation between the individual and society (identity-searching processes)

4. A multi-centred cultural life

- Maintaining a national cultural-political commitment and responsibility, even though part of the decision-making is handed over to local authorities

- Equalising already established institutions and newer, more innovative organisations

- Creating a political culture to enable the actors of cultural life to take initiatives and to take part in the decision-making processes

- Basing other socio-political areas on cultural-political points of view

- Strengthening dialogue between politicians, artists, cultural workers and cultural experts

Copenhagen '96 was a cultural-political initiative, which aimed to unite some of these strategies. To express it in more upbeat terms, Copenhagen '96 — European City of Culture was of such a universal and optimistic character that no area of culture was neglected in its plans and visions. The project tries to pursue a dual political line. On the one hand, a *policy of democratisation* stressing access of citizens and project makers, equalising institutions and free initiatives, viewing environment, sports, international exchange, research and art as dimensions of an extended concept of culture and initiating co-operation and exchange across social, geographical and cultural boundaries. On the other hand, the project was also the result of a *policy of instrumentalisation* which aimed to increase tourism, to give new energy and inspiration to a capital full of conflict, to make the city attractive to business and trade, to create new jobs and to use concrete cultural activities as strategies in socio-political and local political interests. It remains

to be seen if the results will live up to the expectations. Media interest shows that much of the former doubt and scepticism has vanished and given way to an astonishingly positive attitude. The long-term objectives for the processes of democratisation and instrumentalisation cannot be analysed until the project is finished and a couple of years have passed.

ART AND CULTURE REFLECTING LIFE

Our thesis is that, as a modern way of creating art and culture, the cultural project is a fitting response to the identity-seeking process and the forces of individualisation and change, which we see as characterising contemporary society. Cultural projects, as practical manifestations of this cultural policy, contribute to cultural democracy and, at the same time, help to dynamize administrations and cultural institutions which might otherwise be rigid and obdurate.

The numbers of young unemployed cultural activists and the media's interest in cultural news are both important factors in the development of the many cultural projects which have emerged in Denmark during recent years. Many of the projects involve full-time — and professional — artists and project managers. The vital dynamo of a cultural project is that it is self-mobilising, driven by the initiatives, imagination, creativity and work of individuals and groups. A cultural project may give power and influence to the individual citizen or to groups in society, whether they be artists or cultural activists, professionals, semi-professionals or amateurs. In other words, the cultural project represents the potential of civil society[6], whereas traditional cultural management, public administration and cultural industries are governed by principles of order, bureaucracy and profit. Many cultural projects have been successful despite low budgets, insufficient public support and lack of "professionalism" in the traditional sense of the word. They are usually funded under "free means"[7] provisions. Project management, as the strategy and tool for establishing and carrying out cultural projects, thus becomes a central skill and area of knowledge. A cultural policy which wants to encourage cultural projects must also give financial support to project initiatives and assist in guiding and educating qualified project managers.

Funding cultural projects as a method of developing innovative artistic work is a relatively recent phenomenon. The project idea is often an experiment and success is not guaranteed. This means that local cultural politicians take a chance when they support such a project. *Process* matters more than *quality* in cultural projects.[8] Not all projects are ideal and it may happen that the best efforts grind to a halt or become institutionalised, or that the project experiments result in fruitless chaos inimical to co-operation and creativity. The concept of "project" is used in all connections and it is probably possible also to find cultural projects which are not projects in the sense used here: creative, self-mobilising and temporary. The intent of this chapter in arguing that the cultural project is an ideal modern way of organising cultural work is to make these projects more *visible* and to demonstrate the need to develop project management as a tool for strengthening cultural democracy.

Cultural communication in the 1990s continues to be characterised by traditional types of institution, communication and management. Public authorities play an essential role in relation to existing cultural institutions, cultural communication and cultural management. Traditional cultural management, however, is being challenged all over Europe and more recently in the Nordic countries, by multiplicity and competition. The growing competition in the area of art and culture means that the Nordic countries are now copying the management techniques of the United States and Britain. Culture managers frequently pursue advanced studies abroad, especially in arts management or culture administration.

The problem here lies in the fact that arts managers are now being trained in effective sales techniques so that institutions are guaranteed the largest part of the market. Schooled in the principles of efficiency and economy, they forget the basic conflict — or at least the paradoxes — involved in creating and communicating art and culture while managing a cultural institution in accordance with financial management principles.

Cultural projects and cultural management are fields which could profitably be developed and adapted to the principles of cultural democracy in order to strengthen innovative thinking and further the growth of new ideas in art and culture. Such a prospect offers real potential for capable, young, experimental artists and cultural workers, many of whom are currently out of

work and who have little chance of getting a foot in the door of the large established institutions. They have to spend a lot of time doing "other jobs" (that is, non-artistic) in order to make a living at all. And they have to compromise their own artistic integrity and ambitions to satisfy the requirements of society and the need to earn a living wage. Much enthusiasm, idealism and brilliant artistic ideas are lost because young artists have to fight too hard in order to survive financially.

How is it possible through political initiatives and innovative thinking to give young artists better living and working conditions? How can cultural managers and cultural intermediaries become qualified to support and strengthen young artists and to improve the conditions of cultural workers? It is necessary to open up opportunities for new initiatives which can be found outside of — and in spite of — established and traditional cultural institutions. Copenhagen '96, *Kulturhus Aarhus* and The Cultural Fund — are all examples of cultural democracy working well in practice.

It is especially important to maintain a national cultural policy which does not leave all cultural-political authority to local authorities. The state has a responsibility to help young artists develop new initiatives and to motivate cultural political debate and innovative thinking: to create the economic, physical and cultural framework for innovative art and culture. Using cultural projects as a way of creating new art, it is a public responsibility to qualify and train project managers and project workers, just as cultural secretaries, cultural intermediaries and cultural administrators are being trained. This does not imply "professionalisation" and standardisation of the project work: the main characteristics of cultural projects must still be variety and difference.

The concept of cultural officer, though a threatened species in Scandinavia, is instructive in this regard. These officers are interesting for their dual function which incorporates both a purely bureaucratic role within public administration and their duty to stimulate, motivate and animate local groups and individuals to participate actively in cultural events. In the light of the need to develop and strengthen cultural democracy, it may be that publicly employed cultural officers cannot continue playing a double role. We need good bureaucrats who are specialists in the administration of public affairs but in addition it is important to develop new positions and professions which specialise in the

"animateur" function and which physically and administratively are placed outside public administration. The cultural worker "in the field" has a lot in common with the project manager, needing similar levels of competence and qualifications. Working "in the field" involves project management; an enthusiastic, inventive and independent person is needed to fulfil such a role. The most important function of the cultural worker "in the field" is the ability to motivate and advise other people who have ideas for concrete projects.

So far, there is no tradition of employing this kind of cultural worker within the public sector, and it seems unlikely now, when public funds for cultural activities are limited and insufficient and public positions are threatened that such appointments will be made. Nevertheless to foster cultural democracy, such local and public cultural workers will be essential to create activities, co-ordinate various initiatives and ensure contact and information between public authorities and the people involved directly in cultural life.

IMPLICATIONS FOR MANAGEMENT TRAINING

The above discussion has clear implications for the training of culture administrators and managers. The type of project manager needed today possesses personal qualities, education and experience which are suited to the particular requirements of cultural projects. Above all, such a person must be adept in the management of creativity, while having a command of the more usual management skills.

For this reason, training institutions have a very important role in the development of project management and cultural projects. Such institutions help to shape future cultural workers and to develop theory and research as the basis for cultural-political thinking and debate. Therefore, rather than turning out a standardised version of the cultural bureaucrat, such institutions can be instrumental in stimulating the innovation which is endemic to cultural projects by:

- Strengthening the theoretical and practical competence of potential project managers

- Emphasising the personal and individual qualities of each trainee

- Developing theory and research which contributes to good practice and heightens the visibility of cultural projects

- Opening avenues of co-operation with all that is vital in cultural life, locally, nationally and internationally.

It should be noted too that in order to strengthen cultural democracy, it is vital to develop the general cultural competence of citizens and to create initiators instead of passive consumers. This is a task not only for schools and training institutions but also for cultural institutions, administrations and local associations.

Notes

[1] See for example *Handlingsplan for Kulturby '96*, European City of Culture, Copenhagen 1993.

[2] Terms like "kulturprosjekt" (culture projects), "kulturarbeid" (culture work), "kulturformidling" (communicating culture) and "kulturforvaltning" (culture administration) etc. are closely connected to the way arts and culture are organized and funded in the Nordic countries. There are no exact equivalents for these terms in English.

[3] The cultural-searching processes include:

1. *Subjectivification*: an attempt to re-establish social relationships and proximity, by imitating intimacy, close relationships and expressiveness, e.g. workshops in body language and expressive dance, group-therapy etc.

2. *Ontologification*: an attempt to find certainty and metaphysical answers to compensate for loss of meaning; includes new-religious groups, fundamentalist and spiritual movements.

3. *Intensification*: an attempt to intensify and fill something with (artificial) meaning, to replace emptiness; involves aestheticisation and artificial reality. Lifestyles become the meaning of life and computers, empty signs and fascinating experiences form a substitute for life and reality.

[4] Trine Bille Hansen, a Danish researcher, rejects these cultural-economic myths (for instance in her 1993 report *Kulturens økonomiske betydning — "State of the Art"*, AKM/memo, Copenhagen: Amternes Forlag).

[5] *Kulturfonden* (The Culture Fund), was established as a permanent government fund in 1993. Before that, it had existed as an experiment for three years. The establishment of *Kulturfonden* has given rise to many sceptical and critical discussions, even though it takes only a very small proportion of the total budget for cultural affairs on the national level.

[6] The term "civil society" is taken from sociology and is linked to "state" and "market". It is a type of rationality which is contrasted both with market (profit) and state (power). Per Mangset (1992) describes *cultural-political* rationalities: a creative cultural rationality (which handles innovation and chaos); an administrative rationality (which handles order); and a market-economic rationality which is instrumental and related to profit. At all times the cultural system will be influenced by the tension between state, market and civil society, between order, profit and chaos. The creative cultural rationality exists in art, reflection, opinion and cultural communication, whereas the administrative rationality relates to management, rules, reproduction and government. The market-economic rationality is linked to cultural industry, production, technology, profit, etc. Cultural life, the cultural sector and the cultural policy all exist in a field of tension between these three poles.

[7] This type of cultural project only receives a small proportion of the total budget for cultural activities. In relation to Scandinavia there are major differences between the towns and the country, between the centre and the periphery. Whereas cultural projects relate to the reality of the towns, there are also organisations and associations which are rich in tradition — at the local and the national levels — and which are important in the presentation of culture.

[8] Henrik Kaare Nielsen has tried to distinguish some of the criteria for quality which have been in use. He notes three positions which have manifested themselves in the current debate: (1) a universalistic-normative linking of quality and fine culture/professional art based on uni-cultural self-knowledge; (2) a relativistic "anything-goes" position, where quality is of little interest; and (3) a particularistic-normative position where quality can only be defined within certain contexts. Nielsen then introduces his own position as a fourth variation: a pluralistic-universalistic normativity, where *the experience process* determines quality. In other words, the quality of a work of art, a process of creation, or cultural activity is related to the artist's/participant's work on the complexity and identity ambivalences of modernity. (See also: Henrik Kaare Nielsen: *Kvalitet — men hvilken?* in Kyndrup & Nielsen, 1993, 15ff.)

References

"Copenhagen — City of Culture 1996: Kulturby '96 — Handlingsplan" (1993).

Hansen, Trine Bille (1993), "Kulturens økonomiske betydning — State of the art", AKM/memo, Copenhagen: Amternes Forlag.

Hillmann-Chartrand, Harry & McCaughey, Claire (1989), "The Arm's Length Principle and the Arts: An International Perspective — Past, Present and Future", in Milton C. Cummings, Jr. & J. Mark Davidson Schuster (eds.): *Who's to Pay for the Arts? The International Search for Models of Arts Support*, New York: ACA Books.

Kyndrup, Morten & Nielsen, Henrik Kaare (eds.) (1993) "Æstetik og Kultur i 90'erne", Centre for Interdisciplinary Aesthetic Studies, Aarhus: Aarhus University Press

Langsted, Joern (1990) "Double Strategies in a Modern Cultural Policy", *The Journal of Arts Management and Law*, vol. 19, no. 4.

Langsted, Joern (ed) (1990) *Strategies — Studies in Modern Cultural Policy*, Aarhus: Aarhus University Press.

Mangset, Per (1992) *Kulturliv og forvaltning, innføring i kulturpolitikk,* Oslo: Oslo University Press.

Nielsen, Henrik Kaare (1993a) *Kultur og Modernitet*, Aarhus: Aarhus University Press.

Nielsen, Henrik Kaare (1993b) "Youth Culture and the completion of cultural modernization" in *Young Nordic Journal of Youth Research,* vol. 1, no. 3.

Nielsen, Henrik Kaare (1994): "Det ambivalente civilsamfund", in *Social Kritik* 29/1994, Copenhagen.

Ziehe, Thomas (1989) "Ambivalens og mangfoldighet" *Politisk Revy*, Viborg.

PART SIX

HUMAN RESOURCE ISSUES IN CULTURE MANAGEMENT

16

SKILLS AND COMPETENCIES:
THE CULTURAL MANAGER[1]

Paula Clancy

INTRODUCTION

The nature of the cultural sector is such as to suggest that the skills and competencies needed for its management are different to those required for management in other areas of the economy. As well as the fundamental differentiating feature — the management of the creative process — the cultural sector is one which is certainly in the course of transition and perhaps even of transformation. Leading into the next century the arts face a number of challenges, all of which have implications for the task of its management: an increasing move towards centralisation of sources of public funds for cultural expenditure as well as a greater reliance on private sources; a greater emphasis on decentralisation and of broadening social class access to the arts; a new emphasis on partnerships between public and private sectors and of integration of the arts with other social and economic activities and a broadening of valid goals for cultural activity to include those of job creation and economic profit. While all of these issues are subject to ongoing and often fierce debate, they have already had a deep impact on the environment within which cultural managers must operate. Arts management involves the arts manager as mediator between different stakeholders: the national state institutions, the local authorities, funding agencies including the European Commission, the artist and the audience. As a business manager the arts manager is involved in all the tasks of the management of any enterprise or of aspects of that enterprise. In addition, arts management is about the management of creativity and innovation, involving the manager in risk-taking ventures and requiring them to be entrepreneurial in approach. The arts

manager is also an idealist who "is intimately concerned each day in promoting works with a strong social content, in making societal and educational decisions about priorities and in the production of material which is always openly or secretly disruptive — that is, art" (Pick, 1980: 10).

For those involved in museum services, the management challenge is one of achieving the necessary balance between two major client groups: between housing and caring for the collections on the one hand, and on the other, the needs of the user, including general visitors, scholars and educational groups, with regard to access to the collections. One of the most significant aspects of the museum area is its growth and increasing diversity. In Ireland, this is most evident in the increasing number of heritage and visitor attractions, whether privately or publicly developed. This growth and diversity involves museum service personnel in a greater number of more complex tasks than has previously been the case (*Museum Professional Training and Career Structure*, 1987; Boylan, 1992).

In this changing environment what kind of jobs are being created in the cultural sector? How do cultural managers view their careers? How well rewarded are they? How is the sector managed and how can effective management be fostered in cultural organisations? These are the central questions addressed in this chapter. Their treatment derives from a study of cultural sector managers conducted in Ireland[2] which examines the competencies, knowledge and skills needed for management in the arts and heritage for the foreseeable future.

PROFILE OF THE SECTOR

It is important to understand the nature of the sector in order to understand the nature of the manager's job and the implications of different aspects of the environment, particularly those which are peculiar to the sector, for the tasks which must be performed, and for the skills and knowledge which are required. These tasks and competencies cannot be divorced from the environment within which cultural managers work (Boyatzis, 1982).

Arts organisations are not homogenous entities but instead reflect the diversity which exists both within and between the different artforms they encompass. They include art galleries, exhibition spaces, studios, drama, dance, film and music venues and production companies; festival organisations and support and

development organisations for each of the artforms; arts centres which deal with a multiplicity of arts forms; community arts organisations; and the principal umbrella and policy development bodies.

Museums, defined as organisations which "acquire, conserve, research, communicate and exhibit material evidence of man and its environment for the purposes of study, education and enjoyment" (*Museum's Yearbook 1996/97*:352), include traditional national and local authority museums, art galleries and historic centres.

Nonetheless, the cultural manager works within an environment with a number of shared structural characteristics which shape their job. Among the most important of these characteristics are the small scale and financial instability of organisations within the sector, the heavy reliance on non-standard and peripheral forms of work and the growth in new organisations combined with a high turnover of others.

Instability

One of the salient characteristics of the cultural sector is the relative instability of its organisational structure. The sector does have a number of well-established organisations, particularly in the museums area, although some of the smaller heritage-type organisations are less financially secure. In addition, in recent years, with the growth of cultural tourism, there has been a big increase in the number of museum-type organisations. More than half of arts organisations have been in existence 10 years or less. There is a relatively high turnover of arts organisations, with a number closing down, in many cases because of insufficient funding, and others continually coming on stream to replace them, often drawing on the same pool of personnel.

Scale

Management in the cultural sector, which is composed largely of small- or medium-sized enterprises (SMEs), in many cases with only one employee, frequently combines general management tasks with responsibility for the specialist function of the enterprise — for example, artistic director in the case of the arts, or curator in the case of museum services.

In this context management responsibilities are extremely broad-ranging, even more so where the director/manager is the only employee and as such is responsible for all aspects of running the organisation. For example, the task of financial budgeting could include not only preparing and controlling the budget but also tasks as varied as the actual book-keeping and raising of funds. The management of the building could include the physical installation of equipment and/or movement of furniture. Collections management can include acting as guide. The quotations from cultural managers provided in Figure 16.1 illustrate the reality of this experience.

FIGURE 16.1: QUOTATIONS FROM CULTURAL MANAGERS OF SMALL ENTERPRISES

"... we employ an accountant and solicitor when required but do everything else from long-term business planning to sweeping the back-yard."

"The post of director is the only full-time paid position in the organisation. Working to an executive committee elected annually, the job encompasses the roles of programme director, development officer and administrator. An actual job description would run to several pages and I regret I do not have the time to complete one."

"With no full-time staff we [respondent and partner] have assumed almost all administrative tasks as well as acting as artistic directors, producers, choreographers, dancers, company managers, tour managers, teachers and development officers. Help!"

"The job description would cover every type of job related to such an organisation from director to office boy, from marketing and sales manager to filing clerk."

"My job entails everything from marketing, fundraising, administration, tour guiding, maintenance etc. Funding is always a problem and I get a salary when money is available."

NATURE OF THE WORK FORCE

Non-standard Work

The fluidity of the organisational structure is reflected in the nature of employment in the sector. Parallel with a relatively small proportion of core, full-time permanent positions, particularly in the arts sub-sector, there is a significant use of non-standard work — contract/temporary and part-time work and a heavy reliance on government employment schemes and volunteers.

All categories of staff are affected but the extent to which it also applies to management personnel merits particular comment. There has been a considerable shift in the organisation of work in general towards an emphasis on flexibility (Atkinson, 1984). This shift has resulted in a new model of work organisation which categorises the work force into two distinct groups: increasing numbers of peripheral workers combined with a small, stable core of workers. This latter group are considered to have skills which are specific and important to the organisation and are thus rewarded with permanent, pensionable jobs within a clearly-defined career structure. Managers, particularly at senior level, are normally defined as such a core group and it is a striking differentiating feature of the arts sub-sector that the majority of its managers are working under conditions normally associated with more peripheral groups of workers. More than one-quarter of museum managers are working in other than permanent full-time positions. In the arts only 44 per cent are employed in a full-time permanent capacity[3] and nearly half of all arts managers have experienced both periods of unemployment, and higher than average movement between jobs.

Use of Government Employment Schemes and Volunteers

For many organisations, the only way in which staff can be employed is through the availability of government-employment schemes and a reliance on volunteers. There is considerable dissatisfaction among cultural managers about this issue since the short-term and part-time nature of the involvement of staff employed under these schemes conflicts with the nature of the work of cultural organisations, much of which is developmental and process-oriented.

Use of non-standard forms of work combined with heavy reli-
ance on government schemes and volunteers creates difficult hu-
man resource management issues which must be confronted by
the cultural manager on a daily basis. For example, since the ac-
quisition of training and experience is often a slow process, the
peripheral position of much of the work force and the consequent
high level of staff turnover is a major drain on the scarce resources
of the individual organisation.

Pay

Cultural managers, particularly in the arts, are poorly paid com-
pared with similar groups in the economy as a whole. While atti-
tudes to work reflect the widely-held perception that cultural
sector managers are passionately committed to their work, and
while this is the most important aspect of their work to them, arts
managers also indicate that pay is important, and is an area where
there is considerable dissatisfaction. Indeed, while it is true to say
that most managers are content to stay in their present positions
or move to a similar position in a different organisation in the
sector, a notable minority within the arts area, the majority of
these being at director and assistant director level, would like to
move out of the sector altogether. The principal reasons given are
to do with pay and conditions.

This pattern of a mobile and unstable structure raises serious
questions and has a number of policy implications. At the indi-
vidual organisation level we can speculate that there is a negative
impact on the morale of employees. Corporate memory within
the organisation is also likely to suffer. At national level, there is
much discussion of state intervention to support the cultural in-
dustries for reasons, inter alia, of potential employment growth.
However, it is more difficult to make the case for employment
which is characterised by low pay and insecurity.

GROWTH IN NEW ORGANISATIONS

Establishing the Organisation

A significant feature of the job for many managers in both the arts
and the museum areas is that of setting up and establishing their
organisation in a greenfield setting.

In the arts sub-sector this feature of work is indicative of the relatively high turnover of organisations, which is also suggested by the high level of job mobility found among arts managers. Management in a new and emerging organisation presents different management challenges to that of maintaining a well established enterprise:

> it takes a specific knowledge, expertise and most of all a rare and complete commitment as an organisational manager for a company in the birth pangs of creation, especially in a company that may intend to remain small, selective and out of the mainstream of artistic activity in commercial, critical and financial terms (Jeffri, 1980:193).

WHO ARE THE CULTURAL MANAGERS?

The profile of the typical cultural manager is that of a young, well-educated and experienced person, who is almost as likely to be female as male. In Ireland, cultural managers are predominately young, well-educated — the majority to degree level — primarily in arts or museum-related subjects. Despite their age profile they are very experienced, the majority with more than eight years work experience; in the arts this experience for almost two-thirds of them is in the arts sector; in the museum area, 40 per cent have worked predominantly in museum organisations. Women represent a higher proportion of managers in the cultural sector than is the case in other sectors of the economy.

In the economy generally, paid employment continues to be predominantly gender-specific with management jobs being typically male, better paid and with better working conditions, promotion prospects and access to training (O'Connor, 1996).

WHAT IS THE JOB OF THE CULTURAL MANAGER?

Having set the environmental context, we now turn to an assessment of what it is that the cultural manager does: what is generic to all management jobs and what is specific to the job as cultural manager. From this we identify the competencies which are needed to perform the job effectively.

Management Jobs in the Arts

Management jobs in the arts reflect the diversity of organisational structures and include directors and chief executives of arts organisations, local authority-employed arts officers, senior managers in the large arts organisations, and the senior officers of State, or State-funded but independent, policy and development agencies.

Directors of arts facilities and programmes, including arts centres, galleries, festivals and performing venues, represent a significant proportion of the managers in the arts sector. These managers have a broad range of management tasks, including that of general manager, bearing the ultimate responsibility for all aspects of the organisation.

While the vast majority of managers in the cultural sector can be classified as general managers, often the only manager and indeed the only paid employee in the organisation, there is also a small number of organisations which are of sufficient scale to employ a relatively large number of staff which in turn warrants a management structure.

The management tasks of senior personnel in these organisations are a subset of the general managers' functions in a particular functional area such as personnel, marketing, financial control, public relations, development, general administration. They can also comprise all of these functions in one specialist area of activity of the organisation — for example, responsibility for a particular artform in a multi-purpose arts facility. These managers are the heads of department or head of function within their organisation (see Figure 16.2).

Management Jobs in Museums

Three broad categories of manager have been identified in the museum sector: director/curator of museums; heritage attraction manager and senior managers in larger museum organisations. However, the management tasks listed in Figure 16.3 as tasks of the director/curator are also aspects of the management job in heritage attractions/visitors centres.

FIGURE 16.2: TYPES OF MANAGEMENT JOBS WITHIN THE ARTS SUBSECTOR AND SOME KEY CHARACTERISTICS OF THESE JOBS

	Director/Chief Executive of Arts Enterprise	Local Authority Arts Officer	State-funded Development Agency	Senior Manager in Large Organisation
• Policy Development				
National/Provincial		•		
Local		•*	•	
Organisation	•		•	•
• Planning				
National/Provincial		•		
Local		•*	•	
Organisation	•		•	•
• Management of Resources				
Financial:				
Budget Planning/Control	•	•	•	•
Assessing Grant Applications		•	•	•
Staff:				
Recruitment	•	•*	•**	•
Delegation/Control	•	•	•**	•
Development	•	•*	•**	•
Facility/Building including accommodation of events; staging sets; procuring and maintaining fittings; security and overseeing capital developments	•	•*		•
Retailing/sales/box office	•			•

FIGURE 16.2 CONTINUED

	Director/Chief Executive of Arts Enterprise	Local Authority Arts Officer	State-funded Development Agency	Senior Manager in Large Organisation
Management of artistic programme/project, including negotiation with artists and/or performing companies at:				
National/Provincial		•	•	
Local area	•	•*		•
Organisation	•	•	•	•
Marketing and promotion, including a representational/advocacy/lobbying role	•	•	•**	•
Fundraising, including arranging sponsorship and writing funding applications				
Establishment and ongoing liaison with other organisations/institutions including community, educational and cultural groups	•	•	•	•
Ensure organisation's compliance with all relevant legal requirements	•	•	•+	•
Servicing a board/management committee	•	•	•	•

Notes to figure:
* = some NI officers only
** = not all officers
† = at chief executive level

Museums, including historic houses and parks, can be differentiated from heritage centres as organisations which acquire, conserve, research, communicate and exhibit material evidence of man and his environment, while heritage centres, folkparks and interpretative centres exclude original artefacts and are primarily facilities which interpret aspects of environmental and/or cultural heritage through media. In practice, these distinctions are not always easy to make with many organisations providing multiple or more than one museum service. Consequently, broadly the same range of management tasks apply across the museums and heritage area although emphases will differ within specific organisations.

General managers of large museum service organisations, including the national institutions, have a broader scope of responsibility at a greater level of abstraction while the general manager of the small organisation — the county museums, specialised museums and those run by independent trusts — have a narrower range of tasks with which they must be involved to a much greater degree of detail. As was found in the context of many arts organisations, many of these smaller or specialised museums function with only one paid employee.

Many of the management tasks of senior management staff below director level in the national museum organisations, particularly for those who head up a section or a department, are the same as those for the general manager but do not have the same scope or decision-making power and often require a greater involvement in a specialist aspect of the overall activities of the institution. There are also post-holders in specialised management functions, including marketing, personnel, finance and administration.

More specialised management activities in the heritage area can include a specialist position within a larger, perhaps non-museum organisation — for example, advisor to a local authority or national or regional tourist organisation on the development of a heritage centre or visitors' attraction.

Comparison of Arts and Museum Management Jobs

In comparing the management tasks of both arts and museum managers at the necessarily broad level of generality itemised in Figures 16.2 and 16.3, the most noteworthy feature is the degree of

commonality not only between the different categories of arts manager but also between arts and museum managers.

A number of key differences, however, merit attention. The first of these relates to the different substantive task of arts and museum areas: for the museum manager there is an emphasis on the tasks associated with collections management and for the arts manager there is a major importance attached to the managing of the relationship with the artist.

FIGURE 16.3: TYPES OF MANAGEMENT JOBS WITHIN THE MUSEUM SUBSECTOR AND SOME KEY CHARACTERISTICS OF THESE JOBS

	Director/Curator/ Manager of Museum/Heritage Organisations	Senior Manager/Curator/ Keeper in Large Museum Organisation
• Policy Development		
National/Provincial	•	
Local	•	
Organisation	•	•
• Planning		
National/Provincial	•	
Local	•	
Organisation	•	•
• Management of Resources		
Financial:		
Budget Planning/Control	•	•
Staff:		
Recruitment	•	•
Delegation/Control	•	•
Development	•	•
Facility/Building: including accommodation of events; staging sets; procuring and maintaining fittings, security and overseeing capital developments	•	•
Retailing/sales/box office	•	•

FIGURE 16.3 CONTINUED

	Director/Curator/ Manager of Museum/Heritage Organisations	Senior Manager/Curator/ Keeper in Large Museum Organisation
• Management of exhibitions/ programme/project includ- ing negotiation with owners	•	•
• Collections management including researching, recording, categorising and restoration of material	•	•
• Marketing and promotion:		
Representational/advocacy/ lobbying role	•	•
Education	•	•
Literature	•	•
• Fundraising, including arranging sponsorship and writing funding applications	•	•
• Establishment and ongoing liaison with other organisa- tions/institutions including community, educational and cultural groups	•	•
• Ensure organisation's com- pliance with all relevant legal requirements	•	•
• Servicing a board/ management committee	•	•

In keeping with the importance of the educational role of mu- seum organisations, there is also more emphasis on the educa- tional function including the preparation of educational materials for the museum manager. (It should be noted that some arts or- ganisations also have an educational function and in some cases this is their primary function.)

The functions of local authority-employed arts officers and the officers of state-funded policy and development agencies are not replicated in the same way in the museums sector — for example, the task of administering funds and of assessing grant applica- tions is peculiar to the arts area.

MANAGEMENT TASKS AND MANAGEMENT COMPETENCIES

The assessment of the education and training needs of managers in the cultural sector is based on identifying both the key tasks common to the sector and the relevant competencies needed to perform effectively the job of cultural manager (Woodruff, 1992).[4] This approach derives from a view that management education and training should move beyond the teaching of theoretical frameworks of generic management functions and disciplines and be given practical relevance in the context of a given management job (Cameron & Whetten, 1984). Furthermore, particularly in a sector which is experiencing rapid change and which, as will be seen from the following discussion, has a number of unique management functions, the most appropriate source of information on management tasks and competencies are cultural managers themselves.

Management Tasks

The job profiles of the cultural manager in the previous section shows that there are at least six broad types of management jobs across the cultural sector, with many sub-variations within each of these types and considerable overlap between them. From this analysis a composite list of the key management tasks across the sector has been developed.

Arts Managers. When the tasks are ranked from most important to least important, four discrete clusters of tasks, as identified by arts managers themselves, emerge. The first cluster comprises a number of general management tasks: planning for the organisation; programme and project planning; financial budgeting and goal-setting. All of these tasks are the responsibility of the chief officer of an organisation (Thompson and Strickland, 1989). More than three-quarters of arts managers indicated that these were important in their jobs.

As discussed in the previous section, the task of setting goals and of planning in cultural organisations can arise at a number of different levels, ranging from the national/provincial level, to regional/local policy development and planning in the case of local authority-employed managers, to the individual organisation as a whole and finally for a particular department or functional area of an organisation. Setting goals and planning may be the actual responsibility of the manager or may be one to which, as a senior

manager, they are expected to make an input. This task is usually one carried out in association with a governing body, board of directors or management committee.

TABLE 16.1: IMPORTANCE OF SPECIFIC MANAGEMENT TASKS TO ARTS MANAGERS

Tasks	Rank
Cluster One	
Planning for the organisation	1
Financial Budgeting	1
Planning Programmes	3
Goal Setting	4
Cluster Two	
Managing relationships with national institutions/funding agencies	5
Promotion of organisation	6
Managing relationships with other organisations	7
Managing relationships with artists	8
Programmes/projects management	9
Managing relationships with governing body of own organisation	10
Managing relationships with visitors/users of service	11
Cluster Three	
Delegation and control of staff activities	12
Fund Raising	13
Managing relationships with audiences	14
Staff Development	15
Staff Recruitment	16
Cluster Four	
Buildings Management	17
Retailing/sales management	18

In the cultural sector, the message which comes through over and over again is that scarcity of resources, in particular, financial resources, regardless of the scale of the organisation, is a major difficulty with which managers must grapple. For many managers, particularly local authority arts officers and officers of national funding agencies, financial budgeting also involves the assessment of grant applications.

The second cluster comprises a mix of all three categories of management tasks: general, functional and cultural sector specific.

Managing relationships with the different stakeholders in the organisation, including national institutions/funding agencies, artists, governing body of organisation, visitors/users of the service, and with other organisations were the next most important. Managing relationships with the governing body of the organisation is for many in the cultural sector a key aspect of their role, with the main task being that of servicing a committee and acting as its secretary. Managing relationships with artists is also regarded as important and is a task which, given the hostility of many artists to the role of arts administrators, is fraught with tension and difficulty. It is a commonly-held view among artists (and also among some managers) that investment in management takes from investment in the arts and artists.

Management of individual projects or programmes of activities were also listed within this cluster and, as we discussed earlier, this can be at an organisational, regional or national level.

In a third cluster were the functional management tasks of marketing and human resource management. The human resource management tasks include delegation and control of staff activities, staff development and staff recruitment. The latter two are of much less importance, which is not surprising in view of the small scale of the sector, where frequently the cultural manager has no staff to recruit or manage, and given also the peripheral nature of much of the workforce which would act as a disincentive to staff development programmes.

Also included in this cluster is the task of fund-raising which could include managing relationships with sponsors and funding authorities, as well as the preparation of grant applications.

Managing relationships with audiences is ranked as only fourteenth in importance out of eighteen tasks, lower than the importance attached to managing relationships with artists, ranked eighth, or with the State, ranked fifth. This suggests that in the struggle for balance the needs and demands of all three of these stake-holders, the ultimate client — the audience — comes a relatively poor third.

Finally, the management tasks ranked in the bottom cluster in terms of importance are building management and retailing/sales management — the latter an activity which is still developing in importance, although regarded by many key informants as an area of activity, even within publicly-owned institutions, which will become increasingly important as a source of income to the organisation, as fund-raising and, in particular, finding appropriate sponsorship, becomes ever more competitive.

Museum Managers. For museum managers the most important task is one which is unique to the area: the management of relationships with visitors/users of the service. Planning for the organisation, goal-setting and planning of programmes — all three functions of the general manager — are also ranked in the top four (see Table 16.2).

A second cluster of tasks can be identified which have in common that they are all dealing with the internal management of the organisation. Managing relationships with the governing body of the organisation is the first of these, followed by promotion of the organisation, financial budgeting, delegation and control of staff activities and programmes/projects management.

The third cluster, and relatively low down the scale, comprises the management of relationships with external stakeholders including national institutions/funding agencies, with audiences and with other organisations.

A fourth cluster is made up of a number of disparate tasks: museums collections management, a reflection of the wide variation in the nature of the organisations in the museums area; staff recruitment and staff development; and, at the bottom of the scale of importance, buildings management, fundraising and retailing/sales management.

Management Competencies

Having discussed the key tasks of the cultural manager's job we turn now to an assessment of the competencies which are needed to perform these tasks effectively. The definition of management competencies which will be used is the set of knowledge, skills and qualities required for effective management in the cultural sector.

TABLE 16.2: IMPORTANCE OF SPECIFIC MANAGEMENT TASKS TO
MUSEUM MANAGERS

Tasks	Rank
Cluster One	
Managing relationships with visitors/users of service	1
Planning for the organisation	2
Goal Setting	3
Planning programmes	4
Cluster Two	
Managing relationships with governing body of own organisation	5
Promotion of organisation	6
Financial budgeting	7
Delegation and control of staff activities	7
Programmes/projects management	9
Cluster Three	
Managing relationships with national institutions/funding agencies	10
Managing relationships with audiences	11
Managing relationships with other organisations	12
Staff Development	13
Cluster Four	
Museums collections management	14
Staff Recruitment	15
Buildings Management	16
Fund Raising	17
Retailing/sales management	18

A total of sixteen management competencies were identified. The
sixteen encompass skills which can be further categorised into
skills of planning and problem-solving, communication and ad-
vocacy, delegation and control, information gathering and net-
working, and financial, personal qualities and knowledge areas.

Arts Managers. The planning skill (i.e. the ability to effectively
schedule time, tasks and activities, to organise resources and to
establish a course of action to accomplish specific goals) was
given the highest ranking in terms of important competencies
necessary for the work of arts managers. Financial capability is
also considered important; the ability to quantify and organise

needed financial resources and to monitor their expenditure accurately ranked joint third. The personal quality of self-confidence (the ability to express confidence and to be decisive) is regarded as an important competency by almost all arts managers. The skill of listening to others' viewpoints, negotiating sensitively and taking account of others' needs was also in the first cluster (see Table 16.3).

The second of the two clusters of skills and competencies are a range of communication and networking skills including the ability to make effective written and verbal presentations to others, and to develop and maintain networks and formal channels of communication with the outside world.

A mixture of other personal qualities, knowledge and skills were ranked in the second half of the scale, including the ability to grasp a complex problem quickly, the ability to influence people and "win the day", the ability to stick to a plan and not to get side-tracked, the ability to assign tasks to others and to monitor their performance, and the ability to conduct effective group meetings.

Arts managers also rank the ability to keep abreast of relevant local, national and international political, economic and cultural developments as relatively low in importance.

Museum Managers. Together with the skills necessary for planning and project management, museum managers rank communication skills very high in the scale of important competencies. These skills include the ability to make effective written and verbal presentations and the ability to listen to others' viewpoints, negotiate sensitively and take account of others' needs (see Table 16.4).

Personal qualities including the ability to express confidence and to be decisive together with the ability to stick to a plan and not get side-tracked are also regarded as important, together with the ability to grasp a complex problem quickly.

A significant area of difference between arts managers and museum managers is in their need for the ability to quantify and organise financial resources and to monitor their expenditure accurately.

TABLE 16.3: RANKING OF MANAGEMENT COMPETENCIES BY ARTS MANAGERS

Tasks	Rank
Cluster One	
Ability to effectively schedule time, tasks and activities, to organise resources and to establish a course of action to accomplish specific goals	1
Ability to express confidence and to be decisive	2
Ability to listen to others' viewpoints, negotiate sensitively and take account of others' needs	3
Ability to quantify and organise needed financial resources and to monitor their expenditure accurately	3
Cluster Two	
Ability to make effective written presentations to others	5
Ability to make effective verbal presentations to others	6
Ability to develop and maintain networks and formal channels of communication with the outside world	7
Knowledge of funding resources	8
Cluster Three	
Ability to grasp a complex problem quickly	9
Ability to influence people and "win the day"	10
Ability to stick to a plan and not get side-tracked	11
Ability to assign tasks to others and to monitor their performance	12
Ability to conduct effective group meetings	13
Ability to keep abreast of relevant local, national and international political, economic and cultural developments	14
Knowledge of local, national and international structures	15
Knowledge of legal issues	16

TABLE 16.4: RANKING OF MANAGEMENT COMPETENCIES BY MUSEUM MANAGERS

Tasks	Rank
Cluster One	
Ability to make effective written presentations to others	1
Ability to effectively schedule time, tasks and activities, to organise resources and to establish a course of action to accomplish specific goals	1
Ability to make effective verbal presentations to others	3
Ability to listen to others' viewpoints, negotiate sensitively and take account of others' needs	3
Ability to express confidence and to be decisive	5
Cluster Two	
Ability to stick to a plan and not get side-tracked	6
Ability to assign tasks to others and to monitor their performance	7
Ability to grasp a complex problem quickly	8
Cluster Three	
Ability to quantify and organise needed financial resources and to monitor their expenditure accurately	9
Ability to influence people and "win the day"	10
Ability to develop and maintain networks and formal channels of communication with the outside world	11
Ability to keep abreast of relevant local, national and international political, economic and cultural developments	12
Ability to conduct effective group meetings	13
Knowledge of funding sources	14
Knowledge of local, national and international structures	15
Knowledge of legal issues	16

Museums, particularly national and local-authority institutions, are bureaucratic in their organisational structure. As a consequence such organisations are more likely to be internally focused. This is reflected in the fact that many of the skills and

competencies appropriate for either a flatter organisational structure or for interacting with the outside world are ranked in the second half of the scale. These include the ability to influence people and "win the day", the ability to develop and maintain networks and formal channels of communication with the outside world, the ability to keep abreast of relevant local, national and international political, economic and cultural developments, and the ability to conduct effective group meetings as well as a knowledge of funding resources.

Comparison between Arts and Museum Managers. A knowledge of the broader context of the cultural sector, both national and international, is considered of lesser importance by managers in the cultural sector as a whole. Both arts managers and museum managers agree on those areas of knowledge and competence which are of least importance to them in their work as they perceive it: they both rank knowledge of local, national and international structures and knowledge of legal issues at the bottom of their ranking of importance of competencies.

SUMMARY AND CONCLUSIONS

A number of key features of cultural management have emerged. First, a relatively challenging environment prevails, characterised by low pay, insecurity and instability. Second, cultural managers emerge as young, vocationally-committed, well-educated and experienced, and less hampered by gender considerations than is the case in other sectors. Third, the job of cultural manager is primarily that of the general manager with the emphasis, perhaps necessarily, on tasks such as goal-setting, planning and financial management.

Although there is considerable commonality between arts and museum managers, some interesting differences merit comment. In general, arts managers place a greater emphasis on tasks associated with an outward-looking focus — the most important of which is managing relationships with national institutions/funding agencies — while museum managers are more inclined to look inward to the internal functioning of the organisation itself — for example, ranking the managing of relationships with the governing body of the organisation high in the scale of importance. An important exception to this is the fact that

museum managers regard managing relationships with visitors/users of the service as of primary importance.

A number of management tasks were identified which are specific to the cultural sector, including most notably the management of relationships with artists (for arts managers) and relationships with visitors/users (for museums). While these particular tasks are regarded as important (in fact, museum managers rank relationships with visitors/users as first in importance), in general the pattern is for cultural sector-specific tasks to be regarded as of lesser importance. For example, managing relationships with audiences is ranked as only fourteenth in importance out of eighteen tasks for arts managers, lower than the importance attached to managing relationships with artists, or with national institutions/funding agencies.

Respondents were also asked to evaluate a list of management competencies needed to effectively perform these tasks. While there are some differences between arts and museum managers in the importance they attach to the competencies required for their jobs, for both groups there is an emphasis on many of the competencies related to the tasks of planning.

Knowledge of legal issues and of local, national and international structures are ranked low in both groups, but arts managers attach much greater importance to knowledge of funding sources and the ability to develop networks and formal channels of communication with the outside world than do museum managers.

Training Implications

The purpose of identifying the key tasks and competencies is to provide those developing management education and training programmes with information on what it is cultural managers need to know and be able to do in order to perform their job effectively in a holistic manner.

Overall, there is a perception among existing cultural managers that they are proficient in the various elements of their jobs. This is an assessment which must be taken seriously since, as we have seen, they are a highly educated and experienced group. However, there are two areas suggested where further training and upgrading of skills is indicated.

One of these is identified by the respondents themselves where they present a difference between the importance with which tasks and competencies are regarded and their perceived level of

proficiency. For all tasks and competencies the level of signifi-
cance of the relationships between importance and proficiency is
such as to suggest that at least some managers would benefit from
an upgrading in their skills. However, for some of these compe-
tencies the gap between proficiency and importance is wider. In
the arts, these competencies are the planning and organising skill
and the personal quality of ability to stick to a plan and not get
side-tracked.

The second area of potential for training is one where further
investigation is required before appropriate courses can be de-
vised. Disparities found in the relationships between tasks and
associated competencies suggest either that the competencies
needed to perform them effectively are not yet well understood,
or that there is a perception that no well-defined or specific skills
are required to be proficient in this area of work. For the arts
manager, this involves the whole area of managing relationships
with various stakeholders (i.e. artists, visitors/users of the serv-
ice, governing body of organisation and audiences). In addition,
the areas of buildings management and retailing/sales manage-
ment require further examination. For museum managers, manag-
ing relationships with visitors/users of the service, with the gov-
erning body of the organisation and with audiences merits further
investigation, together with museums collections management,
promotion of the organisation and also building management.

Notes

[1] This Chapter is based on *Managing the Cultural Sector: Essential Competencies for
Managers in Arts, Culture and Heritage in Ireland*, by Paula Clancy, published by
Oak Tree Press in association with the Graduate School of Business, UCD,
1994.

[2] The research was carried out in three stages. First, a database of arts organisa-
tions and museum services organisations, was developed, through (i) a series
of discussion with key informants in the sector and (ii) the use of available
documentary sources. Second, a series of focus groups and one-to-one inter-
views were conducted with key informants and cultural managers. The objec-
tive of these interviews was to identify and to explore in some depth the im-
portant issues in the management process in the cultural sector. The results of
these were used to identify relevant management tasks and competencies and
shape a questionnaire which was the basis of the third stage of the research
process: a survey of cultural organisations and a survey of senior cultural

managers. The study is the first of its kind to encompass the whole island of Ireland, and provides a useful opportunity for comparison, for the two parts of the island to learn of the other's experiences and systems and to examine areas of potential co-operation. The study spans the whole cultural sector in that it covers both the arts and heritage. It focuses in particular on all those professional organisations, and the senior management personnel — cultural managers — who work for them, within the public domain. Cultural Managers are those who have a track record within the sector i.e., those who have worked within the sector for a significant period of time and/or have acquired specialist training. They are also the decision-makers and will have input into the shaping of policy, either at a national or local level.

[3] It should be noted that for many arts managers the term "full-time permanent" may encompass those who are working without a fixed-term contract, and that very few have permanence in the sense of a "job for life."

[4] Through a series of focus groups and one-to-one interviews with a cross-section of cultural managers, a composite list of important tasks further categorised into general tasks, functional tasks and tasks which are specific to the cultural sector and a second list of competencies categorised into skills, knowledge and personal qualities were developed. The wider group of survey respondents then evaluated these lists along two dimensions: importance to their job and the level of proficiency they felt they had in them. The majority of respondents rated most of the eighteen tasks and sixteen competencies as either important or very important, thus indicating that the identification of the key tasks and competencies from the first stage of the research was supported by the general population of senior cultural managers.

References

Atkinson, J. (1984), "Manpower Strategies for Flexible Organizations", *Personnel Management*, August, 28–31.

Boyatzis, R.E. (1982), *The Competent Manager: A Model for Effective Performance*, New York, NY: John Wiley and Sons.

Boylan, P. (Ed.) (1992), *Museums 2000*, London: Routledge.

Cameron, K.S. and Whetten, D.S. (1984), *Developing Management Skills*, London: Scott, Foresman & Co.

Jeffri, J. (1980), *The Emerging Arts: Management, Survival and Growth*, New York, NY: Praeger Publishers.

Museum Professional Training and Career Structure, (1987), London: Museums and Galleries Commission (Hale Report).

Museum's Yearbook 1996/97, London: Museums Association.

O'Connor, Pat (1996), "Organisational Culture as a Barrier to Women's Promotion", *The Economic and Social Review,* vol. 27, no. 3, 205–234

Pick, J. (1980), *Arts Administration,* New York, NY: Methuen Inc.

Thompson, A.A. and Strickland, A.J. (1989), *Strategy Formulation and Implementation: Tasks of the General Manager,* Boston, MA: BPI/Irwin.

Wickham, J. (1993), "New Forms of Work in Ireland: An analysis of the 'New Forms of Work and Activity' Data Set", European Foundation for the Improvement of Living and Working Conditions, Working Paper No: WP/93/31/EN.

Woodruff, C. (1992), "What is Meant by a Competency" in R. Boam and P. Sparrow (eds.) *Designing and Achieving Competency: a Competency-based Approach to Developing People and Organisation,* Maidenhead: McGraw-Hill, 16–29.

17

MANAGEMENT BOARDS OF ARTS ORGANISATIONS[1]

Pierre-François Ouellette and Laurent Lapierre

> Choreographing dance, making music, producing plays or mounting exhibitions are simple tasks compared with developing a fund-raising and leadership board (Thorn, 1990:51).

This chapter offers some thoughts on the boards of management or trustees of arts organisations. First, the state of the research and articles published by specialists on the subject will be presented (Ouellette & Lapierre, 1995a and 1995b). Secondly, we will highlight some reflections that have come about from practical experience as an executive and as a trustee of cultural organisations as well as from clinical research undertaken on executive directors of cultural organisations (Lapierre, 1994).

A REVIEW OF THE LITERATURE

A large number of arts organisations throughout the world are constituted as non-profit companies. This corporate structure varies from one country to another but the similar legal framework based on common law makes it the most common (DiMaggio & Anheier, 1990). Boards of management are established in accordance with this framework. The law decrees that all non-profit organisations must have a board of trustees of at least three persons. The status of non-profit organisation is granted to organisations whose purpose is not to make profit but rather to contribute to the common good. Its mission, beliefs and values are at the core of its *raison d'être*. That the law imposes legal responsibilities on trustees is frequently demonstrated in court cases.

[1] Paper originally presented at the AIMAC (Management Arts and Culture International Association) conference, 1995

They are obliged to guarantee the integrity of the organisation and to demonstrate diligence, skill, care and prudence. The law holds them responsible to the public for the organisation. Ultimate authority lies with them. The director of the organisation reports to this board.

Why is it necessary to take on a corporate form in the arts world? For the past 40 years, a large number of organisations have constituted themselves legally so as to be able to receive financial aid from governments and foundations (McDaniel & Thorn, 1990). Were it not for the pressure exerted by grant-aiding bodies and foundations, there would be much fewer legally incorporated arts bodies and the concern of the director to establish who holds ultimate responsibility for management would doubtless be much less urgent. Thus, the director of the arts organisation must inevitably face this question of responsibility.

> I always think that boards of management are not the ideal structure but we have yet to find anything better. What matters is how effective they are (McAvity, 1990).

> ver and over, directors of training courses for regional museum associations and museum workers noted misunderstanding between board and director as the chief cause of concern in museum management (Dickenson, 1991).

Practitioners and consultants alike have amassed considerable literature on the roles, responsibilities and activities of a board of trustees. Some of these, like Cyril Houle (1989), are concerned that these precepts have no empirical validity. Marion Paquet (1988) suggests that the role of the board is to define the mission of the organisation, to determine the rhythm of its activities, to ensure its continuity and to promote its identity. Houle identifies the following 11 functions:

1. To ensure that the activities of the organisation are in accordance with its mission

2. To establish long-term plans

3. To oversee the programmes of the organisation

4. To recruit and supervise the director

5. To work with the director and other staff

6. To act as an arbiter between the director and other staff

7. To establish policies

8. To ensure that legal and ethical responsibilities are fulfilled

9. To acquire and manage financial resources

10. To manage the relationship between the organisation and its environment

11. To oversee the performance of the board and its members.

As was noted by the historian Peter Dobkin Hall in 1990, scholarly literature on boards of trustees is quite slim. Recent academic interest seems to stem from the importance given to the subject by professional associations and to the financing of research by certain North American foundations. We have counted some 60 studies since 1987, published primarily in two reviews: *Non-profit Management and Leadership* and *Non-profit and Voluntary Sector Quarterly*. We should note too that an important research programme is currently underway at Yale University. The most commonly cited theoretical models are those of Zald (1969), Pfeffer and Salancik (1978), Kramer (1985) and Middleton (1987). They propose contingent models based on the theory of open systems which links the characteristics of the organisational environment, the organisation, the board (comprising its functions, structure, composition, size), the workings of the board (e.g. shared vision, conflict with the director, involvement in strategic planning, role in everyday matters) and the performance of the board and the organisation.

The empirical literature is strongly based on these models. It attempts a response to some major questions. Who are the board members? What do they do? Why? How do they go about it? What effect does this have? A quantitative approach is the most usual. Researchers try to verify hypotheses although knowledge of the subject is still too slight to give them anything of great significance to verify (Pettigrew, 1992). Arts organisations are not the main subject of such research (except for Urice, 1990 and Radbourne, 1993) but sometimes are part of the sample surveyed. Respondents are primarily directors and not trustees or board members.

These research projects have made it possible to relativise several precepts put forward by normative texts. The structure, processes and functions of boards of trustees and their relations with managers vary. They are influenced by the legal, political, social and economic contexts which apply in the particular time and place (Hall, 1990a, 1990c; Abzug et al., 1992). The sector of activity, the age of the organisation, its size, longevity, the stage of its life-cycle: all affect the specifics of its behaviour (Bradshaw, Murray & Wolpin, 1992). Differences of class, profession, motivation, genre and personality come into play in the relationship both within the board and between the board and the director. Opinions are divided as to the impact of the board on organisational performance.

Some researchers assert that boards of management play an important liaison role between the organisation and its environment even if the principal actor is now the government granting agency (Harlan & Saidel, 1994); others, adopting a qualitative methodology, say that the new environmental contexts give preeminence to the director (Bernstein, 1991). The idea that the inclusion of business people delivers benefits is challenged. They tend to meddle in daily activities (Hall, 1990c) and not to be of great value when it comes to increasing resources (Siciliano & Floyd, 1993). The involvement of board members in the planning exercise seems to be regarded as beneficial but managerial experience is not a decisive factor in this (Siciliano & Floyd, 1993; Bradshaw et al., 1992).

The extent to which board members identify personally with the organisation contributes to their effectiveness (Chait, Holland & Taylor, 1991). Boards of management which are too homogeneous are less equipped to deal with environmental changes (Middleton, 1989). Boards do not in general reflect the composition of society: they are mostly composed of men (Abzug et al., 1992; Urice, 1990). In terms of their roles, board members consider themselves more as "workers" than as experts, as people who lend their name or as fiduciaries (Widmer, 1993). Also, many among them would not be able to explain properly where their fiduciary responsibility lies (Siciliano & Spiro, 1992).

The director emerges from this literature as the person responsible for the governance of the organisation. Board members recognise that the director is to a large extent responsible for the successes and failures of the organisation (Herman & Heimovics,

1990). The responsibility for the board and its obligations fall on them. They are the central pivot of the organisation, responsible for "activating the board" (Drucker, 1990). But should we not be talking about the whole top management team as opposed to only the director? This relationship is all the more delicate in the arts world because of the distinction — too often a dichotomy — between artistic direction and general management. All studies to date have restricted themselves to considering the director as the person who wields authority. In the field of arts management, this type of approach may be too limiting. Should not one also distinguish between different fields of activity? Are not the concerns of museum directors quite different to those of theatre companies? We have not found reference in any study to the director who is also a board member of their organisation: is this not a phenomenon which exists and is therefore worthy of study?

> As executive director of a regional dance service organisation, I have continued to think that there surely must be one structure for a board of trustees that would simultaneously provide wisdom in governance (overseeing both organisational development and board programmatic (*sic*) policy-making) and guidance in ensuring that our organisation would remain true and accountable to its constituency and mission and possess strong fund-raising abilities. I currently do not think this is a realistic hope, at least not for this kind of organisation (Lilian Goldthwaite in McDaniel & Thorn, 1990:76).

A NECESSARY EVIL

From the point of view of general management (whether it is artistic direction, administration or some form of dual arrangement) boards of management are perceived a little in the same way as democracy: that is to say, the least bad of all the different forms of government. There are many reasons why the general management of arts organisations holds this ambivalent attitude toward their boards.

In the case of the entrepreneur (generally an artist), we have already seen above that the law requires that they appoint a board of management if they wish to obtain financial assistance from grant-giving bodies. In this way entrepreneurs are forced to create an administrative entity which will assume legal responsibility for the project; which will receive grants; which may question the

artistic direction, programming and annual budget projections chosen by the entrepreneur; and which may, should the occasion arise, replace them as the head of the project.

The artist often feels excluded from a project which may be very personal or even essential for them. The mistrust which they then begin to feel towards their board is understandable. For an artistic entrepreneur, it is the artistic mission which comes first, not commercial, administrative or community considerations. Even if there are artistic projects which should die with the withdrawal or departure of the creator, the legal entity created to direct the enterprise will wish to ensure its perpetuity, since board members are conditioned to ensure the continuity of enterprises and trained to make them function effectively. Then a new director who can suggest a fresh orientation and a new direction will be employed.

Even in the case of enterprises which have survived their creator and have become formal institutions, there is much ambiguity about the role which their board of management should really play. From a North American perspective, the board is there mainly to go in search of funds. The average number of board members in the US is therefore rather high (18 according to Urice, 1990) while in Australia it is only six (Radbourne, 1993).

Roles would be more clearly defined and understood if a distinction were made between, on the one hand, a "foundation" whose aim would be to create and manage a fund which should be used to support and sustain the activities of an arts organisation and, on the other, a real board of management which takes responsibility for its leadership, while delegating to an executive committee those decisions which affect the implementation of the policy chosen by the institution. The board of management of the Symphony Orchestra of Montreal which has 80 members is in fact just such a foundation and fulfils this role exclusively. The same is true of many artistic institutions in North America. A real board of management has rarely more than ten persons. It supervises the strategic management of the institution, comprising three main responsibilities:

- The employment of the general manager

- Approval of the proposed artistic direction and programming as well as the annual budget projections

- Regular evaluation of the performance of the organisation and the contribution made by its general manager.

Board members are not artists. Rather they are chosen for their judgement. If they are capable of employing an artistic director or a general manager, they are also capable of evaluating and rewarding them. Regular evaluation is therefore both a right of the general director and a duty for the board of management.

We have seen earlier that the artistic mission comes first for the entrepreneur or artistic director. Even if, in theory, one agrees generally that in such institutions administration is subordinate to and at the service of the artistic direction, the "iron law of bureaucracy", to use Gouldner's expression, always impinges. There is an inevitable opposition between the ends pursued by an arts organisation and the organisational means necessary to achieve these ends. Board members come from a certain organisational and bureaucratic perspective, even if they are unaware of this. One could even talk about an "iron law of technocracy". Funding bodies exert more and more pressure, forcing organisations to adopt long-term development plans. This pressure is reinforced by the presence of board members who are sometimes appointed by these agencies. Management concerns, like economic concerns, have of necessity an effect on the artistic mission. These planning requirements tend to make the management of arts organisations more technocratic and thus, in the eyes of artists, render boards of management more suspect. To illustrate our point, we note that in a large music organisation in Montreal, a planning committee of the board of management was established and worked for two years on the major policy orientation of the organisation without once meeting its artistic director.

In recent years, there have been stormy debates about how to structure the general management of an arts organisation. Who should have precedence? The artist or the manager? Should general direction be a balance of the artistic and the managerial? Should the general manager be *ex officio* a member of the board of management with a right to vote or even a right to veto? Each formula has its supporters and detractors but in the end, the people, rather than the organisational structure, determine the success or failure of each solution.

As for the relationship between board members and their manager, it is clear from the organisations which have been stud-

ied that the effectiveness of a board of management depends to a large extent on the skill of the director at exploiting this considerable seam of resources. If there isn't a relationship of confidence between the members and their manager, if a "positive chemistry" is lacking, not only will the marriage not take place but the two parties will damage each other. Here too, the quality and the productiveness of relationships will depend to a large extent on the individuals involved, and the formalisation of precise roles will not change much in the final analysis. The confidence of board members is based upon their perception and evidence of the competence shown by their manager. He or she knows the area and can give to the organisation a recognised and distinctive competence; he or she animates and directs the internal team, controls the costs, manages revenue (from activities, grants and subscriptions) and knows how to win the public.

Finally, the qualifications required to be a member of the board of an arts organisation vary according to whether one is in the domain of museology, theatre, music or dance, according to the size of the enterprise and according to the type of town or city where it is situated.

CONCLUSION

Whether by examining normative texts or accounts of empirical research or listening to the directors of arts organisations, one must conclude that boards of management remain a live issue for board members as well as managers. It is useless to attempt to conduct empirical research which covers every aspect of the subject or to propose a model which will work in all circumstances. The problem calls rather for an approach which takes each artistic domain and each type of enterprise separately and on a case-by-case basis. By meeting board members and managers who work at the core of either successful or problematic enterprises, one can highlight some of the factors which lead to a fuller understanding and offer some guidelines to assist both boards of management and managers who wish to see the issue with greater clarity.

References

Abzug, R., DiMaggio, P., Gray, B.H., Heekang, L. & Useem, M. (1992), "Changes in the Structure and Composition of Nonprofit Boards of Trustees: Cases from Boston and Cleveland, 1925–1985", Working Paper PONPO no. 173, New Haven, CT: Yale University.

Bernstein, S.R. (1991), *Managing Contracted Services in Non-profit Agency: Administrative, Ethical and Political Issues*, Philadelphia, PA: Temple University Press.

Bradshaw, P., Murray V. & Wolpin J. (1992), "Do Nonprofit Boards Make a Difference? An Exploration of the Relationship Between Board Structure, Process and Effectiveness", *Nonprofit and Voluntary Quarterly*, February 1992.

Chait, R.P., Holland, T.P. & Taylor, B.E. (1991), *The Effective Board of Trustees*, New York, NY: Macmillan.

Dickenson, V. (1991), "An Inquiry into the Relationship between Museum Boards and Management ", *Curator*, vol. 34, no. 4, 291–303

DiMaggio, P. & Anheier, H. (1990), "The Sociology of Nonprofit Organizations and Sectors", *Annual Review of Sociology*, 16:137–159.

Drucker, P.F. (1990), "Lessons for Successful Nonprofit Governance", *Nonprofit Management and Leadership* vol. 1, no. 1, 7–14.

Gouldner, A.W. (1954), *Patterns of Industrial Bureaucracy*, New York, NY: Free Press.

Hall, P.D. (1990a), "Cultures of Trusteeship in the United States", PONPO Working Paper no. 153, New Haven, CT: Yale University.

Hall, P.D. (1990b), "Understanding Nonprofits Trustees", *Philanthropy Monthly*, 23 (March 1990), 10–15.

Hall, P.D. (1990c), "Conflicting Managerial Cultures in Nonprofit Organizations", *Nonprofit Management and Leadership*, vol. 1, no. 2, 153–165.

Harlan, S. & Saidel, J. (1994), "Board Members' Influence on the Government–Nonprofit Relationship", *Nonprofit Management and Leadership*, 5(2), Winter.

Herman, R.D. & Heimovics, R.D. (1990), "The Effective Nonprofit Executive: Leader of the Board", *Nonprofit Management and Leadership*, vol. 1, no. 2, 167–180.

Houle, C.O. (1989), *Governing Boards: Their Nature and Nurture*, San Francisco, CA: Jossey-Bass.

Kramer, R. (1985), "Towards a Contingency Model of Board–Executive Relations", *Administration in Social Work*, vol. 19, no. 3, 15–33.

Lapierre, L. (1994), "La gestion des entreprises artistiques: Recueil de textes et d'histoires de cas", Montréal: École des HEC.

McAvity, J. (ed.) (1990), *Muse*, vol. 7, no. 4, Special edition on Museum Governance.

McDaniel, N. & Thorn, G. (eds.) (1990), "Governance in the Arts: Trusteeship in Transition", a special issue of *The Journal of Arts Management and Law*, Summer.

Middleton, M. (1987), "Nonprofit Boards of Directors: Beyond the Governance Function" in Powell, W. (ed.), *The Nonprofit Sector, A Research Handbook*, New Haven, CT: Yale University Press.

Middleton, M. (1989), "The Characteristics and Influence of Intraboard Networks: A Case Study of A Nonprofit Board of Directors", in Herman, R.D., Van Til, J. (eds.), *Nonprofit Boards of Directors*, New Brunswick, NJ: Transaction Publishers.

Ouellette, P.-F. & Lapierre, L. (1995a), "Bibliographie annotée sur la gestion des entreprises artistiques", Rapport de recherche, Montréal: École des HEC.

Ouellette, P.-F., Lapierre, L. (1995b), "La recherche sur les conseils d'administration d'organismes sans but lucratif: réflexions autour d'une revue de la littérature", Rapport de recherche, Montréal: École des HEC.

Paquet, M. & Humphries (1988), *Cultural Board Development Resources: An Annotated Bibliography*, Centre for Cultural Management, University of Waterloo.

Pettigrew, A.M. (1992), "On Studying Managerial Elites", *Strategic Management Journal*, vol. 13, special Winter edition, 163–182.

Pfeffer, J. & Salancik, G. (1978), *The External Control of Organizations*, New York, NY: Harper and Row.

Radbourne, J. (1993), "Recruitment and Training of Board Members for the 90s and Beyond" in *Actes de la Deuxième Conférence Internationale sur le Management des Arts et de la Culture*, Jouy En Josas.

Siciliano, J.I. & Floyd, S.W. (1993), "Nonprofit Boards, Strategic Management and Organizational Performance: An Empirical Study of YMCA Organizations", PONPO Working Paper 183, New Haven, CT: Yale University.

Siciliano, J.I. & Spiro, G. (1992), "The Unclear Status of Nonprofit Directors: An Empirical Survey of Director Liabilities", *Administration in Social Work*, 16(1):69–80.

Thorn, G. (1990), "On Board Mythology" in McDaniel, N. & Thorn, G. (eds.), *Trusteeship in Transition — A Special Issue of The Journal of Arts Management and Law*, Summer 1990, 51.

Urice, J.K. (1990), "Not-For-Profit Arts Trustees: A Report of a National Sample", *Journal of Cultural Economics*, vol. 14, no. 2, 53–71.

Widmer, C. (1993), "Role Conflict, Role Ambiguity and Role Overload of Directors of Nonprofit Human Science Organisations", *Nonprofit and Voluntary Sector Quarterly*, vol. 22, no. 4, 339–356.

Zald, M. N. (1969), "The Power and Functions of Boards of Directors: A Theoretical Synthesis", *American Journal of Sociology*, vol. 75, no. 1, 97–111.

18

THE TENSION BETWEEN ARTISTIC LEADERS AND MANAGEMENT IN ARTS ORGANISATIONS: THE CASE OF THE BARCELONA SYMPHONY ORCHESTRA

Xavier Castañer

Tension between administrative and professional staff is a common phenomenon in arts organisations (DiMaggio, 1987) that reflects the conflict between artistic and organisational goals (Chiapello, 1994). Some authors regard this situation as a particular case of the more generic conflict between professionals and management in professional organisations such as research organisations, hospitals, universities and social services departments (Thompson, 1967). Although organisational literature suggests several causes for this management–professional conflict (Gouldner, 1957; Organ and Greene, 1981; Wallace, 1995), few solutions have been advanced[1] (see Raelin, 1991, 1995 for an exception.)

Moreover, artist–management conflict is not always recognised as a cause of leadership instability involving a succession of managers and/or a high rate of artist turnover. However, leadership instability is generally considered to affect organisational performance in business firms, hospitals, sports organisations and also performing arts organisations (Chiapello (1994) offers an excellent exception to this generalisation.)

In fact, as early as 1963, managerial succession was considered a crucial issue in organisation studies (Grusky, 1963), due to its effects on performance. However, as I will discuss, results of quantitative empirical studies on the organisational effects of succession have been mixed and have seldom proposed ways of alleviating and handling the conflict in order to avoid traumatic succession.

In addition, few studies deal with the causes and consequences of music director succession in performing arts organisations

(what could be called technical staff succession in other professional organisations) and there are almost no studies on the design of control mechanisms.

This case study of the Barcelona Symphony Orchestra (BSO) attempts to fill these two gaps by studying music director (MD) succession in a performing arts organisation and introducing different organisational theories in order to explore their usefulness in explaining and alleviating the tension between artists and management. Organisation theory is chosen as the main theoretical background because it has addressed organisational conflict from a normative angle, developing a contingent theory of organisational control that suggests three different types of co-ordination mechanisms.

I have chosen the case study method[2] because I want to understand the reasons (why) and the process (how) of music director turnover in the Barcelona Symphony Orchestra.

This chapter is organised as follows. First, I present the case. The second section defines the concept of artistic leadership succession and discusses its causes. The third section addresses the consequences of leadership succession within the context of the leadership–performance debate. The fourth section explores organisational control theory as a potential way to alleviate tension and provides specific examples from the literature on managing professionals and organisational commitment. In the fifth section, the control through values option is assessed by analysing the BSO organisational culture and the mental images of the orchestra held by BSO management. The chapter concludes with a summary of the managerial implications and some suggestions for further research.

THE CASE: THE BARCELONA SYMPHONY ORCHESTRA

In recent years, there has been an increase in the instability of artistic and managerial leadership in a number of Spain's artistic sectors, among them museums,[3] orchestras and theatres.[4]

Leadership Succession

The orchestra, originally known as the Municipal Orchestra of Barcelona (OMB), was founded in 1944 by Eduard Toldrà, then director of the Municipal Conservatory. Previous attempts to found orchestras in Barcelona, among them an attempt by Catalan

cellist Pau Casals, were short-lived. However, Toldrà's project was backed by a city councillor, who proposed incorporating the orchestra as a municipal service in order to ensure its survival (Martorell, 1995).

After Toldrà's death in 1968, the orchestra was renamed the Barcelona City Orchestra (OCB) and its directorship given to one of Toldrà's disciples, Antoni Ros-Marbà, who held the position until 1979. Toldrà and Ros-Marbà lasted longer than any other music directors (MD) in the orchestra's history. Since Ros-Marbà's departure, the pattern has been quite different. Salvador Mas, a student of Ros-Marbà's, was music director until 1981 and then contracted as principal guest conductor for the 1981–82 season. After a year with no music director, Ros-Marbà returned in 1984. However, in 1986 he was replaced by the first non-Spanish MD, Franz-Paul Decker, who was then music director of the Montreal Symphony Orchestra. Decker conducted the orchestra until 1991. García Navarro, another Spanish conductor, then took over as MD but resigned in 1993, after a bitter disagreement with the management team. The MD's post will have been vacant for almost three years by the time Lawrence Foster, a US conductor, takes over in 1996. In the interim, the Board of Trustees contracted Decker as principal guest conductor and Abili Fort, a former viola player in the orchestra and present artistic manager, took charge of the programming.

During the last 16 years, no music director has lasted longer than five years. Beginning with Mas, the average tenure has been three years (see Table 18.1).

Since 1979 the Barcelona Symphony Orchestra has had five different MDs. Officially, no one has been fired, although the departure of García Navarro can be considered as a forced resignation.

Considerable disagreement has always marked the relationship between the music director and management. Mas's relationship with the city's councillor for cultural affairs was not very good. When Mas left, Ros-Marbà returned. This time around, however, he lasted only two seasons. The main source of conflict with Ros-Marbà, who was also music director of the National Symphony Orchestra in Madrid, was the creation in 1985 of a management team, which reduced his power base. When earlier attempts to reduce the music director's influence had failed, the

Mayor had appointed Ramon Martínez Fraile as the chairman of the Orchestra's Board of Trustees. He, in turn, commissioned Jaume Masferrer to conduct a study of the orchestra's future. Masferrer recommended disbanding the orchestra and reconstructing it, with new labour regulations and a new management structure. As a result of this study, a three-man management team was created, with Jaume Masferrer as general manager, Abili Fort as artistic manager and Andreu Puig as administrative director.

TABLE 18.1: TENURE OF MUSIC DIRECTORS IN THE BSO

Musical Director	Period	Number of Years
Toldrà	1944–68	22
Ros-Marbà	1968–79	11
Mas	1979–81	3
Ros-Marbà	1983–86	3
Decker	1986–91	5
Garcia Navarro	1991–93	3
vacant	1993–96	—

Source: The author

After Ros-Marbà's resignation in 1986, the first non-Spanish MD, Decker, was brought in to restructure the orchestra, replacing many of the "public servant" musicians and hiring musicians from abroad, especially as soloists. Local musicians strongly objected and organised several protest actions[5] but management supported Decker's decisions. Apart from his selection and promotion policies, Decker's conductorship transformed the musicians' behaviour and culture. There was a notorious incident in early 1987 when the orchestra was performing Brahms' second symphony: the leader of the brass section came in two bars early; the rest of the orchestra unsuccessfully tried to cover up the mistake and Decker stopped the performance and asked the orchestra to start the movement again. The players were embarrassed and ashamed and when they came to the same passage the horn made the same mistake. Decker halted the orchestra again and began the movement yet another time. In the opinion of the artistic manager, by stopping the orchestra twice Decker challenged the culture of mechanical performance that used to

characterise the orchestra and initiated a new era of professional pride.

Despite the Board's support of Decker's conductorship and personnel policy, the Board and the conductor disagreed over the inclusion of contemporary Catalan music in the program, one of the orchestra's goals publicly stated in its by-laws. Decker cut down the number of contemporary Catalan works in the programs for the following seasons, complaining about their quality and the lack of interest demonstrated by the audience, who tended to enter the auditorium after the contemporary piece had been performed.[6] The Board forced Decker to include more contemporary Catalan music and the conductor began showing less commitment to the orchestra and looking elsewhere for tours and recording engagements.

Most recently, Garcia Navarro's personal style, which was reflected in his choice of programs, promotion strategy (the design of a new logo which included for the first time his name as music director) and his demand that the orchestra pay his personal expenses, clashed with management.

Organisational Structure and Funding

As a municipal agency, the orchestra was initially overseen by a Board of Trustees (Patronat), composed of political appointees, members of the City Council representing political parties and representatives of the regional musical world such as composers and choir conductors. The orchestra currently employs 97 musicians and 10 staff members and has a budget of 1,000 million pesetas (c. IR£4.8 million), 30 per cent of which is revenue from ticket sales.

In 1989 the city decided to change the governance structure and create the Municipal Music Institute, which until 1995 hosted the orchestra, the band and the archive for contemporary music.

Until 1995 the orchestra was under the umbrella of the City Council, receiving some funding from the Catalan regional government (the Generalitat). In 1991, after acknowledging the regional character of the orchestra and its growing need for financial resources, the Generalitat agreed to join the City Council in a consortium which would govern the orchestra and the new auditorium.[7] However, the Consortium was not formally

constituted until 1994. The Municipal Music Institute was disbanded in March 1995 and ownership of the orchestra was then transferred to the Consortium with the orchestra being renamed the National Symphony Orchestra of Catalonia and Barcelona. In late 1995 the Consortium decided to make the orchestra a legally autonomous agency in order to facilitate administrative procedures.

Managerial Turnover

Since the establishment of managerial positions, the orchestra has had three managerial terms: Jaume Masferrer served as general manager from 1985 to 1989 and again from 1991 to 1995, with Raimon Ribera replacing him between 1989 and 1991.

Masferrer, a local businessman, resigned in 1989, when Eulalia Vintró, leader of the Barcelona Communist Party and third deputy mayor, took over as Institute chairperson. Vintró then appointed Ribera, former director of the Miró Museum, as general manager of the orchestra.

After the municipal elections in 1991, the well-known architect and city planner, Oriol Bohigas, was appointed councillor for cultural affairs and chairman of the Institute's Board of Trustees. After reviewing financial and organisational performance under Ribera, he asked Masferrer to come back. Bohigas resigned in 1993, following several disagreements with the mayor over specific projects such as the Museum of Contemporary Art and the overall resources allocated to culture. He was succeeded by Joaquim de Nadal, who left the orchestra's management team untouched. The Consortium was reorganised at the end of 1995 and Masferrer was once again fired, this time on the grounds of having failed to develop a strategic plan for the orchestra. That same year Maragall was re-elected mayor of Barcelona. He has not yet appointed a general manager for the orchestra, although a new position of fund-raising director has been created.[8]

Managerial succession in the orchestra seems to have some relationship to political and bureaucratic changes (the case of Masferrer's first resignation) as well as with performance (the case of Ribera's replacement and Masferrer's second dismissal). It can be argued that managerial succession is influenced by the public nature of the BSO[9] which means that political cycles cause the general manager to be replaced at least every four years (see Table 18.2).

TABLE 18.2: MAYOR, THE COUNCILLOR OF CULTURAL AFFAIRS AND THE BSO GENERAL MANAGER: A PATTERN OF SUCCESSION

Year	Mayor	Councillor of Cultural Affairs	BSO General Manager*
1979	Serra	Prades	
1983	Maragall	Capmany	
1985		Martinez Fraile	Masferrer
1987	Maragall	Mascarell**	
1989		(Vintró)	Ribera
1991	Maragall	Bohigas	Masferrer
1993		de Nadal	
1995	Maragall		vacant***

*Prior to the creation of the post of general manager, an administrator was in charge of personnel administration.

**Maragall decided to deflect the power struggle between the two candidates (Subirós and Mascarell) to succeed Martínez Fraile by leaving the position of Councillor for Cultural Affairs vacant and personally overseeing the work of Mascarell's task as co-ordinator of cultural affairs. This situation led to Vintró, third deputy mayor, being appointed to chair the Municipal Music Institute.

***With the reorganisation of the Department of Culture, Miquel Lumbierres, who had been co-ordinator of the Department under Bohigas, was appointed general manager of the Consortium and Victor Blanes, former general manager of the now defunct Municipal Performance Institute, was named fund-raising director, both acting as general managers of the orchestra.

Source: the author

CAUSES OF LEADERSHIP TURNOVER

As I have stated, the purpose of this chapter is twofold. In the first place, I want to provide explanations for the relationship between management and artistic leadership in the BSO. Second, I would like to provide arts managers with some guidelines to deal with or at least lessen the conflict.

In this section I will deal with some preliminary questions: is the BSO's music director turnover a special case or a common feature in symphony orchestras? Second, is artistic leadership turnover similar to or different from managerial succession in other types of organisations? I will then search for different explanations of leadership succession and explore their relevance to the BSO case.

Music Director Turnover

Conflict between management and MDs and professional turnover in symphony orchestras is not a strictly Spanish problem. Conflict has also caused high rates of MD succession in France (both in national organisations such as La Bastille Opéra and in small regional orchestras[10]) and in the US as reported by Seitz (1988). Lebrecht's (1991) account of conductor behaviour further proves this point.

However, anecdotes and case studies[11] should be complemented with a systematic analysis of music director succession and tenure in a sample of orchestras which would first require distinguishing several types of orchestras by size,[12] cultural and institutional context and government role.[13] This is beyond the scope of this chapter. Castañer (1995) notes that music directorship tenure tends to diminish and lasts around four years on average. It seems that more prominent conductors remain longer in order to shape the best orchestras, while their lesser known counterparts switch more frequently. This is consistent with Eitzen and Yetman (1972:114) who find a similar distillation process within the sports sector, i.e. that the more successful coaches of sports teams are more likely to be retained.

It would also be interesting to contrast MD tenure with both managerial and technical leadership in other types of organisations. Despite the extensive literature on managerial succession, few studies report empirical data about managerial or technical turnover that would make it possible to systematically compare artistic turnover in arts organisations with turnover in other service, professional or non-profit organisations. Nevertheless, for sports organisations, Eitzen and Yetman (1972:112) report that coaching tenure averaged 5.9 years. Some partial evidence on managerial turnover in hospitals suggests that the rates of succession are similar to music director succession (Alexander et al., 1993).

Causes of Leadership Turnover

Many studies of managerial succession proceed to develop hypotheses about the consequences of turnover without first distinguishing different causes of succession. Therefore, I propose to identify five different causes of succession (Grusky, 1963; Alexander et al., 1993):

1. Retirement or death (withdrawal from professional life)

2. Dismissal by the Board on grounds of poor performance

3. Resignation motivated by disagreement

4. Resignation motivated by a better offer elsewhere (more money or better professional conditions)

5. Change of ownership due to merger, acquisition or creation of a consortium.

A further explanation was also advanced by Wagner et al. (1984) in a study that indicated that top management group turnover in 31 large manufacturing companies was positively related to demographic distance between managers, measured on the basis of both age and date-of-entry similarity. I ignore this alternative explanation here inasmuch as music directors are not usually considered members of senior management.

The information conveyed by the different types of turnover is very different and should be taken into account while developing empirical measures and models. In this chapter I am concerned with the second and third types of succession.

Zeigler (1991) argued that artistic succession in the US is caused by changes in the nature of leadership, the new funding environment, a growing reliance on marketing, the changing composition of boards of trustees, an increased emphasis on institutionalisation and an obsession with permanence. His analysis is consistent with Galinsky and Lehman's observation of a convergence trend towards pluralistic funding in Eastern European and British orchestras. In fact, Zeigler (1991:62) points out that these factors affect orchestras, mentioning the absence of permanent leaders (conductors) and the increasing need to rely on box office receipts and private donors who control the board.

However, in the BSO case, we have observed that neither financial nor political pressures can explain MD succession. Therefore, let us proceed to examine alternative explanations.

Poor Performance. Grusky (1963) was the first to report a negative correlation between performance and turnover. This empirical regularity was interpreted as an indication that high-performing organisations will have lower rates of managerial turnover (Eitzen & Yetman, 1972). However, Grusky did not

distinguish between performance before and after succession and therefore he did not address the issue of causality. As Eitzen and Yetman (1972:115) demonstrated, "turnover and team perform-ance are inversely related but this relationship depends upon the (baseball) team's performance prior to the change".

Some recent studies report that managers in poorly performing firms are more likely to be replaced (Khanna & Poulsen, 1995) and that turnover occurs when reported annual earnings per share fall short of board expectations (Puffer & Weintrop, 1991).

However, it is not clear if replaced managers can be blamed for poor performance. In a recent study, Khanna and Poulsen (1995) observed that the managers of 128 firms that had filed for failure made very similar decisions to those firms that performed better and therefore financial distress cannot be attributed to incompe-tence or excessively self-serving managerial decisions. Khanna and Poulsen (1995) suggest that when managers are blamed for financial distress they are serving as scapegoats.[14]

Moreover, poor performance has been considered a cause of artistic director succession. Based on some case studies, DiMaggio (1987:213) says that:

> . . . artistic directors who fail to stay within budget or who mount avant-garde productions that drive away paying audiences may be sanctioned or even dismissed.

In order to systematically assess the impact of performance on artistic turnover, we would need to measure both organisational and MD performance. However, measuring performance in performing arts organisations, as in most non-profit organisa-tions, is a very complex task (Moss Kanter & Summers, 1987). It is dependent on the constituency that assesses its effectiveness (Steers, 1975) and is therefore subjective.

In the BSO, managerial or Board discontent with performance does not appear to be the main cause of MD succession. Decker's attempts to revitalise the orchestra were welcomed and García Navarro's strong leadership increased the professional motivation of musicians, who started coming to rehearsals with the score perfectly learned. As already mentioned, conflict over repertoire and programming was the main reason for MD turnover in the BSO.

Disagreement. The fundamental message of Zeigler's analysis seems to be the growing emphasis in arts organisations on market and financial goals rather than on artistic issues. To illustrate this point, Zeigler (1991:64) quotes the Cleveland Orchestra manager:

> We have created institutions where the balance between the purest artistic ideals and financial realities has shifted, with the latter assuming an increasing influence as financial pressures mount. In the process, our orchestras, whose artistic responsibility must be to lead rather than to follow taste, have become increasingly market-oriented in pursuit of short-term revenue.

In her excellent analysis of French cultural organisations, Chiapello (1994) argues that artist–management conflict reflects a power struggle which is expressed through two opposed discourses: the artistic and the managerial, although it must be stressed that these are stereotyped images of both artistic and managerial work. Table 18.3 reproduces Chiapello's definition of the basic elements of these discourses.

Again, the basic clash between artists and management seems to lie in the creative–commercial dichotomy. However, this clash may be overstressed, especially for some kinds of organisations. Although most artists — painters, sculptors, composers, etc. — would claim that their work is highly creative and that commercial concerns may clash with the pursuit of creativity, Chiapello (1994) ranges arts products and services on a scale of innovativeness and argues that a symphony's task of interpreting music is not very innovative.[15] DiMaggio (1987:207) also relativizes the assumption of quality and innovation-driven artists:

> Although many artists and curators, especially those in the major professional organisations, strive for perfection in production values, it seems reasonable to assume that others, like mortals in other occupations, seek simply to get by.

Moreover, the sociological approach has tended to stress other factors such as increasing normalisation, specialisation and supervision as the basis of the professional–management conflict (Gouldner, 1957; Wallace, 1995). Table 18.4 shows the Raelin (1991) synthesis of the different values of professionals and managers.[16]

Table 18.3: Artistic and Managerial Discourses

	Artistic	*Managerial*
Task Features	Risk	Calculation
	Innovation	Standardisation
	Exploration	Exploitation
	Low value if it can be planned	High value if it can be planned
	Cannot be absolutely assessed	Everything can be measured
	Money is not the only measure	Money is the universal measure
Actors	Sensitive	Judicious
	Intuitive	Rational
	Bohemian	Conformist
	Unpredictable	Predictable

Source: Chiapello (1994).

The underlying assumption of the role conflict theory or the professional-bureaucratic conflict model is that commitment to the organisation and the profession is zero-sum: greater commitment to one implies less commitment to the other (Gouldner, 1957). Bureaucratic formalities and routines are perceived to negatively affect professional norms, reduce the capacity of professionals to exercise their autonomy and erode their status. However, recent empirical studies question the role conflict thesis. First of all, role conflict theory is grounded in two extreme and idealised views of professional work (as solo work) and (large) bureaucratic organisation (Wallace, 1995). Secondly, both Wallace (1995) and Tuma and Grimes (1981)[17] demonstrate that organisational and professional commitment are two different variables and not the extremes of a single variable continuum. Organisational and professional commitment are affected by some contextual factors which can be influenced by management (recruitment, training, socialisation, etc.).

In fact, the conflict between management and MD, or between management and artists in general, does not appear to be based on problems of specialisation, normalisation or supervision. Most artists are hired to perform specialised functions, especially in music ensembles such as symphony orchestras. Moreover, there

TABLE 18.4: POLARISED VALUES OF PROFESSIONALS AND
MANAGEMENT

	Professional Complaints	*Management Complaints*
Problem of overspecialisation	Managers who require overspeciali-sation	Professionals who wish to remain overprofessionalised
Problem of autonomy	Managers who underspecify ends but overspecify means and expect adherence to the organisational hierarchy	Professionals who demand autonomy over and participa-tion in ends as well as means
Problem of supervision	Managers who maintain close supervision	Professionals who resist close supervi-sion by insisting on professional stan-dards of evaluation
Problem of formalisation	Managers who show respect for authority and who believe in formalising control of professional practice	Professionals who might defy authority or disregard organ-isational procedures.

Source: Raelin (1991:168).

are few formal procedures other than scheduled rehearsal times. Lastly, supervision is mainly carried out by another artist, i.e. the music director of an orchestra or the director of a theatre perform-ance. The problem does not lie in the specification of means but in the determination of ends, as illustrated in Decker's refusal to program the works of contemporary Catalan composers.

After having reviewed different explanations of artist–management conflict and before proceeding to examine possible ways of alleviating this tension, I will now address the conse-quences of leadership turnover.

CONSEQUENCES OF LEADERSHIP TURNOVER

Why do we have to devote energies to studying and reflecting on artistic turnover? What are its effects on the organisation? Should we try to avoid leadership succession or should we promote it? The analysis of the consequences of leadership succession involves exploring the role of leadership and its impact on organisational performance.

Consequences of Leadership Succession: A Review of the Literature

There are three theories on the effects of managerial succession (Allen et al., 1979): (a) it improves performance, (b) it disrupts organisational activity or (c) it has no effect. And in fact, the empirical evidence on turnover effects is mixed. While Grusky (1963) found negative and disruptive effects of managerial turnover in baseball teams, other studies involving baseball (Gamson and Scotch, 1964), basketball and football teams (Brown, 1982) as well as publishing companies (Carroll, 1984) and other private firms (Khanna and Poulsen, 1995) have shown that succession has no causal impact on performance.

As mentioned, Eitzen and Yetman (1972) concluded that turnover and team performance are inversely related, confirming Grusky's results, but that this relationship depends upon the team's performance prior to the change. Lastly, no empirical study seems to support the thesis that succession improves performance.

While Grusky's finding promoted a conservative position, other empirical studies appear to favour a deterministic view of organisational performance, where leadership plays a minimal role.

The Role of Leadership

Since the beginning of the 1960s there has been a great deal of discussion about the impact of leadership on organisational performance. The Gamson and Scotch (1964) study was the first to suggest the limited effect of leadership, based on their analysis of the impact of leadership turnover on performance. On the

other hand, Lieberson and O'Connor (1972) showed that after accounting for industry and company size, leadership accounted for only 14.5 per cent of the total variance of profit margin.

However, Berkeley (1988:397) points out that Lieberson and O'Connor's influential findings have been misinterpreted: it is only logical that size as "the independent variable that displays the largest variance" explains the largest part of total variance in the aggregate analysis of organisational performance, while the leadership effect is small. However, when performance variations over time are observed in individual firms, Berkeley demonstrates that leadership accounts for a larger proportion of variance that is not explained by contextual variables (62 per cent for profit and 30 per cent for profit margin).

Studies of the effects of managerial succession cannot be used to conclude that managers have little impact on long-term organisational performance (Allen et al., 1979:179; Khanna and Poulsen, 1995). Although current performance appears to be explained in the main by past performance, it doesn't mean that managers have no role. Past performance which results from a set of managerial decisions on the accumulation of resources and development of organisational routines and capabilities has to be explained. Moreover, leadership tenure cannot be used as the only variable to study leadership. At most it measures the longevity of leadership but it does not account for leaders' actions, decisions or roles.[18]

The deterministic conception that leaders have no significant impact on performance stems from the sociological approach, which has been challenged by the strategic choice approach (Astley and Van de Ven, 1983). Strategic management (Child, 1972) believes that leaders can adapt their organisations to the environment through the design of variegated strategies. Moreover, Hambrick and Mason (1984) have embodied their argument about the influence of top management on performance in their upper-echelon theory, which has received some empirical support.[19]

However, these studies cannot support a conservative or revolutionary approach to top-management tenure. While Grusky implied a conservative position, Finkelstein and Hambrick's finding that long-tenured managerial teams apply more persistent strategies which conform to the central tendencies of the industry,

turning in a performance that is very similar to industry average, would suggest that some rejuvenating policies are needed in order to foster entrepreneurship and innovation.

The Role of Artistic Leadership

Unfortunately, empirical analysis of the impact of turnover on organisational performance cannot be so clearly delineated for arts organisations. There is no clear measure, such as baseball or basketball league rankings, for orchestral performance. Moreover, there is no clear evidence that local and regional symphony orchestras compete with one another. Rather they compete with other leisure activities offered to a certain segment of the local population.

Furthermore, we need to assess the consequences of rapid turnover in relation to the task performed by artistic leaders in arts organisations. In other words, we need to examine the role of artistic leaders in general and orchestra conductors in particular.

I would argue that artistic directors usually have a significant impact on both short- and long-term organisational performance. For symphony orchestras, Allmendinger and Hackman (1992) posited that three of the music director's tasks have an impact on organisational performance: direction-setting, organisational initiatives and coaching.

Music directors set up programs for the season and for individual concerts, thereby defining the service. Moreover, they schedule tours and recording. Through these direction-setting activities, conductors shape the orchestra's reputation (as specialised in specific repertoires) both locally and internationally.

Conductors influence the quality of their orchestras by supervising the selection, recruitment and promotion processes of musicians. Coaching is an essential skill for conductors, enabling them to get the best from their musicians. A collaborative and stimulating atmosphere results in better concert performances than a climate in which the conductor and the musicians are adversaries.[20]

Organisational initiatives, such as designing an outreach youth concert program or developing a new image of the orchestra, may also have an impact on the orchestra's public image.

Consequences of Turnover in Performing Arts Organisations

Accelerated artistic leadership turnover (two to three years) can be considered a signal of malfunction and crisis. Rapid turnover, as experienced in the BSO, is usually interpreted as a negative outcome for several reasons:

- It interrupts the orchestra's progress under a particular conductor

- It interrupts the reputation for a certain kind of programming and repertoire, linked with the conductor

- It involves bargaining costs, related to severance pay and other conditions of dismissal

- It involves costs incurred in searching for a new MD

- It undermines the morale of the artistic personnel.

However, it can also be argued that leadership turnover favours innovation (Gabarro, 1985), as the new leader provides new ideas and carries out new projects.[21] Eitzen and Yetman (1972) observed that the relationship between coaching shifts in college basketball teams and performance was curvilinear: the longer the coaching tenure, the greater the team's success but after a certain length of time (thirteen years or more), team effectiveness begins to decline. This indicates that some stability of leadership is good but that it also has some long-run limitations. It could be argued that the negative impact of long-term tenure on performance is due to inertia, lack of an innovative approach and complacency.

In symphony conducting, a kind of cyclical pattern is observed: new conductors spark performance with new repertoire and perspectives but once the new style is assimilated, the musicians experience a need for new stimuli. As mentioned earlier, BSO management believes that replacing Ros Marbà with Decker led to a positive change in the orchestra. Moreover, it is usually stated that appointing outsiders will more likely break the status quo than promoting insiders. Helmich and Brown (1972) empirically demonstrated that outsiders are more likely than inside successors to take a mandate and more willing to change existing situations and break with traditional patterns. In fact, although almost all MDs are organisational outsiders, Decker was

the first BSO music director who can be considered a real outsider, as both Marbà and Mas were Catalan and disciples of Toldrà.

However, later developments, such as Decker being succeeded by García Navarro, indicate that replacement of conductors has not changed the system of roles and relationships between the management team, the music director and the musicians. Although the impact of succession on performance is mixed, the lack of a new approach to the music director role means that conflict may recur.

Assuming the existence of some tension and the potential negative consequences of MD turnover, I will explore several solutions based on organisational theory.

DEALING WITH ORGANISATIONAL CONFLICT

Two different approaches will be surveyed in this section. On the one hand, organisation control theory suggests a contingent approach involving three different types of control mechanisms. On the other hand, the literature on the management of professionals has explored some specific mechanisms.

It is obvious that there are different types of arts organisations and therefore a contingent approach to control in arts organisations should be taken.[22] The discussion of the adequacy of control mechanisms will deal mainly with the specific case of symphony orchestras and top artistic positions.

Symphony Orchestras as Special Types of Organisations

Conflict is usually solved through co-ordination mechanisms, a central issue in organisational theory. At a generic level, Mintzberg (1979) suggested a typology of organisational configurations based on their primary co-ordinating mechanism (see Table 18.5).

Most arts organisations are usually considered as professional organisations, i.e. organisations staffed by professional artists. This is also the case of symphony orchestras. However, Mintzberg (1979) posited that symphony orchestras are an example of hybrid configurations, where two co-ordination mechanisms simultaneously intervene. He defined the symphony orchestra as a meritocratic autarchy because highly trained musicians are selected, evaluated and promoted on the basis of merit and by peers but they perform their task with no autonomy under the

strict direction of the conductor. In fact, we could argue the concept of musicians as professionals.

TABLE 18.5: CO-ORDINATION MECHANISMS AND ORGANISATIONAL CONFIGURATIONS

Co-ordination Mechanism	Organisational Configuration
Direct supervision	Simple organisation
Formal procedures (standardised tasks)	Machine bureaucracy
Professional norms (standardised skills)	Professional bureaucracy
Standardised outputs	Divisional form
Mutual adjustment	Adhocracy

Source: Mintzberg (1979).

Schein (in Schön, 1983:24) identifies three components of professional knowledge:

1. An underlying discipline or basic science component on which the practice from which it is developed rests

2. An applied science or engineering component from which many of the day-to-day diagnostic procedures and problem-solutions are derived

3. A skills and attitudinal component that concerns the actual delivery of services to the client, using the underlying basic and applied knowledge.

The paradigmatic professionals are lawyers and physicians. Examples of professional organisations include medical clinics, research institutes, architectural offices, accounting and law firms (Wallace, 1995).

The above-mentioned professions and their related organisations share some features: they diagnose specific situations using scientific knowledge learned through formal education and have direct interaction with the client.[23]

Musicians' performance appears not to be supported by a basic science despite their use of solfeggio, harmony and acoustics to understand the production of sound and to be able to read

musical scores, which could be interpreted as the diagnostic task. Nevertheless, it is clear that they do not interact with clients or diagnose the audience's needs.

However, Schön argues against the positivist technical rationality paradigm that underlies this conception of professionalism and advocates a new definition of the professional practitioner who performs a critical function: reflection in action. Reflection in action is for Schön an artistic ability and correspondingly he uses jazz improvisation as an example (1983:55–6). Therefore, the symphony conductor's task of listening to musicians' performance and deciding which parts to rehearse and how to mold each work, could be considered reflection in action.

Although the definition of professional could be used as a political and rhetorical argument in the artist–management conflict, it would not help us to solve it. Moreover, the co-ordination mechanisms mentioned by Mintzberg to characterise symphony orchestras do not deal with management–MD relationships.

Generic Control Recipes

Taking as its basis Thompson's (1967) contingent framework of decision-making styles, organisational control theory suggests that the appropriateness of different control mechanisms depends on the type of situation in terms of task programmability (due to the knowledge of the transformation process) and outcome measurability (see Figure 18.1).[24]

To the two governance forms of markets (through contracts that establish the expected outcome) and hierarchies (authority through direct supervision), Ouchi (1980) adds a third — clans — where co-ordination is achieved through values. Shared values help to build trust, which reinforces the organisational culture. Socialisation mechanisms lead towards co-ordination because they "foster a programming of people that renders their behaviour more predictable and autonomous of hierarchical surveillance" (Pennings and Woiceshyn, 1987).[25]

FIGURE 18.1: THE CONTINGENT MODEL OF ORGANISATIONAL CONTROL

Task Programmability

	High	*Low*
High	Behavioural or outcome-based	Outcome-based
Low	Behavioural	Socialisation

(left axis: **Outcome Measurability**)

Source: Ouchi (1979) and Eisenhardt (1985).

Ouchi (1979) suggested that market incentives which control outcome are adequate when the outcome is measurable, whether or not the task is highly programmable. Hierarchical or direct supervision (behavioural control) is appropriate when operations are known and programmable whether or not the outcome is measurable. Finally, socialisation (clan control) is the only available mechanism when the two previous conditions are not met.

In my opinion, neither the hierarchical supervision of conductor behaviour nor outcome-based incentives can be implemented in the relationship between management and music directors. In fact, BSO management has relied on contracts as their control mechanism, though these can only specify the number of concerts performed with the orchestra during each season.

Features of the management–MD relationships include:

1. The conductor's function can only be established in terms of inputs (number of rehearsals) and outputs (number of concerts and recordings).

2. But the relevant information for management is the outcome, in terms of the quality of the concerts, improved public reputation and revenues.

3. The conductor's efforts and their impact on the outcome cannot be observed due to informational asymmetry: the manager has no specialised knowledge which enables him to evaluate the conductor.

Therefore, the theoretical alternative is socialisation which implies the development of an organisational culture. This would mean that personal relationships are not hierarchically structured but co-ordinated goals emerge as the outcome of horizontal negotiation and shared values.

Specific Recipes for Managing Professionals

Managing MD or artistic leaders is complex in that most mechanisms suggested for the management of professionals (Raelin, 1991) cannot be applied. Control of ends or management by objectives are difficult to implement due to the elusive nature of artistic outcomes and their measurement. Other measures such as the internal labour market cannot be applied because MDs already occupy the top artistic position in the organisation. Orchestra conductors can be considered cosmopolitan, externally oriented professionals[26] in the sense that:

1. They usually combine music directorship in one orchestra with guest conductorship in several others

2. As MDs, they are able to build reciprocal relationships with other conductors whom they invite to conduct their orchestra and vice versa,[27] and

3. They envision their present work as a reputation-building task with recordings and tours preparing them for their next assignment.

Moreover, the conflict over the relative power of management and the conductor to set organisational goals cannot be solved

through the allocation of autonomy which Raelin (1995) suggested for academia, where he recommends that management should be given strategic and administrative autonomy and faculty operational autonomy. The conflict between management and artists does not stem from bureaucratic normalisation at the operational or administrative level, but from dissent about organisational goals: that is to say, strategic decision-making.

Therefore, what is relevant to our problem with a top cosmopolitan, externally-oriented professional is how to increase that person's organisational commitment, without affecting their professional orientation.

Organisational commitment is defined (Hunt and Morgan, 1994) as the attachment resulting from, or based on, an employee's compliance (conformity driven by rewards and punishment), identification (a desire for affiliation) and internalisation (congruence of the individual's values with organisational goals and values). In the case of MDs' commitment to their symphony orchestras we are basically concerned with the acceptance of organisational goals and the willingness to make an effort to attain those goals.[28]

In their work on research organisations, Tuma and Grimes (1981) argued that organisations can select professionals in order to get different mixes of professional and organisational commitment. The selection process can therefore be used to maximise compliance. However, again the cosmopolitan nature of music directorship reduces the capacity of orchestral management to alter substantially standard contracting practices. However, a clear definition of the MD profile and more extensive search processes would help.

Wallace (1995) also found that organisational commitment can be fostered if the professionals perceive that highly legitimate professional criteria are used in the process of selection. This factor may be of extreme importance as one of the MD's main roles is to shape the composition of the orchestra, through the recruitment and promotion of musicians.

Moreover, Wallace (1995:249) found that organisational commitment appears to be highly dependent on professionals' opportunities for career advancement and the criteria used in the distribution of rewards such as pay and promotions.[29] However, the orchestra conductor's position at the top of the professional

ladder precludes the possibility of upward mobility within the organisation. The only solution could be to create a position of resident/assistant conductor, the occupant of which would be more interested in working towards promotion to the post of MD.

Lastly, although the relative prestige of the orchestra and its local community can be important factors affecting MD identification, management cannot affect these. Therefore, internalisation of organisational values once more appears to be the only tool with which to smooth the relationship between artistic leaders and managers.

SOCIALISED CO-ORDINATION THROUGH ORGANISATIONAL CULTURE

Socialisation as a mechanism of control is grounded in a theory of motivation that goes beyond opportunistic self-interest to allow for reciprocity and equity (Barney, 1990). Human interaction in the clan (Ouchi, 1980) is not only guided by rational economic calculation but also by rules of appropriate behaviour.

Socialisation aims precisely to develop a sense of organisational loyalty and commitment through processes such as selection, induction, training and internal promotion that instil a concrete set of organisational values.[30] Therefore, an organisational culture is defined as a shared set of cognitions (world and organisational vision) expressed, among other things, in material artefacts (logos, badges, etc.), routines, rituals, language, myths and storytelling about organisational heroes (Pettigrew, 1979; Denison, 1990).

However, socialisation does not always lead to greater commitment to organisational goals. As van Maanen's (1975) seminal study reveals, socialisation of police recruits results in a final perspective or organisational norm which stresses a "lay low, don't make waves" approach, accompanied by a decline of motivational attitudes and organisational commitment.

The Existence of Organisational Culture in the BSO

Wilkins and Ouchi (1983) posited that the existence of an organisational culture requires shared social knowledge composed of a paradigm and goal congruence. A general paradigm is a sort of master routine that helps participants determine what is in the best interest of the collective. The paradigm provides categories, shared frameworks and processing routines for

comprehending information and avoiding misunderstandings when an unfamiliar problem is faced. Goal congruence is not to be confused with goal-sharing and is defined by two underlying assumptions: (a) that joint effort is the best way to achieve individual self-interest and (b) that in the long run both honest and dishonest people will be discovered and dealt with accordingly. As we can see, both elements emphasise co-operation as a basic value.

The failure to retain motivated conductors and their sometimes opportunistic behaviour (constructing reciprocal networks with other MDs, commissioning work from relatives and friends, hiring on a personal basis, etc.) appears to demonstrate the lack of shared values that would foster the MD's commitment to the organisation, even though the Barcelona Symphony Orchestra seems to satisfy the conditions that Wilkins and Ouchi (1983) posited for the emergence of an organisational culture.[31]

1. The orchestra has more than 50 years of history and musicians' membership is relatively stable.

2. Lifetime employment practices were standard until 1985, when the management team backed Decker's policy of replacing public servant musicians. However, public servants still account for a significant proportion of the orchestra's work force (25 per cent) and another 60 per cent have guaranteed lifetime employment.

3. Moreover, when the orchestra was created in 1945 no other symphony orchestra existed in Catalonia[32] and as a municipal organisation it has enjoyed secure funding.

However, it could be said that prior to 1985 there was an organisational culture which could be termed clanic in the sense used by Hofstede et al (1990) who see it as the opposite of professional. In fact, there is a shared perception that before the advent of Decker as MD, BSO musicians behaved as a clan, protecting themselves against both the orchestral management and the MD. Musicians and the MD built reciprocal relationships based on maintaining the *status quo*: musicians would not be pressed to improve performance and in turn they would not question the MD's position and commitment. The organisational culture was based on low professional commitment. Moreover, musicians

explicitly discouraged other colleagues from attempting to join the orchestra, a clear feature of closed-clanic organisational cultures. However, when Decker introduced a competitive system to fill soloist positions, a sense of professionalism destroyed clannish complacency.[33] Decker's appointment therefore seemed to represent the end of a conservationist culture which, according to Hofstede et al. (1990:305), is a closed system, characterised by a strong need for security and promotion on past merits.

Managing Organisational Culture

The appointment of Decker as the BSO music director seems to have eroded the previous organisational culture. The rules of the game governing musicians/MD/management relationships appear to have been broken. However, no new rules have been made and this may explain the persistence and exacerbation of the tension between management and the music director.

If socialising the MD into an organisational culture is the only remaining alternative for co-ordinating artistic leaders and management, the possibility of managing culture should be explored. Different authors have argued that shaping organisational culture is the prime managerial task (Schein, 1985). In this sense, culture is assumed to be manipulable by leaders and managers.[34]

Schein (1985) suggests two types of mechanisms for developing an organisational culture. Primary mechanisms include the objects of managerial attention, managerial reaction to unexpected incidents, deliberate role modelling, resource allocation criteria and selection and promotion criteria. As secondary mechanisms, Schein mentions organisational structure and systems, physical lay-out, stories and myths and formal mission statements.

As can be observed, Schein's list of cultural management tools appears to be more directed towards instilling the managerial ideology and socialising new members within this ideology, which can be located at any point on a co-operation–competitiveness continuum. The cultural task of managers therefore implies the prior definition of an organisational mission and values to be instilled.

The Capacity of Managers to Become Imaginative Leaders

The capacity of BSO's managers to instil values appears to be blocked by their own images of the organisation. Organisational images or metaphors belong to the signification level of organisational cultures (Riley, 1983) and affect the interpretation and legitimisation of managerial behaviour. Furthermore, organisational images embedded in organisational vocabularies condition the sense-making process (Weick, 1995) through which managers enact the environment.

In my conversations with the orchestra's first general manager and its artistic manager, they both related to the image of the orchestra as an *inverted pyramid*, a common image for most professional organisations (Mendoza, 1994). Through this image the management team expresses its perception of powerlessness in its relationship with the musicians: musicians are rewarded with high salaries and usually enjoy more recognition and status than management.

More important, however, are the metaphors through which managers describe the function of the organisation in the current society. In one interview, the general manager described the orchestra as a *stagecoach*, an old-fashioned vehicle, with which to entertain citizens of the late twentieth century. Moreover, the artistic manager sees the orchestra as a *dinosaur*, with a big body and small and fragile legs, that is on the road to extinction.

Both the stagecoach and dinosaur images portray an out-dated and pessimistic view of the orchestra's role in society, which may well increase management's feeling of powerlessness.

These images, together with the inverted pyramid, reflect the lack of an organisational mission and may explain inability to change and innovate. Not surprisingly, product and organisational innovation are almost totally lacking[35] (the only innovation in the last decade has been the creation of a series of free chamber concerts performed at the City Hall and some concerts for schools).

The orchestra environment has changed considerably and will continue to change, particularly as new technologies provide consumers with new choices for home entertainment. In spite of the tremendous changes in the entertainment industry, and especially in the sub-sector of live entertainment, BSO management hasn't developed new images of the organisation or

envisioned new missions to renew its function in society. Management seems basically concerned with securing the public resources required to keep the orchestra alive (musicians' costs), keeping the deficit stable and minimising interpersonal conflicts with the conductor and musicians.

In my opinion, the possibility of managing the tension between artistic and organisational interests depends on whether management's own mental framework, i.e. their mental images of the orchestra, can be changed. As Barr et al. (1992) have pointed out, organisational renewal requires that a firm's senior managers make timely adjustments in their mental models in accordance with significant changes in the environment.[36] The challenge is that even if managers adequately perceive the environmental changes that trigger organisational misalignment, they must develop new images of the organisation in order to regain the needed fit.

But sense-making about new environmental contexts is not sufficient to regain fit. As Gioia and Chittipeddi (1991) have described when writing about a university president, after environmental sense-making, an effective leader enacts and communicates his new images through a sense-giving process.

CONCLUSIONS

This chapter has tried to shed some light on the crucial problem of artistic leadership succession in arts organisations by studying the case of music director turnover in the Barcelona Symphony Orchestra. The chapter began with a review of several streams of the organisational literature that deal with the causes and the consequences of leadership succession and assesses their relevance for the BSO case, discussing the role of artistic leadership, its influence on organisational performance and the consequences of rapid turnover.

In the BSO case, artistic leadership succession tends to be caused mainly by disagreement over organisational goals. I argue that artistic–management tension in performing arts organisations does not arise from normalisation and specialisation of professional work. It is therefore posited that the discussion about managerial and artistic–professional conflict seems to be over-stressed.

In order to find ways to alleviate the tension over goals, three different streams of literature have been explored: organisational control, management of professionals and organisational commitment. Several of the standard solutions for managing professionals appeared not to be applicable to music directors, who are a special breed of cosmopolitan professionals.

Socialisation of MDs into an organisational culture appears to be the only option and this led me to explore the existence of an organisational culture in the BSO and its management. However, the capacity of BSO management to develop a new organisational culture to replace the former clan spirit seems to be limited by their mental images of the organisation.

The results of this case study are speculative. Generalisation to other performing arts organisations is precluded by at least two limitations: first of all, it deals with one type of performing art organisation, symphony orchestras which have been character-ised as a fairly non-innovative kind of art organisation. Moreover, the BSO presents some specific features — such as being a large, public organisation and having a permanent artistic staff — which may inhibit the generalisation of my findings.[37]

However, it could be argued that in private arts organisations the tension between artistic and commercial goals is more acute (DiMaggio, 1987) than in their public counterparts.

Further research using both quantitative and qualitative meth-ods should try to uncover the impact of artistic leadership on organisational performance and, in particular, focus on how new sense-making, organisational imaging and sense-giving takes place in arts organisations.[38]

Notes

[1] Commenting on the US situation, Zeigler (1991:60) argues that: "The problems, politics and challenges of providing for artistic and managerial change in the arts have become an issue of near-crisis proportions in recent years."

[2] As Yin (1981:59) defines it, an explanatory case study consists of: (a) an accurate rendition of the facts of the case; (b) some consideration of alternative explanations of these facts; and (c) a conclusion based on the single explanation that appears most congruent with the facts. For a discussion of case-study versus quantitative methods, see Denison (1990).

[3] For instance, in the field of art museums, newly created organisations such as the Barcelona Contemporary Art Museum (MACB) and the *Museu Nacional d'Art de Catalunya* (MNAC) both had at least two different general managers before they even opened.

[4] Sometimes it is difficult to distinguish between managerial and artistic turn-over since most executive managers have an artistic background.

[5] On two occasions, the musicians performed wearing sun glasses to publicly demonstrate their discontent.

[6] This is the opposite of Board–MD relationship described in Arian (1971) and Hart (1973) where board members disliked modern music and even fired music directors who pressed to include it in their programs.

[7] Like most regional orchestras in Spain, the BSO could be considered a fourth model to add to Galinski and Lehman's typology (1995). Similar to West German orchestras in that they were largely created and financed by municipal and regional governments, the BSO is, nevertheless, a special case because it was founded before democracy was restored to Spain, heralding a move towards decentralisation that led to the creation of several regional orchestras, supported by regional and local administrators. In fact, many of these were created after 1985, among them the symphony orchestras of Seville, Malaga, Granada, Cordoba, Tenerife, Gran Canaria, Euskadi, Bilbao, Madrid, Asturias and Galicia.

[8] The creation of this position could be considered a sign of the Galinsky and Lehman (1995) convergence thesis, as all symphony orchestras come to face similar and global pressures, among them reduced public support and the need to look for funding from a variety of sources. However, the creation of the fund-raising position, together with the vacancy at the general-manager level, also masks an internal conflict between senior officers, triggered by downsizing in the city's department of culture. Moreover the BSO does not appear to display the other features of the convergence thesis: community involvement and outreach and organisational partnerships.

[9] See Ramamurti (1986) for an analysis of government-dependent organisations.

[10] In her study of five French orchestras, Chiapello (1994:297) reports that the opera orchestra has had five different conductors since 1982, with the tenure of the previous four averaging only two years.

[11] See Castañer (1995) for a chronology of conductor succession in the London Symphony, the London Philharmonic, the BBC and the Czech Philharmonic Orchestra based on Lebrecht (1991).

[12] For instance, the US American Symphony Orchestra League (ASOL) usually classifies its members in three different categories: philharmonic, medium and small orchestras. Size is assumed to be related to reputation

[13] See the set of variables that Galinski and Lehman (1995:120) use to distinguish different models of symphony orchestras, particularly the primary funding source, the dominant actor (whether management, the music director or musicians), the role of conductor and the power of musicians' unions.

[14] Observing that coaching changes had little effect on team performance, Gamson and Scotch (1964) suggested that new managers (in college basketball teams) usually blamed former managers, in what is known as a "scapegoating" strategy. In a slightly different version of the scapegoating phenomenon, Boeker (1992) has recently demonstrated that powerful CEOs tend to dismiss members of their top-management team when performance is poor.

[15] This is not to say that music playing is not a creative process. See, for instance, the case of jazz improvisation (Bastien and Hostager, 1988).

[16] Raelin (1991) added two other problems or sources of conflict: real-practice and ethical responsibility.

[17] Tuma and Grimes (1981) found that there is no statistical association between organisational and professional commitment in research-oriented universities.

[18] A recent study by Smith et al. (1994) proves that executive demographic variables such as executive tenure were directly related to performance. Moreover, other demographic variables (education, experience, etc.) of top managers appear directly related to executive dynamic processes such as communication and integration which are directly related to performance.

[19] See footnote 18. Moreover, Finkelstein and Hambrick (1990) validated the contingent approach to managerial discretion suggested by Hrebiniak and Joyce (1985), in which different types of environment will determine the degree of managerial discretion, i.e. the latitude of action available to top executives.

[20] See how Spiteri's rough approach finally led to his dismissal as MD of the Madrid Symphony Orchestra (Gómez and Turina, 1994).

[21] Organisational economics — agency theory (Fama, 1980; Jensen and Meckling, 1976) — maintains that firms tend to perform efficiently because managers can be replaced through internal and external markets.

[22] See Chiapello (1994) for a typology of arts organisations based on whether artistic work is produced internally or externally, and when internal, whether by permanent or temporary artistic staff.

[23] Quoting Schein, Schön (1983:45) states that "one of the hallmarks of the professional . . . is his ability to take a convergent knowledge base and convert it into professional services that are tailored to the unique requirements of the client system".

[24] See Eisenhardt (1985) for an empirical test that supports the theory.

[25] Organisational economics have provided an efficientist explanation of organisational culture as a control mechanism (Wilkins and Ouchi, 1983): when organisational members share the same values, each one can expect specific patterns of behaviour, and therefore co-ordination costs are reduced.

[26] Gouldner (1957, 1958) considered that professionals could be distinguished along a cosmopolitan–local axis. While cosmopolitan professionals are externally oriented, local professionals are more internally oriented, displaying a higher level of organisational commitment.

[27] See Lebrecht (1991) for a lively illustration of insider dealing through Baremboim's Jewish circle, called by some "the Kosher Nostra".

[28] I dismiss the dimension of identification as the desire to maintain organisational membership, due to the external orientation of cosmopolitan artists.

[29] In Wallace's empirical study, work motivation rather than any of the structural characteristics appears to be the most important determinant of professional commitment.

[30] As Pennings and Woiceshyn (1987:82) put it, "organisations invest heavily in training, employee development, or more generally socialisation, which is a primary medium for imparting a common set of norms and values to organisation's members".

[31] They cite the following enhancing conditions: long history and stable membership, absence of institutional alternatives, significant technical advantage at the founding stage, adoption of existing cultures in a particular profession, religious group or particular geographical area and funding from "committed" sources.

[32] The Opera House had another orchestra, many of whose members also performed with the BSO. It was not until the mid-1980s that some chamber orchestras were formed (Orquestra Simfònica del Vallès, Orquestra del Teatre Lliure, Orquestra de Cadaqués) filling some gaps left by the BSO in both repertoire and geographic coverage.

[33] Following Hofstede et al.'s (1990) dimensions of organisational culture, I would suggest avoiding the use of the clan metaphor for co-ordination through values, because it identifies with an autarchical image of the organisation and not all organisational cultures are necessarily clanic.

[34] This instrumental approach to organisational values is paradoxical in the sense that collective norms are by definition shaped through social processes and therefore cannot be hierarchically imposed. Some authors, like Aktouf (1993), consider this approach as an attempt by management to use culture as a new power instrument to be wielded by the hierarchical system.

[35] Low innovativeness in performing arts organisations seems to be a general phenomenon. In his study of the production function in the Royal Shakespeare Company, Gapinski (1984:461) found that technical progress was especially weak: "not much had been done to organisational patterns at the Aldwych and the Stratford during the years under consideration".

[36] Along these same lines, it is interesting to note that radical humanists (Aktouf, 1993) argue that by recognising and scrutinising their own metaphors and images, managers can change certain aspects of their organisations.

[37] See Goodman and Goodman (1976) for an analysis of a theatre group as an example of a temporary art system and Murnighan and Colon's (1991) study of an example of small performing arts organisations such as string quartets.

[38] See Bougon et al. (1977) for a sophisticated analysis of cognition in a jazz orchestra.

References

Aktouf, O. (1993), "Management and Theories of Organisations in the 1990s: Toward a Critical Radical Humanism?" *Academy of Management Review*, vol. 17, no. 3, 407–431.

Alexander, J.A., Fennell, M.L. & Halpern, M.T. (1993), "Leadership Instability in Hospitals: the Influence of Board–CEO Relations and Organisational Growth and Decline", *Administrative Science Quarterly*, no. 38, 74–99.

Allen, M., Panian, S. & Lotz, R. (1979), "Managerial Succession and Organisational Performance: a Recalcitrant Problem Revisited", *Administrative Science Quarterly*, no. 24, 167–180.

Allmendinger, J. & Hackman, J.R. (1992), "Bringing Music to People: Continuity and Discontinuity in East German Orchestras", *Harvard Business School working paper*, June.

Arian, E. (1971), *Bach, Beethoven and Bureaucracy: The Case of the Philadelphia Orchestra*, Alabama: University of Alabama Press.

Astley, W.G. & Van de Ven, A. (1983), "Central Perspectives and Debates in Organisation Theory", *Administrative Science Quarterly*, no. 28, 245–273.

Barney, Jay B. (1990), "The Debate Between Traditional Management Theory and Organisational Economics: Substantive Differences or Intergroup Conflict?", *Academy of Management Review*, no. 15.

Barr, P., Stimpert, J.L. & Huff, A.S. (1992), "Cognitive Change, Strategic Action and Organizational Renewal", *Strategic Management Journal*, no. 13, 15–36.

Bastien, D. & Hostager, T. (1988), "Jazz as a Process of Organizational Innovation", *Communication Research*, no. 15, 582–602.

Berkeley, A. (1988), "Does Leadership Make a Difference to Organizational Performance", *Administrative Science Quarterly*, no. 33, 388–400.

Boeker, W. (1992), "Power and Managerial Dismissal: Scapegoating at the Top", *Administrative Science Quarterly*, no. 37, 400–421.

Bougon, M., Weick, K. & Binkhorst, D. (1977), "Cognition in Organizations: An Analysis of The Utrecht Jazz Orchestra", *Administrative Science Quarterly*, no. 22, 606–639.

Brown, M.C. (1982), "Administrative Succession and Organizational Performance: The Succession Effect", *Administrative Science Quarterly*, no. 27, 1–16.

Carroll, G. (1984), "Dynamics of Publisher Succession in Newspaper Organizations", *Administrative Science Quarterly*, no. 29, 93–113.

Castañer, X. (1995), "Managing Professionals in Arts Organizations: the Case of the Barcelona Symphony Orchestra", *Proceedings of the third AIMAC conference*, London.

Chiapello, E. (1994), *Les modes de contrôle des organisations artistiques*, (unpublished Ph.D. dissertation), Univ. Paris IX Dauphine, Paris.

Child, J. (1972), "Organization Structure, Environment and Performance: The Role of Strategic Choice", *Sociology*, no. 6, 1–22.

Denison, D.R. (1990), *Corporate Culture and Organizational Effectiveness*, New York, NY: John Wiley and Sons.

DiMaggio, Paul. (1987), "Nonprofit Organizations in the Production and Distribution of Culture", in *The Nonprofit Sector: A Research Handbook* (Powell, W. ed.), New Haven, CT and London: Yale University Press.

Eisenhardt, Kathleen M. (1985), "Control: Organizational and Economic Approaches" *Management Science*, vol. 31, no. 2, 134–149.

Eitzen, D. and Yetman, N. (1972), "Managerial Change, Longevity and Organizational Effectiveness", *Administrative Science Quarterly*, 110–116.

Fama, E. (1980), "Agency Problems and the Theory of the Firm", *Journal of Political Economy*, no. 88, 288–307.

Finkelstein, S. & Hambrick, D. (1990), "Top Management Team Tenure and Organizational Outcomes: The Moderating Role of Managerial Discretion", *Administrative Science Quarterly*, no. 35, 484–503.

Gabarro, J. (1986), "When a New Manager Takes Charge", *Harvard Business Review*, May–June, no. 3, 110–123.

Galinski, A. & Lehman, E. (1995), "Emergence, Divergence, Convergence: Three Models of Symphony Orchestras at The Crossroads", *European Journal of Cultural Policy*, vol. 2, no. 1, 117–139.

Gamson, W. & Scotch, N. (1964), "Scapegoating in Baseball", *American Journal of Sociology*, no. 70, 69–72.

Gapinski, J.H. (1984), "The Economics of Performing Shakespeare", *American Economic Review*, 458–466.

Gioia, D. & Chittipeddi, K. (1991), "Sensemaking and Sensegiving in Strategic Change Initiation", *Strategic Management Journal*, no. 12, 433–448.

Goodman, R.A. & Goodman, L.P. (1976), "Some Management Issues in Temporary Systems: A Study of Professional Development and Manpower — The Theater Case", *Administrative Science Quarterly*, no. 21, 494–501.

Gómez, C. and Turina, J. (1994), *La Orquesta Sinfónica de Madrid. 90 años de historia*, Madrid: Alianza Música.

Gouldner, A. (1957), "Cosmopolitans and Locals: Toward an Analysis of Latent Social Roles-I", *Administrative Science Quarterly*, no. 2, 281–306.

Gouldner, A. (1958), "Cosmopolitans and Locals: Toward an Analysis of Latent Social Roles-II", *Administrative Science Quarterly*, no. 2, 444–480.

Grusky, O. (1963), "Managerial Succession and Organizational Effectiveness", *American Journal of Sociology*, no. 69, 21–31.

Hambrick, D. & Mason, P. (1984), "Upper Echelons: The Organization as a Reflection of its Top Managers", *Academy of Management Review*, no. 9, 193–206.

Hart, P. (1973), *Orpheus in the New World: the Symphony Orchestra as an American Cultural Institution*, New York, NY: W.W. Norton.

Helmich, D. & Brown, W. (1972), "Successor Type and Organizational Change in the Corporate Enterprise", *Administrative Science Quarterly*, 371–381.

Hofstede, G., Neuijen, B., Daval, D. & Sanders, G. (1990), "Measuring Organizational Cultures: A Qualitative and Quantitative Study

Across Twenty Cases", *Administrative Science Quarterly*, no. 35, 286–316.

Hrebiniak, L. & Joyce, W. (1985), "Organizational adaptation: strategic choice and environmental determinism", *Administrative Science Quarterly*, no. 30, 336–349.

Hunt, S. & Morgan, R. (1994), "Organizational Commitment: One of Many Commitments or Key Mediating Constructs", *Academy of Management Journal*, no. 37, 1568–1587.

Jensen, M. & Meckling, W. (1976), "Theory of the Firm: Managerial Behavior, Agency Costs and Ownership Structure", *Journal of Financial Economics*, no. 3, 305–60.

Khanna, N. & Poulsen, A. (1995), "Managers of Financially Distressed Firms: Villains or Scapegoats?", *The Journal of Finance*, vol. L, no. 3, 919–940.

Lebrecht, N. (1991), *The Maestro Myth*, New York, NY: Citadel Press.

Lieberson, S. & O'Connor, J. (1972), "Leadership and Organizational Performance: a Study of Large Corporations", *American Sociological Review*, no. 37, 117–130.

Martorell, O. (1995), *Quasi un segle de simfonisme a Barcelona*, Barcelona: Beta Editorial.

Mendoza, X. (1994), "La función directiva en las organizaciones de profesionales", *Simposio CIFA*, Barcelona, octubre.

Mintzberg, H. (1979), *The Structuring of Organizations*, Englewood Cliffs: Prentice-Hall.

Moss Kanter, R. & Summers, D. (1987), "Doing Well while Doing Good: Dilemmas of Performance Measurement in Nonprofit Organizations and the Need for a Multiple-Constituency Approach", in *The Nonprofit Sector. A Research Handbook* (Powell, W. ed.), New Haven, CT and London: Yale University Press.

Murnighan, J.K. & Conlon, D. (1991), "The Dynamics of Intense Work Groups: A Study of British String Quartets", *Administrative Science Quarterly*, no. 36, 165–186.

Organ, D.W. & Greene, C. (1981), "The Effects of Formalization in Professional Involvement: a Compensatory Process Approach", *Administrative Science Quarterly*, no. 26, 237–252.

Ouchi, W. (1979), "A Conceptual Framework for the Design of Organizational Control Mechanisms", *Management Science*, vol. 25, no. 9, 833–847.

Ouchi, W. (1980), "Markets, Bureaucracies and Clans", *Administrative Science Quarterly*, no. 25, 124–141.

Pennings, J. & Woiceshyn, J. (1987), "A Typology of Organization Control and Its Metaphors", in *Research in the Sociology of Organizations*, JAI Press, 5, 73–104.

Pettigrew, A.M. (1979), "On Studying Organizational Cultures", *Administrative Science Quarterly*, no. 24, 570–581.

Puffer, S. & Weintrop, J. (1991), "Corporate Performance and CEO Turnover: The Role of Performance Expectations", *Administrative Science Quarterly*, no. 36, 1–19.

Raelin, J.A. (1991), *The Clash of Cultures: Managers Managing Professionals*, Boston, MA: Harvard Business School Press.

Raelin, J.A. (1995), "How to Manage your Local Professor", *Academy of Management Journal*, Best Paper Proceedings, 207–211.

Ramamurti, R. (1986), "Strategic Planning in Government-Dependent Business", *Long Range Planning*, vol. 19, no. 3, 62–71.

Riley, P. (1983), "A Structurationist Account of Political Culture", *Administrative Science Quarterly*, 414–437.

Schein, E. (1973), *Professional Education*, New York, NY: McGraw-Hill.

Schein, E. (1985), *Organizational Culture and Leadership*, San Francisco, CA: Jossey and Bass.

Schön, D. (1983), *The Reflective Practitioner*, New York, NY: Basic Books.

Seitz, Peter. (1988), "Orchestra Planners and Players: Harmony or Dissonance?", Reprinted from the December 1981 issue of Symphony Magazine in *Principles of Orchestra Management*, Washington DC: American Symphony Orchestra League.

Smith, K.G, Smith, K.A., Olian, J., Sims, H., O'Bannon, D. & Scully, J. (1994), "Top Management Team Demography and Process: The

Role of Social Integration and Communication", *Administrative Science Quarterly*, no. 39, 412–438.

Steers, R. (1975), "Problems in the Measurement of Organizational Effectiveness", *Administrative Science Quarterly*, no. 20, 546–558.

Thompson, J.D. (1967), *Organizations in Action*, New York, NY: McGraw-Hill.

Tuma, N. and Grimes, A. (1981), "A Comparison of Models of Role Orientations of Professionals in a Research-Oriented University", *Administrative Science Quarterly*, 187–206.

van Maanen, J. (1975), "Police Socialization: a Longitudinal Examination of Job Attitudes in an Urban Police Department", *Administrative Science Quarterly*, no. 20, 207–228.

Wagner, W., Pfeffer, J. & O'Reilly, C. (1984), "Organizational Demography and Turnover in Top-Management Groups", *Administrative Science Quarterly*, no. 29, 74–92.

Wallace, J. (1995), "Organizational and Professional Commitment in the Professional and Nonprofessional Organizations", *Administrative Science Quarterly*, no. 40, 228–255.

Weick, K. (1995), *Sensemaking in Organizations*, London: Sage.

Wilkins, A. & Ouchi, W.G. (1983), "Efficient Cultures: Exploring the Relationship between Culture and Organizational Performance", *Administrative Science Quarterly*, no. 28, 468–481.

Yin, R.K. (1981), "The Case Study Crisis: Some Answers", *Administrative Science Quarterly*, no. 26, 58–65.

Zeigler, Joseph W. (1991), "Succession and What's Behind It", *Journal of Arts Management and Law*, winter, 57–70.

19

MANAGING A THEATRE PRODUCTION: CONFLICT, COMMUNICATION AND COMPETENCE

Arja Ropo and Marja Eriksson

Artistic and business objectives come together in the management of an arts organisation: this chapter addresses the need for attention to both in theatre management. Like most organisations, a theatre usually employs both strategic and operational objectives. Here we discuss the problems that theatre managers face in trying to meet both of these. Our purpose is to study how the different levels of objectives are addressed within one specific theatre production.

By strategic objectives we mean the long-term goals for the whole organisation which are usually formulated and negotiated by the top management of the organisation. Operational objectives deal with short-term practices carried out normally on a daily and weekly basis by employees. Mainstream management literature assumes that operational objectives are implemented in the context of strategic objectives. In a theatre the selection of a specific type of repertoire, such as choosing between popular comedies and more "sophisticated" plays, is an instance of a strategic objective, while the aim of developing co-operation between the actors, the director, the technical staff and the theatre management constitutes what we term an operational objective.

In order to describe the process of managing a theatre production, it is important first to identify the key participants or players. These include the director of the play, the artistic director, the administrative manager and the performing artists. Second, we describe their interaction in trying to reach the strategic and operational objectives over time (Ropo, Eriksson & Vapaavuori, 1995). In addition, we outline the different phases of the production process. We describe how the key participants perceived objectives in one particular case, how their communication and

commitment evolved and how the emerging conflicts were handled. We suggest that competent theatre managers should appreciate the significance of communication, commitment and conflict resolution in formulating and implementing the strategy of the theatre.

In studying the management of a theatre production in a Finnish theatre, we learned first that successful theatre management calls for an acknowledgement of the focus of commitment of the manager as well as that of the other key participants. In this instance, conflicts arose because different parties were committed to different levels of objectives (strategic and operational). Our second lesson was that conflicts may be solved to some extent through improved communication. However, communication cannot be seen as a general panacea for all the difficulties which arise in managing a theatre production.

LEADERSHIP AND MANAGEMENT OF CULTURAL ORGANISATIONS

In this section, we will discuss some aspects of the leadership and management of cultural organisations (Uusitalo & Korhonen, 1986). We emphasise the need for managerial competence in knowledge-based and service organisations such as theatres (Nordhaug & Gronhaug, 1994; Holmes & Joyce, 1993).

Managing Cultural Organisations

Economists have focused primarily on the financial problems of cultural organisations. Such studies have succeeded in legitimising public funding but it is only since the late 1980s that attention has turned to the internal factors which have an impact on both the artistic and economic success of these organisations. For example, one organisational study has found that the conductor of an orchestra was the most significant variable in explaining concert attendance figures (Uusitalo & Korhonen, 1986; Greckel and Felton, 1986).

An empirical study of Finnish theatres in the late 1980s revealed some of the objectives and counterforces or obstacles at play in the management of cultural organisations. Examination of the operational objectives indicated an emphasis on the high motivation of personnel, high artistic quality, good co-operation, increased audience numbers and economic stability. The strategic

objectives focused on the high quality of repertoires, the development of effective ensembles and the public image of the theatre. The major obstacles encountered by the operational management were bureaucratic attitudes and resistance to change, risk and unpredictability in production and internal conflict. At the strategic level, problems arose from production pressure, difficulties in ensemble creation and negative attitudes on the part of the mass media. The theatre managers who were interviewed were striving toward higher quality work as well as quantitative growth, in terms of audience numbers, income etc. (Uusitalo & Korhonen, 1986).

The same study (Uusitalo & Korhonen, 1986) indicates that artistic goals received more emphasis than financial ones. However, the programme of the theatres showed clearly that compromises between artistic and financial goals were often needed. In spite of their wish to provide an artistically challenging programme, every large city theatre presented a popular musical comedy on its program once a year. Such compromises have become even more common since the economic recession in Finland.

Commitment, Conflict and Communication

A resource-based view in contemporary studies of leadership and the management of business organisations underlines the importance of the development of organisational competence (Holmes & Joyce, 1993; Winch & Schneider, 1993). This is particularly true of labour-intensive organisations like theatres where the need for renewal calls for a constant emphasis on the importance of human resources and their management. Such renewal is essential in order to attract repeat visits from the audience (Ropo & Eriksson, 1996).

The literature focusing on knowledge-based organisations (e.g. Stebbins & Shani, 1995) also offers an insight into cultural institutions. A theatre is an intense combination of a knowledge-based organisation and a cultural service. Providing cultural services is usually non-routine work involving different types of professionals who constantly face unexpected situations and frequent problems. This is inevitable in organisations which seek to provide the unique experiences offered in musical performances, theatre productions and art exhibitions.

The social subsystem of a theatre is complex. Apart from the usual formal and rational objectives, the different groups in a theatre have a range of personal expectations and ambitions. Such objectives often find expression in policy statements which the theatre management considers to be shared and objective. Stebbins and Shani (1995) suggest that objectives must be discussed jointly before mutual goals can be decided. Experts and knowledge workers tend to be quite autonomous and contemporary management literature raises the question of whether such people can be managed in a traditional way, i.e. through strategic and operational objectives articulated by top management.

Integration of operation (people and activities) is a crucial managerial task in any business. Similarly, integrating people and production is the most challenging task of theatre management and involves above all the effective handling of human resources while striving to attain strategic and operational objectives. In order to show what is involved, we shall describe how leadership competences, such as communication skills, the nurturing of commitment and the management of conflict, contribute to and develop within the process.

This chapter seeks primarily to identify the managerial competences needed to manage a theatre production. By competence we mean the knowledge, skills and capabilities which individuals, teams and the organisation develop over time. Such competence is a collective organisational capability (Eriksson and Ropo, 1994; Ropo, 1989). The success of an organisation in achieving its strategic and operational objectives is influenced by such structural factors as control and decision-making and human resource issues such as selection and rewards. Collective organisational capabilities cannot be reduced to the individual or functional (e.g. marketing, finance) knowledge and skills by which competence is traditionally defined (Nordhaug and Gronhaug, 1994). In our view, collective organisational capabilities develop over time as the organisation, its structure and its people work together to seek better outcomes.

JAKE'S WOMEN — MANAGING A THEATRE PRODUCTION AT THE TAMPERE THEATRE

In this case study, we illustrate the above theoretical perspectives by describing the actual management of one theatre production in

a major Finnish theatre, the Tampere Theatre. The play is called *Jake's Women*.

The Theatre Tradition in Finland and the Tampere Theatre

In contrast with the growth of theatre in many other European countries where it had its beginnings in the royal courts, the theatre tradition in Finland has its origins in folklore. Theatre in Finland developed in tandem with the formation of the national identity and the Finnish language, becoming a public institution after the Second World War. Nowadays, the theatre is viewed as a public cultural service: 2.3 million tickets were sold in the country in 1994 (total population: 5 million). In the past few years, with drastic public funding cuts in all sectors, management pressures have increased also in theatres.

The city of Tampere (population 170,000) is acclaimed for its cultural activity, especially theatre: every fourth theatre ticket in Finland is sold in Tampere. *Jake's Women* was produced in the Tampere Theatre (TT), one of the two big theatres in the city. (There are ten theatres in all in Tampere which hosts an International Theatre Festival every summer.)

The two main theatres produce very different types of plays. The Tampere Theatre retains a broad repertoire: comedies, musicals and more serious work, while its main rival has historically adopted a more critical perspective and focuses more on "serious" theatre with an important social mission.

The Tampere Theatre has almost 100 employees: 30 actors, 35 technical or administrative staff and about 40 others. The budget of TT is FIM25 million (*c.*£3 million), of which *c.*FIM5 million comes from the government (*c.*£0.6 million) and FIM11.2 million (*c.*£1.4 million) from the city of Tampere. One-third of the budget comes from ticket sales. In 1994, over 80 per cent of all the tickets were sold.

The Tampere Theatre has a board of directors, a theatre manager and an administrative manager. The theatre manager is the artistic director and also an actor. These key players (the artistic director and the administrative manager) manage as a team at the Tampere Theatre, making most decisions jointly. This involves choosing the plays, the directors and the actors. The artistic director is the public figurehead of the theatre while the administrative manager concentrates on operational management. It is customary to recruit free-lance directors for each new production.

About the Play

Jake's Women by Neil Simon relates the story of a middle-aged man's relationships with the important women in his life: his ex-wife, wife, mistress, daughter, sister, mother and psychiatrist. The play gives a rich insight at several levels into the life of a "post-modern" man. The main character, "Jake", has the capacity to "call" each of the women to the scene, either from the past or the present, to communicate with them and let them communicate with each other. The line between real time and fantasy, between past and present is vague. It is funny, sad and touching, all at the same time.

Rehearsals began in September 1993. Interrupted shortly after, they recommenced in October 1994. The first-night performance was at the beginning of December 1994.

Initiating the Process — Choosing the Play and the Director

Objectives and Expectations of the Administrative Manager. The administrative manager of the Tampere Theatre saw the play in New York during the summer of 1992. Plays are normally suggested by dramatists, directors or the artistic director. In this case however, the administrative manager considered the play would fit well with TT's repertoire. He had the manuscript read and accepted by the artistic director who then acquired rights and commissioned a translation.

The primary reason for choosing this particular play was the opportunity it offered to the lead actor, who would otherwise not have had any challenging roles in the following season. It also offered good roles to many of the actresses in the theatre.

The artistic director sought a director for *Jake's Women* at rather short notice. The managers thought that the director should ideally be a man with experience in directing comedies.

The administrative manager of Tampere Theatre (TT) deals with three kinds of plays: first, those that absolutely must succeed; second, those that are not expected to succeed — in financial terms, that is — and third, plays that have the potential to succeed if they are carefully prepared (i.e. if the production process is properly managed and there is full co-operation between the different players). He believed that *Jake's Women* belonged to the third category and the play was expected to easily have more than forty performances, after which the theatre would make a profit.

Objectives and Expectations of the Artistic Manager. The artistic director's main aim is to provide valuable experiences for and to give pleasure to the audience. More challenging, sophisticated works with higher artistic intent and which attract a smaller audience are financially possible only on the surplus delivered by more profitable plays. Therefore, the Tampere Theatre tries to serve different types of customers.

> This theatre institution justifies its existence as a service institution but the financial support, without which we would not exist at all, should not be cut so tight that we cannot do any lyrical plays. That is why I am not afraid of making money with some plays; we do it to be able to produce more artistic works. Of course, we also try to succeed financially with these artistic plays and naturally to get big audiences. It happens sometimes but more often it doesn't (*Artistic Director*).

Mutual Objectives and Expectations of the Administrative and Artistic Managers. Neither of the managers set any high artistic objectives for this play. They expected it to be an entertaining comedy, which would also give people some food for thought. Their first major concern was to find a director for the play and preferably a man because they felt that a male director would have a better understanding of the mind of the key male charac-ter. However, because of the tight timing and also because a fe-male director personally contacted the theatre managers, the managers decided to hire her in February 1993. They had no per-sonal experience of her earlier work but she came recommended by people in other theatres. She had worked as a freelance direc-tor mainly in Helsinki. The managers discussed their expectations for the play with the director and told her that they had looked in the first instance for a male director. She was encouraged to em-phasise the male perspective in her direction.

Objectives and Expectations of the Director. The director had found the text interesting because of the contemporary nature of the play, dealing as it did with the problems of modern people. However, her attitude to the play differed to that of the managers in that she was interested in directing a drama — not merely pre-senting an entertaining comedy.

> I phoned the theatre manager and he asked me to read the play. . .
> Today one must make do with almost any kind of play (because
> there is so little work). When I read it, I thought it was not so bad.
> So I said that I'd do it. . . . I regard myself as a serious theatre di-
> rector: I am definitely not interested in doing musicals or specta-
> cle-type plays. . . . I hate comedies, I think they are disgusting. Of
> course a play may have some funny scenes but I hate when people
> try to make a comedy: it is usually so stupid and unchallenging for
> the audience (*Director*).

The director did not want to have anything to do with the budget
or money. Neither was she interested in proposals which would
make the play easier for people to understand. Seeing herself as
an artist, she did not want to compromise her artistic goals:

> . . . in some small theatres I may be told that I'm not allowed to
> spend any money but in these bigger theatres, which I classify as
> professional ones, I don't have to have anything to do with that
> kind of thing, thank God. . . . Sometimes I get very cynical I admit
> and wonder if they really have to bring in the kind of audience
> which doesn't get anything out of this performance. . . . No, I can-
> not even think that way! (to work to please the average audience).
> . . . many people have said to me . . . don't do it like that because it
> is so hard to understand but I cannot give in. I'm not the type! I
> would have no self-respect left! (*Director*).

The director did not consider the managers of the Tampere Thea-
tre her bosses in any traditional sense. She expected to be given
artistic freedom. However, she would expect some feedback dur-
ing the production process.

> When I think of the plays I have directed, I usually have been
> given a free hand. No-one ever checked what I was doing or told
> me what to do next or how to do it. I was given this freedom . . . at
> TT, too . . . feedback is most welcome. One needs support or at
> least some ideas . . . ideally during the process while you still have
> a chance to play with things (*Director*).

By opening night her job is done but she attends some of the per-
formances so as to keep an eye on the general direction of the
play. Her job is to see to the big picture, to make the actors work
well together and to take charge of the production.

FIGURE 19.1: OBJECTIVES AND EXPECTATIONS OF THE KEY
PARTICIPANTS

Key Participants	Objectives and Expectations
Artistic Director	• To find a play that matches the repertoire of TT (entertainment) • To find a play that the audience likes (funny, offers experiences) • To find a suitable director for the text (a male director who understands the mind of a man and gets the "comedy" out of the text) • To find interesting and ambitious roles for the actors (to keep them competent and professionally ambitious)
Administrative Manager	• To find a play that matches the repertoire of TT (entertainment) • To keep the actors and actresses employed • To find a suitable director for the text (a male director who understands the mind of a man and gets the "comedy" out of the text) • To keep the play within budget (so that it is realistic to expect profits) • To increase the theatre ticket sales
Director of the Play	• To deliver the message of the play (man in a mid-life crisis) • To foster the confidence of the audience (that dealing with the complications of life is possible) • To give a deep aesthetic experience

Role Distribution

Having agreed the play and chosen the director, the three key players (administrative manager, artistic director and the director) discussed the distribution of their respective roles. As shown in Figure 19.1, the artistic director and the administrative manager had two sets of objectives for the performing personnel of the theatre: first, the artistic director wanted to provide challenging roles for the company members in order to maintain and foster their professional competence. At a more basic level, he and the

administrative manager had to look after the employment of their artists. The actors and actresses were on a monthly payroll which presumed a certain number of appropriate roles. Furthermore, they wanted to find a role which would act as a suitable vehicle for a particular male actor (a so-called star) at the theatre.

The artistic director and the administrative manager made some suggestions about roles which the director of the play broadly accepted. The director did not have any direct experience of the actors and actresses at the Tampere Theatre nor did she know the managers of the theatre. There was some discussion of the personal problems the star-actor had had in the past.

> It is always very difficult for me as a visiting director to immediately see how the actors work together and what they are like . . . sometimes the co-operation works but you never know in advance (*Director*).

The First Rehearsal

Rehearsals began in autumn 1993. After four weeks serious communication problems arose. The star-actor suffered a burn-out as a result of the pressure of rehearsals. As the only man on the stage, he felt he was being put down and criticised by the female actresses. The director commented on the situation in the following way:

> It is totally alien to me that an actor can say that a role is too close and that he cannot handle it. In this profession you must be able to play anything from incest to making soup. It is intolerable that you just won't play something. It can be tough, it can be hard and miserable but that is what it is to be an actor (*Director*).

The rehearsals and the first night had to be cancelled. The theatre could not take any risks with the star-actor who had an important role in another comedy, the most successful play at the Tampere Theatre at the time. The director felt her relationship with the actresses was very positive. However, according to the manager, when the play was cancelled some of these had also expressed relief.

Break in the Rehearsal

The administrative and artistic manager did not want to drop the play in spite of the difficulties in arranging an alternative first-night and in replacing the male lead. Finally a suitable actor who was known both to the Tampere Theatre and to the director was engaged from a Helsinki theatre. His contract was just for this particular play and it was agreed that he should get an extra fee after the first forty performances. Since three of the actresses had by now started new roles, these also had to be replaced.

New Rehearsals and the First Night

Rehearsals began again in October 1994. The seven-week rehearsal period to opening night was short but already a lot had been achieved.

> When you get together for the first rehearsal, you already have the big picture in your head; you have got everything ready to a certain point (*Director*).

However, problems arose again in the relationships between the director and the actors. Though the administrative manager found the new star-actor most polite, flexible and professional, there were some disagreements between him and the director.

> I tried to be nice and I always tried to make things clear with good humour. He did not refuse to do what I wanted but he was not enthusiastic. . . . Even the actresses noticed and asked me if he had something against me. I said yes but I don't know why. I did not want to make a big deal out of it; I just said that we must get on with our work . . . (*Director*).

The actor favoured a naturalistic style of comedy while the director wanted to use more ambitious, surrealistic means of getting across the meaning of the play.

> In the first reading rehearsal I explained that this play mostly takes place in Jake's mind; that is why we cannot be very realistic . . . we can move in time freely without, for example, the lights showing the shift from imagination to realism. . . . A Finnish actor is surprisingly much attached to naturalism or realism. . . . It is impossible to say that the cow is in a tree. . . . For an artist nothing should be strange . . . of course the cow is in a tree (*Director*).

Problems accumulated as the production process got more com-
plicated. The technical staff indicated that they had problems
with the visual designer who had been brought in by the director.
According to the set makers it was difficult to agree on what was
possible on stage. The stage manager felt that the director could
not communicate her vision to the work group. Furthermore, he
(the stage manager) complained that she did not avail of the ex-
pertise of the technical staff. Consequently these were left feeling
like outsiders. In the stage manager's opinion, better communica-
tion was needed.

The director found it difficult to get to know the people in a
new theatre and to establish co-operative working arrangements
within a few weeks. She was used to a lot of autonomy in her
work and was grateful to both the administrative and artistic
managers for not interfering in the production process. At the
same time she knew that some actresses had complained about
her.

> I think that the theatre managers had to listen to complaints about
> me but I respect them for not telling me that (*Director*).

The first night took place at the beginning of December 1994. The
performance was sold out and the critics were positive.

OUTCOMES OF THE PRODUCTION PROCESS: COMMITMENT AND THE NEED FOR CONFLICT RESOLUTION THROUGH COMMUNICATION

Commitment to Strategic Objectives

The choice of play is a key strategic decision in the theatre, as is
the choice of director. Advance publicity on who is going to be the
director of a particular play moulds the expectations of the audi-
ence; it is also indicative of the artistic intent of the theatre. In
addition, at a strategic level, a city theatre must ensure that its
personnel are employed. These aspects of theatre management are
bound up with the long-term economic success of the theatre.

In this case, the play *Jake's Women* was chosen because it was
entertaining enough to be presented as a comedy but it also had a
postmodern message. In addition, it offered a challenging role for
the star-actor and suitable roles for the TT actresses.

Commitment to Operational Objectives

As pointed out above, the operational objectives of theatre management include achieving a high artistic quality in each production, high motivation of personnel, good co-operation and a balanced budget.

In *Jake's Women*, the director found that she could not quite reach her goals but given the circumstances, she was satisfied:

> You can never be totally satisfied. It could have been better, Jake could have been more affecting . . . in seven weeks you cannot get the actors aligned. . . . But the play was as ready as it could be on the first night. I don't think it would have got any better. There are certain things I don't like but it didn't help even though I explained a hundred times about them. When you are preparing a live performance you work through people: they are your "tools", in a sense. I don't think anyone ever directed a play perfectly . . . of course, there are moments (*Director*).

The director was rather satisfied with the artistic outcome. She understood that it is difficult to achieve a deep commitment from the actor and the actresses in such a short time and under the leadership of an outside director.

Meanwhile, the marketing staff were unhappy. The marketing of the play had begun well in advance. In order to ensure that an appropriate image of the play was presented, the director wanted to be involved in the planning of the marketing strategy. The marketing people had attended rehearsals to get a sense of the idea and the style of the play.

> I hoped that the marketing people would attend the rehearsals. It is hard to sell something you don't know anything about (*Administrative Manager*).

The director of the play and the visual designer checked all the marketing material. The director wanted everything to be in line with the performance:

> I told the marketing staff that I had agreed with the visual designer that he would take part in planning and preparing all the marketing material — to make sure that it looked as the director wanted. Some timetable problems occurred . . . when we needed material, he was occupied elsewhere (*Administrative Manager*).

However, the marketing staff found that they did not reach the goals they had set themselves. The marketing of the play had succeeded in awakening the initial interest of the public but after the first performance the play did not sell as well as expected.

> Now our marketing team should be able to segment the audience. I think the people who have seen the performance do look happy afterwards. I have heard very positive comments on the play and negative feedback claims mostly that the play itself was dull (*Administrative Manager*).

After initial feedback, greater flexibility of response or a change in tack by the marketing team might have produced better results.

Resolution of Strategic and Operational Counterforces

Strategic Counterforces. The counterforces which operate at a strategic level in cultural organisations are linked with the difficulty in maintaining both artistic and economic viability in the long run. There are two main problems: first, where does the money come from for theatre productions and second, where do the ideas come from for plays? These give rise to production pressures, difficulties in effective ensemble creation and the transmission of a positive public image, and create inherent conflicts in the management and production of plays.

Jake's Women received positive feedback from the media. However, sales were low and after only ten performances, the run had to be cancelled. The impact on sales of the positive critical reception seemed to be the opposite to what one might expect, a paradox which has been noticed many times before.

> It looks like the play will have to close this spring (1995), though we had planned showing it until the autumn . . . we probably will make no profit (*Administrative Manager*).

Operational Counterforces. Obstacles at the operational level include the bureaucratic attitudes of the artistic personnel in city theatres, as well as resistance to change both among the theatre personnel and the public. There are always risks with different productions and internal conflicts are common.

A theatre production is based on a contractual agreement between the theatre managers and the director. If the managers are not satisfied with the style of a director, they are not able to

replace them because the contract is regulated by copyright law. This protects the director so that no other director can come and change the play. Furthermore, the director's fees cannot be linked to the number of performances.

> I would like to make salary-based contracts with directors. They would get extra money if the number of performances exceeds the contract. I think it would be only fair if a director committed to a certain number of performances. If they think that the play would not be so successful, they simply wouldn't sign up (*Administrative Manager*).

There is little control over the rehearsal period.

> We control the rehearsal period only through the timetables and the bills. We do not interfere with the content in any way. . . . It is our duty to find a director who is competent. . . . We accept all the basic solutions the director makes (*Administrative Manager*).

In *Jake's Women* the attitude of the male star proved a major problem. Communication between the director and the male lead on the one hand, and between the male actor and the actresses on the other, did not work. It seems that the genuine interest on the part of the managers in the production process was not responded to by the director:

> I got the actresses to commit and be positive but the male actor was so negative. . . . The ideal situation would be that the work group becomes so collaborative that it no longer matters who brings the ideas and nobody would be jealous. . . . When I met the administrative director during the rehearsal period he asked me . . . how we are doing. I said fine, thank you. That is what I always say if there is a major catastrophe. . . . I don't rock the boat (*Director*).

The artistic and administrative manager found that communication with the director during the rehearsal phase was rather superficial.

> You cannot say anything straight, they always say yes, yes but nothing happens . . . she (the director) said many times, yes, this is a comedy, what we now are doing, she understands . . . (*Administrative Manager*).

The views of the managers and the director about the role of control and feedback also hindered the production. The contractual agreement leaves the managers with little discretion in this area.

> The only thing you can do [if you see the direction is lousy] is stop the production. You must pay the bills but cancel the performances. . . . The director has the law on his or her side. I cannot change the work the director has already done. If he or she doesn't change his or her opinion when I ask nicely . . . so then we must decide whether the play is performed or not. There are cases when it absolutely would have been wise not to perform the play but it still would have been too rough to stop the process. [In Finland] you cannot control [the rehearsal period]. Because our product is abstract, it is very difficult to say anything about it until it is ready. It may change totally and become a good play during the last rehearsal week . . . but on the whole I think that if you see that the play doesn't work a week before the first night, you should have the courage to cancel it. When a manufacturer sees that a product is poor he doesn't send it to the shop. It would call for a real catastrophe to stop the production of a play (*Artistic Director*).

The director would have liked more feedback from the managers of the theatre:

> One often feels exhausted and blind (during the production process) . . . when someone comes and gives you an idea, you feel grateful. When you are deeply involved in your work you may easily miss even important hints. . . . I have found that feedback meetings (in other theatres) help to build my confidence; one can get suggestions and think them through and decide whether to use them or not. For instance the artistic manager only came to the first night. The administrative manager came to follow the rehearsals and left in the middle. . . . I welcome feedback from knowledgeable people and value the experience of working together for the common good . . . but when someone comes in and leaves without a word, you feel uncomfortable . . . was it so horrible to watch? (*Director*).

The difference in artistic intent between the managers and the director is also a potential area of conflict. A director wishing to develop their capabilities will want to do more difficult and more sophisticated plays. The Tampere Theatre has no permanent director and therefore must shop around for different competences. The alternative is to develop in-house competence in theatre direction. The present situation means that the theatre cannot

develop a house style or even be sure that the play they get is the one they wanted.

> There are too few directors who are interested in directing plays the audience likes and far too many directors who are very good but interested only in directing the plays the audience avoids (*Administrative Manager*).

The director of *Jake's Women* later evaluated the rehearsal process. She found that the managers believed in the capacity of TT to produce comedies but they seemed to disagree about what comedy theatre is. The managers regarded the image of a comedy theatre as a strength but at the same time they felt that this genre might not be sufficiently challenging in terms of their role in developing the professional competence of the artists. There have also been some signs that the public is ready to accept more challenging genres. Furthermore, the director sees that the theatre managers are somewhat ambiguous about new work: they expect something new and at the same time are afraid that the audience will reject the new genre.

> Everybody expects something new and when something fresh is started, then comes the fear . . . am I able to do this? And that fear is expressed in the form of being afraid of being rejected by the audience (*Director*).

CONCLUSIONS

To improve our understanding of theatre management, we studied the production process of *Jake's Women* at the Tampere Theatre. We examined how the theatre tried to reach its artistic and business objectives at the strategic and operational level. We have described how the process was initiated, i.e. how the play and the director was chosen, how the roles were distributed and how the rehearsal process divided into three phases: the first rehearsal period, a break in the rehearsal and the new rehearsal period that reached the first night. We identified and described both the strategic and operational objectives and the expectations of the key players. Furthermore, we analysed the outcomes of the process and how they were reached. During the process, we focused on commitment to objectives and the need for conflict resolution through communication between the main players.

In this case the play did not turn out as expected. The outcomes did not meet the expectations of the key participants: the play was not as affecting as the director had wished; it was not the financial success which the administrative manager had hoped for; nor did it turn out to be as challenging to the actors and actresses as the artistic manager had expected. Both leading actors failed to co-operate with the director. In our opinion, the roots of these difficulties and disappointments lay in the fact that the director was an outsider who made little effort to commit to the management team and the Tampere Theatre in general and who was mainly committed to her own professional ambitions.

In conclusion, we feel that the objectives of the key players were in conflict from the beginning. It is obvious that the managers of the Tampere Theatre had nothing against the ambitious artistic objectives of the director at the operational level of directing the play. Neither did the director have any intention to scupper the financial objectives of the play. It was rather that the type of play did not suit the approach and modus operandi of the director. This suggests that there is a need for greater care in recruiting a director who can help to realise the formal objectives of the theatre management.

Even though many expectations were not met, there were several positive outcomes: the critics liked the play and the audience for the most part found it affecting and entertaining. Though it did not create a profit, it was not a financial loss for the theatre. However, the important lesson is that the capabilities of individuals and groups were not fully utilised. In other words, though a collective competence among the female actors seemed to develop during the process, this was not enough to make the play a success. Competence should have developed across the entire team. In this case, the female actresses should perhaps have been more sensitive to the emerging conflict between themselves and the male star-actor. A more perceptive approach and greater involvement on the part of management would have helped to ease the situation.

Successful theatre management calls for competence in distinguishing between strategic and operational objectives and their relationship to commitment. In this study, we found that the strategic and operational objectives worked against each other and were not in accord with the subjective expectations of the key players. Because of an inability to identify and to clarify the dif-

ferences in these objectives, the key players were committed to different things. As a result, conflicts emerged. Competence was needed to resolve the conflicts but the participants were not able to communicate and communication was also hindered by the different views on the level of co-operation needed during the process.

However, it must be recognised that communication has its limitations in solving such conflicts. There are at least two types of conflicts apparent in this case: structural and interpersonal. Structural conflicts arise as a result of problems with organisational hierarchy and the status and control over resources which goes with it. These types of conflicts are seldom resolvable through communication alone. The competence to deal with this calls for a holistic understanding of the organisational context and the managers' need to be sensitive to the various subsystems of the organisation.

We have indicated in this chapter that for an arts organisation in particular, the relationship between strategic and operational objectives becomes problematic at the implementation stage, as for example in the production of a play. Based on this, we wish to emphasise that a competent theatre management team should have artistic knowledge, skills and understanding in order to be fully sensitive to the internal dynamics of the theatre and to be adept in the effective handling of the complex interrelationships which are part and parcel of the art form.

References

Eriksson, P. & Ropo, A. (1995), "Managing International Brands: A Process of Competence Building", School of Business Administration, University of Tampere, Series A3: Working Papers 24.

Greckel, F. & Felton, M. (1986), "Price and Income of the Demand in for Arts: The case of Louisville", IV International Conference on Cultural Economics, 12–14 May, Avignon, France.

Holmes, L. & Joyce, P. (1993), "Rescuing the Useful Concept of Managerial Competence: From Outcomes Back to Process", *Personnel review*, vol. 22, no. 6.

Nordhaug, O. & Gronhaug, K. (1994), "Competences as Resources in Firms", *The International Journal of Human Resource Management*, vol. 5, no. 1, February.

Ropo, A. (1989), "Leadership and Organisational Change", Acta Universitatis Tamperensis, ser. A, vol. 280, University of Tampere.

Ropo, A. & Eriksson. M. (1996), "Conflicts and Commitments in Managing a Theatre Production: Learning from Unusual Events in an Unusual Context", School of Business Administration, University of Tampere, Series A3: Working Papers 27.

Ropo, A. Eriksson, M. & Vapaavuori, E. (1995), "Managing a Theatre Production: A Processual Competence Perspective", Paper presented at the Third International Conference in Arts Management, 3–5 July, London, UK.

Stebbins, M.W. & Shani (Rami), A.B. (1995), "Organisation Design and the Knowledge Worker", *Leadership & Organisation Development Journal*, vol. 16, no. 1.

Uusitalo, L. & Korhonen M. (1986), "Management of Cultural Organisations", Helsinki School of Economics, Working Papers, F-157.

Winch, G. & Schneider, E. (1993), "Managing the Knowledge-Based Organisation: The Case of Architectural Practice", *Journal of Management Studies*, vol. 30, no. 6, November.

INDEX